AMERICA
A HISTORY IN ART

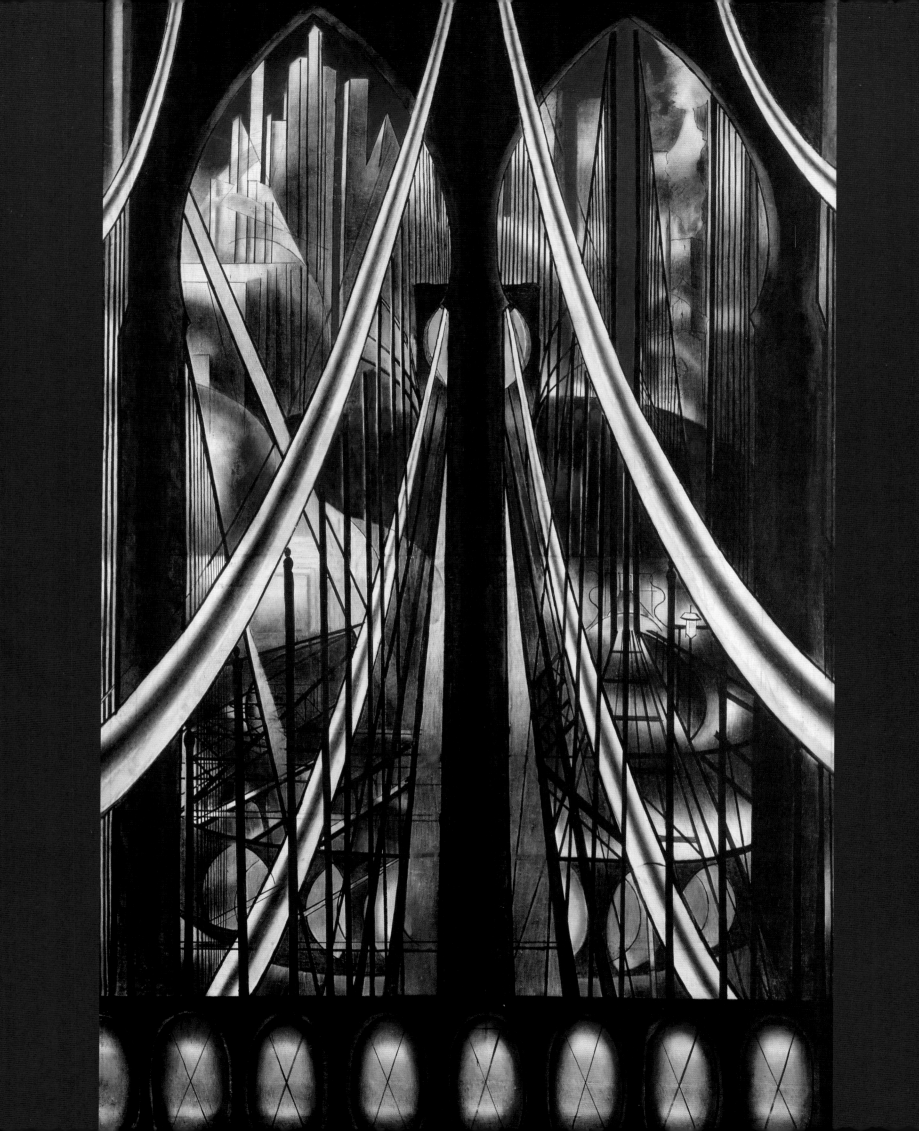

As we look to the past, America's history is both framed and reflected in our art and architecture. This year, we chose to share with you a book that places life and art side by side, *America: A History in Art.* The author, William G. Scheller, examines America's progress and establishes a context for understanding and interpreting the influences that helped shape our country's creative expressions. America's painters, sculptors, photographers and architects have interpreted our nation's most defining moments in ways that can enlighten and inspire.

America has a long tradition of resilience and resourcefulness. Our liberties allow for open and vigorous debate, where every voice can be heard. It is the way we work through challenging times that defines who we are, as individuals, as members of communities and as a country. As we look to the future, we can only imagine the art and architecture that will emerge.

At Packaging Corporation of America, we know it is a privilege to have "America" as part of our name. We strive to earn and share that privilege with all the people we serve, those entrusted to our care. We value innovation, loyalty and delivering on our promises. Our relationships are central to everything we do.

Thomas A. Hassfurther
Executive Vice President
Packaging Corporation of America

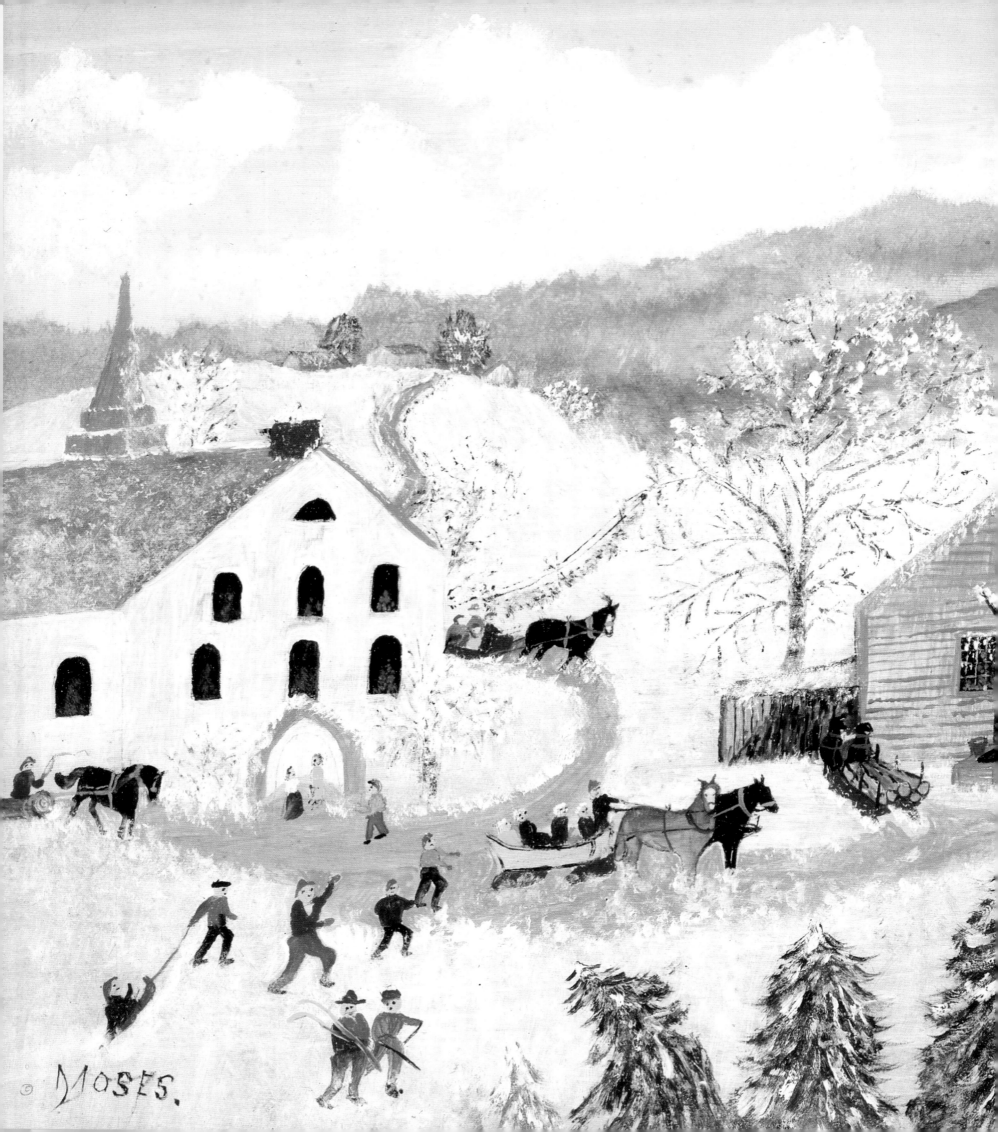

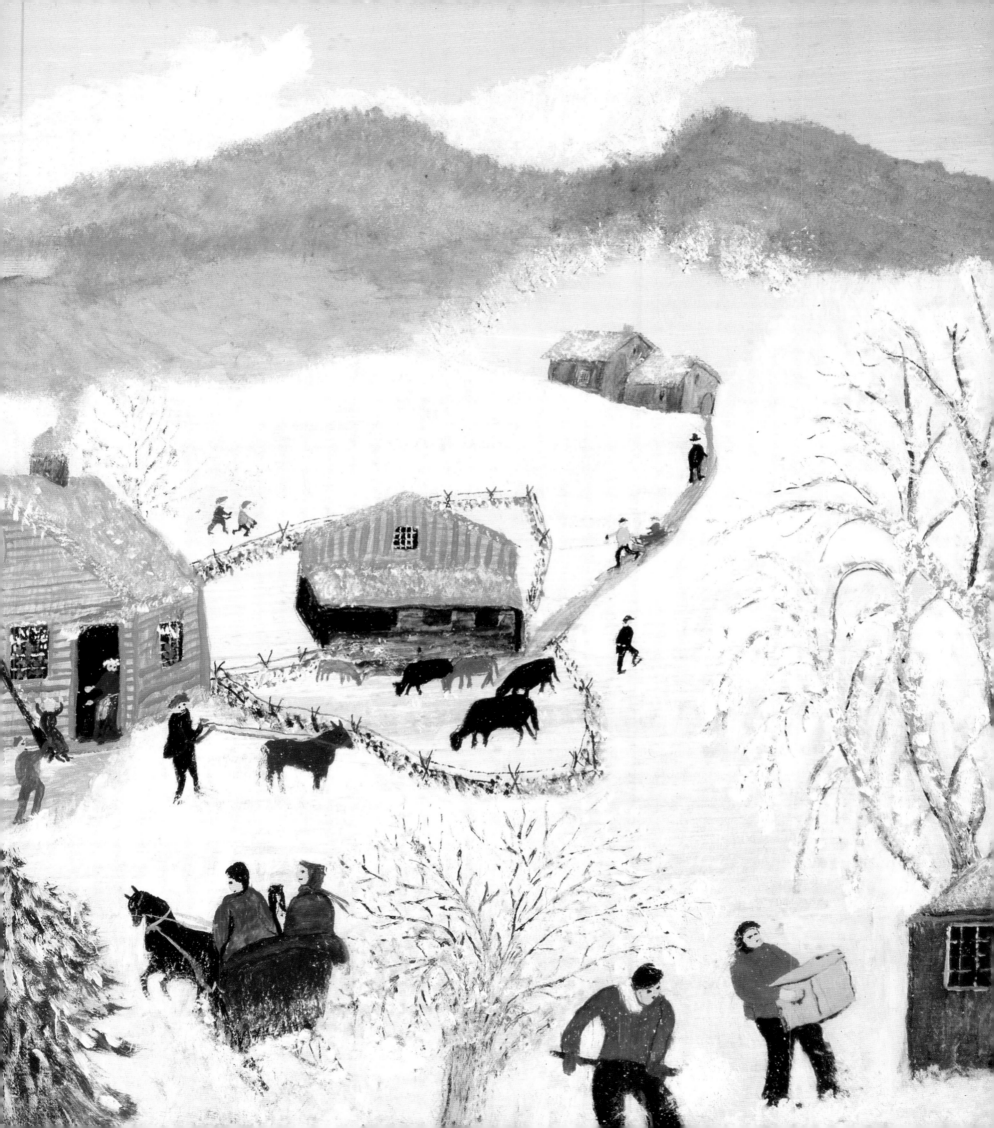

Project director and photo editor: Ellin Yassky/
Medici Editorial Services, LLC
Cover and interior design: Ziga Design, LLC
Copy editor: Deborah T. Zindell

Art credits appear on page 320, which constitutes an extension
of the copyright page.

Manufactured in China

Published by
Black Dog & Leventhal Publishers, Inc.
151 West 19th Street
New York, New York 10011

Distributed by
Workman Publishing Company
225 Varick Street
New York, NY 10014

g f e d c b a

Library of Congress Cataloging-in-Publication Data

America, a history in art : the American journey told by
painters, sculptors, photographers, and architects.
 p. cm.
 ISBN 978-1-57912-779-4
 1. United States--History. 2. United States--In art.

E169.1.A71865 2008
973--dc22
2008019342

ACKNOWLEDGMENTS

No book of this breadth and scope—especially one in which
text and images complement each other in such a complex
fashion—could possibly be the work of a single individual.
From the beginning, I have benefited immensely from close
collaboration with editor and project manager Ellin Yassky,
whose trained eye and background in art history enabled her to
select those paintings, photographs, sculptures, furnishings, and
decorative works best able to illustrate the long and richly
textured story of America's origins and growth. Copy editor
Debby Zindell gave a close, understanding, and constructive
reading to each chapter as it was completed. Charles Ziga, the
book's designer, excelled at the never easy task of bringing text
and illustrations together in a seamless and visually appealing
style, allowing neither to overwhelm the other.

 Finally, I would like to thank J. P. Leventhal and Laura Ross
of Black Dog & Leventhal for the vision and enthusiasm they
brought to this project.

—William G. Scheller
Waterville, Vermont
May 2008

PAGE 2: **Joseph Stella** (1877–1946)
The Voice of the City of New York Interpreted: The Bridge. 1920–22.
Oil and tempera on canvas, 88 ½ x 54 in. (224.8 x 137 cm).
Collection of The Newark Museum, Newark, New Jersey.

PAGES 4–5: **Grandma Moses** (1860–1961)
Deep Snow.
Private Collection.

OPPOSITE: *"Liberty" Hand and Torch, Displayed at the 1876 Centennial
Exhibition.* Ca. 1876.
Library of Congress.

PAGE 8: **E. Sachse & Co.** (fl. 1845–80)
Settler's First Blockhouse. Ca. 1870.
Chromolithograph.
Library of Congress.

PAGE 9: **Bertrand R. Adams** (1907–94)
Lumbering in Arkansas (Mural study, Siloam Springs, Arkansas,
Post Office). Ca. 1940.
Oil on paperboard, 11 ⅝ x 28 in. (29.5 x 71.1 cm).
Smithsonian American Art Museum, Washington, D.C.

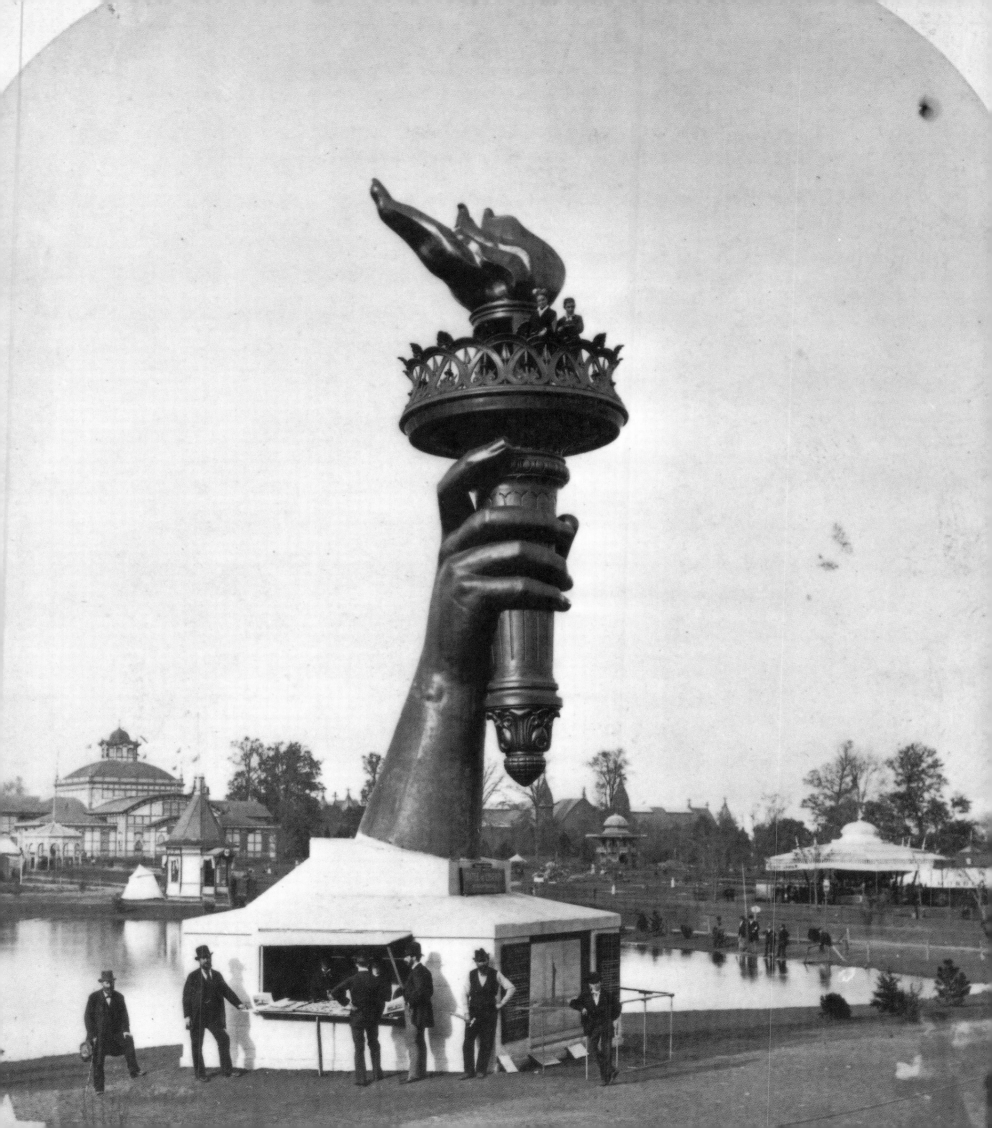

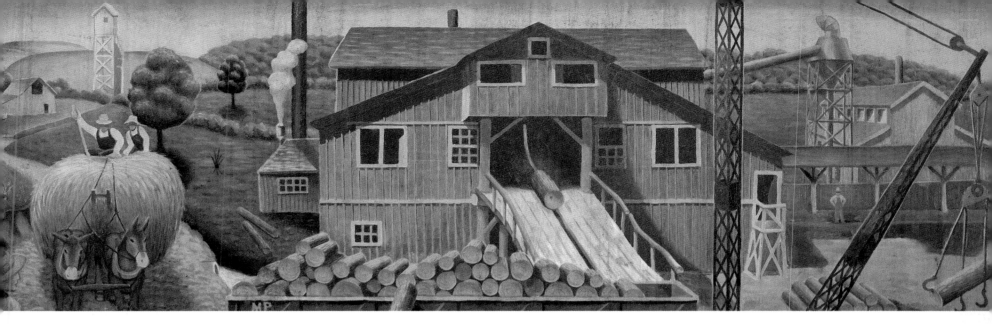

CONTENTS

INTRODUCTION
The Quest for an Independent Vision

The progression of America's history, and the development of its tastes and ideals in the arts, may not have proceeded in lockstep but have nearly always been linked in reason and theme. The United States has been since its inception—indeed since long before its inception, when it wasn't the United States at all and showed no promise of ever so becoming—a study in the balance of pragmatism and idealism; of stubborn cultural independence and slavish devotion to the foreign; of conservatism and experimentation. This has held true in the fine arts, in architecture, and in design, as well as in broader cultural fields.

For the first Americans, there was of course no question of foreign influences, or of an aesthetic that could ever be divorced from the purely practical. Function as the absolute dictator of form is evident in the pueblo dwellings of the Southwest, in the longhouses of the Northeast, and in the teepees of the nomadic tribes of the Great Plains. Color and design were seldom absent from the natives' utilitarian objects, but the key word is *utilitarian*—baskets or pottery enhanced with geometric figuring were baskets and pottery still; and garments intricately ornamented with dyed porcupine quills were first and foremost meant to keep out the weather, unless some ceremonial purpose was served. Figurative art, for American Indians, was primarily narrative, relating mythological events or tribal histories in media such as petroglyphs or painted buffalo hides. History itself,

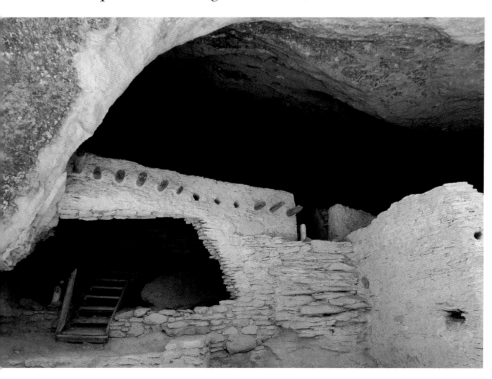

LEFT: *Gila Cliff Dwellings, National Monument, New Mexico.*
The prehistoric Indians of the Mogollon Culture, of which the Mimbres Culture is but one branch, lived in the American Southwest and northern Mexico from approximately 150 C.E. until some time in the 1400s. Seeking the natural protection of the cliff caves, the inhabitants were hunters and gatherers. The natives at the Gila cliff dwellings lived at this spot for only 20 years or so. The reason for their departure is not yet understood.

OPPOSITE: John Singleton Copley (1738–1815)
Self–Portrait. 1780–84.
Oil on canvas, diameter: 18 in. (45.4 cm).
National Portrait Gallery, Smithsonian Institution, Washington, D.C.

At the early age of 28, Copley, who established a Realist art tradition in America—and could be considered colonial America's greatest painter—caught the public's attention in 1766 with the exhibition of his painting *The Boy with the Squirrel.* By 1774, American-born Copley left for London and a tour of Europe to broaden his artistic horizons, eventually establishing his studio in London. Although his heart remained with the colonies, the commissions remained in England. His portraits of John Adams and John Quincy Adams, among other Bostonians, were created during their trips abroad to England.

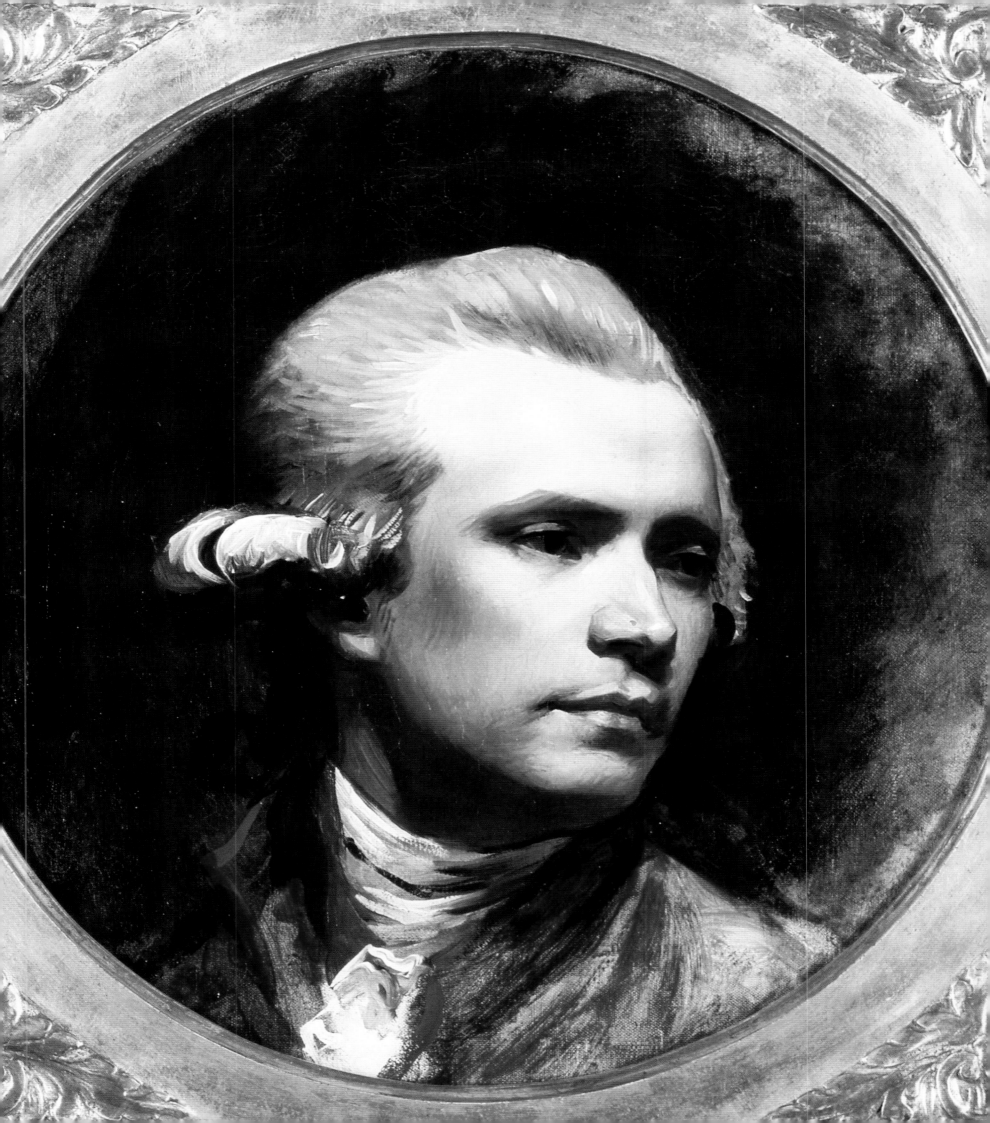

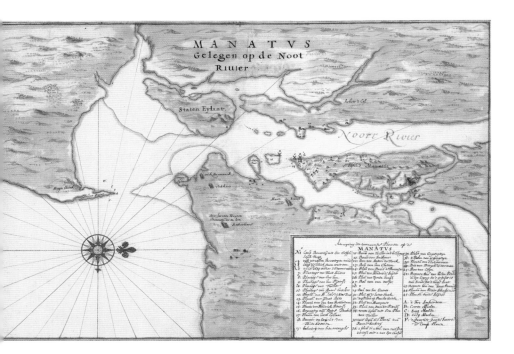

MANATVS
Gelegen op de Noot
Riuier

LEFT: Johannes Vingboons (1617–70)
Manatvs gelegen op de Noot [sic] Riuier. 1639.
Pen-and-ink and watercolor.
Library of Congress.

This annotated map shows the buildings and householders' names in the greater New York area, detailing as well the longhouses of the Lenni Lenape Indians in Brooklyn. The year this map was created, 1639, was marked by the relinquishing of the Dutch West India Company's monopoly on the North American fur trade, thereby allowing colonists to participate in that commercial venture.

BELOW: Charles-Honoré Lannuier (1779–1819)
Card Table. 1817.
Mahogany veneer, white pine, yellow poplar, gilded gesso, vert antique, and gilded brass, 31 1/8 x 36 x 17 3/4 in. (76.2. 91.4 x 45.1 cm).
Gift of Justine VR. Milliken, 1995. The Metropolitan Museum of Art, New York, New York.

Fleeing from the economic unrest and violence of Revolution-era Paris, the French-born Lannuier sought the relative calm and affluence of turn-of-the century New York City. His furniture-making vocabulary was that of refined classical pediments and columns, winged figures and dolphins. The motifs of early-Federal-style art and architecture, among them eagles and pointed stars, along with the plethora of exotic hardwoods, blended perfectly with his classically trained skills as a master craftsman.

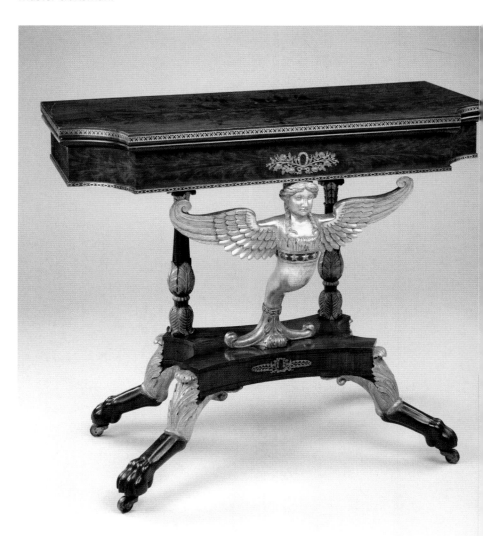

in the absence of advancing technology or foreign invaders, moves at a glacial pace, and changes in native American artistic tastes were likewise immune to sudden transformation. Even after their ultimately disastrous encounters with Europeans, America's native tribes transformed their art primarily through the use of new media—glass beads, new textiles, and the potter's wheel.

When the Europeans did arrive, they brought with them differing ideas of what sort of history they would create, and, less consciously, what sort of art would follow. All came with the cultural trappings of their homelands, and put them to the purposes for which they had crossed the ocean. The Spanish, dedicated to conquest, gold, and the saving of souls, brought the religious art and Baroque church architecture of the Counter-Reformation; the design of their dwellings, born in the heat of Estremadura and Andalucia, translated well in the desert domain they conquered. The French came to trade in beaver pelts, and, secondarily, to save more souls; their homes seemed lifted straight from Brittany, and their religious art, like that of the Spanish, represented the awe and power of Rome.

The newcomers with the purest religious motivation of all came from England, and the souls they were intent on saving were their own. Their flinty brand of Protestantism had no room for art at all, and in fact consciously despised it as frivolity. Their meetinghouses were severely practical in design; and,

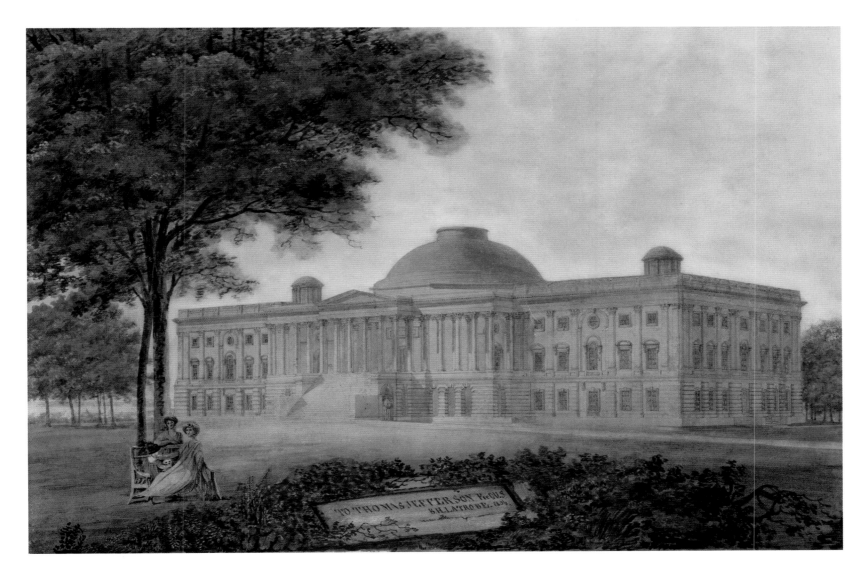

like the French and Spanish, they brought from their homeland their idea of what their dwellings should look like. A scattering of those houses remain, blending into the landscape of New England like imperturbable boulders left by a retreating glacier, and later generations could be forgiven for thinking they had been designed with some minimalist aesthetic in mind, and some Wrightean sense of complementing the local landscape. But they weren't. They were built to hold winter at bay, and keep the godly warm.

The fine arts first appeared in New England in the form of portraiture, representations of persons of high standing in their church and community (the two were inseparable in the seventeenth century), and later of members of respectable families. But the region's resources, and the Puritans' proclivity for demonstrating God's favor through material success, gave rise by century's end to a class of individuals whose respectability derived as much from that

Benjamin Henry Latrobe (1764–1820)
Presentation Drawing of the U.S. Capitol's East Façade. 1806.
Watercolor, ink, wash, 19 ¼ x 23 ¼ in. (49 x 59 cm).
Library of Congress.

In 1803, British-born Benjamin Latrobe took over as chief architect of the U.S. Capitol, this drawing of the east façade showing the Neoclassical influence of the previous four planners. Latrobe renovated the Senate wing and completed the House wing by 1811, only to have it burned by British troops in 1814. A fortuitous rainstorm prevented complete destruction, and by 1815 Latrobe returned to Washington to redesign and make repairs. Famous among his architectural symbols are the corncob and tobacco leaf column capitals, forming a distinctive American order on a par with the classically established Doric, Ionic, and Corinthian models.

success as from piety. Immigrant and native-born artisans were ready to give them furniture and silver, the two media in which eighteenth-century British America was to best reveal its talent in the decorative arts. In a later age, the social critic Thorstein Veblen would coin the term "conspicuous consumption" to describe the veering away from simple utilitarianism

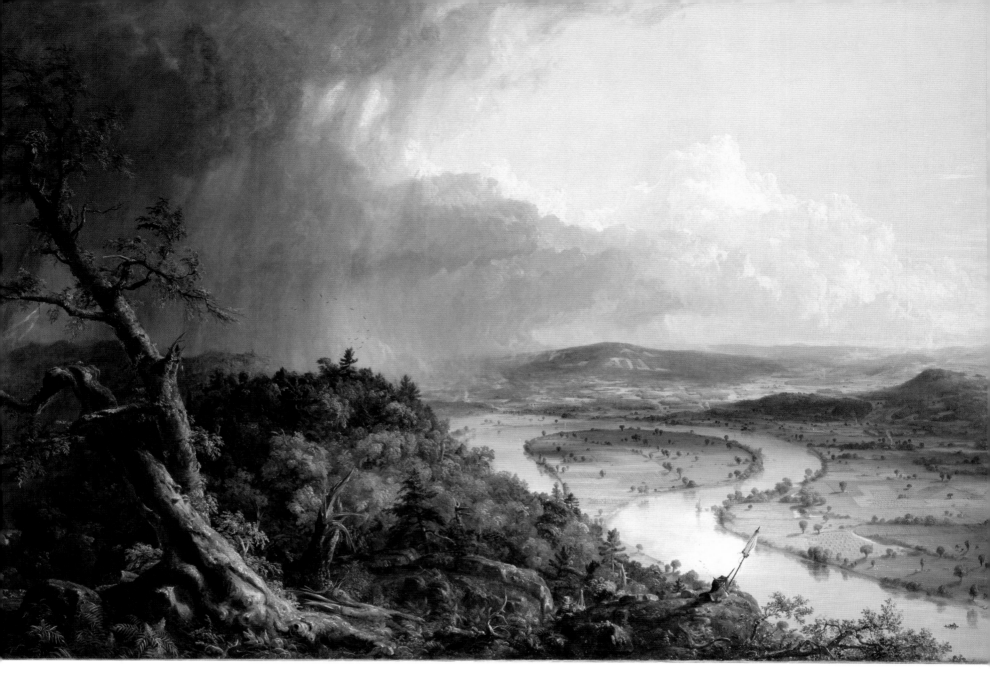

Thomas Cole (1801–48)
View from Mount Holyoke, Northampton, Massachusetts, after a Thunderstorm—The Oxbow. 1836.
Oil on canvas, 51 ½ x 76 in. (130.8 x 193 cm).
Gift of Mrs. Russell Sage, 1908. The Metropolitan Museum of Art, New York, New York.

Heavily influenced by European landscape painting, Thomas Cole depicts a potent, oncoming thunderstorm looming over the looping river, whose form is reminiscent of an oxbow. While the painting may metaphorically speak of the uncontrolled power of nature over civilization, in Cole's own words the scene depicted "a union of the picturesque, the sublime, and the magnificent." This masterful work quieted the voices of European critics who had previously proclaimed that American artists were inattentive to their scenery.

on the part of the comfortable classes. But no merchant princes ever left behind such a gorgeous array of conspicuously consumed walnut, maple, mahogany, and silver. Those ship-owning New England nabobs and Virginia planters left behind images of themselves, as well, by skilled artists such as Thomas Hudson, John Smibert, and the great John Singleton Copley. And when they went to church, it was to elegantly steepled buildings that owed more to Sir Christopher Wren than to the simple idea of keeping out snow and Indians.

That aping of Wren in ecclesiastical architecture was indicative of the first real trend toward consciously importing styles from abroad—after all, the earliest colonists, whether in New England or in step-gabled Dutch New Amsterdam (later New York), built homes that looked like the ones they had left in England because those were the kind of homes they knew how to build. The eighteenth century marked the beginning of a steady succession of borrowed British and continental styles, nearly always arriving with some delay, that continued right on through the influence of French Impressionism on American artists of the late nineteenth century, or of Bauhaus

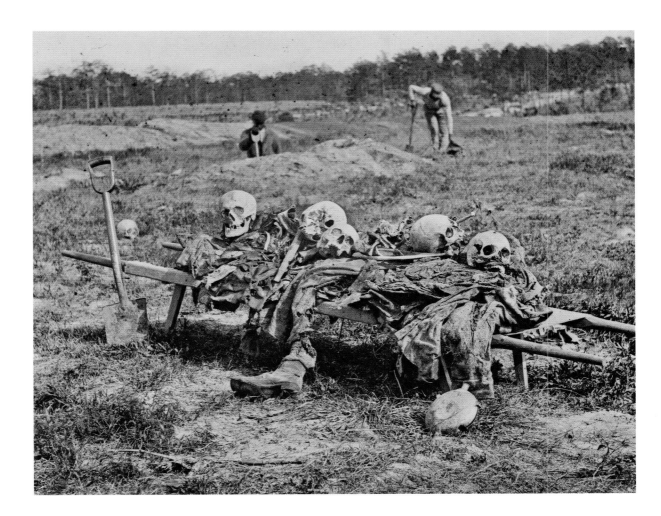

John Reekie (active 1860–69)
Collecting Remains of the Dead on the Battlefield Near Cold Harbor, Virginia. 1865.
Photograph.
Library of Congress.

The slaughter along the seven-mile-long front in Cold Harbor, Virginia, was so enormous that Ulysses S. Grant wrote that this was the only attack he wished he had never ordered. From May 31 until June 12, 1864, the two armies, totaling 170,000 troops, battled, with the Confederate troops as the victor. The carnage left 15,500 casualties, 13,000 of them Union soldiers.

ideas on American architects of the twentieth (the lag time, of course, diminished with advancements in transportation and communication).

The American Revolution offered the first concrete opportunity, and the first philosophical reason, for Americans to attempt an aesthetic break with Great Britain. This was easier said than done, and in fact was not even high on the list of wealthier citizens who, though perhaps not Tory in their political sympathies, remained decidedly Anglophile in matters of culture. The persistence of British taste was apparent in the influence of Robert Adam on American architecture and interior design in the Federal era, and of Thomas Sheraton and George Hepplewhite on American furniture.

But even Adam and Sheraton represented a design trend that fit in nicely with a turning of American taste toward the Neoclassical, which, for the young republic, had overtones that went beyond the superficial realm of design. Looking back to ancient Greece and to the pre-imperial days of the Roman republic, Americans found inspiration for their own experiment in democracy, and the chastely elegant, uncluttered style of Federal-era furniture and architecture helped to convey the idea that a new age of virtue and simplicity had arrived. There was ample room for French influence here as well, given the fact that France had overthrown its old order in the 1789 revolution. French taste, once the Terror had subsided and Napoleon was firmly in power, itself ran heavily toward the motifs of classical antiquity. "Empire" furniture, referring to the styles of Napoleon's regime, was part of fashionable drawing rooms in the United States during the opening decades of the nineteenth century.

In architecture, Thomas Jefferson's designs for the Virginia State Capitol, for the rotunda and pavilions of the University of Virginia, and for his own residence, Monticello, were strongly Neoclassical, as were the colonnaded designs of Benjamin Latrobe and Charles Bulfinch, which were brought to their grandest manifestation—bordering on suggestions of imperial rather than republican Rome—in the United States Capitol. By the 1840s, architects such as Ammi Young,

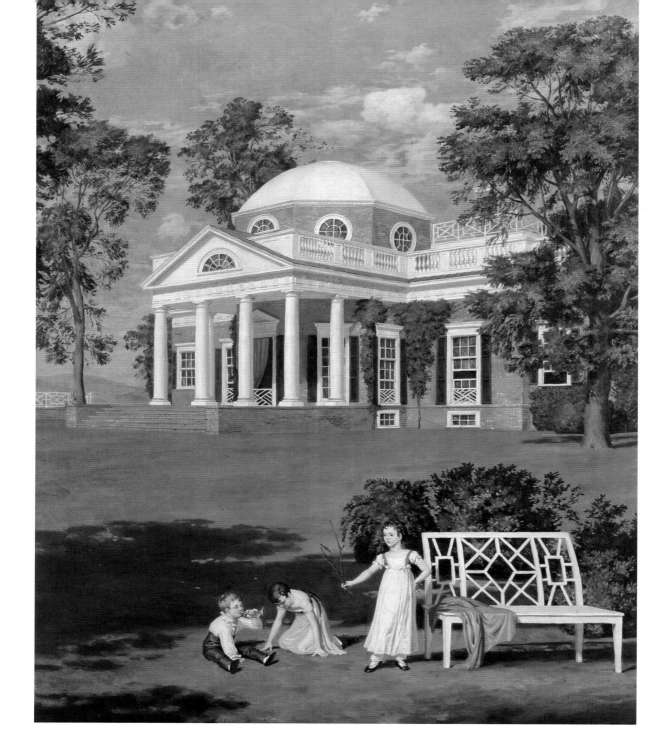

Allyn Cox (1896–1982)
Monticello, Home of U.S. President Thomas Jefferson, Near Charlottesville, Virginia.
Oil on canvas.
Musée de la cooperation franco-americaine, Blérancourt, France.

Monticello, Italian for "little mountain," is the Neoclassical residence Thomas Jefferson built for himself in Virginia. A true "Renaissance man," Jefferson added "architect" to his list of many talents and contributions to this nation. The work on Monticello began in 1768 and was completed in 1809 with the placement of its great dome. The image of the house appears on the reverse of many a 5-cent coin in the United States and on the back of the $2 bill. The creator of this charming scene of Jefferson's home, Allyn Cox, is best known for his many murals that decorate the ceiling and walls of the U.S. Capitol building.

Alexander Parris, and Robert Mills (who designed the Washington Monument) had disguised so many customhouses, courthouses, and other civic structures as Athenian temples that the term "Greek Revival" has since been applied to their era. Even private homes, beneath their pediments and behind their columns, came to look like Peloponnesian throwbacks, and a region in upstate New York took the trend so far as to name dozens of towns after Greek and Roman cities and heroes.

The infatuation with the classical world, which had never affected the fine arts in America as much as it had architecture and design, gave way, in painting, at least, to an appreciation of America not merely as a new, somewhat rougher-edged version of ancient Greece. The young country was seen, rather, as a vast and unspoiled new world, just then being discovered in its entirety by explorers like John Charles Frémont and Zebulon Pike, following in the wake of Lewis and Clark. Landscape painting came into its own with the canvases of the Hudson River School, which had its origins in the tamer but still picturesque Hudson Valley and Catskill Mountains of New York, but soon grew beyond those precincts made familiar by Thomas Cole and Asher Durand to reach the Rocky Mountain vistas painted by Albert Bierstadt and Frederick Church. This was the landscape of a nation unique in history, with a destiny—shouted, it seemed, from the very mountains—lying far beyond that of departed ancient democracies.

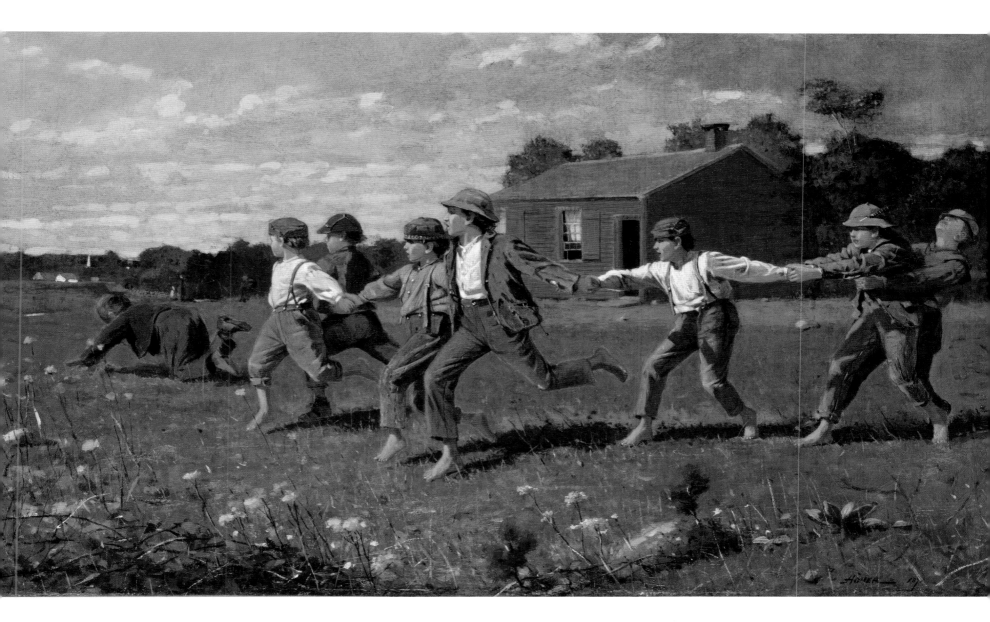

Winslow Homer (1836–1910)
Snap the Whip. 1872.
Oil on canvas, 12 x 20 in. (30.5 x 50.8 cm).
*Gift of Christian A. Zabriskie, 1950. The Metropolitan Museum of Art,
New York, New York.*

After chronicling the horrors of the Civil War in *Harper's Weekly*, Homer
looked toward the future and the simple peace of genre painting
and scenes of the seacoast. In *Snap the Whip*, the one-room
schoolhouse serves as a backdrop to this lineup of young boys playing
this popular game.

The citizens of this dynamic new republic were meanwhile hard at work, making destiny a reality in the most prosaic ways in the genre paintings of artists such as William Sidney Mount and George Caleb Bingham. The taste for these portrayals of raftsmen, fur traders, and country artisans was middlebrow, often sentimental, but nevertheless indicative of a people's pride in itself.

The fact that it was a people soon torn asunder by civil war brought the progress of American art and design not to a halt, but, temporarily at least, into darker and more realistic channels. The new technology of photography was brought to bear on the four-year conflict, most expertly by Mathew Brady and his talented assistants (to whom he usually did not extend credit), as a means of bringing the war home to a populace whose forbears had seen the Revolution first hand or, years later, on canvas. Field artists such as Winslow Homer also put the blood and boredom into newspapers and magazines, printed in the thousands of copies by revolutionary new processes.

After the Civil War, the United States—at least the victorious North—entered into an unprecedented period of industrial development that created a new class of patrons so unused to wealth and unsure of

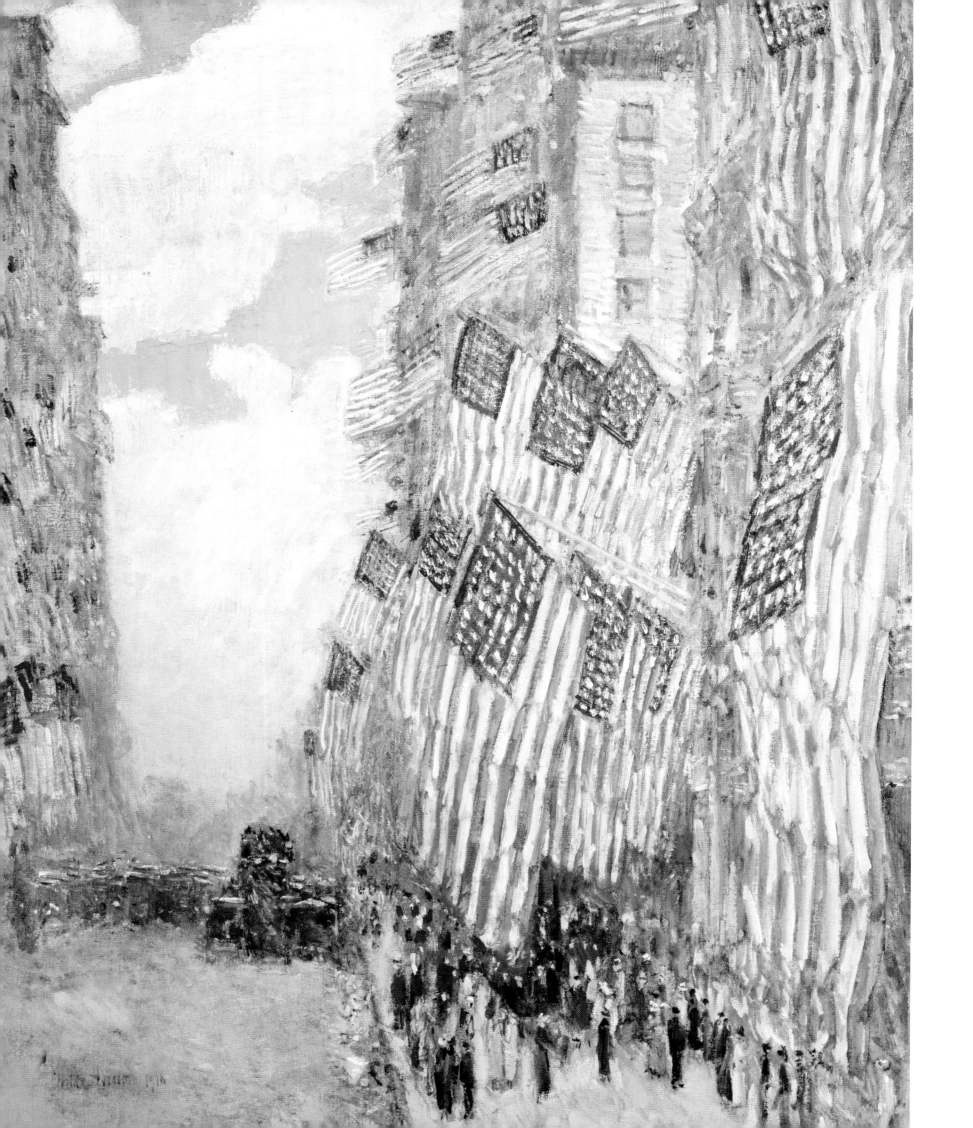

OPPOSITE: **Childe Hassam** (1859–1935)
The Fourth of July, 1916. 1916.
Oil on canvas, 36 x 26 ⅛ in. (91.4 x 66.4 cm).
Private Collection.

This painting, subtitled *The Greatest Display of The American Flag Ever Seen in New York, Climax of the Preparedness Parade in May*, shows the richly festooned buildings of affluent Fifth Avenue in the months before the United States entered World War I. Hassam was at this time a member of the American Artists' Committee of One Hundred, a group of artists who sold their paintings to raise money for French artists already fighting on the European front. Nine months after the event depicted in this painting, the United States declared war on Germany.

RIGHT: **Marcel Duchamp** (1887–1968)
Nude Descending a Staircase (no. 2). 1912.
Oil on canvas, 57 ⅞ x 35 ½ in. (147 x 89.2 cm).
The Louise and Walter Arensberg Collection, 1950. Philadelphia Museum of Art, Philadelphia, Pennsylvania.

With the display of this work at the 1913 Armory Show in New York City, the vision of European modern art burst upon the art scene, in the guise of a mechanized form caught in fragmented motion, combining the synthesis of Cubism and the motion of the Futurists. Perhaps inspired by the photographs of Eadweard Muybridge, one critic quipped that this depicted "an explosion in a shingle factory."

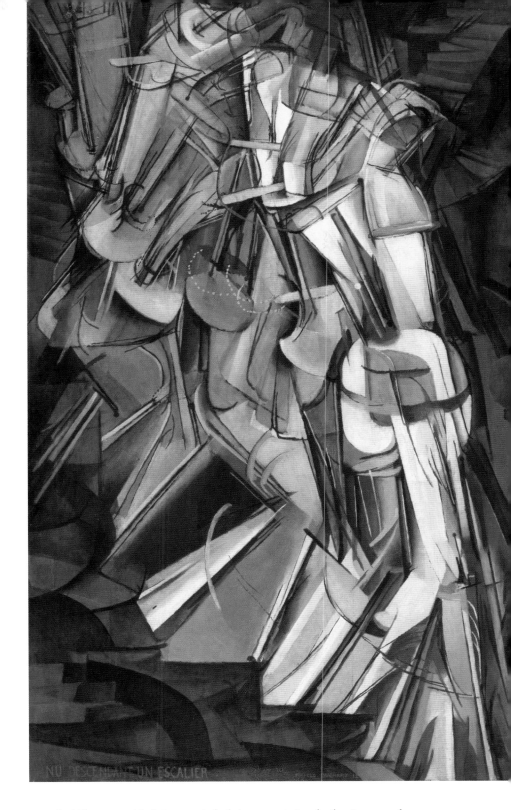

their tastes that foreign influences again became paramount in American art and design. In domestic architecture, the mansarded French Second Empire style prevailed; civic structures were built in a variety of historicist modes, particularly the English-based Gothic Revival, until the French Beaux-Arts movement with its Renaissance-inspired designs became dominant. Except for the slavishly historicist mansions of the very rich, however, residential architecture eventually took an American turn; a tremendous lumber resource enabled the sprawling, asymmetrical Queen Anne style and the H. H. Richardson–influenced Shingle Style to emerge. In furniture, the ponderously ornate high Victorian designs gave way, toward the century's end, to simpler treatments, most radically those of the craftsman movement influenced by William Morris and championed, in America, by Gustav Stickley. Craftsman design, along with the Japanese aesthetic and the revolutionary buildings of Louis Sullivan, was the springboard for the career of America's greatest twentieth-century architect, Frank Lloyd Wright.

Painting and sculpture in late-nineteenth-century America would be substantially dominated by European academic influences, although several native talents put a particularly American stamp on their work. Thomas Eakins, with his empirical clarity, and Winslow Homer, in his seascapes, Adirondack pictures, and pastorals that always steer clear of sentimentalism, laid the groundwork for the urban realism of the coming century's early years—the city paintings of "Ashcan" school artists George Bellows, Robert Henri, and John Sloan. Even certifiable American Impressionists such as Mary Cassatt and Childe Hassam can be credited with a stance of independence from the French masters of the school.

The dawn of the twentieth century marked the emergence of the United States as a global power, a

position immensely enhanced by its place among the victors in the First World War. It was, perhaps, in the best position in its history to declare total artistic independence. But the world had shrunk to the point at which a constant interplay of influences, foreign and domestic, would characterize the new century. By 1913, artists such as Cézanne and Matisse had already influenced a new generation of American painters. But in that year, an exhibition of mostly French artists was held at a Manhattan armory, and Modernism was thrust full force into the American consciousness. The Armory Show, as it was called, polarized opinions on the new work coming out of Europe (and out of many domestic studios), and its particular lightning rod was Marcel Duchamp's *Nude Descending a Staircase*. For the first time, Americans *en masse* were strongly inclined to despise, even ridicule, a school of painting, rather than just mildly prefer something else. The arrival of

OPPOSITE: **Edward Hopper** (1882–1967)
Room in Brooklyn. 1932.
Oil on canvas, 29 ⅛ x 34 in. (73.98 x 86.36 cm).
Museum of Fine Arts, Boston.

Edward Hopper, a figure in the uniquely American Ashcan school of art, created stark portrayals of solitary people in everyday scenes that exploited the empty spaces they inhabited. A room suffused with light and graced with a sense of stillness leaves the viewer with a feeling of loneliness and isolation. The seated figure in the chair is imbued with as much static energy as that of the vase of flowers it parallels.

BELOW: *"We Have Come to Collect the Gratitude That Was Promised to Us for Participating in the World War."* June 1930.

The stock market crash of 1929 was but one of the causes that plunged this country into the grips of the Great Depression. More than 3.2 million unemployed people faced a governmental infrastructure scrambling to provide for its citizens. In June of 1930, 25,000 World War I veterans converged and encamped in Washington, D.C., to press for the passage of "bonus" pay promised to veterans, vowing to remain until the "bonus bill" was passed. In July of 1930, President Hoover signed a $100,000 transportation bill allocating the funding.

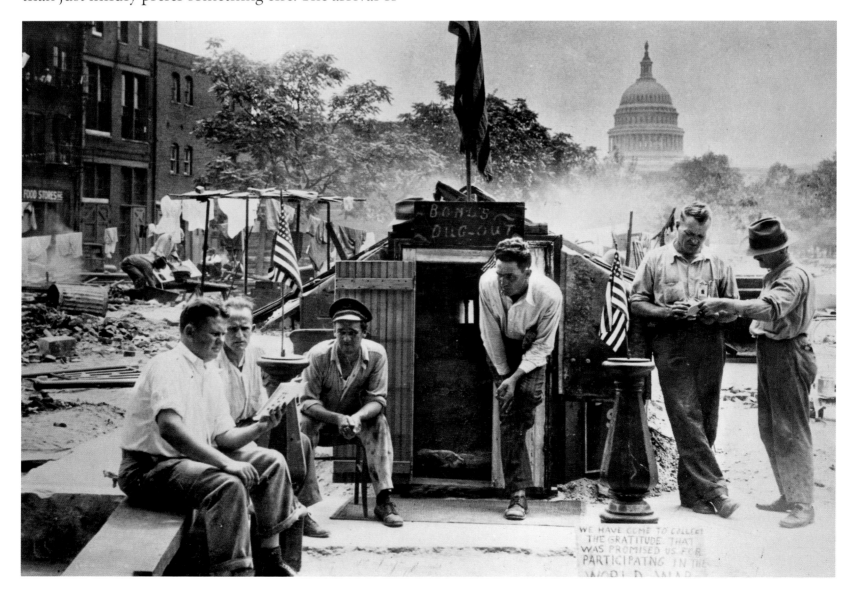

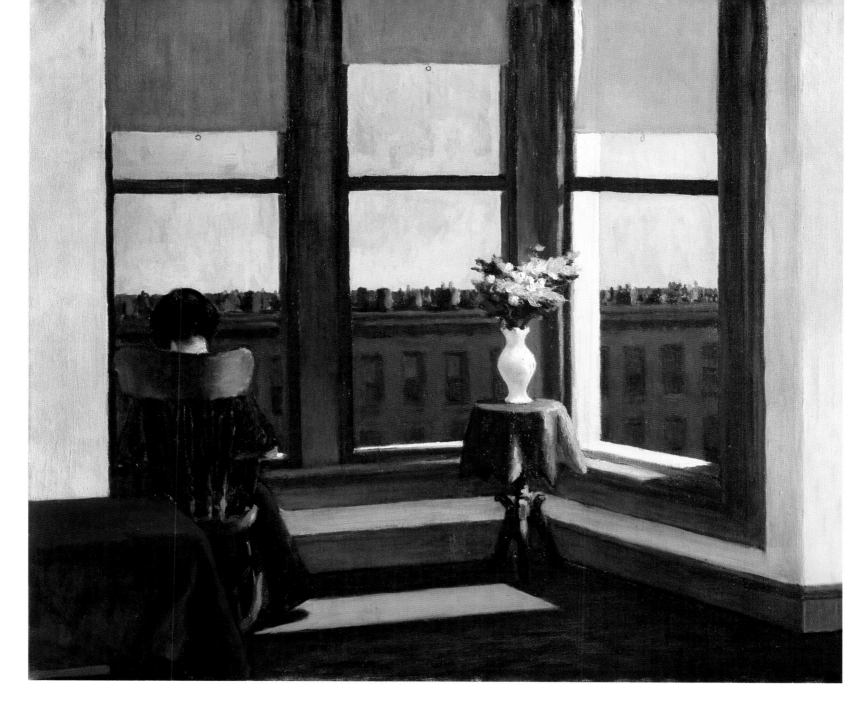

cubism and abstraction in America marked the point at which custodianship and appreciation of much of the visual arts largely became the province of a clerisy, and the critics who wrote for it.

The prosperous, booming 1920s were a fecund time for urban architecture—powerful, flamboyant architecture that, to use a word from the opening line of Sinclair Lewis's contemporary novel *Babbitt*, "aspired." The skyscraper had been born in Chicago 40 years earlier, the product of fast elevators and steel-frame construction. It succeeded most spectacularly in New York, where William van Alen's Art Deco masterpiece, the Chrysler Building, still aspires magnificently. But scarcely a year after the great building's completion, Americans suddenly felt as if they had nothing to aspire to: the Great Depression had seized the land, and a less promising environment

for art—unless it was escapist cinema—could hardly be imagined.

A distinctive body of art did come out of the Depression, and it concerned itself with the common citizen to as great an extent as anything of its kind since the genre painting of the 1840s. The Social Realists carried the torch for oppressed workers, towing a doctrinaire leftist (even Communist) line; while the Regionalists celebrated the vigor and variety of an America far beyond the cities where those workers lived: regionalist Thomas Hart Benton's laborers, on the steamboats and railways of the Midwest, seem heartily immune to oppression. And then there was Edward Hopper, twentieth-century art's great loner, conveyor of an elegiac melancholy so perfect and pure that disparagers of representational art tend to leave him alone.

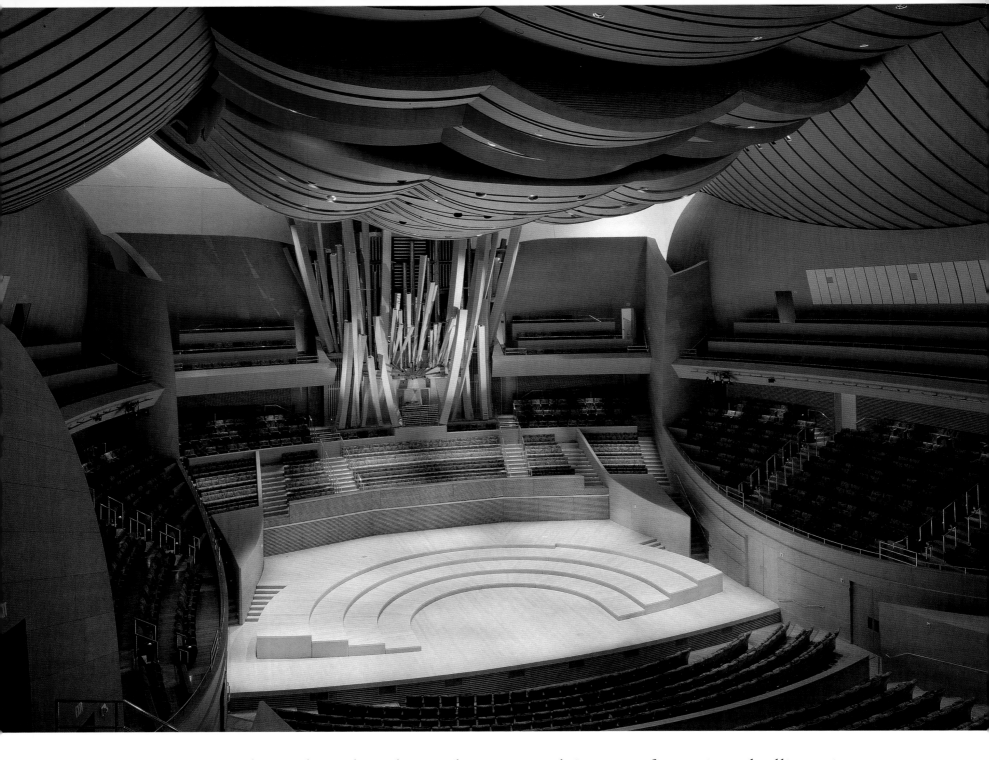

Pompeii. Louise Nevelson and David Smith created sculpture from found objects (but Smith, later in his career, turned to the lean geometry of his stainless-steel "Cubis" series).

American architecture in the postwar years was a continuation of the seldom genteel conversation between the Bauhaus and the prairie romanticism—an unsentimental romanticism, to be sure—of Frank Lloyd Wright and disciples such as California's John Lautner. In the realm of Bauhaus/International-influenced residential architecture, the two great postwar monuments in America are Mies van der Rohe's Farnsworth House and Philip Johnson's Glass House, both elegantly spare, cubist attempts to make an end run around

Wright's notion of marrying a dwelling to its surrounding terrain by eliminating the opaque barriers between house and terrain altogether.

Public architecture at first hewed to the Internationalist line during the postwar era, with fine examples such as Mies and Johnson's Seagram Building and Gordon Bunshaft's Lever House, both in New York, as well as countless featureless glass boxes that finally gave Internationalism a bad name. The revolt, in the late 1970s and 1980s, came in the form of Postmodernism, with its most visible emblem Johnson's AT&T (now Sony) Building, topped by an enormous broken pediment that made it look like an eighteenth-century highboy. But the penchant for such historical references—taken up by architects such as

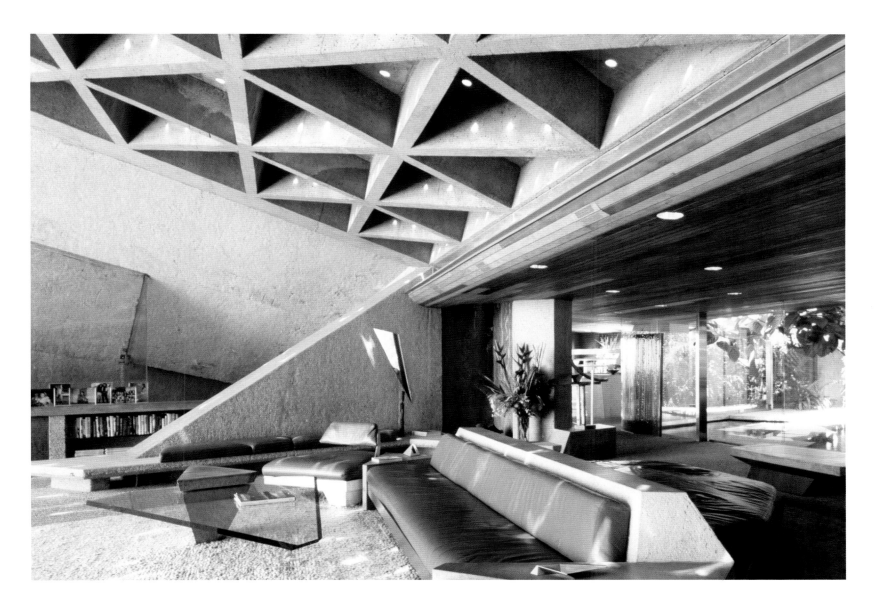

Michael Graves, Robert Venturi, and Robert A. M. Stern—worked its way down, during the '80s, even as far as residential commissions. More recently still, American architecture has turned toward the titanium-sheathed freeform lyricism of Frank Gehry's Los Angeles Walt Disney Concert Hall; toward the whimsical literal-mindedness of Gwathmey Siegel & Associates' Springfield, Massachusetts, Naismith Memorial Basketball of Fame, taking its cue from the shape of the ball; and toward the serenely chaste lines of Richard Meier's Getty Center.

Perched high above a Los Angeles freeway, the Getty Center is a city of art, upon a hill. And a city on a hill is what America started as—before there was such a thing as American art—when John Winthrop drew just such an image to represent the new Puritan town of Boston, so far from that L.A. freeway in distance, time, and taste.

ABOVE: **John Lautner** (1911–94)
Goldstein House, Beverly Hills, California. 1963.

A graduate of Frank Lloyd Wright's Taliesin Fellowship, Lautner's influential architectural works are imbued with his desire to improve human life, and often bear a Space Age edge in their design. Concrete was one of Lautner's preferred materials, as he felt its plastic capabilities allowed for infinite spacial forms. The Goldstein House in Beverly Hills is devoid of 90-degree angles and includes a cantilevered terrace overlooking a cliff's edge. All the materials of the house were included to blend with the raw expression of the dwelling's exterior.

OPPOSITE: **Frank Gehry** (b. 1929)
Interior of the Walt Disney Concert Hall, Los Angeles. 2003.

Frank Gehry's Postmodernist architecture (a moniker to which he does not subscribe) is no stranger to mixed reviews. Costing an estimated $274 million dollars, the reflective qualities of the Walt Disney Concert Hall's stainless steel exteriors have been blamed for creating hot spots on the adjacent sidewalks and for reflecting excessive heat in the neighboring condominiums, conditions remedied by the light sanding of the exterior's panels. The remarkable organ within the concert hall gives the effect of a "logjam turned sideways," and contains 72 stops and 6,125 pipes ranging in length from a few inches to 32 feet.

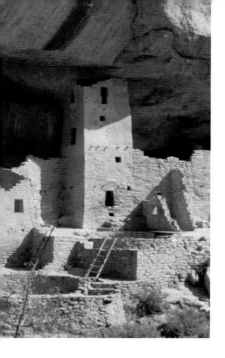

First Americans

(PREHISTORY TO CA. 1600)

"To the Indian, the material world is sentient and intelligent…a mysterious and implacable power resides in inanimate things."

—FRANCIS PARKMAN

The Jesuits in North America in the Seventeenth Century

At the beginning of the seventeenth century, North America became the stage for one of the greatest cultural clashes in human history. It was a clash that had begun more than 100 years earlier, with the Spanish discovery and conquest of the Caribbean and the Mesoamerican mainland; it continued with the encroachment of Spanish, French, Dutch, and English explorers and colonists on lands inhabited for many thousands of years by the diverse native population that the Europeans, initially thinking they had arrived in the East Indies, called Indians. The newcomers from Europe represented no single culture and no single colonialist model. They all possessed much the same technologies in transportation and warfare, but were profoundly dissimilar in nearly all other respects.

The territory that would one day make up the United States was never visited by Christopher Columbus on any of his four voyages of discovery. If any Europeans had seen it at all, they were most likely Portuguese cod fishermen, or Norsemen venturing south from their short-lived settlements in Atlantic Canada around 1000 C.E. In the mid-sixteenth century the Spanish, under whose flag Columbus had sailed,

LEFT: *Platform Effigy Pipe* (Hopewell Culture). 300 B.C.E–500 C.E. *Werner Forman Archive, Ohio State Museum, Columbus, Ohio.*

The Hopewell Culture of the Ohio Valley, which flourished from roughly 200 B.C.E to 500 C.E., was responsible for an extensive array of earthwork walls and mounds built in geometric shapes. This pipe, with a bowl in the shape of a toad, recalls the ceremonial use of tobacco by many native American cultures.

OPPOSITE: *Cliff Palace, Mesa Verde, Colorado* (Pueblo Culture). 1100–1200 C.E. *Werner Forman Archive, Ohio State Museum, Columbus, Ohio.*

The most elaborate dwelling arrangements of all pre-European native American societies were those of the Pueblo Culture of the Southwest. Once the hub of a prominent chiefdom, this cliffside complex housed more than 400 people. Among its more than 200 rooms were 23 of the ceremonial chambers called *kivas*, distinguished by their circular shape.

pressed tentatively northward into the future United States from their bases in Mexico and the Caribbean. They were seekers of treasure, and of souls to save in the name of Roman Catholicism. Their two most famous incursions into North America—aside from their settlements on the Florida coast—were Francisco de Coronado's quixotic trek through the deserts of the Southwest in search of cities of gold; and the longer-lived establishment of California's Franciscan missions. Among those were San Diego, Santa Barbara, San Jose, San Francisco—and the little pueblo named in honor of Mary, Queen of the Angels, *Reina de los Angeles.*

French colonialism, which centered upon regions north of the present U.S. border but sent its tendrils south along the Mississippi and Ohio Valleys, was first

Head Effigy Vessel **(Mississippian Culture). 1300–1500 C.E.** Buffware with red slip pigment, 6 ⅜ x 7 x 7 ¼ in. (16.2 x 17.8 x 18.1 cm). *Founders Society Purchase with funds from the Mary G. and Robert H. Flint Foundation, 1986. Detroit Institute of Arts.*

Flourishing from ca. 900 C.E. to the threshold of the era of Spanish exploration, the Mississippian Culture was an agricultural society centered in the lower Midwest and Mississippi Valley. This effigy of a departed ancestor is representative of the tribes' complex understanding of the relationship between the living and the dead.

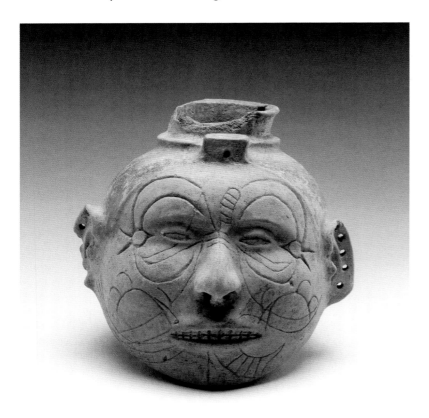

and foremost a matter of trade. It was a system of extracting beaver pelts from a wilderness whose natives (except for the implacably hostile Iroquois) were useful partners in commerce, as well as prospective converts for brave Jesuit missionaries. The fur trade likewise fueled the Dutch colonial experiment.

The English, destined to triumph over all other European colonizers of North America, were largely driven by a different idea. In New England they were Protestant dissidents seeking a New Jerusalem. Theirs would be a realm of pious yeomen farmers and tradesmen, for whom the natives were scarcely more than an obstacle. South of the Chesapeake Bay, the English settlers were less focused on religious freedom than on plantation agriculture, in pursuit of which they not only pushed back the natives, but also imported African slaves.

"The territory that would one day make up the United States was never visited by Christopher Columbus on any of his four voyages of discovery."

The America that the Europeans sought to subdue was a land peopled by tribes whose ancestors were nomads following game across a land bridge from Siberia to Alaska, during an ancient glacial epoch when the level of the Bering Sea had fallen and exposed dry land. The question of just which Ice Age permitted the crossing is an open one; successive discoveries and dating of remains and artifacts have pushed the date back steadily. But it is generally agreed that humans have inhabited the Americas for at least 20,000 years.

Like the European newcomers, the inhabitants of the New World belonged to a diverse system of societies with little in common except a general racial identity. A tremendously complex array of native

John White (fl. 1585–93)
*Algonquin Village of Pomeiock,
Near Gibbs Creek, North
Carolina.* Sixteenth century.
Pen and ink drawing.
British Museum, London.

This sketch made by John White,
leader of a British expedition to
the coastal Carolinas in 1585,
shows the grouping of bark-
covered huts and longhouses
within a defensive palisade that
was a common living
arrangement of woodland
Indians in the Northeast and
Middle Atlantic regions of the
future United States. Multiple-
family dwellings were the norm.

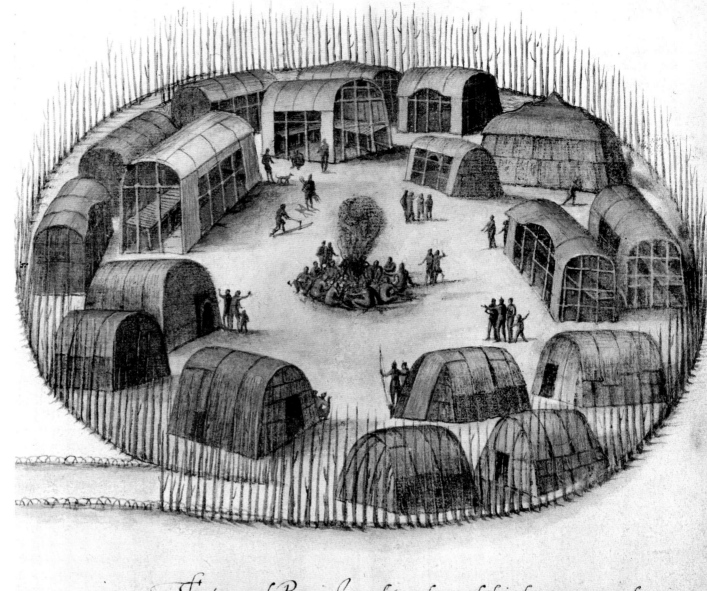

*The towne of Pomeiock and true forme of their howses, couered
and enclosed some w^th matts, and some w^th barcks of trees. All compassed
abowt w^th smale poles stock thick together in stedd of a wall.*

8

cultures had evolved over those 200 or more centuries since the crossing of the Bering land bridge—an array that has often been distilled into a popular image that combines traits of many tribes, but describes few with precision. The Indians of our imagining are nomadic hunters, who lived in portable dwellings; but the teepees of the Plains were no more typical than the bark-sided longhouses of the Northeast, the cedar plank structures of the Pacific Northwest, the multistory pueblos of the Southwest, or the thatched or mud-plastered southeastern Indian abodes. The political sophistication of our stereotypical Indians extended no further than respect for elders and chiefs; but among the nations of the Northeast's Iroquois Confederacy there existed a layering of authority vested in supreme and subordinate councils, and even in a deliberative body that one Jesuit missionary

described as being analogous to the Roman Senate. There were many nomadic tribes, such as the Sioux and Cheyenne, who followed bison across the oceanic reaches of the Great Plains. But there were also far more sedentary nations, such as the Hurons of the eastern Great Lakes region, who practiced agriculture and stored crops against the winter. Native North American culture was so diverse simply because the Indians inhabited a rage of territory so vast that no single mode of living could possibly serve the entire continental population.

The circumstances of climate and geography likewise dictated the Indians' modes of transportation. No native American culture had developed the wheel, and none had devised the sail. One theory holds that the wheel was never invented in the Americas because the hemisphere's two continents had evolved no

animals that could be domesticated sufficiently to make wheeled vehicles practical; until the Spanish brought horses to the New World, even the Plains Indians—who would one day field the most impressive light cavalry in the world—depended only upon travois-dragging dogs for motive power. The absence of tractable beasts of burden is also often suggested as a reason for the rudimentary state of native agriculture: no one has ever figured out how to hitch a bison to a plow.

And what good would a sail have been to native New World societies? The largest bodies of water that

Helmet (Tlingit).
Carved wood, probably cedar.
American Museum of Natural History, New York, New York.

Renowned for their towering totems, which often recounted clan histories in a stylized visual fashion, tribes of the Pacific Northwest such as the Tlingit, Haida, and Tsimshian also carved elaborate masks for ritual ceremonies. This helmet is likely a portrait of its owner, who would have been prominent in his community.

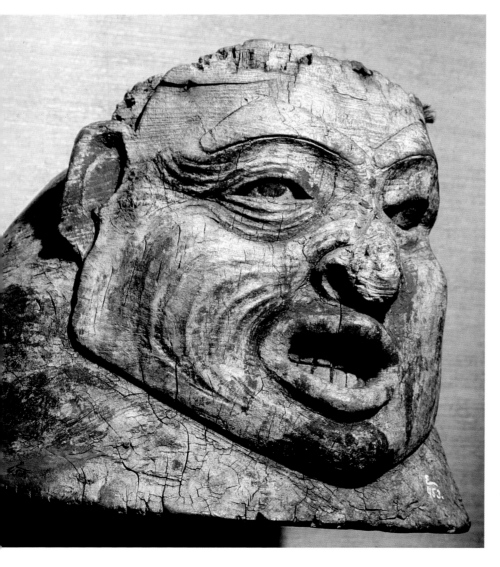

North American Indians had to navigate were the Great Lakes—and, as the early French voyageurs learned, even these could be swiftly traversed by means of the most elegantly practical small watercraft ever devised, the canoe. Bark canoes, drawing so little water that they were as useful in the shallowest streams as on Lake Superior, eventually carried white men to the farthest reaches of the continental interior. They have never been improved on in design, only in materials—but no modern fiberglass or composite canoes can be repaired with materials found en route.

Paddle craft reached their greatest dimensions among the natives of the Pacific Northwest. Tribes such as the Nootkas and Coast Salish fashioned seagoing canoes by hollowing out trunks of the enormous trees that grew in the region's solemn, dripping forests. Those same towering firs and cedars were also the raw material of the Northwest's emblematic totem poles, carved to enhance the prestige of prominent families.

The totems are a reminder of another important aspect of Indian life: cultural expression, too, was dictated by the lay of tribal lands, by the plants and animals and other resources at the natives' disposal. The artistic impulse that found expression in elaborate carvings, in the Northwest, had to seek other media among other tribes. On the treeless Great Plains, the Sioux recorded events in their tribal life by painting narrative scenes on animal hides. Elsewhere, in places as far apart as the upper Midwest of the Ojibway and the Florida of the Seminoles, petroglyphs—figures and symbols incised into rock—served in lieu of written languages.

Representational art was never far advanced among native American societies. Although the urgent motion and energy of, for instance, a bison hunt or a battle might be captured in a scene painted on a bison skin, the figures are no more three-dimensional than on prehistoric European cave paintings. But in their purely decorative work, Indians throughout the North American continent reached a very high level of accomplishment. The basketwork, pottery, and, later, textile work of the southwestern tribes reveals a sensibility capable of vivid expression in geometry and color. And the carved wooden ceremonial masks of the Northwest are things of fierce and fluid beauty.

Owl Ornament for the Prow of a Canoe (Tlingit). Wood, abalone shell, bear fur, height: 47 in. (120 cm). *Werner Forman Archive, Field Museum of Natural History, Chicago.*

This carving of an owl with outstretched wings is typical of the prow ornaments mounted on Tlingit war canoes. The motif was one of the crests used by the Raven division at Klukwan, largest of the Chilkat Tlingit villages.

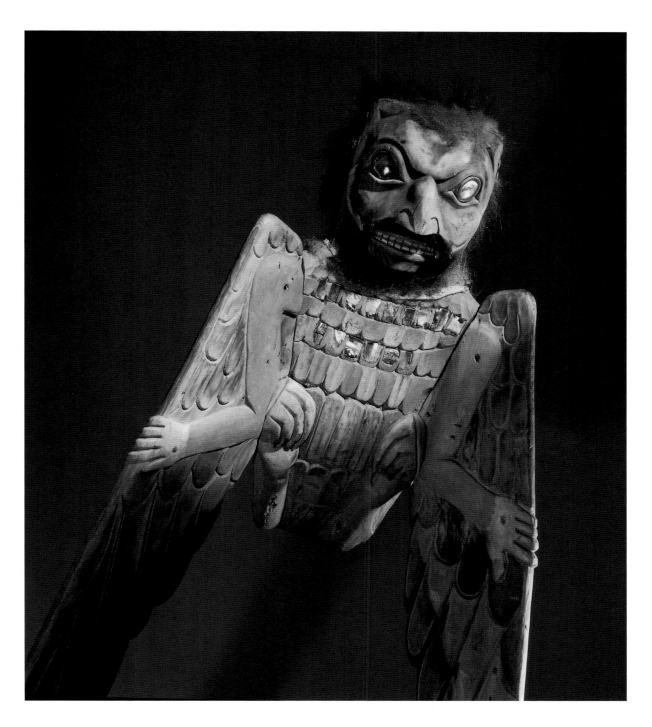

Carvings, whether in wood or stone, as well as clay moldings, brought the extra dimension that painting or petroglyph art could not achieve. Objects as disparate as a Cheyenne ceremonial rattle and a Sioux tobacco pipe show an innate sense of mass and proportion on the part of Indian artisans. The Inuit, or Eskimos, carved exquisitely sleek and stylized representations of bears, marine mammals, and spirit beings in bone, ivory, and what must have been rare and valuable pieces of wood.

Even items as utilitarian as clothing provided a canvas for elaborate artistic expression. Textiles were necessarily limited in use in the days before Europeans introduced sheep, although animal fur and plant materials were woven to make garments, and the northwestern natives used shredded cedar bark as a kind of cloth. But where clothing was made of animal skins, as in the Northeast and on the Great Plains, dyed porcupine quills added texture, pattern, and a rich color palette (beads, which so many tribes employed to give clothing and moccasins an almost mosaiclike luster and intricacy of design, had to await the arrival of the little glass and ceramic baubles as a European trade item). Everywhere on the continent, regardless of

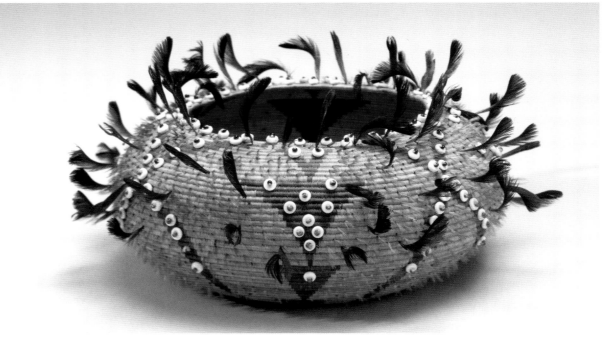

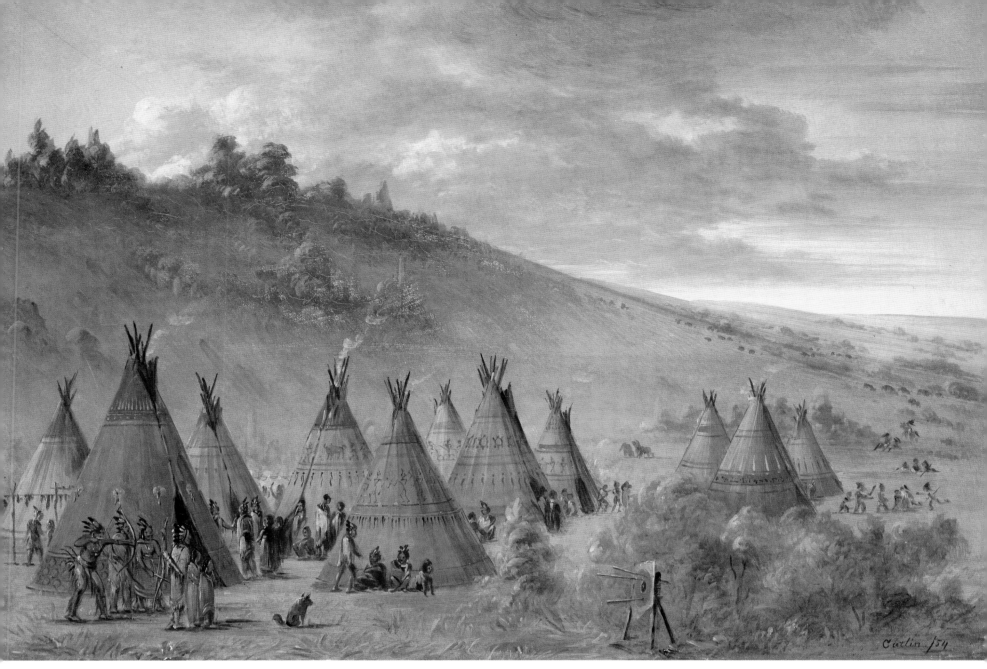

George Catlin (1796–1872)
Ojibwa Village. 1854.
Oil on canvas, 19 x 26 ½ in. (48.5 x 67.5 cm).
Ethnologisches Museum, Staatliche Museen zu Berlin, Berlin, Germany.

By the time Catlin painted this scene of an Ojibwa encampment, showing the typical migratory dwellings that have come to be known as "teepees," the upper Midwestern homeland of this people was well within the range of white settlement.

the materials at hand, the native love of ornament, color, and symbol enriched lives otherwise largely lived in answer to the call of sheer necessity.

Notions of the supernatural, too, enlivened native American life, but Indian religion has long been misunderstood. The "Great Spirit" was a murky and remote concept among native Americans, and more of a wishful construct by white missionaries who wanted a short cut, a vehicle on which to graft a rudimentary understanding of Christianity. Far more real to the natives was a complex system of good and evil spirits that inhabited all creation, animate and inanimate. These spirits influenced humans' lives, and could be approached and interpreted through dreams, totemic devices, and the intervention of shamans. A special spiritual significance was attached to animals that were a mainstay of a tribe's food supply. In the Pacific Northwest, which had the most spectacularly endowed natural larder of any Indian homeland, the salmon was treated with reverence. There was no single concept of an afterlife among the many native societies, but belief in a spirit world, and of some sort of life after death, was nearly universal.

These were but a few aspects—social, artistic, and religious—of the array of native cultures destined to clash with the pioneer vanguard of Europeans that arrived in the New World during the sixteenth and seventeenth centuries.

The Iroquois Confederation

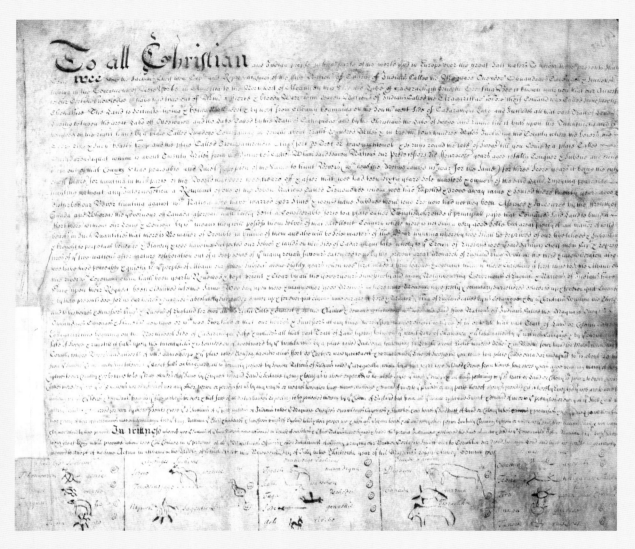

This peace treaty signed by representatives of Great Britain and the five nations of the Iroquois Confederacy—Mohawk, Seneca, Onondaga, Oneida, and Cayuga—reflected the growing dependence by the British settlements upon an alliance with the Iroquois against the French in Quebec, the tribes' longtime enemies.

They called themselves *Haudenosaunee*, the People of the Longhouse, but to the settlers of upstate New York and Canada's St. Lawrence Valley, they were known by the French name Iroquois. The Iroquois were not a single tribe, but a confederation of five tribes: from east to west, these were the Mohawks, Oneidas, Onondagas, Cayugas, and Senecas. During the early eighteenth century, the confederacy grew with the addition of a sixth tribe, the Tuscaroras, who had migrated north from the Carolinas.

The "longhouse" of the name the Iroquois gave themselves referred not only to the elongated, bark-sided dwellings favored by natives of this part of the Northeast. It was also a symbolic longhouse, which the

"The Iroquois were not a single tribe, but a confederation of five tribes: from east to west, these were the Mohawks, Oneidas, Onondagas, Cayugas, and Senecas."

Iroquois regarded as being guarded in the east by the Mohawks, and at the far west, near the Genesee River in the vicinity of present-day Rochester, New York, by the Senecas.

Originally, the five tribes that made up the original Iroquois Confederation were sometime enemies, despite a common language and similar modes of social organization, and a system of clan membership that extended across tribal boundaries. According to tradition, the tribes formed their confederation at the urging of the visionary peacemakers Deganawidah and Hiawatha (not to be confused with Longfellow's fictional Hiawatha, in the poem of that name) sometime in the late sixteenth century, although some scholars have argued for a much earlier date. But whatever the era of its origin, the object of the confederation was clear: an end to enmity among the related tribes, and the establishment of a mechanism for mutual consultation, deliberation, and agreement on matters affecting all of the Haudenosaunee.

Chosen representatives of the member tribes were required to meet at least every five years, but usually gathered each summer. The ruling council was made up of sachems chosen from within the clans that made up each tribe; the sachems were men, but the clans from which they were selected were matriarchies. Although they held lifetime appointments, the sachems could be removed from their positions by clan matriarchs, who could also veto council decisions that might lead to war.

Beneath this principal council was a subsidiary group of sachems chosen because of ability as warriors or orators. Finally, there was the "Senate" referred to by the French Jesuit observer Joseph-François Lafitau. This was a less formally organized body of wise and experienced individuals, a popular assembly given to long and vigorous discussion of the confederation's affairs.

The Iroquois Confederation was the most sophisticated, and certainly the strongest, intertribal organization in what would become the United States. It is often cited as an influence on the framers of the U.S. Constitution, and survives to this day in the Grand Council of the People of the Longhouse, an assembly of 50 chiefs who meet regularly at the confederacy's capital of Onondaga, New York, near

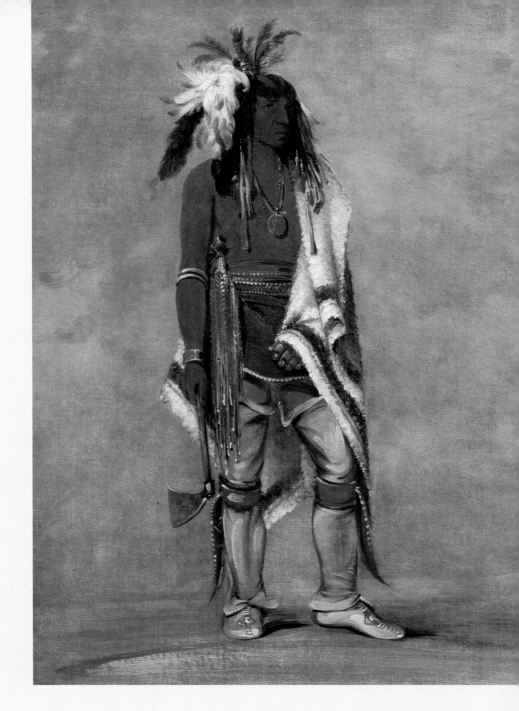

Syracuse. As one of the oldest continuously functioning representative bodies in the world, the Council takes up issues that directly affect the welfare of its tribal constituents within the context of Iroquois law. It has even issued Haudenosaunee passports, which, although not officially recognized by the United States government, have been used by their holders for travel to foreign countries.

George Catlin (1796–1872)
Not-to-way, a Chief. 1835–36.
Smithsonian American Art Museum, Washington, D.C.

By the time George Catlin began painting native Americans, the power of the once-mighty Iroquois Confederation had been broken. Beginning in the 1830s Catlin traveled west, seeking to study and portray tribes not yet affected by encroaching settlement. He began exhibiting his "Indian Gallery" in 1837.

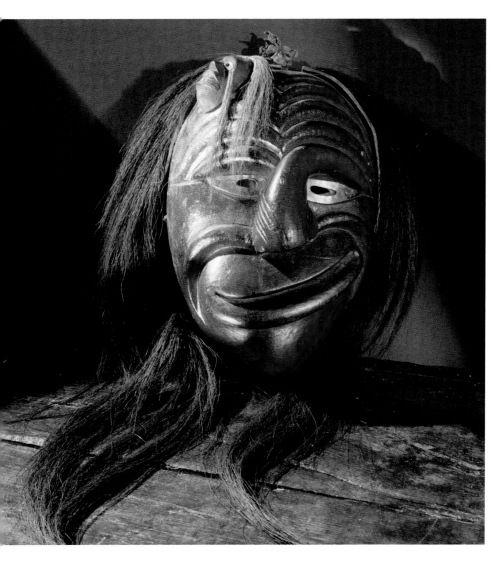

LEFT: *Mask* (Iroquois).
Carved wood.
Private Collection, New York, New York.

Masks such as these were central to the rituals of the False Face Society, a healing society of the Iroquois. Representing mythical entities or apparitions, they were worn during ceremonies conducted in order to drive disease from individuals who had summoned a society member. Membership was conferred upon those healed, or on those who had a revelatory dream.

BELOW: *Coat* (Delaware). 1835–50.
Buckskin, silk ribbon, glass beads, Length: 39 ½ in. (100.3 cm).
Founders Society Purchase. Detroit Institute of Arts.

By the early decades of the nineteenth century, contact between eastern native American tribes and Europeans had been established for some two centuries, and it had long been the practice of native artisans to incorporate trade goods such as silk ribbon and glass beads into garments that would once have been ornamented with local materials such as porcupine quills.

BELOW: *Moccasins* (Cheyenne).
Buckskin and glass beads.
National Museum of Natural History, Smithsonian Institution, Washington, D.C.

The "medicine wheel" pattern was characteristic of moccasins worn by the Cheyenne. Moccasins made from hides were ubiquitous among native American peoples, although the word itself is Algonquin. Designs varied greatly from tribe to tribe; fur linings were generally added for winter wear, and ornamentation was done with pigment or quills before beads became available through trade.

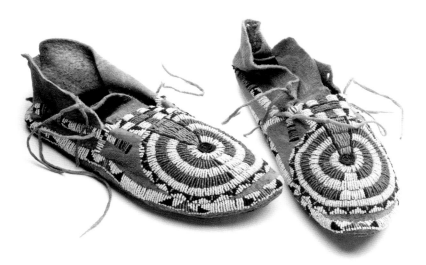

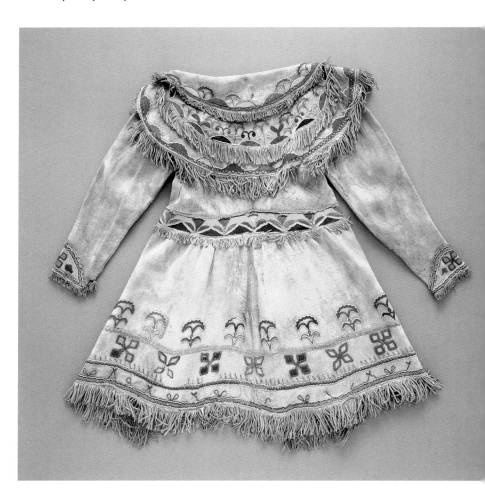

Man's Shirt (Cheyenne).
Ca. 1860.
Buckskin, wool, ermine skin,
human hair, glass beads,
pigment, 46 x 62 in. (116.8 x
157.5 cm).
Founders Society Purchase.
Detroit Institute of Arts.

Plains Indian garments from this
late stage of European contact
show a thorough melding of
traditional colors and decorative
motifs with formerly unavailable
materials. Traditionally, the
Cheyenne would wear clothing
with this level of decoration only
on ceremonial occasions.

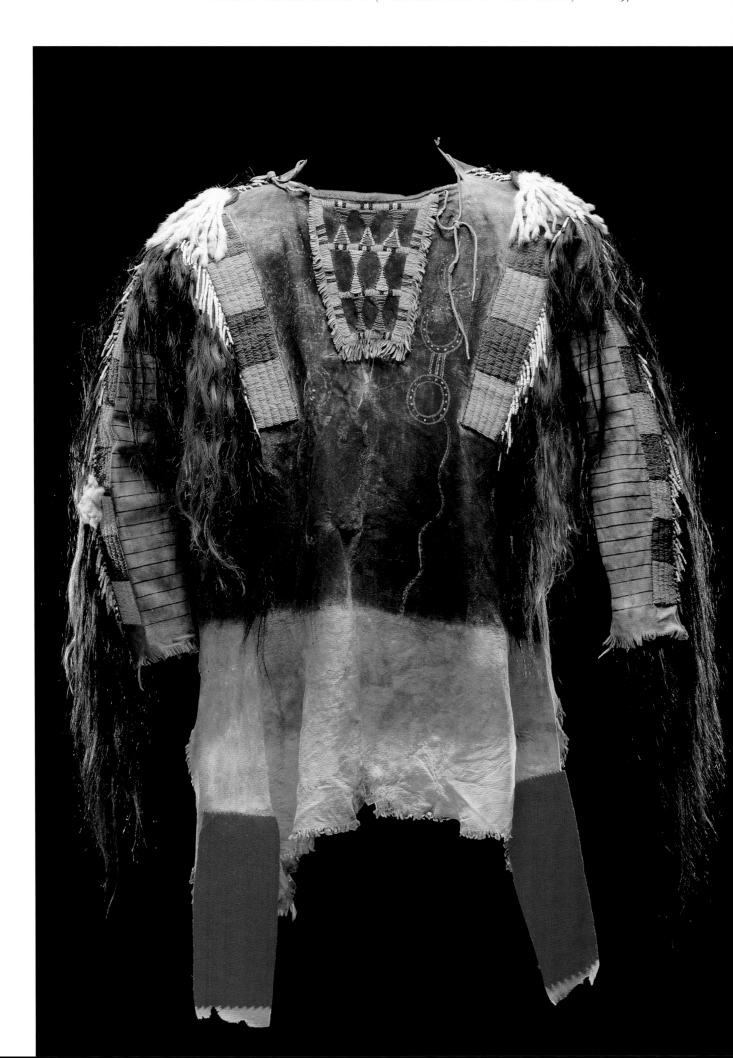

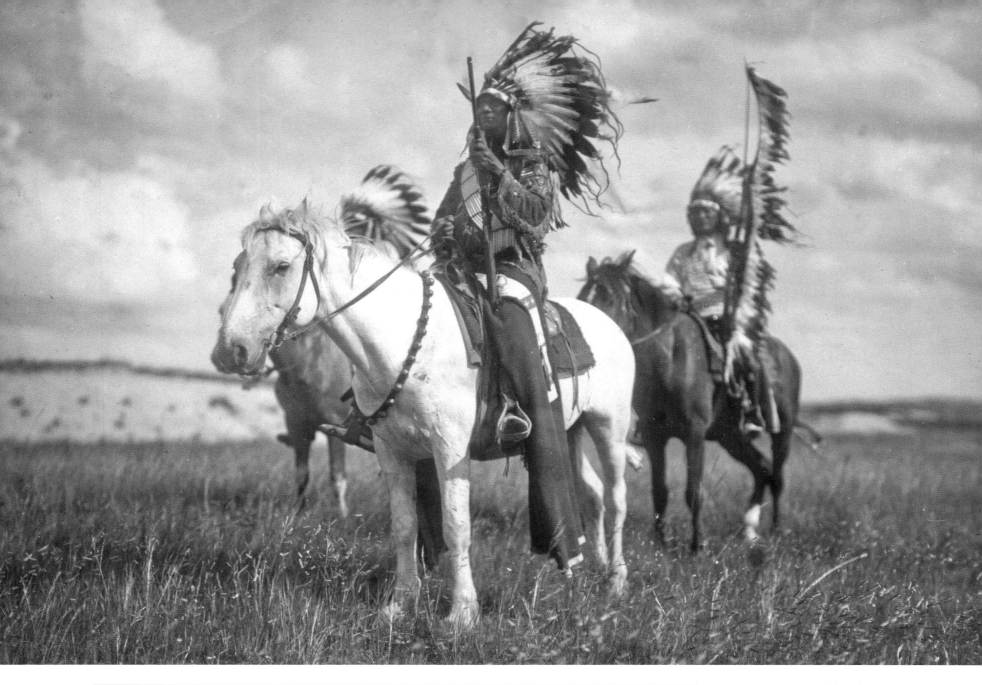

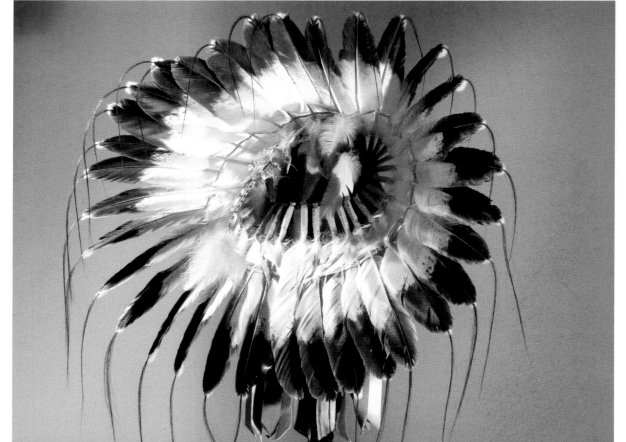

LEFT: *War Bonnet* (Sioux).
Eagle feathers, rawhide.
*Plains Indian Museum, Buffalo
Bill Historical Center, Cody,
Wyoming.*

The eagle-feather bonnet of the
Plains was regarded as a source
of spiritual power among
warriors. Ingenious construction
made the feathers' movements
resemble those of an eagle,
imparting the bird's grace and
gift of noiseless approach to
the wearer.

OPPOSITE: **Edward S. Curtis**
(1868–1952)
Sioux Chiefs. 1905.
Photogravure.
Library of Congress.

By the time Curtis began chronicling the world of the North American Indian, much of that world had vanished—in 1905, the Sioux no longer ruled the prairie. But Curtis was always careful to pose his subjects in attire and equipage that were historically and culturally appropriate to a time that many of them still remembered.

RIGHT: **Edward S. Curtis**
(1868–1952)
Goyathlay ("Geronimo")
(1829–1909). 1907.
Photogravure.
National Portrait Gallery, Smithsonian Institution, Washington, D.C.

The great Apache warrior Goyathlay (the name "Geronimo" is Spanish, of obscure derivation) was the leader of the last Indian guerrilla band to surrender to U.S. authorities, in 1886. His portrayal by Curtis was part of the photographer's vastly ambitious 20-volume project *The North American Indian*.

OVERLEAF: **Edward S. Curtis**
(1868–1952)
Kutenai Woman. Ca. 1910.
Photograph.
Library of Congress.

Curtis's seminal work *The North American Indian* was leather-bound and printed on the finest paper. At a price of $4,200 by 1924, the richly illustrated set was affordable only to those with some means. But the images were truly fascinating—many of them haunting, such as this photo of a Kutenai woman in traditional buckskin dress gazing out at lake waters—probably in Idaho or Montana—a major food source for this hunter-gatherer people.

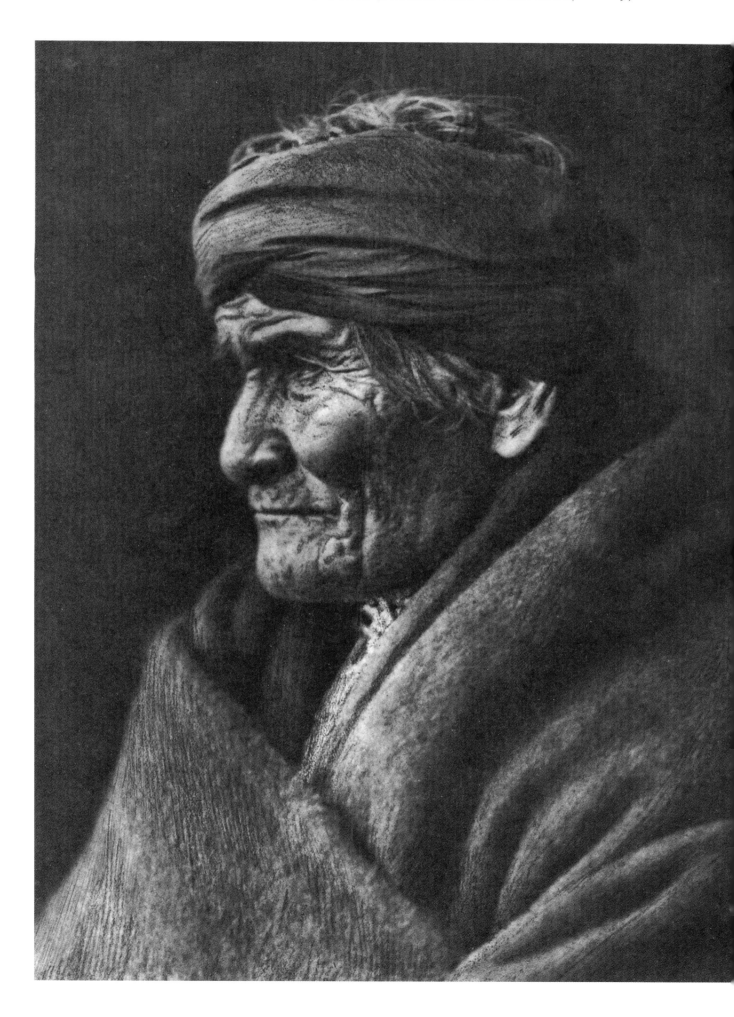

San Ildefonso, where Curtis
photographed this Tewa girl, is
one of 19 surviving New Mexico
pueblos. "Pueblo women are
adept at balancing burdens on
the head," Curtis observed.
"Usually a vessel rests on a fibre
ring, which serves to steady it
and to protect the scalp." The
jar's decoration indicates the
serpent cult's importance to
the Tewa.

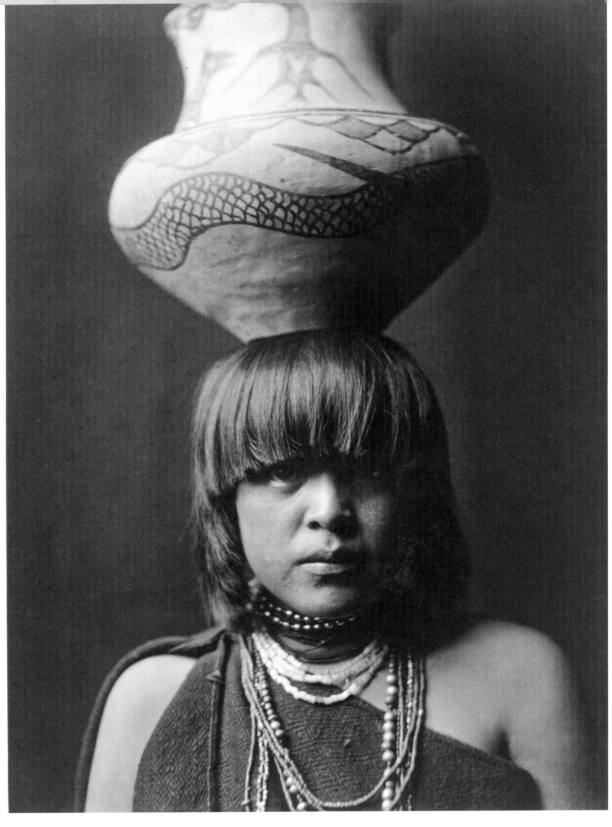

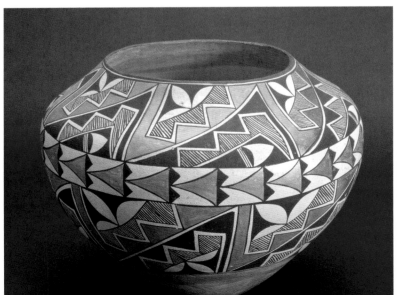

Drawing on a superior local clay source and a long tradition, the people
of the Acoma Pueblo near Santa Fe, New Mexico, continue to produce
light, graceful hand-thrown pottery, tempered with crushed potsherds
and decorated with geometric, bird, and animal motifs. The Acoma
Pueblo is considered to be the oldest continuously inhabited village in
the United States.

BELOW: Edward S. Curtis (1868–1952)
Iron Breast. Ca. 1900.
Photogravure.
Library of Congress.

Iron Breast, of the Piegan Blackfeet, fulfilled Edward S. Curtis's image of the sublime native American—in full-length portrait and attired with war bonnet, tomahawk, and draped animal pelt, the trappings of a proud and resilient people. Curtis first encountered the Piegan in 1898, during the season of the medicine-lodge ceremony, a yearly festival of prayer and sacrifice to the chief god of the Blackfeet, the sun.

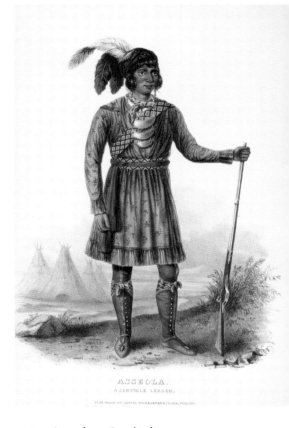

ABOVE: *Asseola, a Seminole Leader.* Ca. 1842.
Colored lithograph.
Library of Congress.

The Seminole of Florida are the only native American tribe that has never signed a peace treaty with the U.S. government. Asseola was a skilled guerrilla commander in the Seminole wars of the 1830s, harassing the U.S. Army in Florida's swamps. Lured into a council of truce, he was treacherously captured, and died in prison.

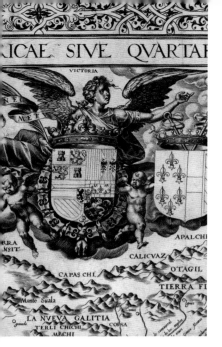

The Experiment Begins

(1600–1700)

"Who can but approve this a most excellent place, both for health & fertility?"

—John Smith, *Description of New England*, 1616

The European colonization of North America began in earnest during the first three decades of the seventeenth century. With the exception of the Spanish, who founded the city of St. Augustine in modern-day Florida in 1565, none of Europe's colonial powers had established a permanent community on the American continental mainland prior to 1600. Voyages of reconnaissance, and ill-starred tentative settlements, had already been made. John Cabot had claimed Newfoundland for England in 1497, thus laying the groundwork for British claims in the New World. Jacques Cartier had sailed up the St. Lawrence in 1535, reaching the Indian

village that occupied the future site of Montreal and paving the way for the explorers, fur traders, and missionaries who would one day reach the mouth of the Mississippi—a river that had been discovered, in 1541, by the Spaniard Hernando de Soto. And the English had attempted to plant a colony in Virginia as early as 1585—the legendary "lost colony" of Roanoke, whose fate has never satisfactorily been ascertained.

It was in 1607, at another site along the deeply indented Virginia shores of the Chesapeake Bay, that the first permanent English settlement in America took hold. This was Jamestown, a community established by the Virginia Company of London, one

LEFT: John White (fl. 1585–93)
St. Augustine, Florida. 1589.
Library of Congress.

Regarded as the oldest inhabited European settlement in North America, St. Augustine was established in 1565 by the Spanish Admiral Pedro Menendez. It was the base from which the Spanish expelled the tiny French Huguenot colony in the northern Florida peninsula. Here, an English cartographer portrays the advantageous situation of the harbor.

OPPOSITE: Diego Gutiérrez (fl. 1554–69)
Americae sive qvartae orbis parties nova et exactissima descriptio (North and South America with Adjacent Seas). 1562.
Engraving by Hieronymus Cock.
Library of Congress.

By the middle of the sixteenth century, the general outlines—if not the relative sizes—of the Western Hemisphere's principal landmasses were understood by European mapmakers. Filled with depictions of New World animals and inhabitants real and imagined, Gutiérrez' map nevertheless shows the regions of Spanish, French, and Portuguese hegemony.

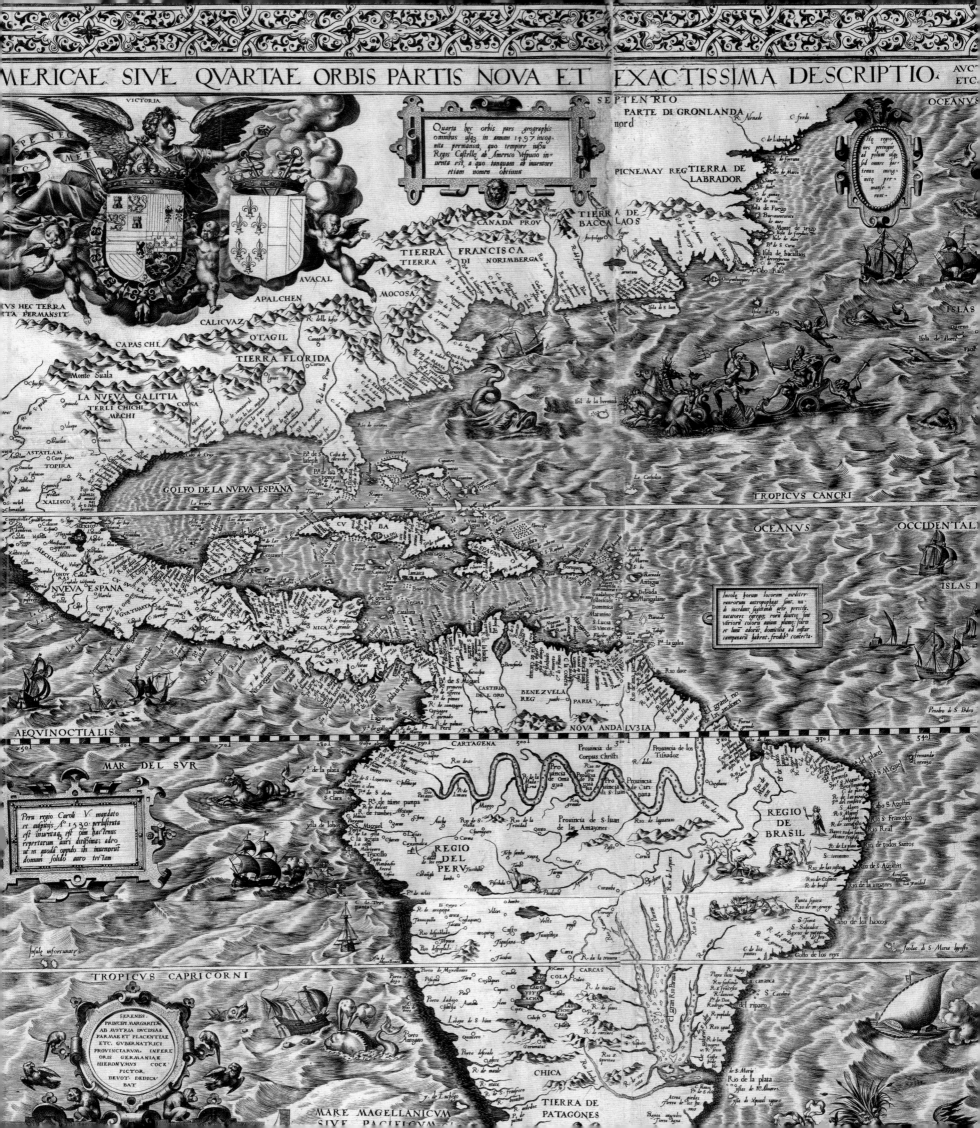

AMERICAE. SIVE QVARTAE ORBIS PARTIS NOVA ET EXACTISSIMA DESCRIPTIO. AVC ETC.

VICTORIA

SEPTENRIO

PARTE DI GRONLANDA
nord

OCEANVS

Quarta hec orbis pars geographis omnibus usq3 in annum 1497 incognita permansit, quo tempore iussu Regis Castelle ab Americo Vespucio inuenta est, a quo tanquam ab inuentore etiam nomen obtinuit

PICNEMAY REG TIERRA DE LABRADOR

CANADA PROV

TIERRA DE BACCALAOS

AVACAL

TIERRA FRANCISCA TIERRA DI NORIMBERGA

APALCHEN

MOCOSA

CALICVAZ

OTAGIL

CAPAS CHI

TIERRA FLORIDA

Monte Suala

LA NVEVA GALITIA
TERLI CHICHI
MECHI

ASTATLAM
TOPIRA

XALISCO

GOLFO DE LA NVEVA ESPAÑA

TROPICVS CANCRI

MEXICO

CVBA

OCEANVS

OCCIDENTAL

LA SPAGNI

MECHVACA

NVEVA ESPANA

ISLAS

Incole eorum locorum mediterraneorum antropophagi sunt, nudi incedunt, sagittandi arte peritiss. naturores corpois, coni duittes sunt variorū colorū auium plumū; solem et lunā adorāt, domicilia ad instar campanarū habent. frondibꝰ contecta.

GVATIMALA

NICA

CASTIRIA DEL ORO

BENEZVELA REG

PARIA

ISLAS

AEQVINOCTIALIS

NOVA ANDALVSIA

CARTAGENA

MAR DEL SVR

Prou. regio Caroli V. mandato et auspitiis A° 1530. perlustrata est inuentaq. est ōim hac tenus repertarum auri ditissima: adeo ut in quodā oppido in inuentorū domuni solido auro trēstam

Prouincia de Corpus Christi

Prouincia de los Trinadoz

REGIO DE BRASIL

Prouincia de S. Iuan de las Amayones

REGIO DEL PERV

AEQVINOCTIALIS

TROPICVS CAPRICORNI

COLA
CARCAS

SERENISS.
PRINCIPI MARGARITÆ
AB AVSTRIA DVCISSAE
PARMAE ET PLACENTIAE
ETC. GVBERNATRICI
PROVINCIARVM. INFERI
ORIS GERMANIAE
HIERONYMVS COCK
PICTOR
DEVOT DEDICA
BAT

CHICA

MARE MAGELLANICVM
SIVE PACIFICVM

TIERRA DE PATAGONES

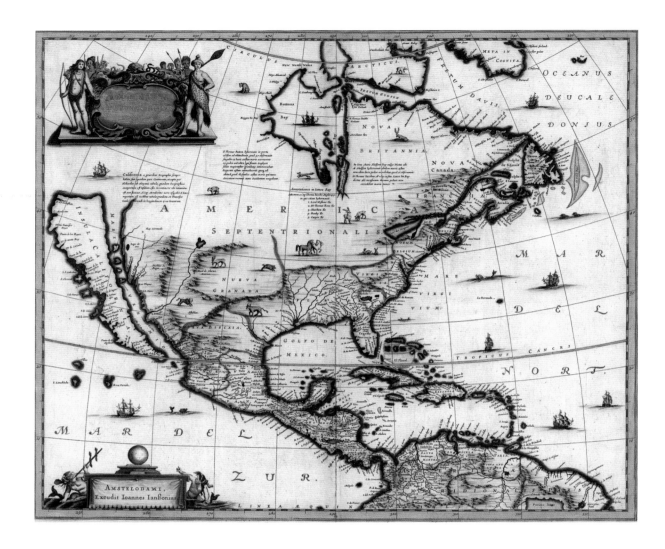

Jan Jansson (1588–1664)
America Septentrionalis.
Ca. 1652.
Library of Congress.

The settled areas of eastern North America are clearly delineated in this map by Jansson, a prolific Dutch cartographer, although knowledge of the continent's west coast was so fragmentary at the time that California is here shown as an island, a possible reference to incomplete awareness of the northern extent of the Sea of Cortez (Gulf of California).

of whose principals was the redoubtable Captain John Smith. Smith, whose published accounts not only of Virginia but also of the New England coast were among the first vivid descriptions of Britain's new American domains, was the captive allegedly rescued from execution by Pocahontas, daughter of Chief Powhatan of the Powhatan Confederation of Indians.

Pocahontas later married John Rolfe, another of the Jamestown colonists, and lived in England prior to her early death; she is one of the first named American Indians to have had her portrait painted by a European artist. As for Rolfe, he gained fame not only for his marriage to an Indian princess, but for first cultivating the crop that became the backbone of colonial Virginia's agricultural economy: tobacco. Tobacco was the first great staple of the southern colonies' plantation system, a system fortified—and ultimately marked for disaster—by the importation of African slaves, beginning in 1619. In an ironic coincidence, that same year marked the meeting of the New World's first

> *"It was in 1607, at another site along the deeply indented Virginia shores of the Chesapeake Bay, that the first permanent English settlement in America took hold."*

elected legislative body, at Jamestown. It was out of the matrix of Virginia's democratic institutions that, a century and a half later, the voices of Thomas Jefferson, James Madison, and Patrick Henry emerged. But during those same seminal years, the spread of large-scale single-crop agriculture—first tobacco, then rice and finally cotton—made slavery a vital if

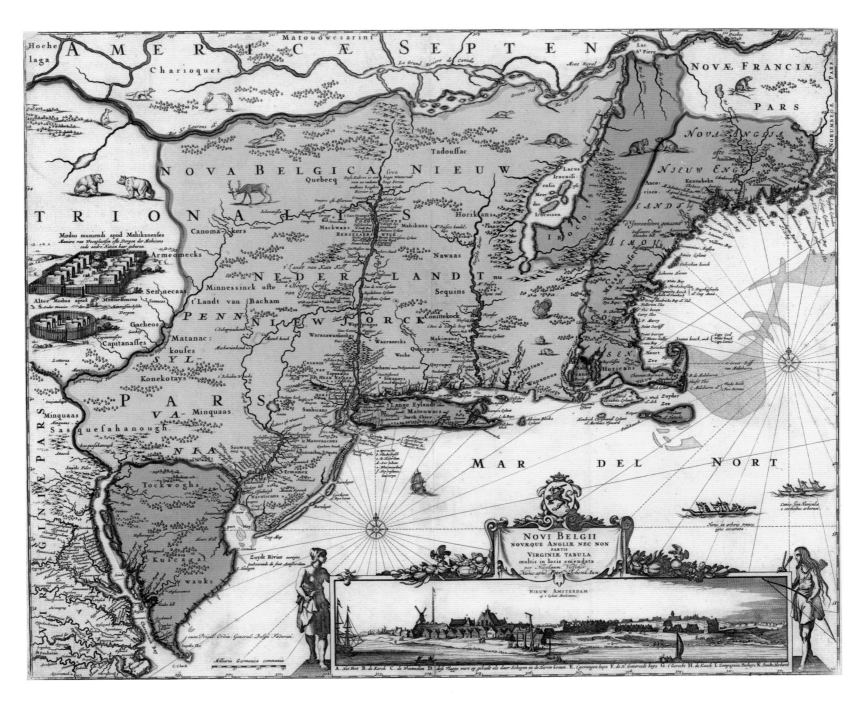

Nicolaes Visscher (1649–1702)
Nieux Amsterdam op t eylant Manhattans (New Amsterdam and the Island of Manhattan). 1685.
Library of Congress.

Visscher, whose father and son were also renowned mapmakers in the great age of Dutch cartography, here shows the Middle Atlantic and New England coasts 20 years after the British occupation of New Amsterdam, which they renamed New York. His choice of coloration reflects no historically accurate demarcation of colonial possessions.

corrosive institution throughout the southern colonies that spread westward from their first footholds along the Atlantic coast. Another legacy of the South's plantation economy was a dispersed population, with relatively few large urban centers.

A vastly different pattern of settlement commenced well to the north of Virginia. For generations, European cod fishermen had touched briefly along the rugged coastline of New England, to dry their catch and take on water; long before, the Vikings may possibly have ventured this far south of their outposts in Atlantic Canada. By the early 1600s the territory was claimed by England, which sent

expeditions under Bartholomew Gosnold, George Weymouth, and Martin Pring to scout the coast for harbors and resources. Pring and several associates led 100 would-be colonists in attempting a settlement

the cod-rich Atlantic, the towns of Salem, Danvers, Cambridge, Lexington, Concord, Gloucester, Ipswich, Newbury, and dozens of others came to life. Beyond the Massachusetts Bay Colony's borders, dissenters from the Puritans' religious orthodoxy launched the new colonies of Rhode Island and Connecticut, while other adventurers established Portsmouth, New Hampshire, and the fishing and shipbuilding outposts along Maine's rock-bound coast. By the

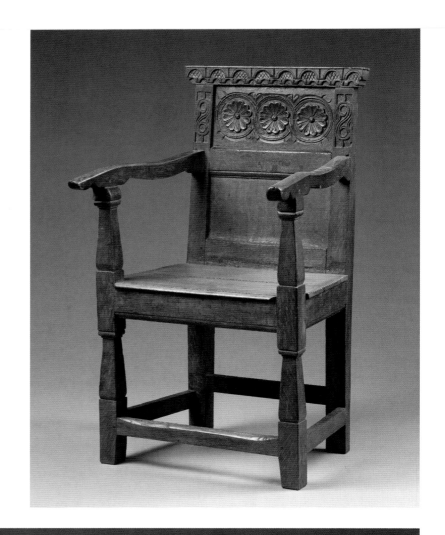

RIGHT: *Joined Great Chair.* 1640–95.
Oak, 40 ¾ x 22 ¾ x 16 ⅝ in. (103.5 x 57.8 x 42.2 cm).
Peabody Essex Museum, Salem, Massachusetts.

During the early colonial era, an armchair such as this symbolized domestic authority. Framed with mortise-and-tenon joints, it is decorated with low-relief carving. The front legs and arms are square rather than lathe-turned, and refined with tools such as a plane or gouge. The design is typical of East Anglia, where many early Massachusetts settlers originated.

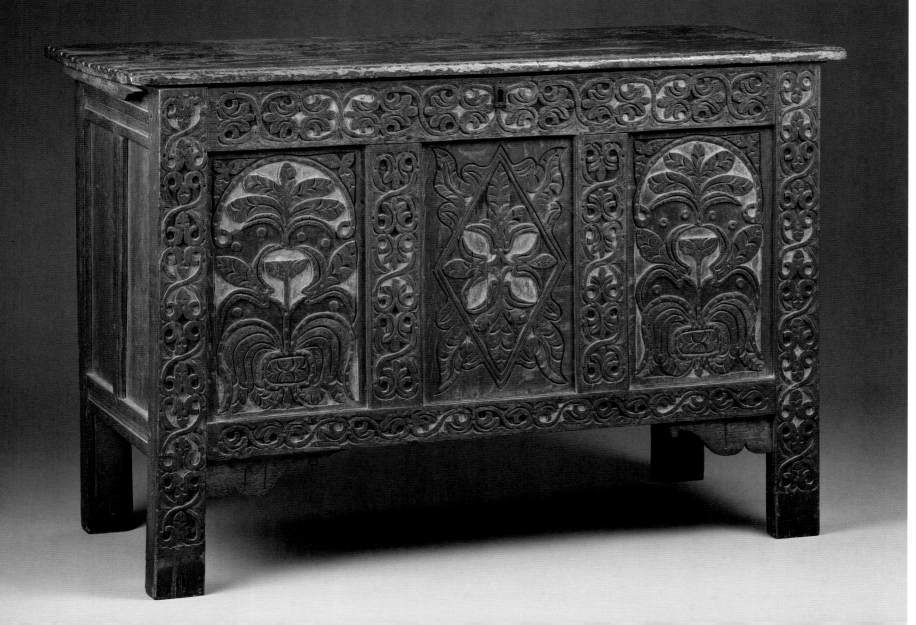

OPPOSITE, BOTTOM: Thomas Dennis
(attrib.) (1638–1706)
Joined Chest. 1670–1700.
Oak and white pine,
30 ½ x 44 ⅜ x 19 in.
(77.5 x 112.7 x 48.3 cm).
Museum of Fine Arts, Boston.

The prevalent designs employed
in seventeenth-century
Massachusetts woodworking can
often be traced back to specific
areas of England. The shallow
relief carving that almost entirely
covers the façade of this piece is
evocative of the Devon style, as is
its surviving original painted
decoration.

RIGHT: *Chest of Drawers with
Doors.* 1670–1700.
Oak, walnut, cedar, pine,
36 ⅜ x 44 ⅜ x 22 ¾ in.
(92.4 x 112.7 x 57.8 cm).
Museum of Fine Arts, Boston.

Made in New Haven, Connecticut,
this chest reflects the London
style, with inlaid checkerboard
and sawtooth motifs, and
decorative spindles with unusual
acorn caps. An economy in the
use of materials reflects the
English "wood famine" the maker
of this piece had likely grown up
with; even with New England's
abundant forests, old habits
died hard.

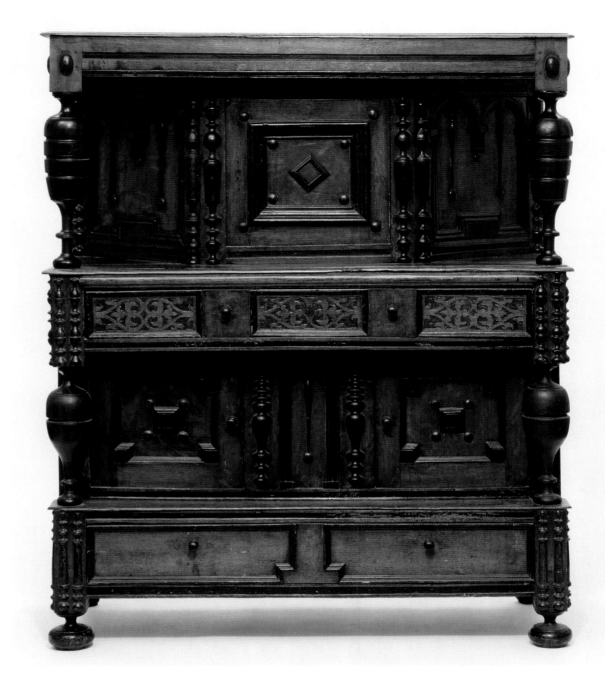

second half of the seventeenth century New England yeomen had penetrated the interior, with Hartford and Springfield taking hold along the banks of the Connecticut River.

A different sort of religious rebel was responsible for the most significant English settlement between Virginia and New England. Quakers, led by William Penn, sailed to the head of Delaware Bay and in 1682 established the royally chartered colony of Pennsylvania and its capital, Philadelphia, "the city of brotherly love." Within a century, Philadelphia would grow to become the second-largest English-speaking city in the world, after London.

The English were not alone in organizing the first colonies along the eastern seaboard of the future United States. Acting upon claims based on Henry Hudson's 1609 explorations, entrepreneurs from the Netherlands established the Dutch West India Company. They built the fur-trading post of Fort Orange at the head of navigation on the Hudson River, where Albany would later stand. And in 1625, another Dutch contingent carved out a town at the tip of a narrow island commanding the head of the great natural harbor that had been visited by Henry Hudson and, a century earlier, by the Italian Giovanni da Verrazzano. The Dutch colony was called New

Cupboard. 1685–90.
Oak, maple, white pine.
Museum of Fine Arts, Boston.

Cupboards used to store and display textiles, silver, and other valuables were one of the most expensive furnishings in late-seventeenth-century New England. This richly embellished example, made in northern Essex County, Massachusetts, displays nearly the full vocabulary of seventeenth-century ornament. At least 10 woodworking families were then active in this part of the colony.

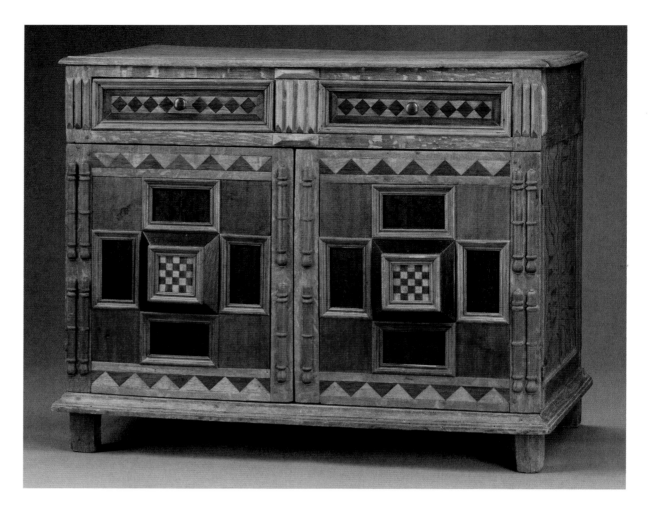

Netherlands, and the island village, New Amsterdam. Only with the English takeover of the Dutch domains, in 1664, would the still-insignificant settlement be renamed in honor of the Duke of York.

The Dutch days in New Amsterdam, whimsically chronicled nearly 200 years later by Washington Irving in his guise as "Diedrich Knickerbocker," were a time of authoritarian rule by the Dutch West India Company's governors, notably the irascible Peter Stuyvesant. Pennsylvania, though guided in its early years by William Penn, was governed along generally democratic lines without harsh ecclesiastical interference; and the southern colonies, largely settled by adherents of the Church of England prior to the later arrival of Scotch-Irish religious dissidents, followed a pattern of secular representative government. But the model of civic organization best remembered from the early colonial period is that of Puritan New England, where religion and government were so thoroughly intertwined that voting members of each community (property-holding men, of course) had to be members of the church. Deviation from

Puritan theology was deviation from the law: Roger Williams, founder of Rhode Island, had been banished from the Massachusetts Bay Colony for his heretical opinions, and the Quaker Mary Dyer was hanged on Boston Common. The portraits that have come down to us from seventeenth-century New England show a godly, grim, and stiff-necked sampling of a population that they likely represented well.

And yet, Puritan intransigence was not without its lasting advantages. The proudly independent communities gathered beneath their original colonial charters chafed defiantly under the attempted revocation of those charters by the imperious James II, and that monarch's 1686 appointment of Sir Edmund Andros as royal governor of all New England. With James's overthrow in the "Glorious Revolution" of 1688, Andros was clapped in irons and sent back to England. (The colonies got their independent charters back, but only on the condition that they allow citizens of all religious affiliations to vote.)

The Puritans also pioneered higher education in North America, founding Harvard College in 1636—

a mere six years after the settlement of nearby Boston. Harvard was established to provide clergymen for the colony, fluent in Latin and Hebrew, but even at the humblest levels of society, literacy was encouraged so that the faithful could read the Scriptures. Yale opened its doors—also to prospective ministers—in New Haven, Connecticut, in 1701. By then, the colony of Virginia had its own institution of higher learning in the College of William and Mary—eventually the alma mater of Thomas Jefferson—although the South long lagged behind New England in this regard: its plantation grandees traditionally sent their sons to England to complete their educations.

By the end of the seventeenth century, the English colonies dominated the Atlantic seaboard. Except along the frontiers, the threat of conflict with the Indians had abated—especially, in New England, after the 1675–76 King Philip's War broke the fighting spirit and ability of the Wompanoags and Narragansetts of Massachusetts and Rhode Island. The remaining great peril, as the citizens of Deerfield, Massachusetts, learned all too well during the bloody raids of the early 1700s, was from the French in Canada and their Indian allies. That was a

threat to be addressed decades later, in the French and Indian War. For now, as the century turned, the task was to turn an isolated skein of societies—a tight-knit theocracy in the north, and a patchwork of plantations in the south—into a secular proto-nation with its own sense of destiny.

ABOVE: **John Coney** (1655 or 1656–1722)
Sugar Box. 1680–85.
Silver, 4 3/16 x 6 x 7 3/4 in.
(10.6 x 15.2 x 19.7 cm).
Museum of Fine Arts, Boston.

John Coney, under whom Paul Revere's father Apollos Rivoire apprenticed, was one of the most prominent Boston silversmiths of his day. The intricate workmanship and considerable expense of his era's American silver sugar boxes—of which only 10 survive—reflect the status of sugar as a luxury item in early New England.

LEFT: **Henry Hurst** (1666–1717)
Tankard. Ca. 1700.
Silver, height: 7 in. (17.8 cm); diameter at base: 5 3/16 in. (13.2 cm); diameter at lip: 4 3/8 in. (11.1 cm).
Museum of Fine Arts, Boston.

Tankards were covered vessels used most often for beer, ale, or hard cider, and ranged in size up to four quarts capacity. The Swedish-born Hurst brought his native country's typical embossed fruit-and-foliage handle decoration to this unusual Boston specimen, one of only three pieces known to bear his mark.

The Salem Witch Trials

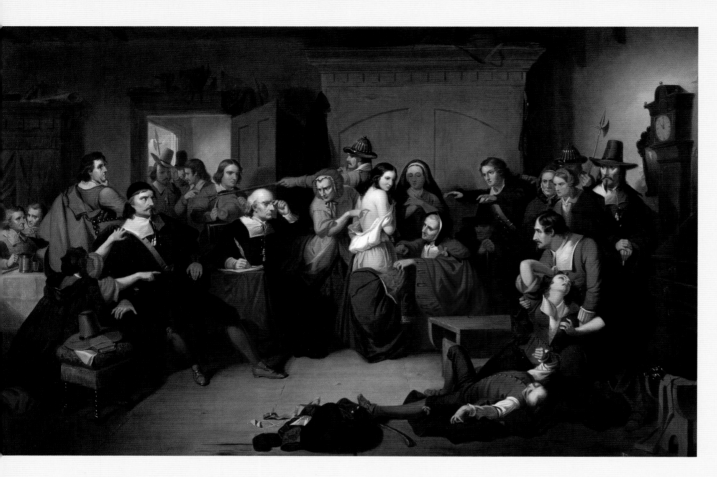

Salem, Massachusetts, is probably the only city in the world that has an image of a witch on a broomstick emblazoned on its police cars. But the city's spooky logo—as well as its cheerful enthusiasm for Halloween—has its origin in one of the darkest episodes in America's past.

In seventeenth-century Europe, persecution of supposed witches was widespread. Puritan New England, with its fervent belief in satanic powers working through mortal men and women, provided fertile ground for an American witch-hunt—and all of the ingredients came together in Salem, Massachusetts, during the summer of 1692.

Salem Village, today's Danvers, was a community of some 600 small farmers and tradesmen several miles inland from Salem Town, the famous seaport that eventually bore the stigma—and enjoys the modern-day celebrity—of the witch trials. The minister at Salem Village was one Samuel Parris, whose household included a nine-year-old daughter, Betty, a twelve-year-

old orphan niece, Abigail Williams, and a Barbados-born slave named Tituba. During the long winter months, Tituba regaled the girls and their friends with the supernatural folk tales of her native island, and would help them dabble in fortune-telling. But when the girls' vivid imaginations ran away with them, they began to act out their stress in physical contortions. Reverend Parris called in a doctor, who found nothing wrong with them. Perhaps, the doctor ventured, they had been bewitched.

Wary at first of making direct accusations, Betty finally named Tituba. The other girls spoke up next, pointing their fingers at two local women, Sarah Osborne and Sarah Good. Neither was in a good position to fend off the accusations—old Sarah Osborne had long avoided church services, and Sarah Good was a homeless beggar.

Two magistrates came to Salem Village to launch the investigation. While the accused were being questioned, Betty, Abigail, and six other girls writhed

and screamed on the floor. Sarah Good and Sarah Osborne maintained their innocence—but Tituba confessed. She said that a man in black had made her sign in a book, and that Good, Osborne, and others had done the same. Following her confession, she and the other two women were jailed.

> "During the long winter months, Tituba regaled the girls and their friends with the supernatural folk tales of her native island, and would help them dabble in fortune-telling."

The accusations now spread beyond the Parris household. In March, Ann Putnam accused Martha Corey of having afflicted her. Next Rebecca Nurse, an elderly woman with an unblemished reputation, was cited by Ann Putnam and the other girls. They alleged that her specter would appear to them at night, poking, pinching, and otherwise harassing them. Putnam also accused a former Salem Village minister, George Burroughs, of being the master witch of Massachusetts. By June of 1692, some 200 people had been jailed, and Governor William Phips established a special court to bring them to trial.

The first trial resulted in the conviction and hanging of Bridget Bishop, who was said to have possessed dolls that she stuck with pins in order to afflict her neighbors. Sarah Good, Sarah Wilds, Elizabeth Howe, Susannah Martin, and Rebecca Nurse were tried next; all were convicted and executed.

As the jails filled with even more accused witches, George Jacobs Sr., the Reverend George Burroughs, John and Elizabeth Proctor, Martha Carrier, and John Willard appeared before the court. All six were found guilty, and all were hanged except the pregnant Elizabeth Proctor.

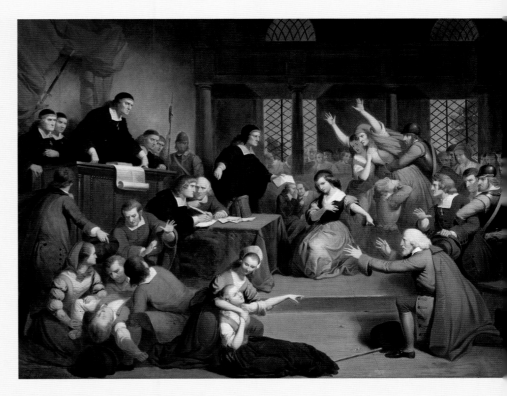

Tompkins Harrison Matteson (1813–84)
The Trial of George Jacobs, August 5, 1692. 1855.
Oil on canvas, 39 x 53 in. (15.4 x 20.7 cm).
Gift of R. W. Ropes. Peabody Essex Museum, Salem Massachusetts.

George Jacobs Sr. was accused along with his son, daughter-in-law, and granddaughter of witchcraft during the Salem proceedings of 1692. "You tax me for a wizard," Jacobs asserted during the trial. "You may as well tax me for a buzzard. I have done no harm." Convicted of being in league with the Devil, he was hanged.

Only one of the accused was executed by a means other than the gallows (none were burned, as was often the fashion in Europe). Giles Corey refused to answer the court's questions, and the sheriff was ordered to pile rocks upon him until he agreed to cooperate. He never gave in, and died after two days of increasing, crushing weight.

The final victims of the hysteria were Wilmott Reed, Martha Corey, Mary Easty, Margaret Scott, Alice Parker, Ann Pudeater, Samuel Wardwell, and Mary Parker, all hanged on September 22, 1692. But by the time of their deaths, public support for the trials was waning, and most people were certain that innocent lives were being lost. On October 12, 1692, Governor Phips ordered that there be no further arrests. He dissolved the special court by the end of the month, and pardoned the remaining accused the following May. Tituba, who had been jailed but never convicted and executed, was sold to pay the cost of her incarceration.

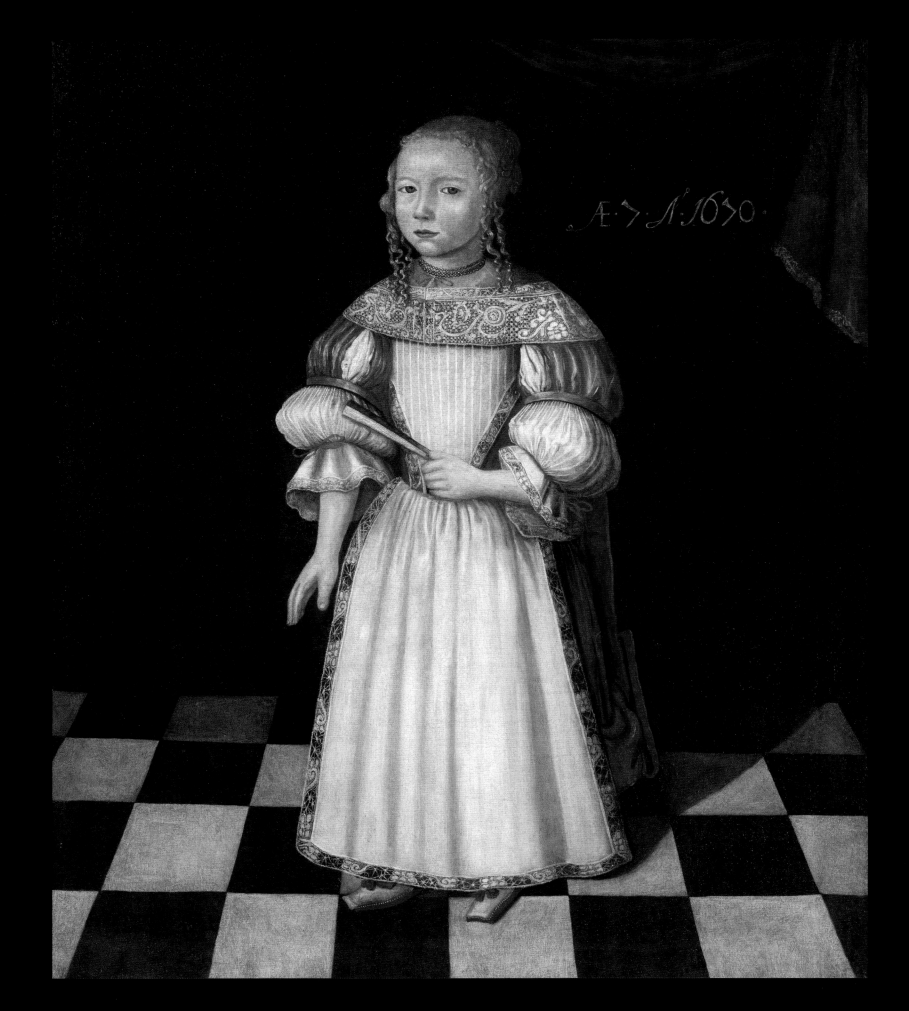

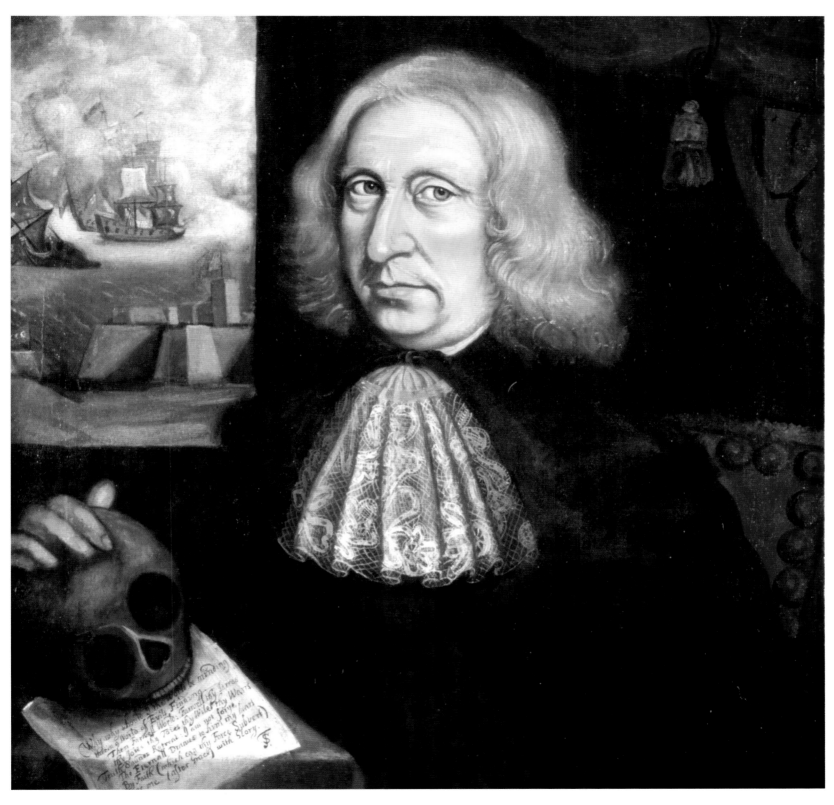

OPPOSITE: Freake-Gibbs Painter (n.d.)
Margaret Gibbs. Ca. 1670.
Oil on canvas, 40 ½ x 33 ⅛ in. (102.8 x 84.1 cm).
Museum of Fine Arts, Boston.

The commissioning of children's portraits as early as 1670 is proof of young Boston's rapid growth and burgeoning prosperity. Margaret was one of three children of the merchant Robert Gibbs, whose children Robert and Henry were also portrayed by this unknown painter. The flat, color-rich style is Elizabethan, with Dutch influences.

ABOVE: Thomas Smith (d. 1691)
Self-Portrait. Ca. 1680.
Oil on canvas.
Worcester Art Museum, Worcester, Massachusetts.

This earliest American self-portrait is the only seventeenth-century New England portrait whose artist has been identified. Smith's attire shows that he was wealthy; his inclusion of the skull and initialed poem—both symbols of mortality—along with a technique that creates an illusion of space, show his familiarity with Dutch and British conventions of his era.

Colonial Noontide

(1700–70)

"From hundreds of shipyards and shops, from sunup to sundown, came the tapping of hammers, the thump of hand looms, the creak of wooden machinery."

—Esther Forbes, *Paul Revere and the World He Lived In*

When we think of colonial America, the image that comes to the mind's eye is almost invariably that of the English colonies during the eighteenth century. This was the era when—at least in the young urban centers such as Boston, New York, Philadelphia, and Charleston and their near environs—the first rough edges of colonial life had been smoothed, and when

energies formerly applied entirely to survival could now be turned toward social amenities and the decorative arts. A century that could, three-quarters of the way through its progress, produce the intellectual lights of the American Revolution was clearly no longer a hardscrabble frontier society.

There was a frontier, of course, and it was no farther west than the Appalachian Mountains. And plenty of

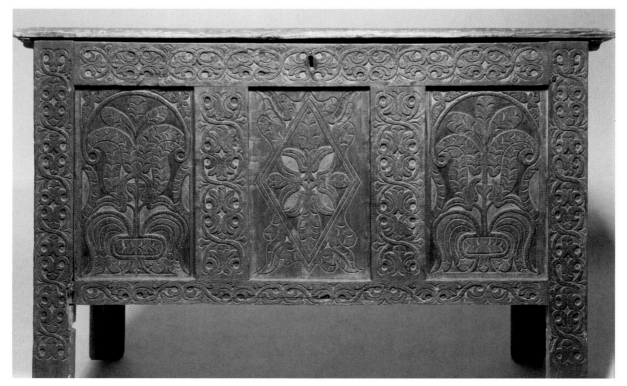

LEFT: *Chest.* 1690–1710. Carved and painted pine and oak. 31 ½ x 46 ½ in. (80 x 118.1 cm). *Private Collection.*

American cabinetmaking developed well before the end of the seventeenth century, with English-trained artisans and an apparently limitless supply of native materials.

OPPOSITE: Pieter Vanderlyn (1687–1778) *Catherine Ogden* (1709–97). Ca. 1730. Oil on canvas, 57 x 37 ¼ in. (144.8 x 94.6 cm). *Collection of The Newark Museum, Newark, New Jersey.*

Born in the Netherlands, Pieter Vanderlyn immigrated to New York in 1718 and spent much of his career painting members of the landed gentry of the Hudson River Valley.

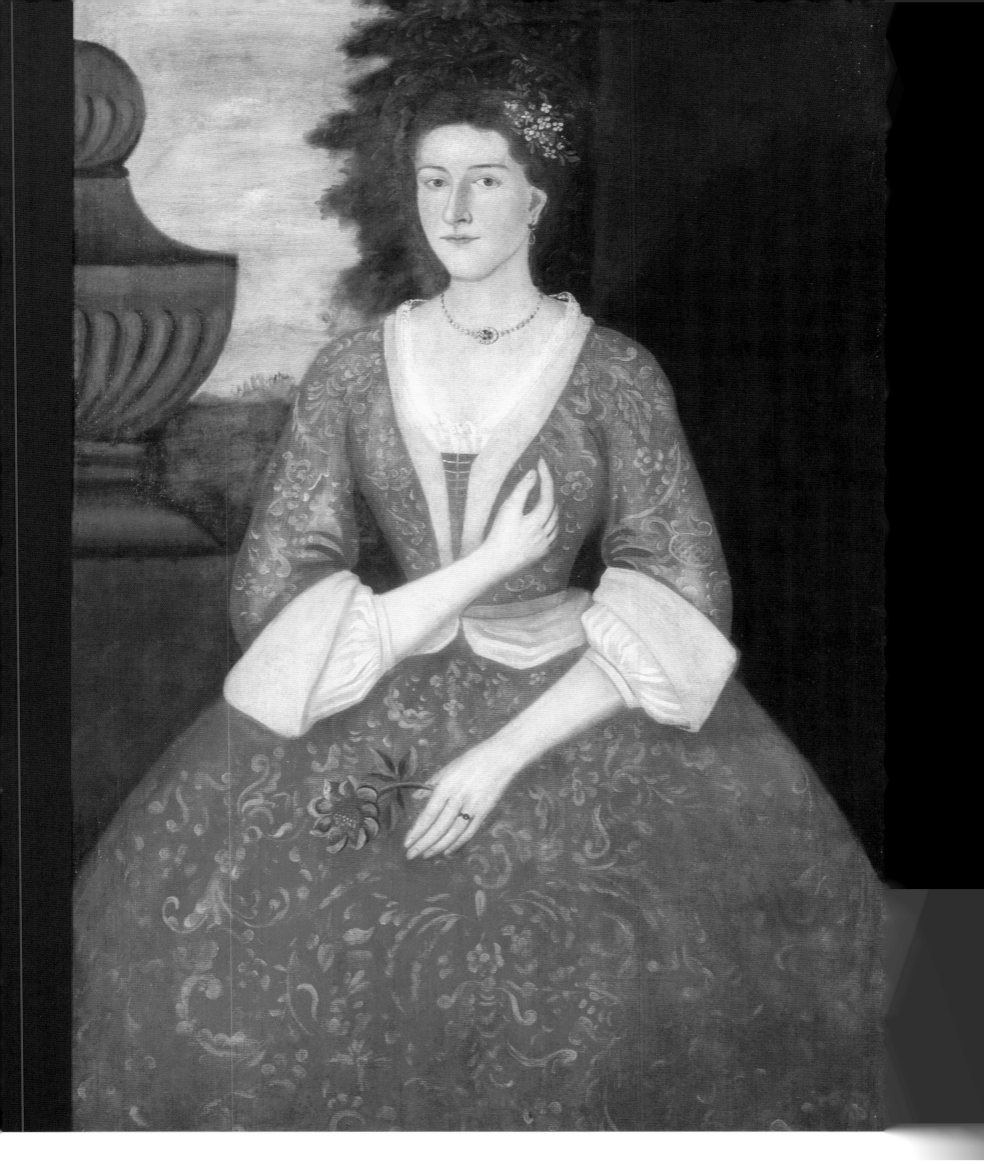

John Smibert (1688–1751)
*Dean Berkeley and His Entourage
(The Bermuda Group).*
1729 or 1739.
Oil on canvas, 69 ½ x 93 in.
(176.5 x 236.2 cm).
*Gift of Isaac Lothrop.
Yale University Art Gallery, New
Haven, Connecticut.*

Scottish-born Smibert, the first
academically trained painter to
work in the American colonies,
came to Boston as part of a
group lead by the Anglican
churchman Dean George Berkeley.
Berkeley planned to establish an
academy in Bermuda, at which
Smibert would teach painting;
the scheme failed, and the artist
remained in Boston as a painter
of prominent citizens.

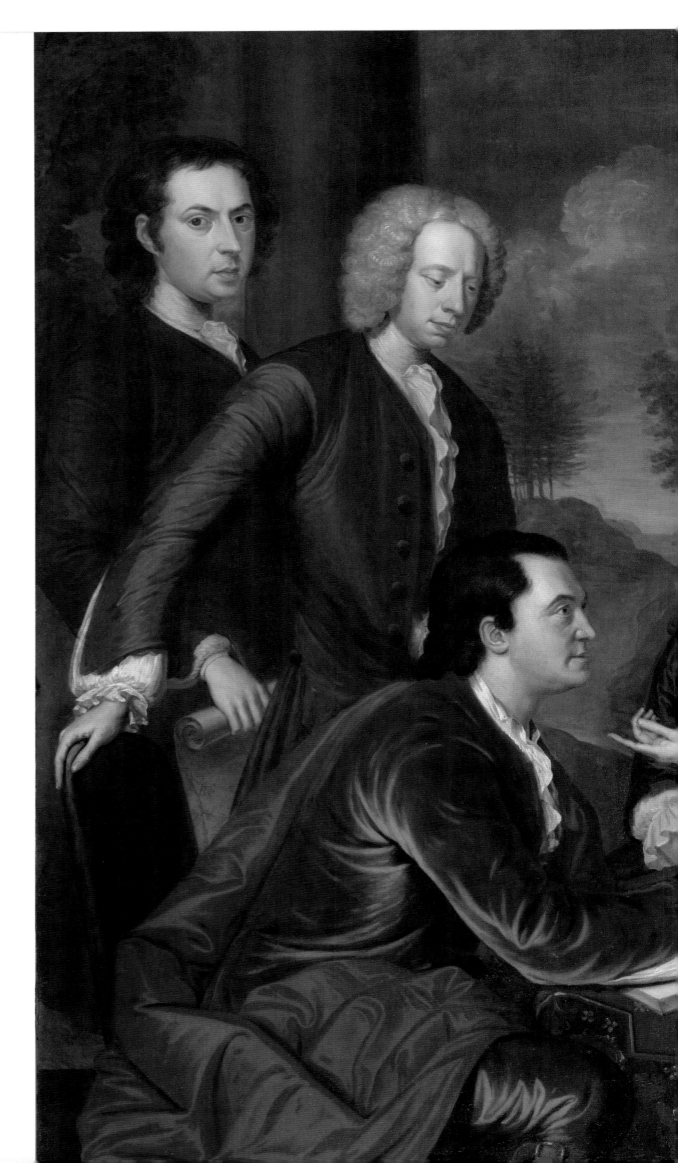

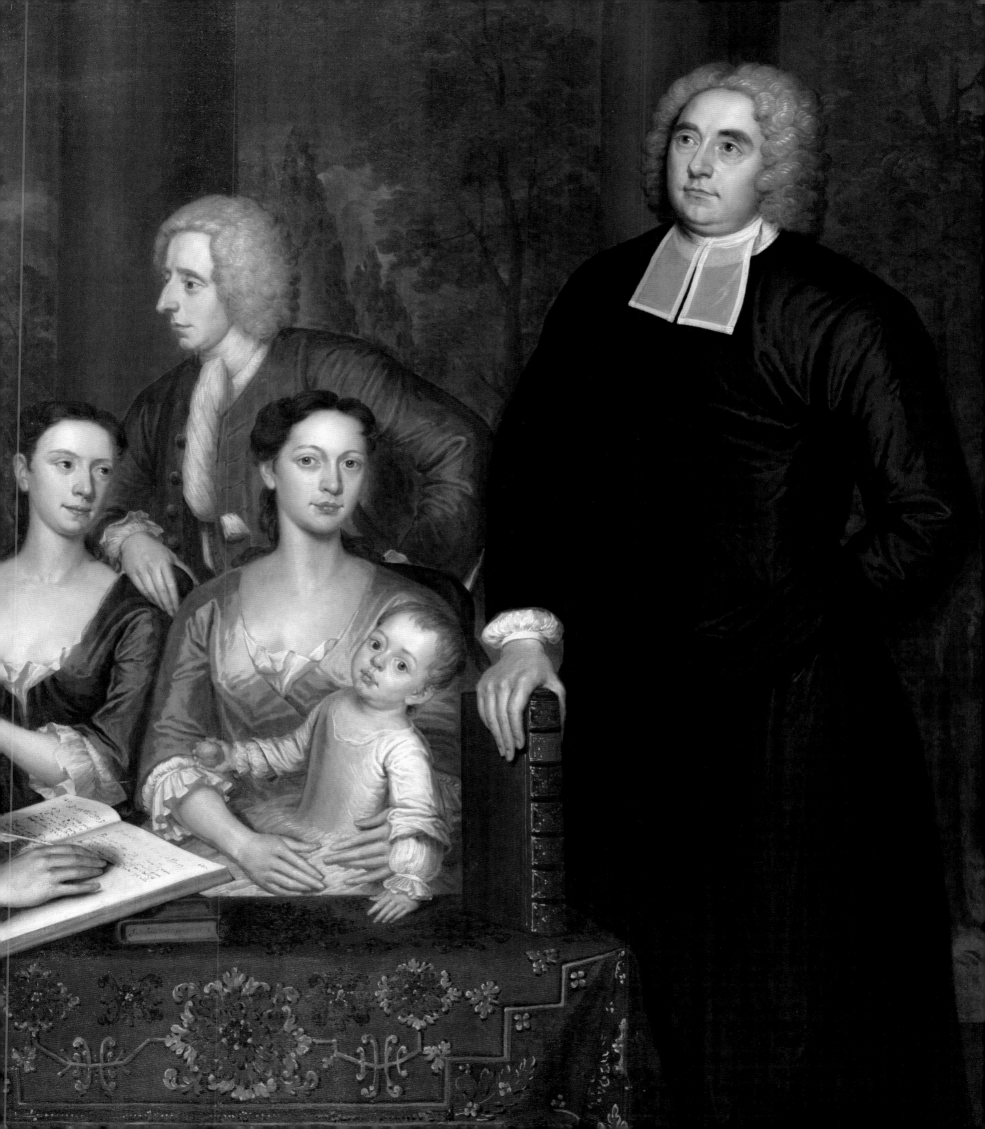

John Valentine Haidt (1700–80)
Young Moravian Girl. 1755–60.
Oil on canvas, 30 ⅜ x 25 ¼ in.
(77.2 x 64.2 cm).
*Smithsonian American Art
Museum, Washington, D.C.*

The Moravians were one of the
German religious refugee groups
that arrived in the Middle
Atlantic colonies in the mid-
eighteenth century. Haidt was
himself part of this migration,
arriving in Pennsylvania in 1754.
Trained as an artist in Europe,
he painted members of the
colony's Moravian community,
while serving as a deacon in
his church.

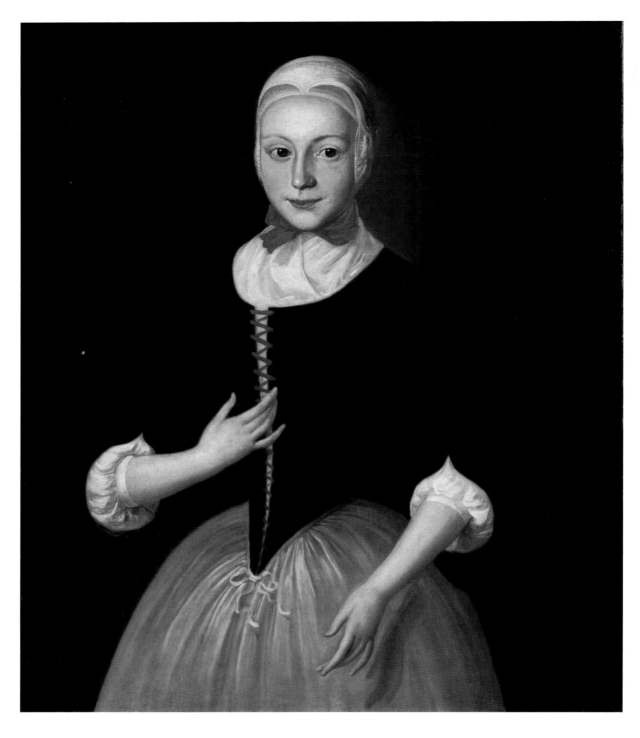

1,150,000 by 1750 (by the end of the century, it would
exceed five million). Much of the colonies' growth
during the 1700s was the result not only of a
burgeoning English population, but also of
immigration from other lands both within and
outside the British Isles. In 1716, Governor Alexander
Spotswood of Virginia led an expedition into the
Shenandoah Valley, on the western slopes of the Blue
Ridge Mountains, opening vast new territories that
would soon attract the Scotch-Irish pioneers who still
make up the region's bedrock ethnic stock. The fertile
interior of Pennsylvania became host to German
religious dissidents, the "Pennsylvania Dutch"
(Deutsch) of later years. As unclaimed farmland
became scarcer in long-settled New England, an
internal migration led newcomers and old families
alike across the Hudson into the central valleys of
New York.

And at the wharves of the eastern seaports, hopeful
fresh arrivals looked to turn their hands to the many
trades that offered promise. These were wide-eyed
foreigners such as the 13-year-old French Huguenot

Apollos Rivoire, who apprenticed to one of Boston's 32 gold- and silversmiths shortly after he landed in late 1715. His son, Paul, would become an especially accomplished member of that profession, and would also achieve fame in an entirely different pursuit. Long before Paul's birth, though, young Apollos had changed the family name to Revere.

The fact that there were 32 craftsmen engaged in producing silver tableware in early-eighteenth-century Boston speaks volumes about colonial America's economic growth and self-sufficiency. Fifty years before Apollos Rivoire's arrival, woodenware would have been the norm in most colonial households, and those few families who could afford silver likely would have imported it from England. Owning fine silver, of course, was a prerogative only of the middle and upper classes, and many more vessels were made of cheaper pewter. But there was, by now, the beginning of a solid middle class of artisans and tradesmen, who were not only better off economically, but largely liberated from earlier Puritan strictures against anything smacking of ostentation. (Puritanism was always conflicted on the subject of material wealth; on one hand, worldly success was seen as evidence of divine favor; on the other, flaunting wealth was considered unseemly.)

As the century progressed, there were many fine things to spend money on other than teapots and cutlery. The 1700s were a golden age of American furniture craftsmanship, with workshops in Portsmouth, New Hampshire; Newport, Rhode Island; and Philadelphia turning out exquisite pieces in the graceful Queen Anne and Georgian styles—today, a splendid highboy with broken-pediment top and cabriole legs by the right maker can command six or even seven figures at auction.

Architecture likewise reflected a new freedom of expression made possible by prosperity. Early American homes were darkly functional shelters against the elements, especially in the north. Those that survive, stark against the New England landscape or tucked onto the streets of Newburyport and Ipswich, Massachusetts, have a medieval appearance, with low rooflines only one generation removed from thatch, huddled in "saltbox" style against unforgiving north winds. But during the first full American century, pure functionalism gave way—at least for those who could afford it—to the elegance of the English Georgian mode, with brick façades, slated hipped roofs, more and larger windows, and Palladian fanlights above paneled doors that no longer looked as if their main purpose was to keep out the weather and the Indians. Indoors, carved mantelpieces and intricate corner moldings ornamented the homes of the well-to-do. Carpets and wallpaper were still imported—the

American Flint Glass Manufactory
Pocket Flask. Ca. 1765–74.
Blown pattern-molded lead glass, height: 4 ¾ in. (12.1 cm).
Gift of Frederick W. Hunter, 1913. The Metropolitan Museum of Art, New York, New York.

Located in Manheim, Pennsylvania, the American Flint Glass Manufactory was the first domestic glass tableware producer to challenge European imports for quality. During the late eighteenth century, American entrepreneurs, particularly in the Middle Atlantic region, began to take advantage of abundant resources of sand and coloring minerals to produce a wide variety of glassware.

system was anathema. What was worse, the Indian tribes allied with the French had made northern New England a perilous place to settle.

The friction between the two great colonial rivals kindled into flame in 1754, when skirmishes along the Ohio Valley marked the beginning of the French and Indian War. The war, named not because it was a conflict between the French and the Indians but because it pitted both against the British and the American colonial militias, lasted for six years, a period during which France and Great Britain clashed in Europe's Seven Years' War. The culmination of the struggle in the New World came at Quebec, in September of 1759, when British General James Wolfe defeated the French under the Marquis of Montcalm in a battle which cost both commanders their lives. Montreal fell in the following autumn, and New France ceased to exist.

But the germ of a new conflict was concealed in the British victory. The war had been an expensive one, for which Britain felt its colonies should pay their share in more than the currency of colonial lives lost in battle. The solution, London felt, lay in increased taxes—but the colonists had different ideas.

OPPOSITE: *The Great Hall of Van Rensselaer Manor House.* 1765–69.
Gift of Mrs. William Bayard Van Rensselaer, in memory of her husband, 1928. The Metropolitan Museum of Art, New York, New York.

The estates of the Dutch "patroons" of the Hudson River Valley were virtually feudal fiefdoms. Perhaps the greatest was Rensselaerwyck, which incorporated a vast tract around the present city of Albany. This room was salvaged from the last manor house to stand on the property; it was dismantled in 1895.

RIGHT: John Singleton Copley (1738–1815)
Henry Pelham (Boy with a Squirrel). 1765.
Oil on canvas, 30 ⅜ x 25 ⅛ in. (77 x 63.8 cm).
Gift of the artist's great-granddaughter, 1978. Museum of Fine Arts, Boston.

The self-trained Copley was widely praised in London for this masterful portrait of his stepbrother, and achieved renown in his native Boston for perceptive portraits of prominent citizens. But America's greatest pre-Revolutionary painter acted on his Tory sympathies by moving to England, leaving his Beacon Hill estate to be developed as the exclusive neighborhood it remains.

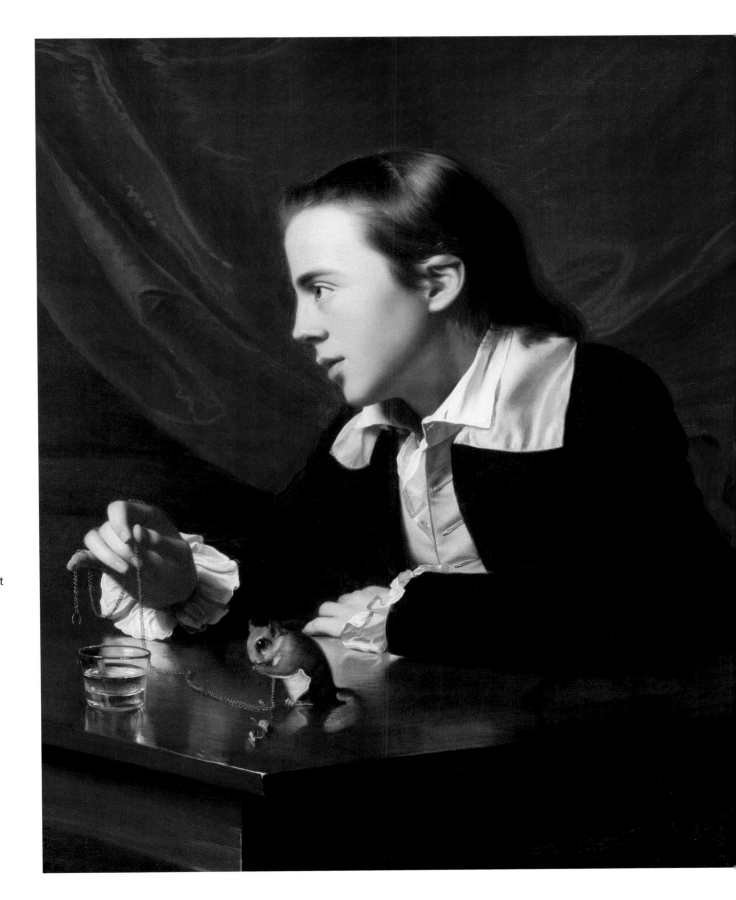

Benjamin Franklin: America's Star of the Enlightenment

Perhaps the best evidence of colonial America's coming of age in the eighteenth century is the career of Benjamin Franklin, the Philadelphia polymath who excelled as a scientist, inventor, author, political activist, and diplomat. Unlike the great European figures of the Age of Enlightenment—thinkers such as Voltaire, Rousseau, and Hume—Franklin is remembered not only for his ideas, but for the practical institutions and inventions he gave to the world. He exemplified what later came to be called "Yankee ingenuity," and lives in the popular imagination as the wise old uncle of America's revolutionary era. An intensely practical man, he is known around the world for the most practical of reasons: his is the face on the U.S. $100 bill.

Benjamin Franklin was born in Boston in 1706. By the time he was 10 years old, this future holder of an honorary doctorate from Oxford had completed all the formal schooling he would ever have, and begun work in his father's soap and tallow business. He soon learned the printer's trade as an apprentice to his half-brother James, eventually writing the anonymous "Mrs. Silence Dogood" letters that appeared in the elder Franklin's *New England Courant* newspaper. But quarrels with James led the 17-year-old Franklin to leave Boston for Philadelphia. He arrived in the colonies' largest city penniless, with—according to the story he later told in his famous *Autobiography*—a baker's roll tucked beneath each arm.

> *"But Franklin was no Puritan scold.... He was a deist, favoring good works and a useful life over doctrinal orthodoxy."*

Franklin worked as a printer in Philadelphia, as well as for a two-year period in London after being sent there to purchase printing equipment. It was after his return, in 1726, that his career as a publisher, scientist, and

relentless improver of civic life began to flourish. His printing business financed his ownership of the *Pennsylvania Gazette*, and, more importantly, allowed him to launch *Poor Richard's Almanac*. Franklin's advocacy of temperance, frugality, industry, resolution, and other classic Yankee virtues found a steady outlet in the *Almanac*, the vehicle for so many homey aphorisms that have since become folk wisdom.

But Franklin was no Puritan scold. Like other figures of the Enlightenment, he was a deist, favoring good works and a useful life over doctrinal orthodoxy; he respected Christ's teachings, but doubted his divinity. In his personal life, too, Franklin flouted convention: he lived with Deborah Reed as his common-law wife, and his son William—later the last Loyalist governor of New Jersey—was born out of this informal style of wedlock. Too much has been made, however, of Franklin's involvement with the "Hell Fire Club," a society of dissolute aristocrats he may or may not have been involved with during later stays in England.

A list of Franklin's contributions during his Philadelphia years reads like a litany drawn from 10 men's lives. He established a post office, fire department, and fire insurance company; set up the first American lending library; researched and named the Gulf Stream; and invented the lightning rod, odometer, Franklin stove, bifocals, flexible urinary catheter, and the glass armonica, a musical contrivance of moistened spinning glass disks. He did not "discover" electricity, but, with his famous kite experiment, proved its identity in lightning.

Having served in the Pennsylvania Assembly, Franklin was sent in 1757 as its representative in London, where he would spend much of his time during the years leading up to the Revolution. He returned to Philadelphia in May of 1775, and was immediately chosen as a member of the Second Continental Congress. Nearing 70, he was about to embark on the final and most politically important phase of his career. He helped draft the Declaration of Independence, and served as an emissary to France, where he forged that nation's alliance with the fledgling United States. (During his stay in Paris, he achieved celebrity status and was wildly popular with the ladies of the capital.) He joined with John Adams and John Jay to negotiate the peace treaty with

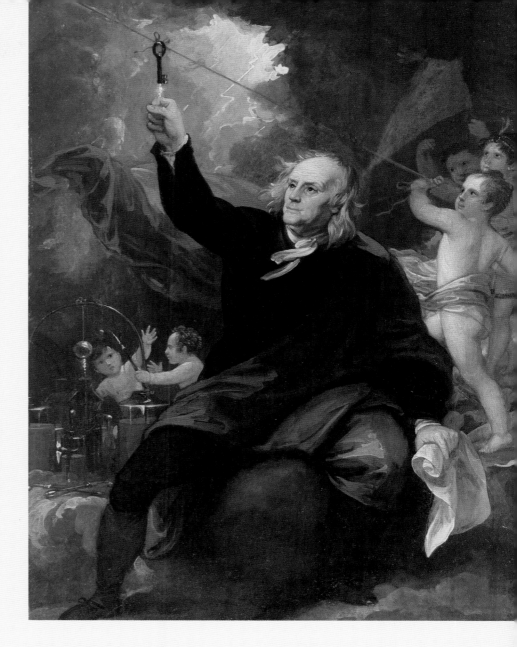

Great Britain, and came home to take part in the Constitutional Convention.

Franklin died in Philadelphia in 1790, at age 84.

ABOVE: **Benjamin West** (1738–1820)
Benjamin Franklin Drawing Electricity from the Sky. Ca. 1816.
Oil on slate, 13 ⅜ x 10 ¹⁄₁₆ in. (34 x 25.6 cm).
Gift of Mr. and Mrs. Wharton Sinkler, 1958. Philadelphia Museum of Art, Philadelphia, Pennsylvania.

This portrayal of Franklin as a modern Prometheus possesses the characteristic drama of West's grand canvases of historical subjects. The American-born painter trained in Europe and spent much of his career in England, where he became the second president of the Royal Academy.

OPPOSITE: **Jean Antoine Houdon** (1748–1828)
Portrait of Benjamin Franklin. 1779.
Plaster.
Musée de la cooperation franco-americaine, Blérancourt, France.

This is one of several busts of Franklin made by Houdon, who similarly portrayed George Washington. Franklin, who captivated Parisian social and intellectual circles during his ambassadorship to France (1776–85), never sat formally for the celebrated sculptor, who relied on impressions from their meetings.

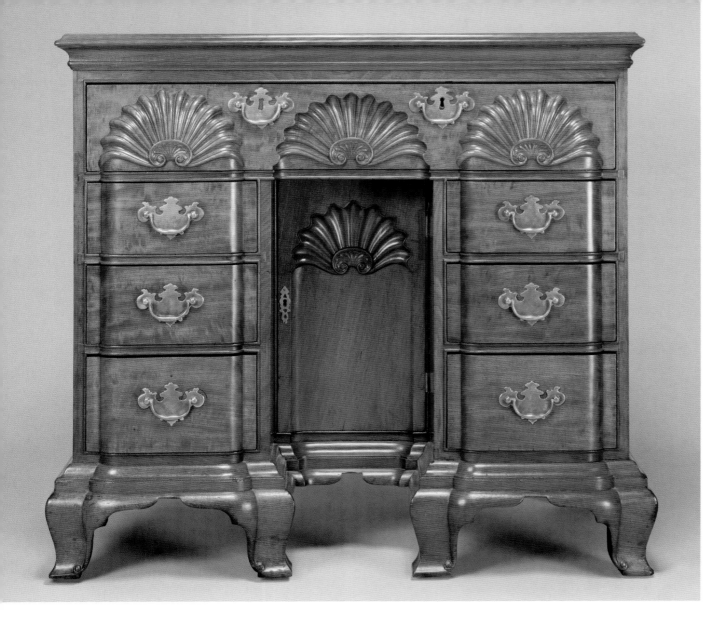

OPPOSITE: **Ralph Earl** (1751–1801)
Roger Sherman (1721–93).
Ca. 1775.
Oil on canvas, 64 ⅝ x 49 ⅝ in.
(164.1 x 126 cm).
*Gift of Roger Sherman White,
B.A. 1899, LL.B. 1902. Yale
University Art Gallery, New
Haven, Connecticut.*

Roger Sherman was a delegate to the Continental Congress, where he served on the committee drafting the Declaration of Independence, and to the Constitutional Convention. He later represented Connecticut in the U.S. Senate. Ralph Earl, who had studied in England with Benjamin West, was so highly regarded that he received the Sherman commission despite his Tory sympathies.

ABOVE: **John Townsend** (attrib.) (1732–1809)
Bureau Table. Ca. 1765.
Mahogany, chestnut, tulip poplar, white pine, 34 ⅜ x 36 ½ x 20 ½ in.
(87.3 x 92.7 x 52.1 cm).
*Gift of Mrs. Russell Sage, 1909. The Metropolitan Museum of Art, New
York, New York.*

The block-and-shell motif was a favorite of John Townsend, one of a family of Quaker cabinetmakers active in Newport, Rhode Island, when that city was second only to Boston as a New England port. This example dates to Townsend's introduction of the style, which added the shell design to the already popular block-front drawer treatment.

RIGHT: **Joseph Smith** (fl. 1760s)
Tea Caddy. 1767.
Earthenware with white slip decoration. 6 ¾ x 5 x 5 in.
(17.1 x 12.7 x 12.7 cm).
*Gift of C. Sanford Bull, B.A. 1893. Yale University Art Gallery,
New Haven, Connecticut.*

Fired at lower temperatures than stoneware or porcelain and consequently more porous, earthenware was a less expensive early American alternative to British or European imports. Joseph Smith, whose pottery was in Wrightstown, Pennsylvania, glazed this tea caddy with slip (liquid clay) and likely used red iron oxide as a colorant.

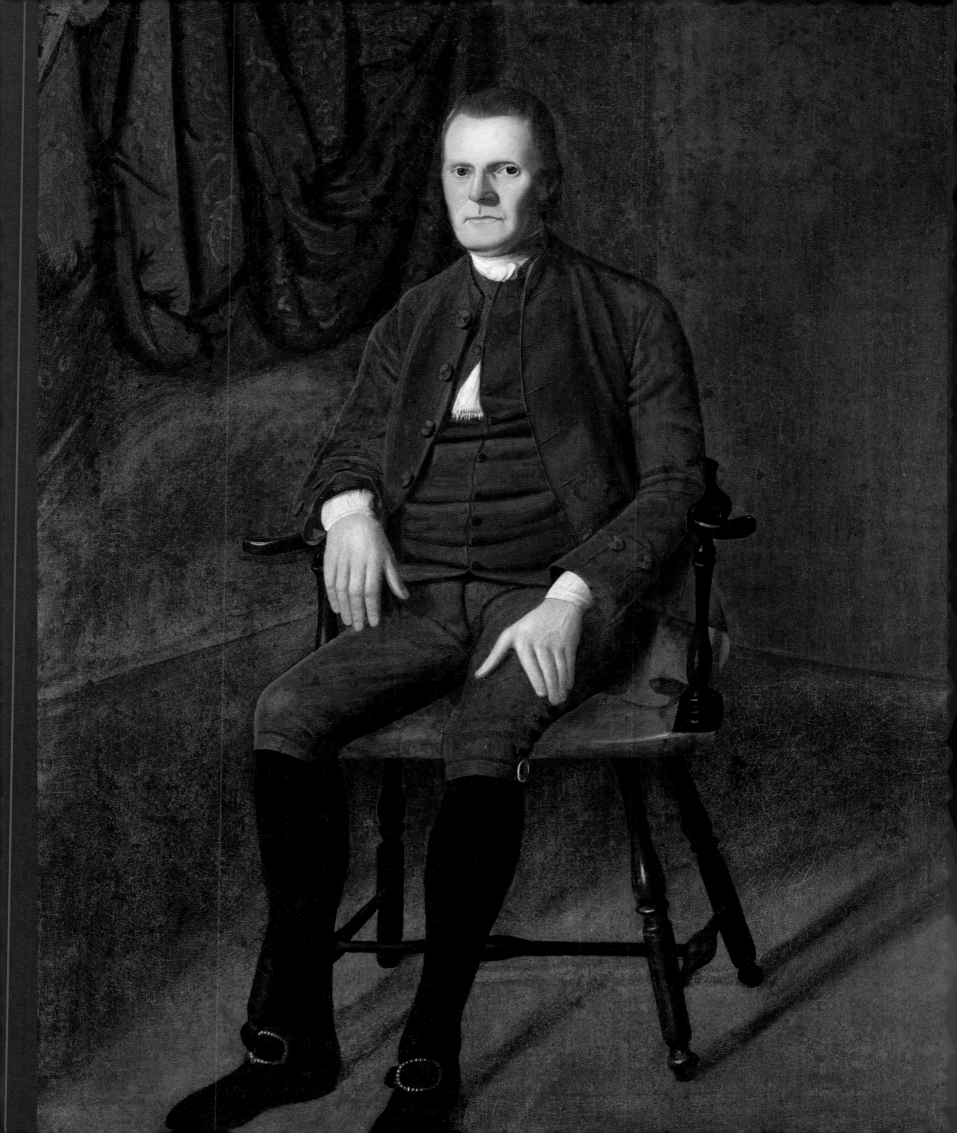

The American Revolution

(1770–83)

*"You know the rest. In the books you have read,
How the British regulars fired and fled—"*

—Henry Wadsworth Longfellow, "Paul Revere's Ride"

The American Revolution is unusual in the world annals of rebellion. It was not an uprising of one class against another; it was fought by members of every echelon of colonial society, and many of its leaders were men of substantial means. Nor was it an uprising of a conquered indigenous people against an overseas colonial master, as was the case in African and Asian rebellions of the twentieth century. The colonists themselves were overwhelmingly of British stock, with a British cultural perspective—a perspective that, although tempered by the special circumstances of life in a place where the frontier was never far away, included British traditions of limited monarchy and representative government. It was, more than anything, a rebellion of one branch of an imperial family against its parent nation. The closest parallel history offers is the struggle of Spain's New World colonies for independence—and that series of conflicts was largely inspired by the example of the United States.

The chafing under colonial rule that led to full-fledged rebellion in the 1770s began with no single act of British repression. The French and Indian War had turned London's attention to the necessity for more direct military control in North America, and to the need for more efficient taxation. In 1755, a single chief of all military forces in the colonies (including Canada) was appointed, independent of local control.

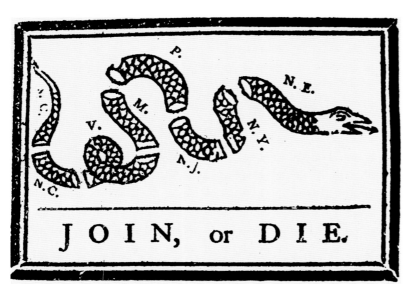

LEFT: Benjamin Franklin (1706–90)
Join, or Die.
Library of Congress.

Franklin's cartoon was first published on May 9, 1754, in his *Pennsylvania Gazette*. It was the first such drawing to be used to illustrate a news story—at that time, to rally the colonies at the outset of the French and Indian War. The image was so popular that it became a call to unity during the Revolutionary War.

OPPOSITE: *First Church of Christ, Congregational, Farmington, Connecticut.* 1771.
Library of Congress.

Connecticut's finest surviving colonial meetinghouse exemplifies an austerely elegant style found throughout New England. The term "meetinghouse" refers to the Congregational Church's central role as not only a religious but also a civic institution.

RIGHT: **Daniel Chester French** (1850–1931)
Concord Minute Man of 1775. 1889.
Bronze, 32 ¼ x 17 ⅜ x 18 ⅜ in. (82 x 43.5 x 46.7 cm).
Smithsonian American Art Museum, Washington, D.C.

This is a smaller version of French's Minute Man statue, which stands at
the Concord battlefield in Massachusetts. Ready "at a minute's notice,"
the Minute Men were the town militias that met the British at Lexington
and Concord on April 19, 1775. The plow symbolizes their status as
citizen soldiers, called from their farms to defend their liberty.

BELOW: **Emanuel Gottlieb Leutze** (1816–68)
Washington Crossing the Delaware. 1851.
Oil on canvas, 149 x 255 in. (378.5 x 647.7 cm).
*Gift of John Stewart Kennedy, 1897. The Metropolitan Museum of Art,
New York, New York.*

Heavily dramatized by the German-born Leutze, Washington's 1776
Christmas crossing of the Delaware to attack a Hessian force at Trenton,
New Jersey, was itself an act of high drama. Now a part of Revolutionary
iconography, this is Leutze's second depiction of the scene. Ironically,
the first was destroyed by a 1942 American bombing of Bremen.

OPPOSITE: **John Trumbull** (1756–1843)
The Capture of the Hessians at Trenton, 26 December 1776. 1786–1828.
Oil on canvas, 21 ¼ x 31 ⅛ in. (54 x 79.1 cm).
Trumbull Collection. Yale University Art Gallery, New Haven, Connecticut.

Taken by surprise, their commander mortally wounded, the Hessian
mercenaries at Trenton quickly surrendered to Washington after his
daring river crossing. This is one of eight renderings by Trumbull of
significant events in the Revolution; originally, he projected 13 paintings.

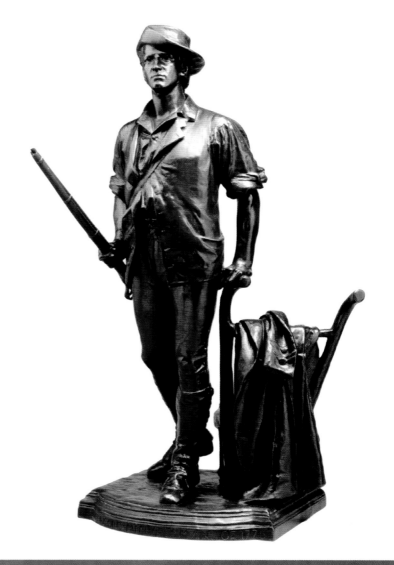

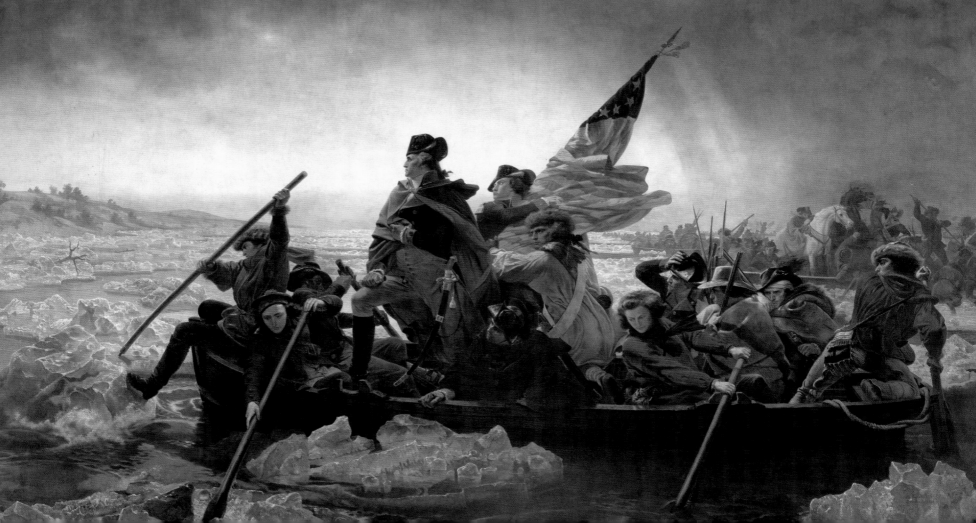

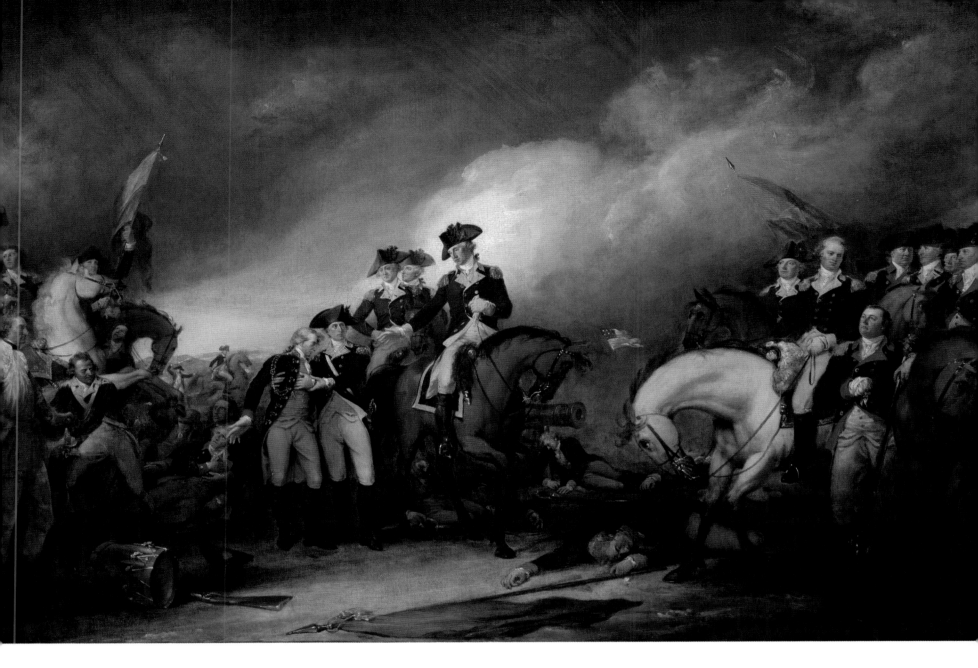

But that desperate year of 1776 is remembered more for a single document than for a string of American military debacles. On July 2, Congress approved a motion calling for a formal declaration of independence. The document, largely the work of Virginia representative Thomas Jefferson, was ordered printed and circulated among the states—they no longer considered themselves colonies—on July 4.

The first hopeful sign that the Declaration would not remain a futile paper effort came on Christmas Eve, 1776. That night, General Washington crossed the Delaware and scored a decisive victory over 1,000 Hessians (mercenaries fighting for the British) at Trenton, New Jersey. Less than two weeks later, the Continentals triumphed again at Princeton. But 1777 turned sour for the Americans when the British, following a September victory at Brandywine Creek, Pennsylvania, occupied Philadelphia after its hasty abandonment by the Continental Congress.

Washington's men spent the winter of 1777–78 at Valley Forge, a bivouac that has become a watchword for cold, misery, and forbearance.

Philadelphia may have been lost—but an epic British disaster was in the making far to the north. The British had planned a grand pincer movement, in which a detachment under Lieutenant Colonel Barry St. Leger would drive eastward along New York's Mohawk Valley from Lake Ontario to meet a larger force coming down from Canada under General John Burgoyne. St. Leger, delayed by several fierce battles along the Mohawk, never met with Burgoyne at Albany as planned. Nor did Burgoyne himself ever reach Albany: stymied by New England militias at the Battle of Bennington, Vermont (actually fought on New York soil), the general met with the first great British defeat of the war at Saratoga on October 7. Ten days later, he surrendered to the American commander, General Horatio Gates.

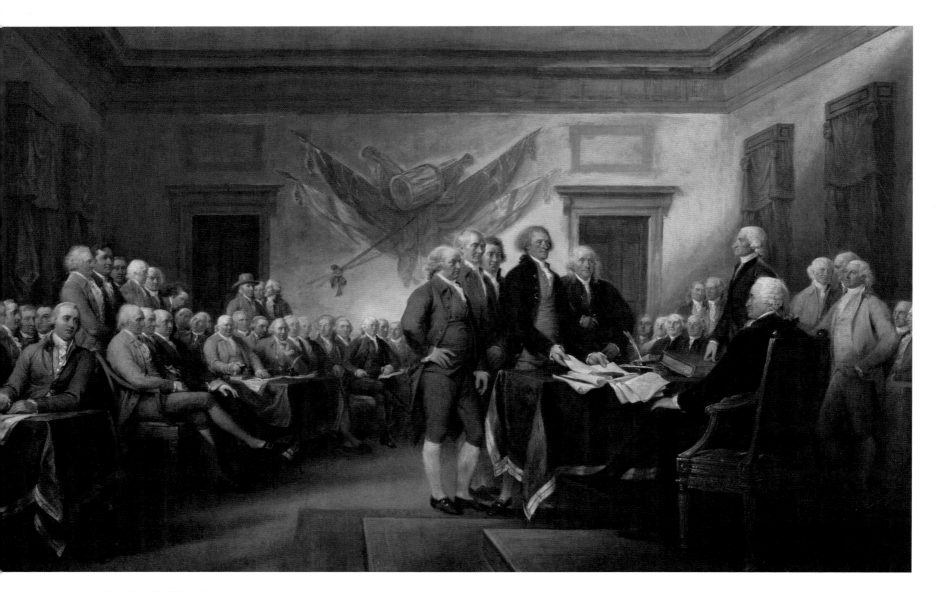

John Trumbull (1756– 1843)
The Declaration of Independence, 4 July 1776. 1786–1820.
Oil on canvas, 20 ⅞ x 31 in. (53 x 78.7 cm).
Trumbull Collection. Yale University Art Gallery, New Haven, Connecticut.

Trumbull was so intent on producing an accurate pictorial account of the birthing moment of the nation that he sought out 36 of the original 47 members of the Continental Congress and painted them from life. Thomas Jefferson helped him with a floor plan of the Philadelphia room in which the Declaration was adopted.

The victory at Saratoga convinced France to enter the war on the American side, although it would be several years before the involvement of Britain's traditional continental enemy would make a significant difference in the Revolution's outcome. The major trend following Saratoga was yet another shift of the main theater of military operations, this time to the south. The British occupied Savannah in late 1778, and seized much of Georgia soon after. Early in 1780, Charleston fell. From then on, the Americans' campaigns in the southern states were largely a matter of the hit-and-run guerrilla tactics of commanders like the "Swamp Fox," Francis Marion, and the deceptive strategic retreats of General Nathanael Greene. The southern campaigns finally came to a dénouement in the summer and fall of 1781, when the British under Lord Cornwallis staked their fortunes on holding a fortified position on Virginia's Yorktown Peninsula. Now the might of the French Navy, and of the contingent of nearly 5,000 French troops under the Comte de Rochambeau sent to assist Washington, were finally brought to bear on the ill-chosen British stronghold. Pinned between Admiral Francois de Grasse's 28 men-of-war and a combined American-French force of some 16,000 infantry and artillerymen, Cornwallis surrendered on October 17, 1781. As the British troops marched out of their fortifications to lay down their weapons, their band played "The World Turned Upside Down."

A world still dominated by great colonial powers truly had been turned upside down. Savannah and Charleston were abandoned by the British in the spring of 1782, and by the end of the year, only New York remained in the hands of the enemy. In London, parliamentary enthusiasm for the war had dwindled rapidly, and a new government elected in 1782 made a termination of hostilities with America a priority. King George III wanted to continue fighting, but as constitutional monarch he was forced to accede to his ministers. A preliminary peace treaty was drafted in November, and the final document—the Treaty of Paris—was signed on September 3, 1783. The United States of America was an independent nation.

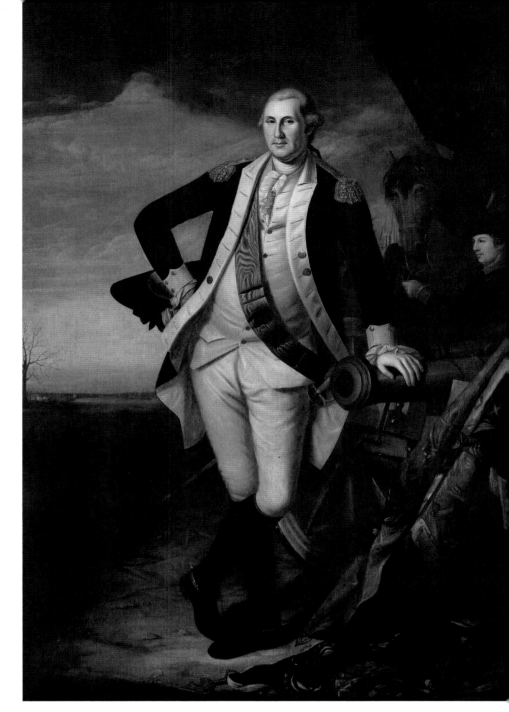

ABOVE: **Charles Willson Peale** (1741–1827)
George Washington. Ca. 1779–81.
Oil on canvas, 95 x 61 ¾ in. (241.3 x 156.8 cm).
Gift of Collis P. Huntington, 1897. The Metropolitan Museum of Art, New York, New York.

Peale's portrayal of a commanding, middle-aged Washington contrasts with the image of a grim, aloof civilian leader drawn from Gilbert Stuart via the dollar bill. Peale was an officer who had wintered at Valley Forge; after the war, he founded the first American museum. Eight of his children, including Rembrandt Peale, became artists.

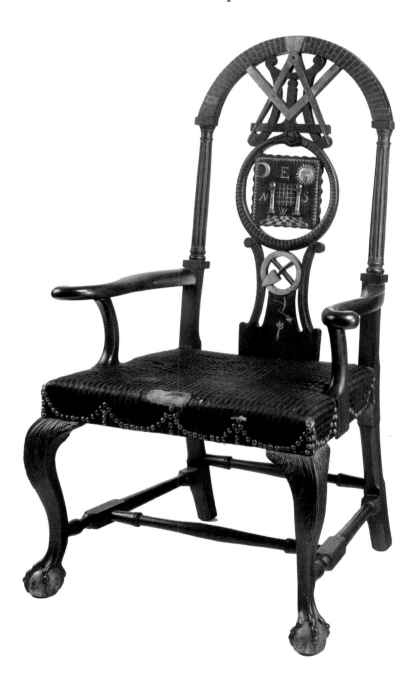

LEFT: *Masonic Armchair*. 1775–90.
Mahogany and maple, 50 ½ x 25 ⅝ x 24 ¾ in. (128.3 x 65.1 x 62.9 cm).
Gift of Mr. and Mrs. George M. Kaufman, 2000. The Metropolitan Museum of Art, New York, New York.

Freemasonry was well established in eighteenth-century America, and many of the republic's founders—including George Washington, Benjamin Franklin, John Hancock, and nearly half of the generals in the Continental Army—were practicing masons. This chair features a blending of Masonic symbolism with features of the Chippendale style popular at the time.

Help from Overseas

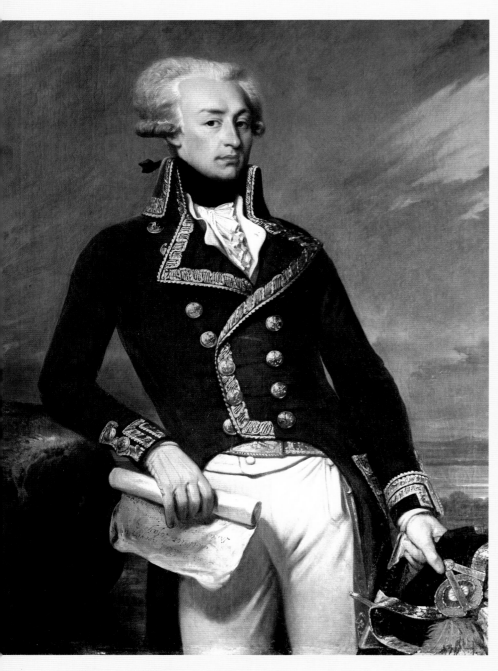

Joseph Désiré Court (1797–1865)
Marie Joseph de Motier, Marquis de Lafayette. 1834.
Oil on canvas, 53 x 39 ½ in. (135 x 100 cm).
Chateaux de Versailles et de Trianon, Versailles, France.

Painted in 1834, the year of Lafayette's death, Court's portrait shows the general as he appeared in 1792, when he commanded a French army during the war with Austria. A lifelong friend of the new American republic, Lafayette named his only son after George Washington.

America owes a debt of gratitude to an unlikely collection of foreign adventurers, each of whom lent crucial support to the Continental Army in its desperate fight against superior British forces. Trained in the tradition-bound world of Europe's standing armies, they brought a measure of discipline and professionalism to the spirited and independent-minded American ranks.

Baron Friedrich von Steuben was a Prussian officer who had seen service in Europe's Seven Years' War. Demobilized from the army, he traveled to France where he met the American diplomats Benjamin Franklin and Silas Deane. Following their suggestion that he offer his services to the United States—and that he represent himself for this purpose as a lieutenant general rather than as a captain, his Prussian rank—von Steuben crossed the Atlantic and was made inspector-general of the Continental Army. He took up his post during the long, bitter winter at Valley Forge, where he drilled the troops along Prussian lines but with just enough flexibility to earn him the respect of officers and enlisted men alike. At the battles of Monmouth and Yorktown, the Americans' crisp performance showed that von Steuben's drills had been effective. The baron became an American citizen after the war, and was granted a pension and an estate of 16,000 acres in upstate New York.

A distinctive pair of Polish patriots brought their love of freedom to America in its hour of need. Tadeusz Kosciuszko, a graduate of military academies in Poland and France, came to America scarcely a month after the signing of the Declaration of Independence. His special expertise was in fortifications, and as a colonel of engineers he made the crucial choice of Bemis Heights for the Battle of Saratoga, and fortified the highlands around West Point on the Hudson River. Later, he distinguished himself in General Nathanael Greene's southern

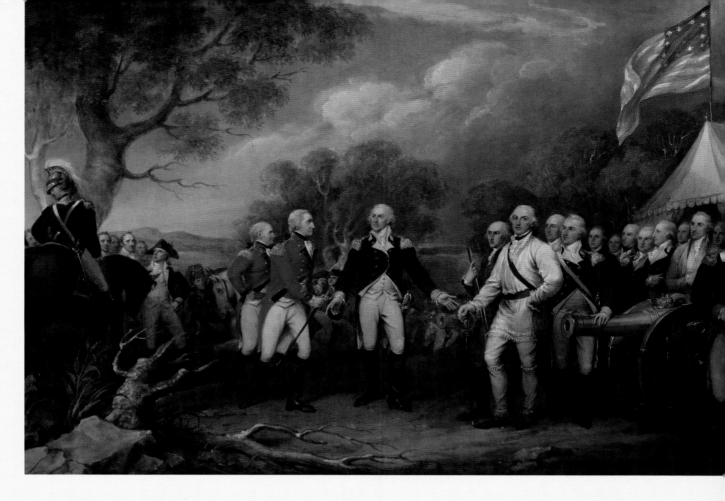

John Trumbull (1756–1843)
The Surrender of General Burgoyne at Saratoga, October 16, 1777. Ca. 1822–32.
Oil on canvas, 21 ⅛ x 30 ⅝ in. (53.7 x 77.8 cm).
Trumbull Collection.
Yale University Art Gallery, New Haven, Connecticut.

John Trumbull once wrote Thomas Jefferson that one of his chief motives in painting was "the wish of commemorating the great events of our country's revolution." Here he depicts a vital turning point of that struggle: Burgoyne's defeat at Saratoga convinced France to enter the war on America's side.

campaigns, and attained the rank of brigadier general. He later unsuccessfully fought for Polish independence from Russia.

> *"Independently wealthy, and an officer in the army of France's old regime, Lafayette initially offered his services to the American cause not out of revolutionary fervor, but as a path to military glory."*

Count Casimir Pulaski was another veteran fighter for Polish freedom, having commanded his country's forces against Russia when he was barely past 20. While in exile in Paris, he met Benjamin Franklin and offered his services to the American cause. Promoted to brigadier general after his gallantry at the Battle of Brandywine, the cavalryman Pulaski raised an

independent corps made up mostly of Pennsylvania Germans, officered by French, German, and Polish emigrés. He helped lift a British siege of Charleston, South Carolina, and then led his corps in an attack on British-held Savannah, Georgia. There he was mortally wounded, and died aboard an American warship anchored nearby.

Perhaps the best known among foreign fighters who aided the American revolutionary cause was Marie-Joseph du Motier, the Marquis de Lafayette. Independently wealthy, and an officer in the army of France's old regime, Lafayette initially offered his services to the American cause not out of revolutionary fervor, but as a path to military glory. Promised a major-generalship by Silas Deane, an American envoy in Paris, he was met at Philadelphia with some disdain: he was only 19, and aspiring to a rank only two levels below George Washington. But when he explained that he expected no pay or pension, the commission was his. He earned the respect that went with it at Brandywine and at Monmouth, and later in the Virginia campaign that led to the British surrender at Yorktown. As an old man, he returned to the U.S. for a triumphal tour in 1824–25, and was remembered nearly a century later in the motto of American troops arriving in France during World War I: "Lafayette, we are here!"

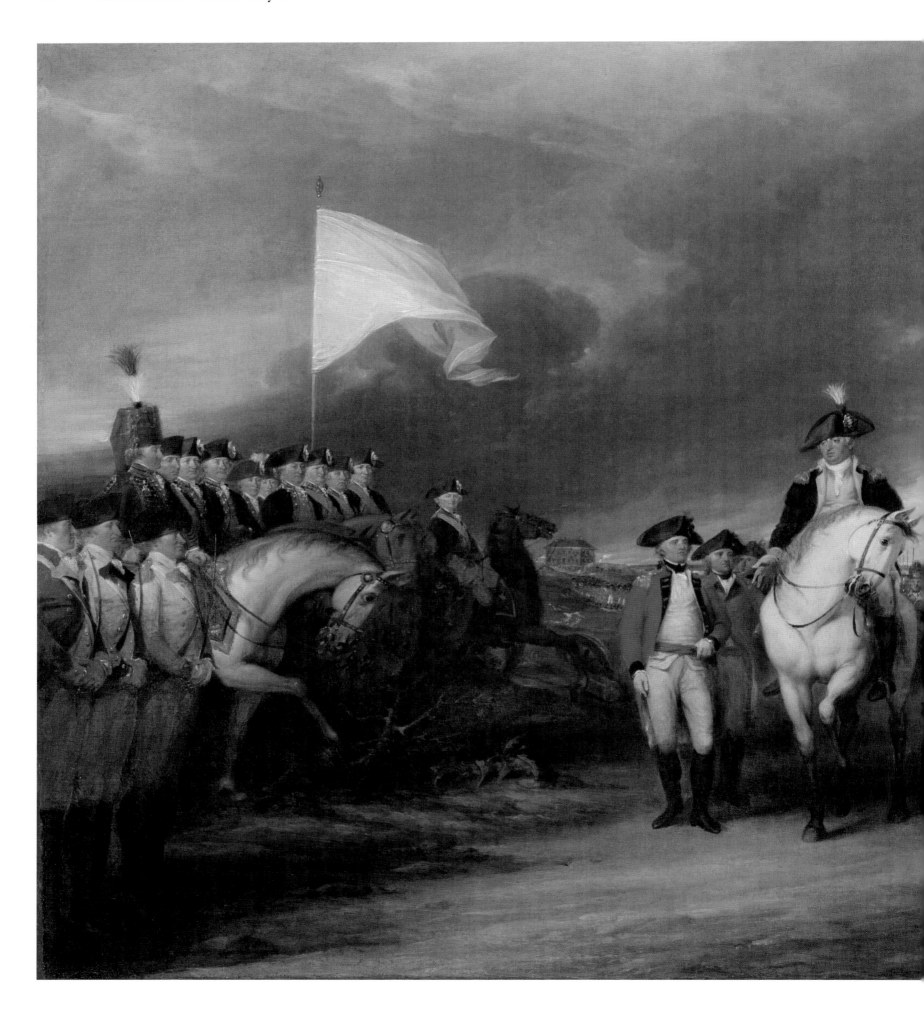

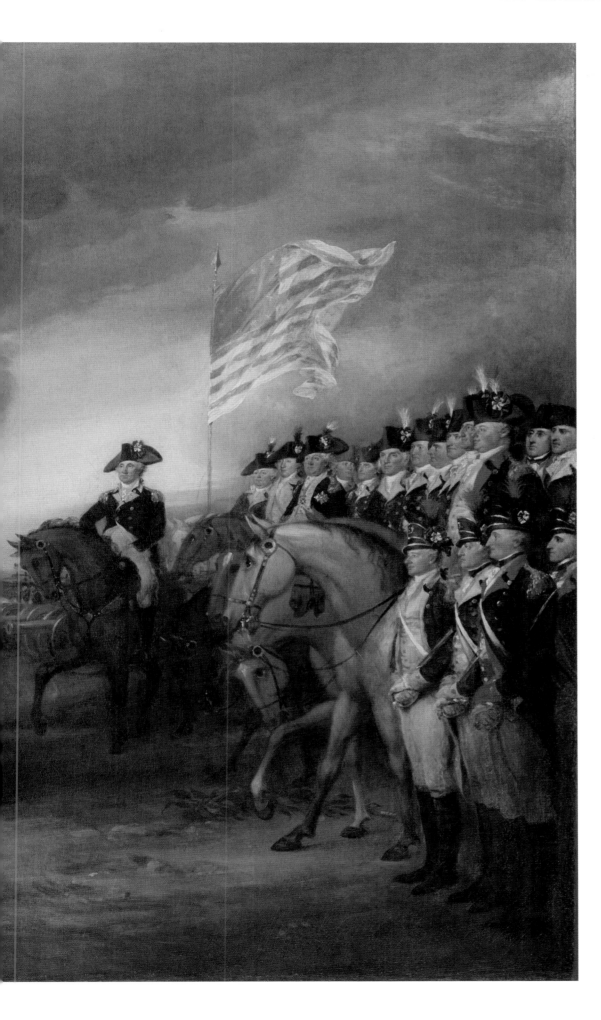

John Trumbull (1756–1843)
The Surrender of Lord Cornwallis at Yorktown, October 19, 1781.
1787–ca. 1828.
Oil on canvas, 21 x 30 ⅝ in.
(53.5 x 77.8 cm).
Trumbull Collection. Yale University Art Gallery, New Haven, Connecticut.

The Revolution's military climax— although it preceded Britain's final recognition of American independence by two years— was Cornwallis's defeat at Yorktown. It was likewise the climax of Trumbull's documentary series, portraying, in the artist's words, "the noblest series of actions which have ever presented themselves to the history of man."

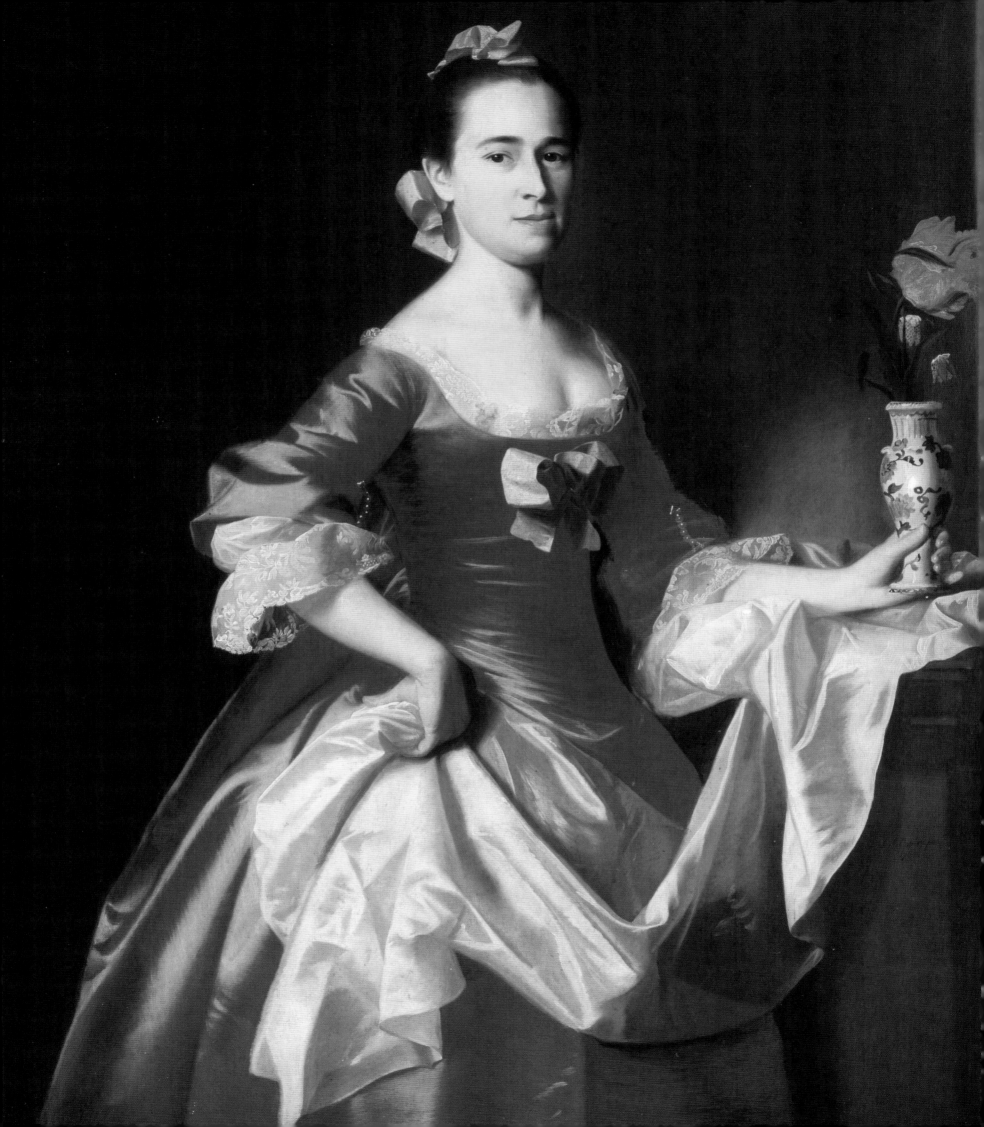

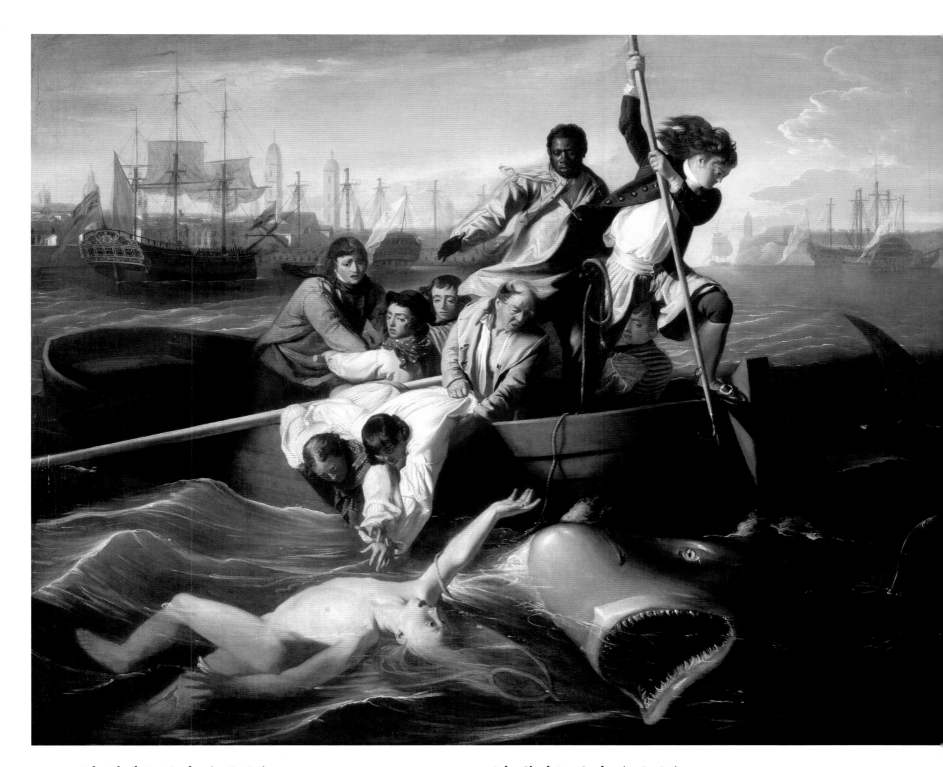

OPPOSITE: John Singleton Copley (1738–1815)
Mrs. George Watson. 1765.
Oil on canvas, 49 ⅞ x 40 in. (126.6 x 101.6 cm).
Smithsonian American Art Museum, Washington, D.C.

Copley's portrait of Mrs. George Watson, wife of a prominent Boston merchant in the years prior to the Revolution, was one of a number of his portrayals of the seaport's rising bourgeoisie. Mrs. Watson's dress and the exquisite porcelain vase at her side attest to a sophistication of taste that approached domestic British standards.

ABOVE: John Singleton Copley (1738–1815)
Watson and the Shark. 1778.
Oil on canvas, 72 ¼ x 90 ⅜ in. (183.2 x 230 cm).
Gift of Mrs. George von Lengerke Meyer, 1889.
Museum of Fine Arts, Boston.

Copley's first large history painting depicted no well-known event, but, rather, a terrifying episode in the life of the man who commissioned it. London financier Brooke Watson lost a leg to a shark off Havana when he was 14. With a composition recalling the Old Masters, Copley portrayed the near-tragedy at its moment of highest drama.

The Federal Era

(1783–1815)

"We can surely boast of having set the world a beautiful example of a government reformed by reason alone without bloodshed."

—THOMAS JEFFERSON

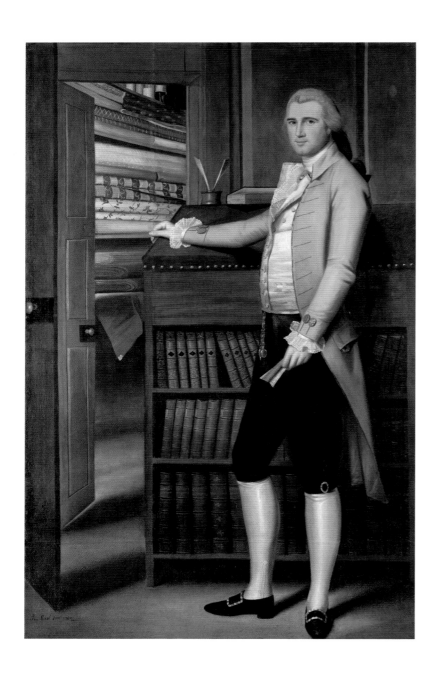

The triumph of Great Britain's former American colonies in the Revolutionary War resulted in the colonies' new status as free and independent states, but it opened up as many questions as it answered. How would the new nation be governed? Would it, in fact, be a nation at all, or simply a loose confederation of sovereign entities? If there were to be a federal union, what would be its guiding political and economic principles, and what policies would govern its relations with foreign powers?

The first attempt to answer these questions was the Articles of Confederation, a system of interstate cooperation and cohesion originally drafted in 1776 but

LEFT: Ralph Earl (1751–1801)
Elijah Boardman. 1789.
Oil on canvas, 83 x 51 in. (210.8 x 129.5 cm).
Bequest of Susan W. Tyler, 1979. The Metropolitan Museum of Art, New York, New York.

Boardman (1760–1823) was a Revolutionary War veteran who built a successful career as a dry-goods merchant in the halcyon business climate of the Federal era. Turning to politics, he held a number of state-level positions in his native Connecticut, and served as a U.S. senator.

OPPOSITE: Rebekah S. Munro (1780–1803)
Sampler. Ca. 1791.
Silk on linen, 15 ¾ x 11 ¾ in. (40 x 29.9 cm).
Gift of Barbara Schiff Sinauer, 1984. The Metropolitan Museum of Art, New York, New York.

Reflecting women's expanding intellectual pursuits, young Rebekah Munro's sampler is embroidered with a popular motto encouraging women to divide their time between reading, writing, and sewing.

With
She has queen
ye american fair.

To ad
orn your mind
bend all your care

...her whom circling years improve
Her GOD the object of her warmest love
Whole useful hours successive as they glide
The Book the Needle and the Pen divide
Who sees her Parents Heart exult with joye
And the fond tear stand sparkling in their eye

REBECCAH S. MUNRO's WORK

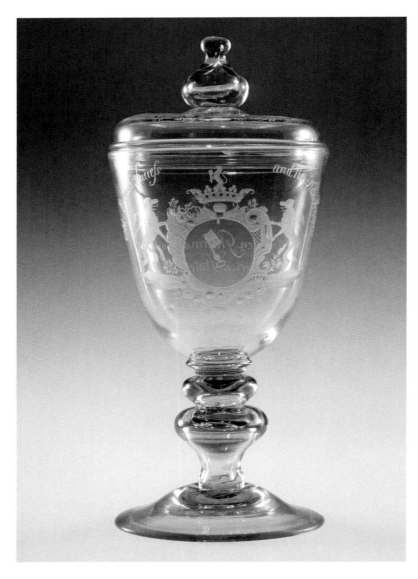

ABOVE: New Bremen Glass Manufactory, Maryland (1787–95)
Goblet. 1788.
Blown glass, height: 11 ¼ in. (28.6 cm).
Rogers Fund, 1928. The Metropolitan Museum of Art, New York, New York.

Eager to wean itself from British imports and establish domestic industries, the U.S. welcomed skilled European entrepreneurs during the Federal era. The New Bremen Glass Manufactory was founded by a German, John Frederick Amelung, who oversaw a self-contained glassmaking community of 500 residents in Frederick County, Maryland.

OPPOSITE, LEFT: Samuel McIntire (attrib.) (1757–1811)
Side Chair. 1794–99.
Mahogany, ebony, ash, birch, white pine, 37 ⅞ x 27 ⅞ x 18 in. (96.2 x 70.8 x 45.7 cm).
Friends of the American Wing Fund, 1962. The Metropolitan Museum of Art, New York, New York.

Samuel McIntire was an architect, builder, woodcarver, and furniture maker responsible for many of the gracefully proportioned Federal houses commissioned by the merchant princes of Salem, Massachusetts, a fabulously prosperous seaport of the era.

not legally in effect until unanimous ratification by the states in 1781. The Articles were not as loose and ineffectual as is commonly believed—they did provide that Congress could make war and peace, borrow and issue money, and enter into treaties, among other prerogatives—but they gave Congress no power over taxation and trade regulation, and made no provision for a federal executive, or a standing judiciary with authority over anything other than maritime affairs. Most problematic of all, perhaps, was the fact that the Articles required the unanimous consent of the states for any amendments.

"The first attempt to answer these questions was the Articles of Confederation…"

The new nation's pressing need was for a document that would accomplish what many Americans thought almost impossible: to preserve the sovereignty of the individual states in as many respects as was practical, yet establish a central government with real authority and a representative apparatus that would prevent a dangerous concentration of power. This was the task undertaken by the Constitutional Convention, which met at Philadelphia in the spring of 1787.

The Constitution that emerged from exhaustive deliberation over the following summer was a masterpiece of compromise. It respected state prerogatives as ensconced in the states' individual constitutions (those documents, in fact, often served as templates for portions of the federal arrangement), yet created a central government with specifically designated powers of its own. Crucial to the arrangement was the principle of separation of powers, with executive, legislative, and judicial branches holding each other in check; and a legislative branch comprised of two houses. The "Connecticut Compromise," proposed by that state's Dr. Samuel Johnson, called for a House of Representatives chosen

by popular election, and a Senate selected by the state legislatures (senators were not elected by direct ballot until the 17th Amendment was adopted in 1913). Dr. Johnson's idea was that "in one branch the people ought to be represented; in the other the states."

Not all of the Constitution's compromises were able to stand the test of time. The southern states were adamant regarding the perpetuation of slavery, and no proposal for abolition was allowed even to come to the table. With regard to representation, each slave was regarded as three-fifths of a person, although of course no individual held in bondage was allowed even three-fifths of a vote. Skirting the slavery issue and allowing the compromise over representation is often regarded as cynical by modern critics of the constitutional deliberations, and it did help set the stage for the Civil War. But the alternative would have been no constitution at all, and a weak, disunited nation that might well have disintegrated as it faced the challenges of its first decades of existence.

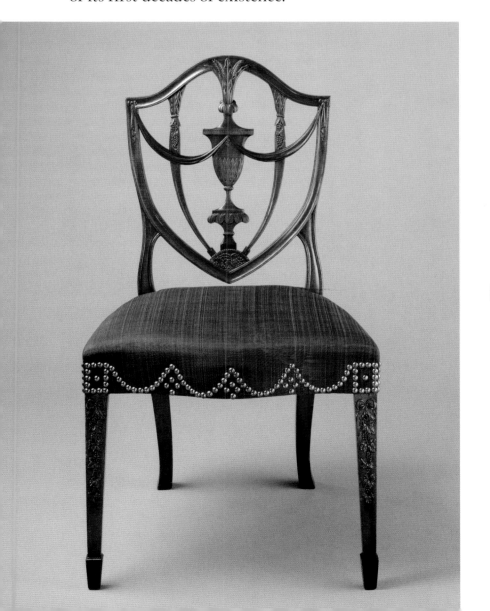

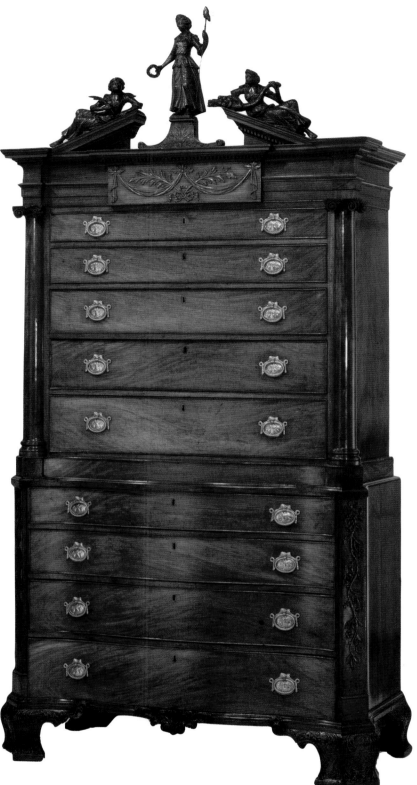

ABOVE: Stephen Badlam (1751–1815)
Chest-on-Chest. 1791.
Mahogany, mahogany veneer on chestnut, eastern white pine, red pine, 101 ⅛ x 51 ½ x 23 ¾ in. (256.9 x 130.8 x 60.3 cm).
Mabel Brady Garvan Collection. Yale University Art Gallery, New Haven, Connecticut.

An officer of artillery in the Revolutionary War, Stephen Badlam turned afterwards to cabinetmaking in Dorchester, Massachusetts. His use of Doric columns at the corners of the upper portion of this chest-on-chest shows the influence of classical motifs on Federal-era furniture.

In order to take effect, the Constitution had to be ratified by nine of the 13 original states. Ratification was the subject of spirited debate in each state legislature, and was accomplished in no small part because of the cogent arguments in its favor put forth by Alexander Hamilton and James Madison in the series of documents called the Federalist Papers. With ratification by New Hampshire, on June 21, 1788, the Constitution was officially established. In March of the following year, George Washington was inaugurated in New York as the first president of the United States.

Ratification of the Constitution did not mean the end of deliberation about the structure and powers of the United States government, or the direction of national policy. The first 10 amendments to the Constitution, since known as the Bill of Rights, were adopted in 1791 in order to explicitly guarantee basic freedoms and individual rights. Meanwhile, within Washington's cabinet and beyond, powerful forces promoted drastically different visions of America's future.

Alexander Hamilton, who had been so passionate an advocate of ratification of the Constitution, was an especially fervent believer in a strong federal

ABOVE: Charles Bulfinch (1763–1844)
Massachusetts State House, Boston. 1795–97.

Built atop Boston's Beacon Hill—which was reduced from its original height at the time of construction—the Massachusetts State House is considered the crowning achievement of Charles Bulfinch, America's greatest Federal-era architect. Later architect of the U.S. Capitol, Bulfinch was master of a chastely proportioned Neoclassical style. The dome, sheathed in copper by Paul Revere, was gilded in 1861.

OPPOSITE: John McComb Jr. (1763–1853) and **Joseph Francois Mangin** (d. after 1818)
City Hall, New York City. 1803–11.

McComb, son of a New York architect, and Mangin, a French émigré who designed the city's original St. Patrick's Cathedral, won a competition for a new City Hall design with this French Renaissance plan, adapted to Federal-era tastes. The building was sited to face the city, which soon spread rapidly northward beyond it.

government and a pillar of the emerging Federalist Party. The Federalists, largely supported by urban moneyed interests, feared that democracy could too easily devolve into mob rule; as a delegate to the Constitutional Convention from New York, he had supported the idea of life terms for the president and Senate, leaving him open to charges that he was an outright monarchist. During his five years as Washington's secretary of the treasury, he turned to practical economic matters, creating a national bank

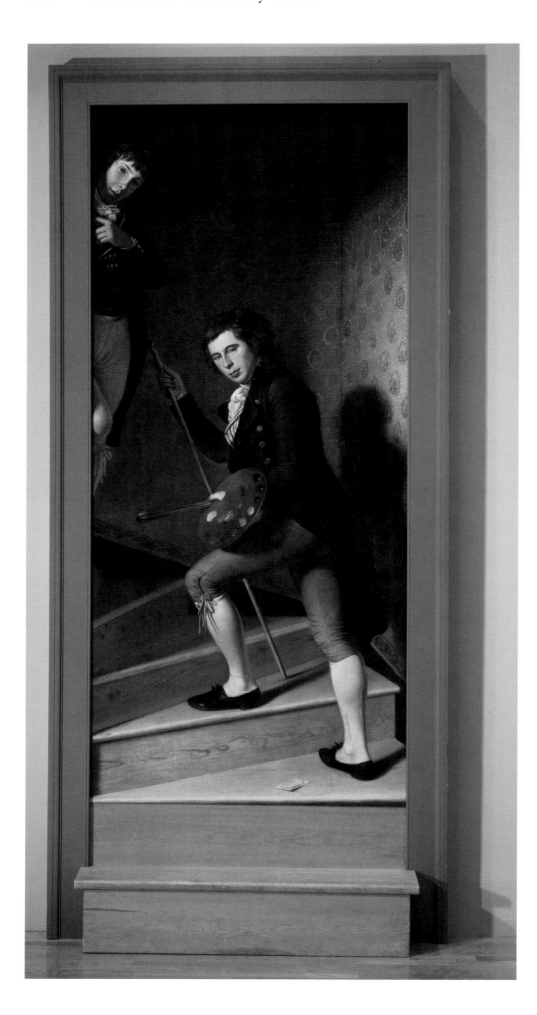

LEFT: **Charles Willson Peale** (1741–1827)
Staircase Group (Portrait of Raphaelle Peale and Titian Ramsey Peale). 1795.
Oil on canvas, 89 ½ x 39 ⅜ in. (227.3 x 100 cm).
The George W. Elkins Collection, 1945. Philadelphia Museum of Art, Philadelphia, Pennsylvania.

Peale's life-size portrayal of two of his children—most of whom were named after great artists—was originally set within a real door frame, with a three-dimensional step at the bottom. Raphaelle Peale (foreground) became an accomplished painter of meticulously detailed still lifes.

OPPOSITE: **Gilbert Stuart** (1755–1828)
George Washington (unfinished). 1796.
Oil on canvas, 47 ¾ x 37 in. (121.3 x 94 cm).
William Francis Warden Fund, John H. and Ernestine A. Payne Fund, Commonwealth Cultural Preservation Trust. Jointly owned by the Museum of Fine Arts, Boston, and the National Portrait Gallery, Washington, D.C.

Painted during the final year of Washington's presidency, and universally familiar as the visage on the dollar bill, this is the third of Gilbert Stuart's portraits of a man already passing into legend during his lifetime. Never finished, it remained in Stuart's possession and was duplicated several times by the artist, and countless times by others.

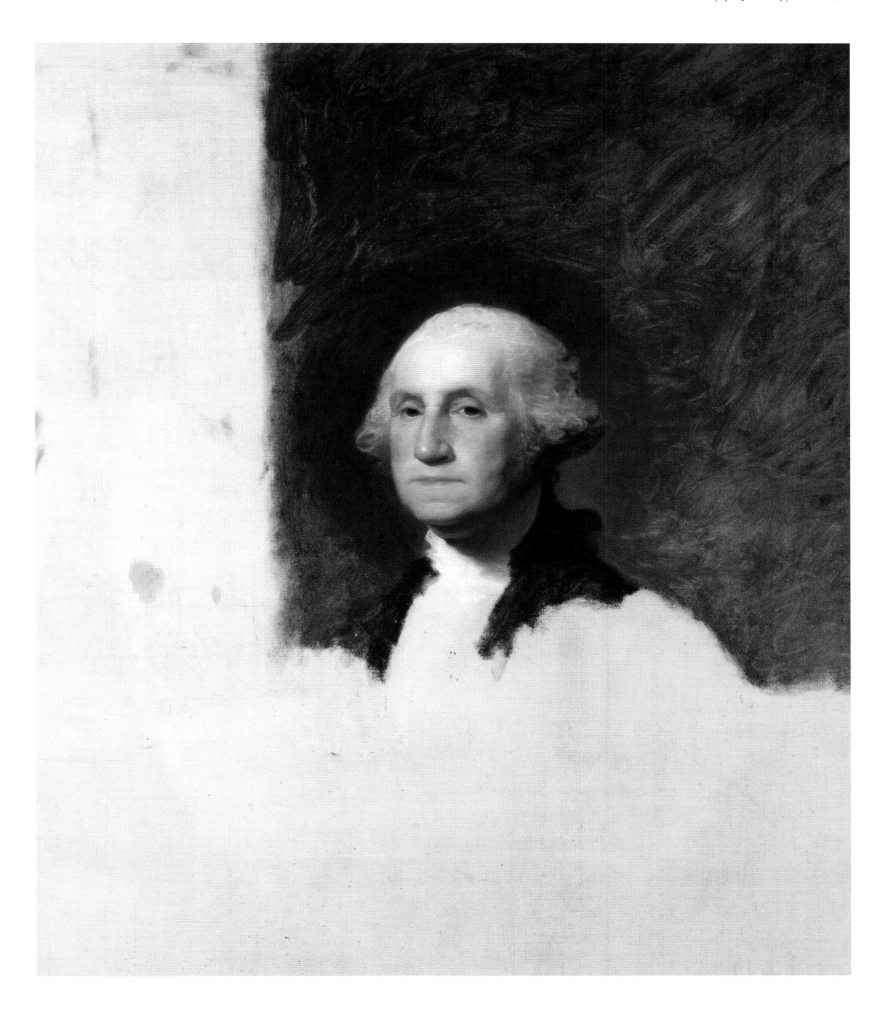

and promoting a modest national debt as a means of establishing credit. He also looked to the future and foresaw the U.S. as a manufacturing nation, with an economy based in its cities.

In strong opposition to Hamilton was Thomas Jefferson, Washington's secretary of state. Jefferson, the leading light of the Democratic-Republican Party, envisioned the United States as an agrarian nation, and mistrusted concentration of political power among wealthy urban elites. He saw the Federalists as "Anglomen" with a dangerous affinity for Great Britain, while he himself was a lifelong Francophile and so ardent a supporter of the French Revolution that his opponents unreasonably charged that he would, if allowed, bring the guillotine to America.

As president, George Washington was the pillar of strength and character that kept these opposing political philosophies from tearing the new nation apart. An opponent of what he termed "entangling alliances," he steered the U.S. between the twin perils of excessive French and English influence, and kept the

Hamilton-Jefferson animosity from poisoning national politics. His single-term successor, John Adams, had neither the universal popularity nor the political adroitness to achieve similar success for the Federalist Party, and the election of 1800 put Thomas Jefferson in the new Executive Mansion.

Jefferson, ever the opponent of unchecked executive power, within three years made one of the most audacious moves of any American president when he purchased, for the sum of $15,000,000, France's vast territory west of the Mississippi River. The Louisiana Purchase doubled the size of the United States, and made the young republic, so recently confined to the Atlantic seaboard, master of two-thirds of the continent between Canada and Mexico.

As president, Jefferson wanted to inventory so vast an acquisition. And as an accomplished amateur naturalist, he was profoundly interested in its animals, plants, landforms, and native inhabitants. The result was his commissioning of the most ambitious exploration in American history, the expedition led by

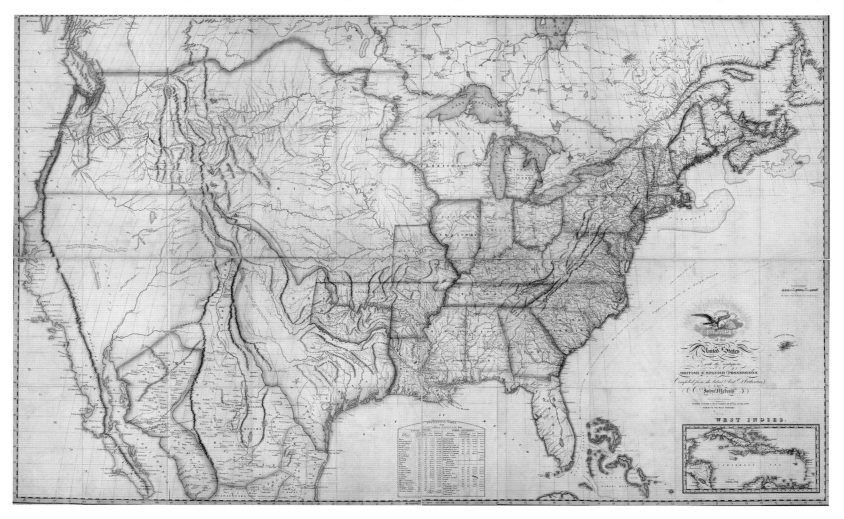

ABOVE: **Thomas Birch** (1779–1851)
Engagement Between the Constitution *and the* Guerrière. 1813.
Oil on canvas, 28 x 36 ½ in. (71.1 x 92 cm).
Ernest Wadsworth Longfellow Fund and Emily L. Ainsley Fund, 1978.
Museum of Fine Arts, Boston.

The United States joined the world's naval powers on August 19, 1812, when the USS *Constitution* defeated the British frigate *Guerrière* off Nova Scotia. Birch, who painted many War of 1812 sea battles, captured the *Constitution*—dubbed "Old Ironsides" for her stout oaken hull—at her moment of victory over the dismasted *Guerrière*.

OPPOSITE: **John Melish** (1771–1822)
Map of the United States. 1816.
Map Division, Astor, Lenox and Tilden Foundations. The New York Public Library, New York, New York.

The Scottish-born Melish published an account of his travels throughout the United States, illustrated with his own maps, to encourage British immigration to the new nation. Here, he draws on information gathered a decade earlier by Lewis and Clark, although details beyond established state and territorial borders are still imprecise.

Meriwether Lewis and William Clark. Lewis and Clark and their "Corps of Discovery" left St. Louis, Missouri, on May 14, 1804—41 men in three boats, heading upstream on the broad Missouri River. For the next 18 months, the party traversed uncharted territory, following the Missouri to its headwaters, crossing the Rocky Mountains, and descending to the Pacific Ocean by way of the Columbia River. Along the way they encountered Indian tribes that had had little or no experience with whites, and made use of the natives' experience—and the guiding of a young Shoshone named Sacagawea—to find their way across the prairies and through desolate mountain passes. Along every mile of the route, the explorers collected samples, and kept detailed journals. The report they made to the president, upon their return in 1806, delighted Jefferson the scientist, but must have daunted Jefferson the statesman, who now realized just how vast and difficult his new acquisition was, in terms of defense and commerce.

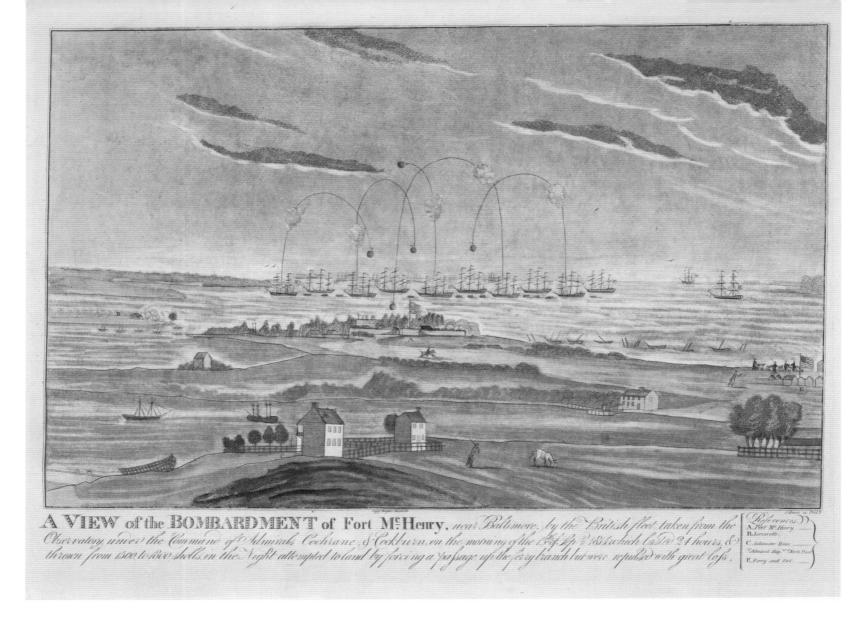

A VIEW of the BOMBARDMENT of Fort McHenry, near Baltimore, by the British fleet, taken from the Observatory, under the Command of Admirals Cochrane & Cockburn, on the morning of the 13th of Sepr. 1814 which lasted 24 hours, & thrown from 1500 to 1800 shells, in the Night attempted to land by forcing a passage up the ferry branch but were repulsed with great loss.

References
A. Fort McHenry
B. Lazaretto
C. Schooner Boats
D. Admiral Ship Devils Peak
E. Ferry and Fort

Commerce in the age of Jefferson was still a seafaring business. The Federal period of the 1790s and the first decade of the 1800s was a golden age for the merchant princes of New England, with ships out of Boston, Salem, Portsmouth, Newport, and other maritime capitals carrying the new American flag to ports around the globe. The China Trade was particularly lucrative. There were Chinese merchants who thought that Salem was a fabulously rich country across the sea, rather than a small city in Massachusetts—a city, to be sure, that had spawned America's first millionaire in the person of Elias Hasket Derby, along with a score of other ship-owning magnificoes who left their mark in the form of Salem's wealth of surviving mansions in the chastely elegant Federal style.

Thomas Jefferson, never the friend of the Massachusetts elite, became these entrepreneurs' mortal enemy when he pressed Congress to pass the Embargo Act of 1807, closing American ports to foreign trade (later, it applied only to Britain and France) in response to the seizure of American commercial vessels on the high seas by British and French warships during the Napoleonic Wars. Jefferson's action was meant to punish the European belligerents by denying them access to American goods, but it accomplished little except to devastate the American economy. Some radical Federalists even talked of secession from the Union, and when the conflict with Britain erupted into war in 1812, Jefferson's successor James Madison was faced with bitter dissent from New Englanders.

The War of 1812, which some historians see as a delayed continuation of the American Revolution by a Great Britain still resentful of the rebellion's outcome, was sparked on several fronts—by British impressment of American seamen, by Indian attacks on the American frontier under British instigation—and was fought by the Americans partly as a defensive action, and partly as an excuse to annex Canada. Waged on land and sea, and on the Great Lakes, it was fought largely to a draw: there would be no further British

incursions on American soil, and Canada would remain a part of the British Empire. When it ended, in 1815, the United States entered an era in which it would be free to pursue its own destiny on the North American continent, without the entanglement of war or alliances with European powers. Europe was, in fact, warned away from any further territorial claims in what the U.S. regarded as its own sphere of influence when President James Monroe announced the doctrine that bears his name. America's birthing years were over. Now it was a continental power in its own right, ready to expand into its new territories with the help of technologies scarcely dreamed of in the Revolutionary and Federal decades.

OPPOSITE: **John Bower** (fl. 1809–19)
A View of the Bombardment of Fort McHenry, Near Baltimore, by the British Fleet. 1814.
Hand-colored aquatint, 11 x 17 ¹⁄₁₆ in. (28.1 x 43.6 cm).
Miriam and Ira D. Wallach Division. The New York Public Library, New York, New York.

The unsuccessful British bombardment of Fort McHenry, at the entrance to Baltimore harbor, is remembered not for its military significance but as the occasion on which Francis Scott Key, a lawyer held on a British ship while trying to secure a prisoner's release, was inspired to write the poem that became the national anthem of the United States.

BELOW: **Amedee Forestier** (d. 1930)
The Signing of the Treaty of Ghent, Christmas Eve, 1814. 1914.
Oil on canvas, 28 x 40 in. (71.1 x 101.6 cm).
Smithsonian American Art Museum, Washington, D.C.

The Treaty of Ghent, commemorated in Forestier's centennial painting, marked the end of the War of 1812, with neither the U.S. nor Great Britain achieving significant gains. One of the American signatories was John Quincy Adams, son of President John Adams and himself a future chief executive.

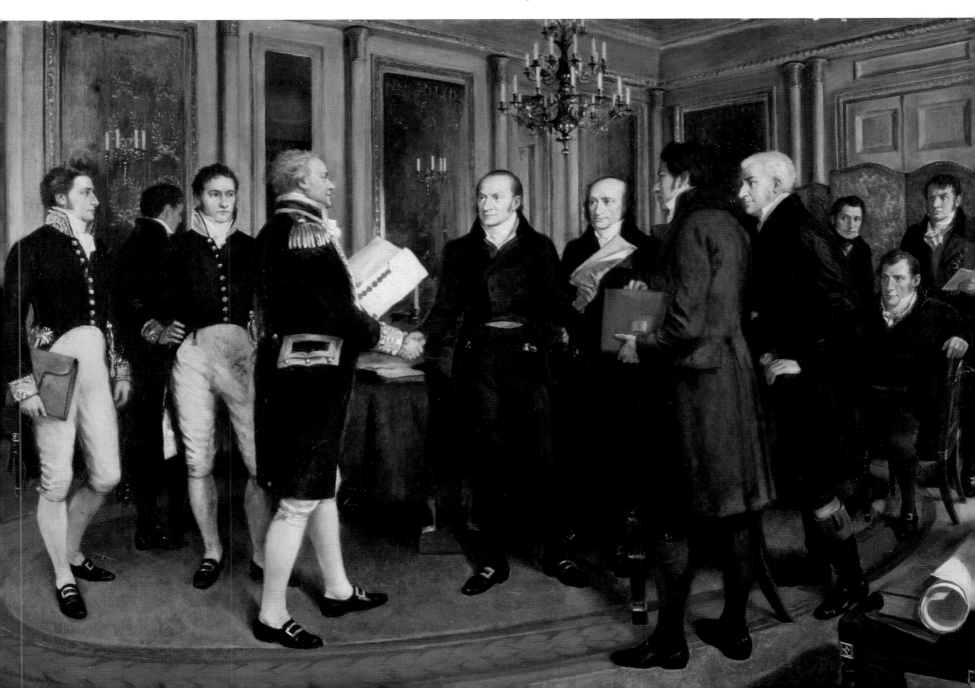

The Hamilton-Burr Duel

Matched Pair of Dueling Pistols, .56 caliber.
English, late eighteenth century.
J.P. Morgan Chase Archives.

These are the pistols used by Alexander Hamilton and Aaron Burr in the duel fought at Weehawken, New Jersey, July 11, 1804. Shot through the liver, Hamilton died the following day. Hamilton had borrowed the weapons from his brother-in-law, John B. Church, who had used them himself in an earlier duel against Burr.

Acrimony between political opponents is nothing new on the American scene—if anything, the snipes and barbs that are part of today's campaigns are far more understated and civilized than the poisonous accusations and outright smears that characterized political contests in the early years of the republic. But the most rancorous of all struggles between Federal-era rivals ended not in a bitter exchange of spoken or printed words, but in an act of violence that ended the life of one of the most accomplished of the founding fathers, and ruined the career of the vice-president of the United States.

Alexander Hamilton's rise during the revolutionary and early Federal eras had been phenomenal, and his contribution to the creation of the American constitutional system can hardly be overstated. From an impoverished boyhood in the West Indies, Hamilton rose to prominence—after adhering to the American cause while a student at

> *"From an impoverished boyhood in the West Indies, Hamilton rose to prominence."*

New York's King's College (later Columbia University)—as an aide-de-camp to George Washington after the outbreak of hostilities. He later served as a New York delegate to the Constitutional Convention, following which he argued brilliantly for the Constitution's ratification in the Federalist Papers, authored in collaboration with James Madison and John Jay. As President Washington's first secretary of the treasury, Hamilton set the new nation on a course of fiscal discipline, and established the first Bank of the United States. On leaving office,

he practiced as a lawyer in New York City, and continued in his role as an ardent spokesman for the Federalist Party. As a Federalist who had argued for a semiaristocratic government with a president and senate enjoying life tenure, his natural political enemies were Democratic-Republican Party stalwarts such as Thomas Jefferson, who advocated a broader-based popular democracy. But he reluctantly supported Jefferson's presidential candidacy when the election of 1800 was thrown into the House of Representatives, in order to prevent Jefferson's opponent, Aaron Burr, from becoming president. Jefferson was awarded the presidency, and Burr assumed the vice-presidency under the election rules of the day.

Hamilton had known Burr when the two men were both practicing law in New York, and had come to despise him as an unscrupulous would-be demagogue. Hamilton's disparagement of Burr included remarks such as, "I feel it to be a religious duty to oppose his career"; he also called the possible elevation of Burr to the presidency a "disgrace" to the nation.

Once made aware of Hamilton's scathing private indictments of his character—and well aware of his public ones—Burr responded with what was already an antiquated formality, but one still honored by old-school adherents to its code: he challenged Hamilton to a duel. The weapons were to be pistols, and the place an isolated level ground partway up the Palisades cliffs of Weehawken, New Jersey, across the Hudson (dueling was illegal in New York). On the morning of July 11, 1804, the two men met at Weehawken. Burr fired first, and Hamilton was mortally wounded, dying the following day.

Aaron Burr remained vice-president until the following March, when Jefferson's second term began, although he was *persona non grata* in political and society circles. He later became involved in a bizarre scheme to peel off the western territories of the United States and rule them as a separate nation. He was acquitted in a subsequent treason trial, and eventually resumed his law practice in New York.

Burr died in 1836, and has since occupied one of the more dubious corners of American history. Alexander Hamilton lives on, as the icon on the $10 denomination of the currency he helped to establish.

John Trumbull (1756–1843)
Alexander Hamilton. 1806.
Oil on canvas, 30 x 24 in. (76.2 x 61 cm).
Gift of Henry Cabot Lodge. National Portrait Gallery, Smithsonian Institution, Washington, D.C.

In a portrait painted two years after Hamilton's death in his tragic duel with Aaron Burr, Trumbull captured the air of confidence—adversaries might have said superiority, or even arrogance—that saw the nation's first treasury secretary through a brilliant career. This painting is the source of the engraving of Hamilton used on the $10 bill.

The first page of the Constitution of the United States is certainly one of the most recognizable pages in the world. Drafted by the delegates of the Philadelphia Convention in 1787 to replace the Articles of Confederation, the physical document resembles legal forms that were common in the eighteenth century. Iron-containing ink made according to the scribe's favorite formula would be applied to parchment with quill pens precisely cut and shaped to achieve the letters' desired look.

RIGHT: **Gilbert Stuart** (1755–1828) *Thomas Jefferson.* 1805/1821. Oil on panel, 26 1/8 x 21 in. (66.4 x 53.3 cm). *Gift of the Regents of the Smithsonian Institution, the Thomas Jefferson Memorial Foundation, and the Enid and Crosby Kemper Foundation. National Portrait Gallery, Smithsonian Institution, Washington, D.C. Owned jointly with Monticello, Thomas Jefferson Foundation.*

Thomas Jefferson asked Gilbert Stuart several times for the portrait he had sat for in 1805—the third president felt the painting would fit suitably with the others in his collection. In 1820 Stuart finally agreed, but instead painted this replica of the original to give to his esteemed sitter. Jefferson accepted this 1821 version apparently not questioning its authenticity, but his daughter is said to have noticed the paint was still wet when it arrived.

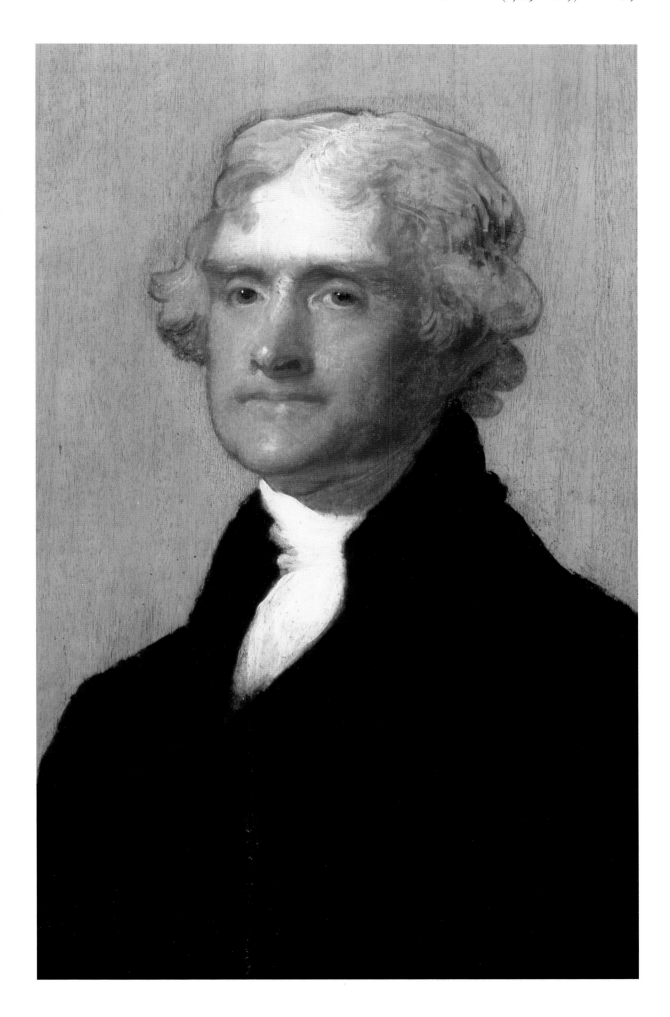

American Expansionism
(1815–60)

"I've got a mule, and her name is Sal,
Fifteen miles on the Erie Canal."

—"Low Bridge," Thomas S. Allen

With the end of the War of 1812, American ships once again sailed out of the merchant cities of the East Coast. But the coming decades brought the introduction of transportation technologies that enabled the nation's attention to turn inland, toward the vast system of inland waterways that had until then served commerce mostly via the canoe-borne fur trade. By the time those technologies had been fully exploited, the greatest natural harbor on the Atlantic seaboard would be linked as firmly with Buffalo, Cleveland, and the Mississippi Valley as with its trading partners across the seas, and the City of New York would forever eclipse the New England ports that had held sway in colonial and Federal times.

There was nothing new, of course, about the technology of canal building; man-made waterways had been a part of the commerce of the British Isles and continental Europe for centuries. Nor were canals a new innovation in nineteenth-century America: entrepreneurs started digging the original water route along New York's Mohawk Valley within a decade after the Revolution. But the 1817 groundbreaking for the Erie Canal marked the true beginning of the nation's canal boom. When this link between the Hudson River and Lake Erie was completed, in 1825, the passage from New York City to the Great Lakes was reduced to a mere 10 days, and the farms, granaries, timberlands,

and nascent manufacturing centers of the hinterland had access to the sea.

The canals' monopoly on long-distance transportation between the interior and the coasts was short-lived. During the 1820s, the father-and-son English inventors George and Robert Stephenson had successfully demonstrated the application of steam for motive power, and by the early 1830s American railroads such as the Mohawk and Hudson, Camden & Amboy, and Baltimore & Ohio had begun to lay track and initiate regular service (significantly, ground for the B&O was ceremonially broken by 90-year-old Charles Carroll, last surviving signer of the Declaration of Independence, who thus became a player in two great American revolutions). Well before mid-century, railroads threaded across the Northeast, brought cotton to market in the South, and had made their first inroads to a Midwest soon to be dominated by a lakeside town that poet Carl Sandburg would one

OPPOSITE: Henry Sargent (1770–1845)
The Dinner Party. Ca. 1821.
Oil on canvas, 61 ⅝ x 49 ¾ in. (156.5 x 126.3 cm).
Museum of Fine Arts, Boston.

Depicting an afternoon dinner at what was likely his own home, Sargent here offers a window onto a gathering of the Boston elite that the man of letters Dr. Oliver Wendell Holmes Sr. labeled "Brahmins." Dinner and salon gatherings such as this were often the matrix from which Boston's great cultural institutions grew.

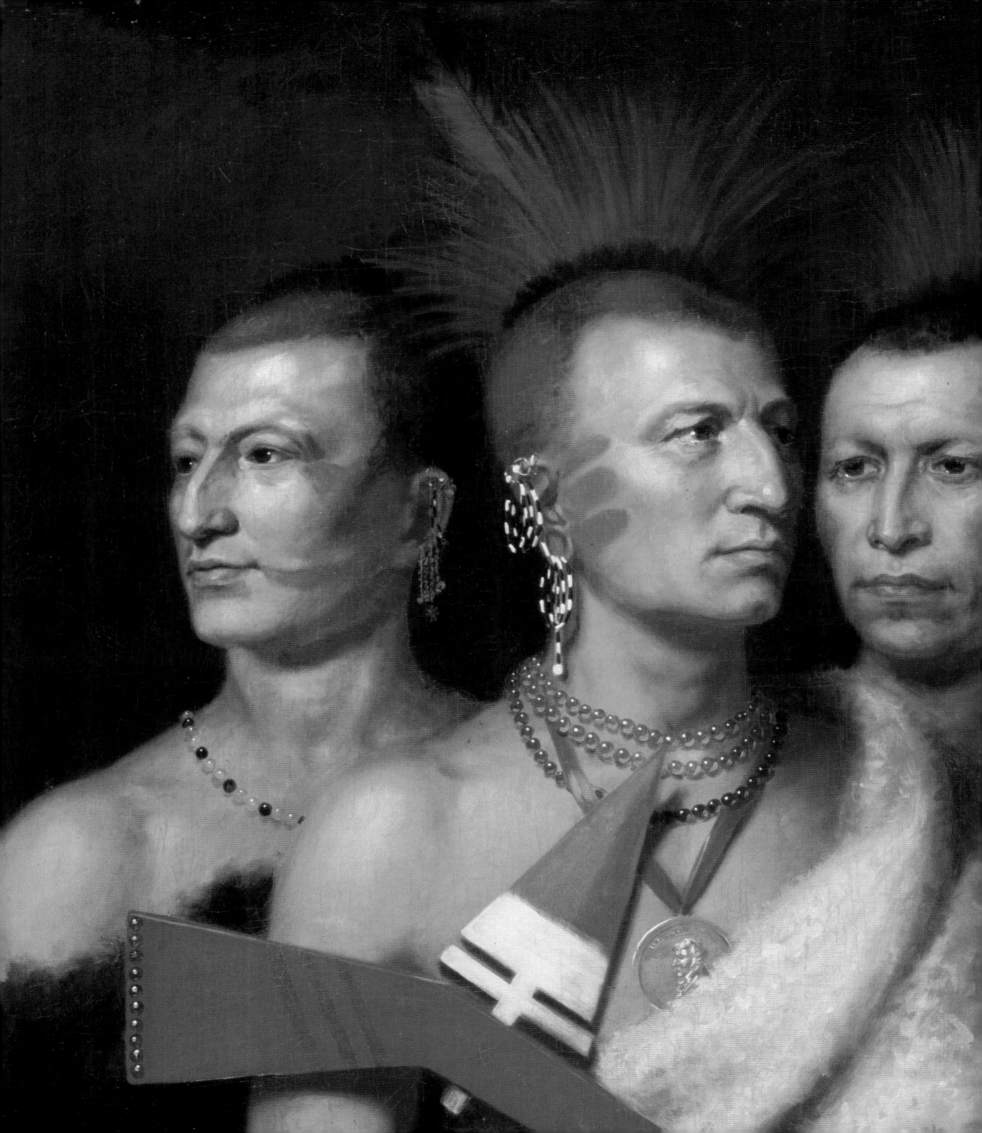

day call "player with railroads, and the nation's freight handler": Chicago.

Together with the steamship lines that had grown rapidly on major rivers and along coastal waterways, the railroads were not only revolutionizing transportation, but also fueling an entirely new engine of wealth creation in the United States. Prior to the industrialization of transport, the wealthiest Americans tended to be either great landowners, or merchants trading upon the high seas. But with steam transportation, as with the water-powered mills now proliferating in New England, a new class of capitalists was emerging. During the second quarter of the nineteenth century, there was money on the land—but it was moving rapidly across it, powered by steam.

Even before the advent of canal and rail transportation, Americans had begun to move west. The 13 original states had been joined by Vermont in 1791, but after the addition of this onetime independent republic, nearly all new candidates for statehood were located west of the Appalachians (the exceptions were Maine, which became a state in 1820; and Florida, acquired from Spain by treaty in 1819 and granted statehood in 1845). Kentucky and Tennessee became states in 1792 and 1796 respectively, having been populated by emigrants from the Middle Atlantic region. The Cumberland Road, begun in 1811 and linking Maryland with the Midwest via Pittsburgh, and the Erie Canal made possible the rapid settlement of Ohio, Indiana, and Illinois, all of which were states by 1818. Farther south, Mississippi (1817) and Alabama (1819) joined the Union as the cultivation of cotton—made more lucrative by Eli Whitney's cotton gin—spread west along with the institution of slavery. Louisiana, accessible and well populated because of its location at the mouth of the Mississippi River, had joined the Union in 1812.

Charles Bird King (1785–1862)
Young Omahaw, War Eagle, Little Missouri, and Pawnees. 1821.
Oil on canvas, 36 ⅛ x 28 in. (91.8 x 71.1 cm).
Gift of Miss Helen Barlow. Smithsonian American Art Museum, Washington, D.C.

Although he painted prominent political figures such as Henry Clay and John C. Calhoun, Charles Bird King is best remembered for his portrayal of leaders of nearly two dozen native American tribes to illustrate Thomas McKenney and James Hall's three-volume *History of the Indian Tribes of North America*, completed in 1844.

John Quidor (1801–81)
Ichabod Crane Flying from the Headless Horseman. Ca. 1828. Oil on canvas, 22 ⅝ x 30 ⅟₁₆ in. (57.5 x 76.4 cm).
Mabel Brady Garvan Collection. Yale University Art Gallery, New Haven, Connecticut.

John Quidor was part of the growing trend toward genre painting, which portrayed the daily lives of Americans in the early nineteenth century. But he also chose themes from literature, as in this rendering of the climax of Washington Irving's *The Legend of Sleepy Hollow*. In his stories, Irving created a droll mythology for the young republic.

American politics, too, underwent a transformation as the nation's focus of attention shifted slowly to the west. Following the presidential administrations of James Monroe and John Quincy Adams, the democratic spirit and values of the trans-Appalachian frontier came to the fore with the 1828 election of Andrew Jackson, the Tennessean hero of the 1814 Battle of New Orleans against the British and veteran Indian fighter. Jackson's era saw the beginning of party nominating conventions, the direct popular election of members of the presidential electoral college, and the broadening of male suffrage: by 1842, requirements that voters must own property had been struck down in every state.

That was white male suffrage, of course. The issue of slavery, carefully neglected during the constitutional debates of a generation earlier, arose as a major point of contention when Missouri applied for statehood in 1820. Northern congressmen wanted to outlaw slavery in the new state, while the South saw a

> *"American politics, too, underwent a transformation as the nation's focus of attention shifted slowly to the west."*

chance to expand the institution. A crisis was forestalled by the Missouri Compromise, under which Missouri was admitted as a slave state, while Maine came into the Union as a free state. The compromise only forestalled the inevitable clash of ideologies, which became more sharply exacerbated as a vigorous abolitionist movement arose in the North, particularly in New England.

United States Capitol, Washington, D.C. (1793–1868, with additions through 1960).

Although George Washington laid the Capitol's cornerstone in 1793, it was essentially unfinished until the cast-iron dome was completed in 1868. A progression of architects—including James Hoban, Benjamin Latrobe, and Charles Bulfinch—gave the vast structure the Neoclassical character that reflects early America's association with the ideals of Greece and republican Rome.

The physical contours of the United States, which had been expanded so dramatically by Jefferson's purchase of the Louisiana Territory from France, were destined to expand westward to their continental limits, as well as north and south, during the 1830s and 1840s. The Webster-Ashburton Treaty settled the boundaries of northern New England and Canada in 1842; six years later, the threat of conflict with Great Britain over the border of the Oregon Territory and British Columbia was likewise peacefully averted. But the United States' largest territorial acquisition of the era was the result of the Mexican War.

Texas was the first flashpoint in the showdown between the U.S. and Mexico. In 1836, American colonists who had settled in this Mexican territory battled their way to independence, and declared a republic. Almost from the beginning, Texans favored annexation by the United States, and in 1844 James K.

Polk was elected U.S. president on a platform which included Texas statehood—it was Polk, not coincidentally, who was most closely associated with the term "manifest destiny," implying the inevitable extension of American territory from the Atlantic to the Pacific. Texas joined the Union late in 1845, and war with Mexico loomed almost immediately. Polk took advantage of the Mexicans' hostility toward Texas statehood—Mexico still considered Texas a rebelling province—and used the opportunity to press outstanding financial claims against the bordering

nation. When negotiations failed, Polk ordered U.S. troops into a contested area along the Rio Grande. Skirmishes ensued, and Congress declared war at the president's request.

When the war ended, in 1848, Polk's concept of manifest destiny was a reality. Mexico ceded all of its northern territories, including the future states of Arizona, New Mexico, Utah, Nevada, and the greatest prize of all—California, destined for statehood in 1850 in the wake of the Gold Rush of 1848. It would take more than 20 years for California to be connected to the east by rail, but overland routes across the prairies and mountains had been well reconnoitered by the late 1840s. Following in the footsteps of Lewis and

Clark, explorers such as Zebulon Pike and John Charles Frémont had paved the way for wagon train migrations, and Brigham Young's party of Mormons were already settling along Utah's Great Salt Lake.

In this age of territorial expansion and invention—after 1844, the first telegraph lines began to connect American cities, joining steamships and railways in shrinking distance—another revolutionary factor came into play. Between 1820 and 1850, more than five million immigrants poured into American seaports. The vast majority of this primarily European wave settled in the cities of the North, providing ready labor for a rapidly industrializing section of the country. Beginning in the 1820s, New England entrepreneurs had begun to harness

the region's abundant water power for the production of textiles; elsewhere in the Northeast, iron foundries, glassworks, mills for processing flour, and locomotive works were proliferating. Scotch-Irish, then German, and finally Irish refugees from the 1840s potato famine were changing the ethnic complexion of the United States, and providing manpower not only for factories, but for building railroads, canals, and other essentials of public infrastructure. The rapid population growth and industrialization of the North would eventually give an insurmountable advantage to the Union in the Civil War. In many ways, that coming struggle would not only be a showdown between slave and free states, or between federalism and states' rights. It would pit a modern industrial society against a semifeudal agrarian system.

The decades immediately preceding the Civil War were a fertile time for ideas and social movements, and

ABOVE: **Thomas Cole** (1801–48)
View of Hoosac Mountain and Pontoosuc Lake Near Pittsfield, Massachusetts.
Oil on canvas, 33 ⅛ x 45 ¼ in. (84.1 x 114.9 cm).
Purchase by exchange; Gift of Mr. and Mrs. Charles Engelhard, 1988. Collection of The Newark Museum, Newark, New Jersey.

Arriving in the U.S. in 1818, aged 17, Thomas Cole brought with him both the nascent British landscape aesthetic in art, and a sense of how readily natural beauty could succumb to industrialism, as it had in much of England. His paintings, the foundation of the Hudson River School, depict an Arcadian America, nature wild yet accessible.

OPPOSITE: **Samuel F. B. Morse** (1791–1872)
Niagara Falls from Table Rock. 1835.
Oil on canvas, 24 x 30 in. (61 x 76.2 cm).
Bequest of Martha C. Karolik for the M. and M. Karolik Collection of American Paintings. Museum of Fine Arts, Boston.

Primarily a painter of portraits and historical subjects, Samuel F. B. Morse was also among early-nineteenth-century artists who found inspiration in America's scenic grandeur. Ironically, Morse is far better known for an invention—the telegraph—that helped usher in an age of technology often inimical to untrammeled nature.

John C. Frémont and the Exploration of the West

"Every large city in the West was originally my camp." John Charles Frémont's not so idle boast was made by an adventurer who, next to Lewis and Clark, was the most tireless and illustrious explorer of the American West. Frémont made his name during the decades that lay between Lewis and Clark's trek to the Pacific and the great wagon train migrations of westbound settlers; he was, in fact, the man most responsible for surveying the routes those pioneers would follow, filling in the blank spaces on the map between St. Louis and the Pacific coast, and ultimately binding California to the East.

> ## "Every large city in the West was originally my camp."
>
> —John Charles Frémont

John Charles Frémont was born in Georgia and grew up in South Carolina, although his southern origins would scarcely be apparent in his later career as a staunch abolitionist and the first Republican candidate for president in 1856. But neither politics, nor his service as a Union general in the Civil War, were what stamped Frémont's name on more than a hundred places throughout the West.

In 1838, at the age of 25, Frémont was commissioned as a lieutenant in the U.S. Army and assigned to help survey wagon and railway routes across the northern Great Plains. Little had been learned of the lands west of the Mississippi and north of the Missouri Rivers since the days of Lewis and Clark; when Frémont first became acquainted with the territory, it was still the domain of unmolested Indian tribes and the fur-trading "mountain men" who had largely adopted their ways.

Armed with his new knowledge of the frontier—and with the wilderness savvy of men like Kit Carson, the fur trapper who gained fame as Frémont's scout—the young explorer was given command of a more ambitious foray, reconnoitering sites for a string of forts ranging from St. Louis to Wyoming. He followed the Platte River to Fort Laramie, and then pressed ahead to the Wind River Range on the Continental Divide. There, he climbed and named one of the highest mountains in the range. From Frémont Peak, he could look west toward other realms to conquer.

A year later, Frémont ventured even farther, finding at South Pass in the Rockies the route that the Oregon Trail would later follow. He and his men crossed the Great Basin, paddled the Great Salt Lake in a rubber boat, reached Oregon via the Snake River, and turned south to cross the Sierra Nevada into California in the depths of winter. Reaching the Sacramento River valley, the party rested at the ranch where, less than a decade later, a chance discovery of glistening nuggets would launch the California Gold Rush. Frémont returned by way of Las Vegas, one of his camps that would become a great city long after his time.

Frémont's last major expedition again took him as far as California, but his arrival in 1845 coincided with the onset of the Mexican War. Now more soldier than explorer, he captured San José and Los Angeles, and served briefly—and not entirely legitimately—as governor of the conquered territory of California. Eventually, he would become a senator representing the new state, and, after the Civil War, governor of the Arizona Territory. But the West was filled with newly minted politicians. Only one could boast of having traversed, mapped, and reported the whole vast region.

ABOVE: Albert Bierstadt (1830–1902)
Among the Sierra Nevada Mountains, California. 1868.
Oil on canvas, 71 x 120 in. (183 x 305 cm).
Smithsonian American Art Museum, Washington, D.C.

Although its name suggested the far tamer landscapes of New York State, the sublimely grandiose style of the Hudson River School, of which Albert Bierstadt was a member, well suited the depiction of Western landscapes that Easterners could scarcely imagine in an era when few photographers had ventured across the Rockies.

OPPOSITE: Mathew Brady (1822–96)
General John C. Frémont. Ca. 1860–65.
Photograph.
National Archives at College Park, Maryland.

John C. Frémont's glory days as a Western explorer had given way to his less successful career as a Union general when he posed for famed photographer Mathew Brady. Frémont ran for president (1856) as the first candidate of the Republican Party.

Ralph Albert Blakelock (1847–1919)
Western Landscape.
Oil on canvas, 34 ¼ x 60 in. (87 x 152.4 cm).
Gift of the Board of Directors of the National Newark and Essex Bank,
1965. Collection of The Newark Museum, Newark, New Jersey.

Self-trained Ralph Albert Blakelock at first worked in the style of the
Hudson River painters, then trended toward Impressionism and its
more somberly hued sub-school of Tonalism. Between 1869 and 1872,
he traveled extensively throughout the West, living among Indians and
portraying the textures, colors, and expansiveness of their world.

Andrew Melrose (1836–1901)
Valley of the Hackensack from the Estate of L. Becker, Esq.,
Union City, New Jersey.
Oil on canvas, 28 ¼ x 58 in. (71.8 x 147.3 cm).
Collection of The Newark Museum, Newark, New Jersey.

Working in northern New Jersey after the Civil War, Scottish-born Andrew Melrose found even in that rapidly industrializing region bucolic scenes worthy of the style of the Hudson River School. Here, it is difficult to imagine that the bustling mouth of that river—not the portion painted by the School's masters—lay just over the artist's shoulder.

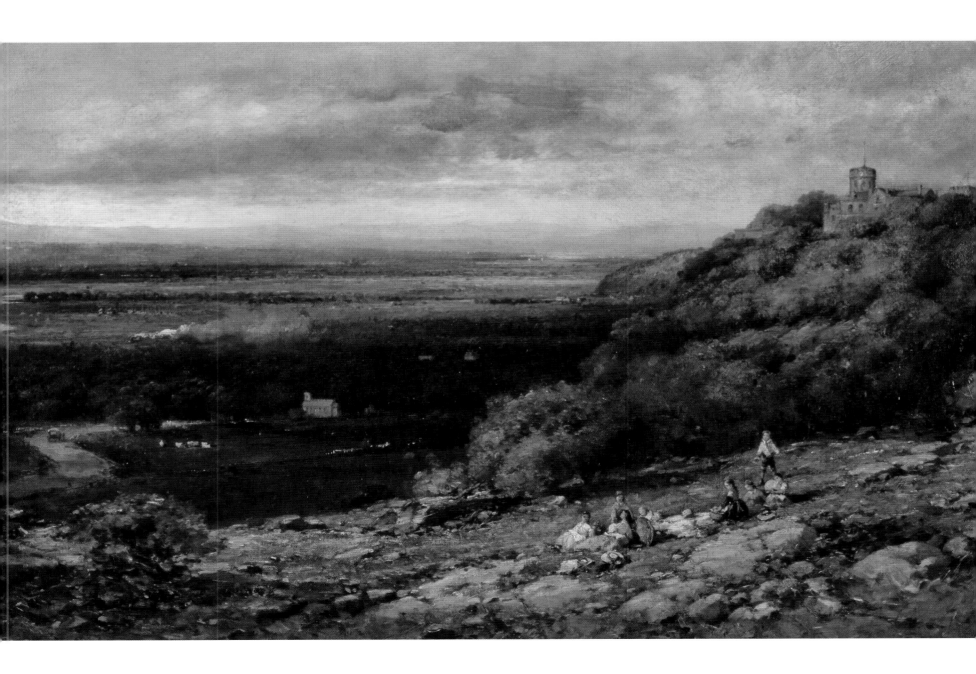

Fitz Henry (Hugh) Lane
(1804–65)
Boston Harbor. Ca. 1850–55.
Oil on canvas, 26 x 42 in.
(66 x 106.7 cm).
Museum of Fine Arts, Boston.

Painted in the Luminist style,
characterized by an otherworldy
serenity and a soft, glowing light,
usually reflected in water, Lane's
canvas shows Boston harbor
near the end of the age of sail;
a steamship approaches at right.
One age supplants another:
Lane's easel must have stood on
the future site of Logan Airport.

Edward Hicks (1780–1849)
The Peaceable Kingdom and Penn's Treaty. 1845.
Oil on canvas, 24 ¼ x 31 in. (61.6 x 78.7 cm).
Bequest of Robert W. Carle, B.A. 1897. Yale University Art Gallery, New Haven, Connecticut.

The primitivist Edward Hicks was a Quaker minister, part of the sect with whom William Penn—shown here concluding a treaty with the Indians—founded Pennsylvania. Hicks populated this allegorical Delaware Valley with the docile animals of the new Eden prophesied by Isaiah; already in the 1840s, early America was recalled in an Edenic light.

Francis William Edmonds (1806–63)
The Speculator. 1852.
Oil on canvas, 25 ⅛ x 30 ⅛ in. (63.7 x 76.4 cm).
Smithsonian American Art Museum, Washington, D.C.

Like John Rogers with his plaster sculptures, and Norman Rockwell in the following century, the genre painters of the early nineteenth century sought to chronicle aspects of everyday life that earlier artists would have considered beneath their talents. Here, Francis William Edmonds comments on his era's fascination with quick, lucrative land deals.

John James Audubon (1780–1851)
The Blue Heron. Plate 217, from *Birds of America.* 1827.
Bibliothèque de l'Institut de France, Institut de France, Paris.

John J. Audubon was America's most notable wildlife artist for more than 50 years, and his *Birds of America*, a collection of 435 life-size prints, is still the preeminent work of its kind. Unlike earlier painters of birds, Audubon imbued his subjects with "life" and was meticulous in his adherence to accuracy; every element was chosen to reflect each bird's unique characteristics, such as behavior, plumage, and habitat. An emigrant to America at age 18, Audubon stands as one of this country's foremost pioneers and an embodiment of the Romantic era, his extensive travels opening his eyes to the remarkable beauty, drama, and fragility around him and kindling a lifelong interest in conservation. The name Audubon continues to be associated with wildlife education and preservation throughout the world.

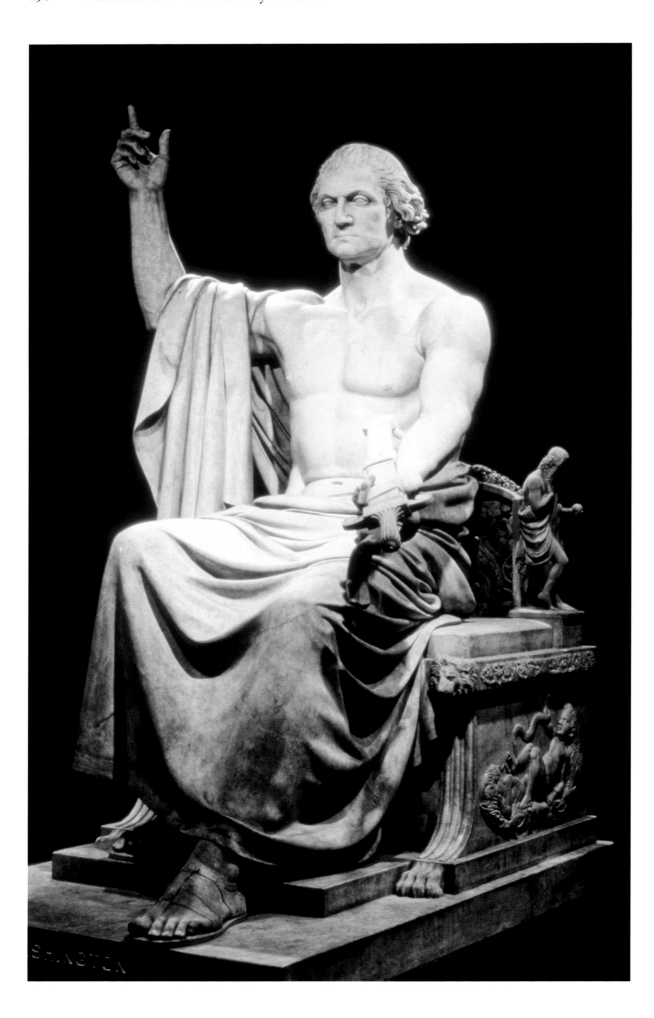

LEFT: Horatio Greenough
(1805–52)
George Washington. 1840.
Marble.
Smithsonian American Art Museum, Washington, D.C.

Greenough's seated statue of Washington, installed in the U.S. Capitol rotunda, brings together several of his era's cultural, political, and artistic trends. Depicting the first president in the garb of classical antiquity plays to his enshrinement as a near-mythic figure, while also satisfying the Greek Revival tastes of a time when even farmhouses were sprouting Doric columns.

OPPOSITE: *Matthew Calbraith Perry.*
Ca. 1854.
Japanese colored wood-block print.
National Portrait Gallery, Smithsonian Institution, Washington, D.C.

The decades preceding the Civil War saw an expansion of America's role in international commerce. In 1853, Commodore Matthew Perry led four U.S. Navy ships into Tokyo harbor; by March 1854, he had concluded negotiations to open the reclusive island nation to trade. This portrait, published in Tokyo that year, is one of the first Japanese depictions of an American.

提督ペルリ省像

寅六十ヲ

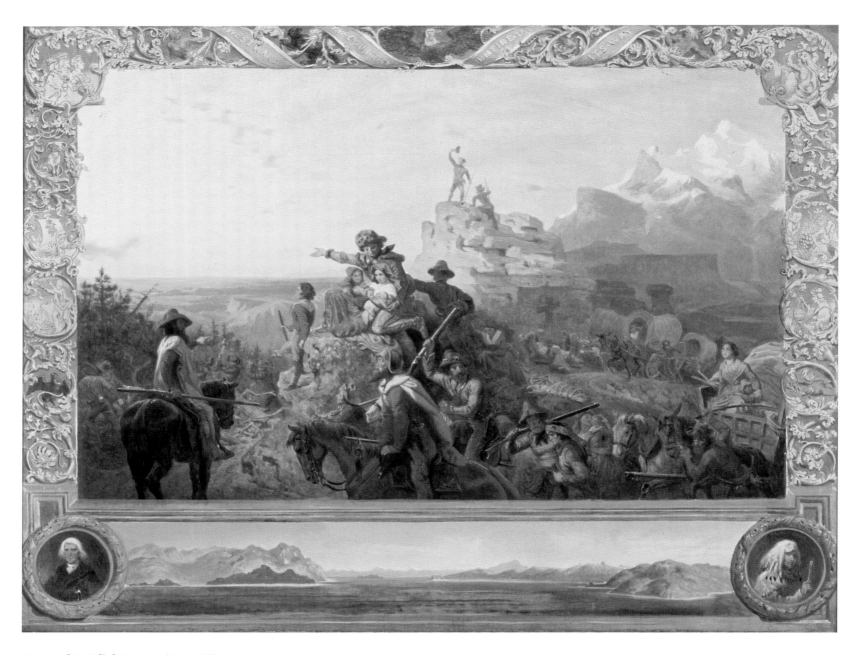

Emanuel Gottlieb Leutze (1816–68)
Westward the Course of Empire Takes Its Way
(Mural Study, U.S. Capitol). 1861.
Oil on canvas, 33 ¼ x 43 ⅜ in. (84.5 x 110.1 cm).
Smithsonian American Art Museum, Washington, D.C.

Best known for his iconic *Washington Crossing the Delaware*, Emanuel
Leutze turned to a different but no less powerful patriotic theme in this
classically composed evocation of the pioneer spirit—and of the notion
that America's destiny lay beyond the western frontier.

Ranney, William Tylee (1813–57) and **William Sidney Mount** (1807–68)
The Pipe of Friendship. 1857–59.
Oil on canvas.
Gift of Dr. J. Ackerman Coles, 1920. Collection of The Newark Museum, Newark, New Jersey.

The expanding frontier was dramatic in concept and seemingly limitless in possibility, ideas often artistically captured in sweeping vistas and wild landscapes. But the human element was depicted as well, this peaceful, calm moment on the Plains showing a mountain man, his pack horse heavily laden with items to be traded, meeting other travelers and sharing a friendly smoke. In the eyes of the general population, these solitary men were often thought of as heroes who inhabited the exotic and mysterious land of the West.

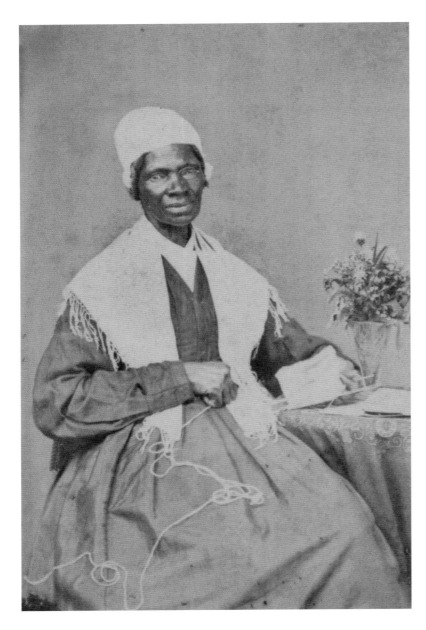

Sojourner Truth (ca. 1797–1883). 1864.
Photograph.
Library of Congress.

Sojourner Truth was born a slave in upstate New York. Emancipated
when slavery became illegal in that state in 1827, she later became
involved in abolitionist and utopian activities and promoted black
enlistment in the Union army. After the war, she championed the idea of
western land grants for freed slaves, to little avail.

entirely in the North. In the South, the primary source
of wealth was the cultivation of cotton, a commodity
so valuable that by 1860 it constituted well over half
the worth of all American exports.

Given such radically different social and economic
structures, it was inevitable that North and South
would have diverging ideas on a wide variety of issues,
not the least of which involved tariffs on imports: the
North favored them, to protect its burgeoning

industries, while the South wanted unimpeded access
to imported goods. It would not have been inevitable
for these differing ideas to lead to open warfare, were
it not for the single overarching issue of what has
been called, with fathomless understatement, the
"peculiar institution": the South's economy, its whole
way of life, was based upon the buying and selling of
human beings to be used as beasts of burden in the
cotton fields. And slavery, ultimately, was beyond
compromise. As historian Bruce Catton wrote, "It
[slavery] was not the only cause of the Civil War, but it
was unquestionably the one cause without which the
war would not have taken place."

> *"It [slavery] was not the only*
> *cause of the Civil War, but it*
> *was unquestionably the one*
> *cause without which the war*
> *would not have taken place."*
>
> —BRUCE CATTON

Not that compromise hadn't been attempted—
there was the Missouri Compromise of 1820, which not
only traded Maine's free-state admittance to the Union
for Missouri's entry as a slave state, but also banned
slavery in any future states carved from lands north of
the latitude of Missouri's southern boundary. A
further compromise, in 1850, brought in California as a
free state but left the slavery question open in Utah
and New Mexico. Developments such as the Dred Scott
decision—in which the U.S. Supreme Court refused to
let a slave who had lived in a free state sue for his
liberty—and a federal Fugitive Slave Act favorable to
slaveholders only partly calmed Southern fears that
the tide was turning against their peculiar institution.
But these instances served to inflame an already
militant abolitionist faction in the North. Even before
the formal beginning of hostilities, violence had
erupted in Kansas, where a proposed vote over free vs.
slave state status had brought in opposing parties out

Lilly Martin Spencer
(1822–1902)
War Spirit at Home (Celebrating the Victory at Vicksburg). 1866.
Oil on canvas, 30 x 32 ½ in. (76.2 x 83.2 cm).
Collection of The Newark Museum, Newark, New Jersey.

The British-born Spencer was a popular genre painter, and perhaps the best-known woman artist of her day. Here she puts a domestic cast on northern reaction to General Ulysses Grant's July 4, 1863, capture of the Confederates' Mississippi River stronghold of Vicksburg—and documents the immediacy with which newspapers could report in the new era of telegraphy.

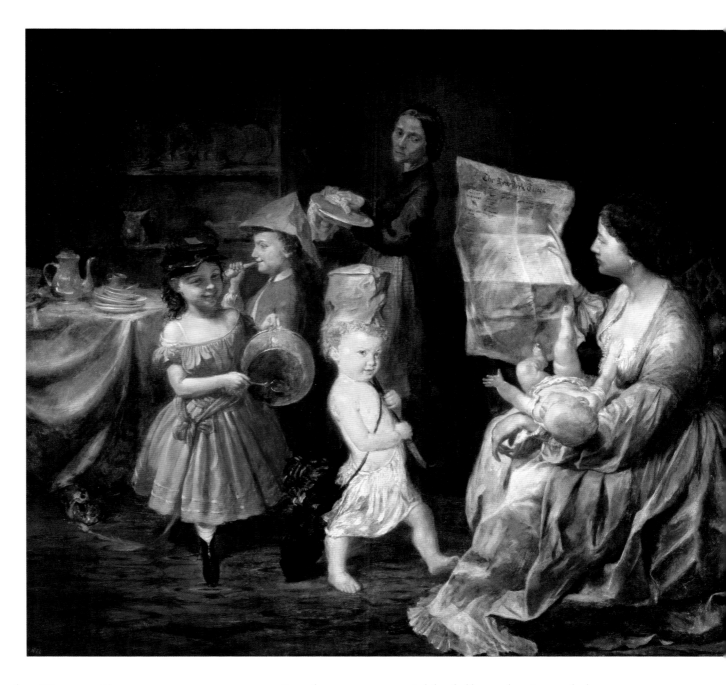

to intimidate each other; and at Harpers Ferry, Virginia, where extremist abolitionist John Brown had attempted to seize a federal armory and use the weapons to start a slave uprising.

The catalyst for Southern action was the 1860 election to the presidency of Abraham Lincoln, the nominee of the new Republican Party. Lincoln himself was no abolitionist, at least not at that early date, but his party's platform was so inimical to the South's perceived economic interests, and Republican ranks were so filled with outright enemies of slavery, that immediate political panic ensued south of the Mason-Dixon Line. South Carolina's legislature voted to secede from the Union before the year was out. Six

more Southern states quickly followed suit, and the Confederate States of America was born.

The opening shots of the war were fired at Fort Sumter, a federal stronghold on an island in the harbor of Charleston, South Carolina. The fort surrendered following an artillery barrage from the shore, and President Lincoln immediately federalized state militias and called for further volunteers. The four remaining southern states quickly joined the Confederacy, and the lines were inexorably drawn.

As with so many wars, the conflict between North and South was expected by many Americans on both sides to be quick, decisive, and glorious—so much so that parties of picnickers set out from Washington to

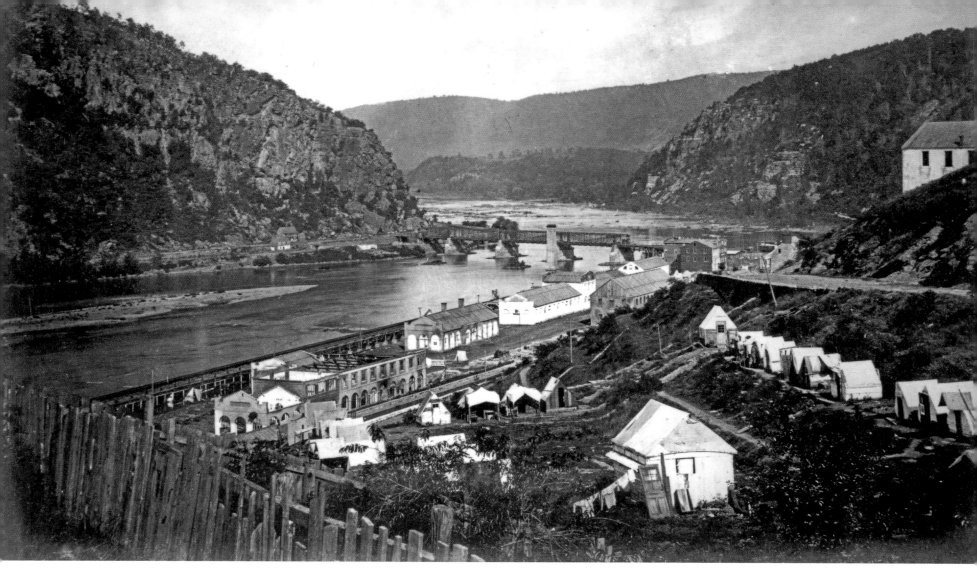

ABOVE: **Alexander Gardner** (1821–82) and **James Gardner** (1832–?)
Meeting of the Shenandoah and Potomac at Harpers Ferry. 1865.
Photograph.
Library of Congress.

Printed by Alexander Gardner from a negative taken by his younger
brother James, this view of Harpers Ferry shows the federal armory
complex that was the target of abolitionist John Brown's abortive 1859
raid, in which he had intended to secure arms for a slave rebellion.

RIGHT: *Walt Whitman*. Ca. 1860–65.
Photograph.
Library of Congress.

Walt Whitman, whose then-controversial verse collection *Leaves of Grass*
had been published in 1855, tended to wounded Union and Confederate
soldiers during his service as a nurse in army hospitals. His prose
recollections of this aspect of the war were published in *Memoranda
During the War* (1875).

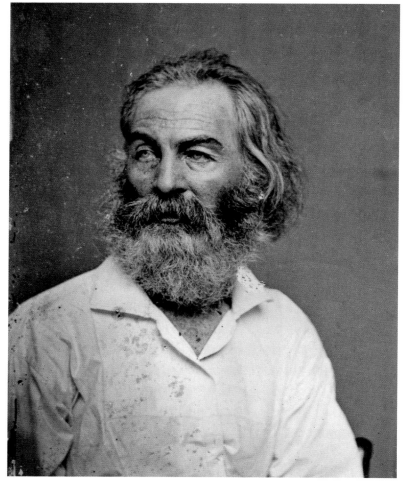

The two antagonists' fortunes in the east teetered
back and forth. At the Battle of Antietam, fought in
northern Virginia in September 1862, Union forces
blocked an attempt by Lee to drive north into
Pennsylvania, ending a brief crest of the Confederate
tide and dashing any hope of the secessionist nation's
recognition by European powers. Soon after, Lincoln
dealt a death blow to the Southern economy by

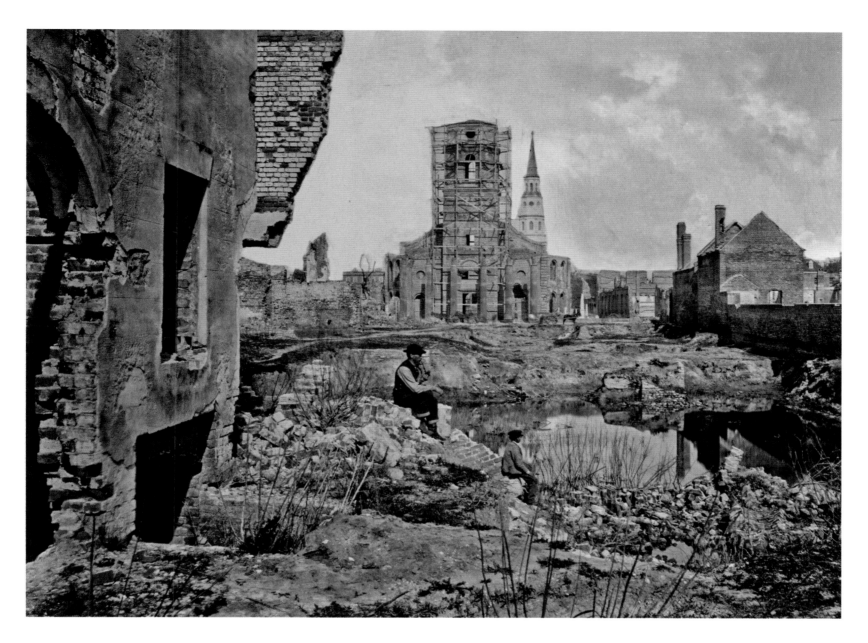

George Barnard (1819–1902)
Ruins in Charleston, South Carolina. 1864–65.
Photograph.
Acquired by exchange with the Library of Congress.
The Museum of Modern Art, New York, New York.

Charleston was evacuated by its citizens and burned by Union forces under General William T. Sherman on February 18, 1865. Barnard, who had previously worked for Mathew Brady but chafed under Brady's policy of taking credit for his employees' work, accompanied Sherman as an official photographer on his Atlanta campaign and March to the Sea.

issuing the Emancipation Proclamation, freeing slaves in areas engaged in active rebellion against the federal government (the 13th amendment to the Constitution, banning slavery altogether, would follow). But the Confederates could still hammer out victories at Fredericksburg, in December 1862, and at Chancellorsville, in May of the following year; and Lee, with his superb Army of Northern Virginia, was capable of another stab across the Mason-Dixon Line. A victory on the Union's own ground, he reasoned, might turn Northerners' sentiments away from continuing the fight. He met General George Meade's forces at Gettysburg on July 1, 1863, and for three days the two armies waged the Civil War's greatest battle. Lee's failure to crack the Union positions—despite the survival of his depleted army (each side suffered

more than 20,000 casualties)—meant that there would never be a credible threat to the Northern homeland again.

What had largely become a war of attrition was essentially lost for the Confederates by the end of 1864. The South fought ferociously that year at

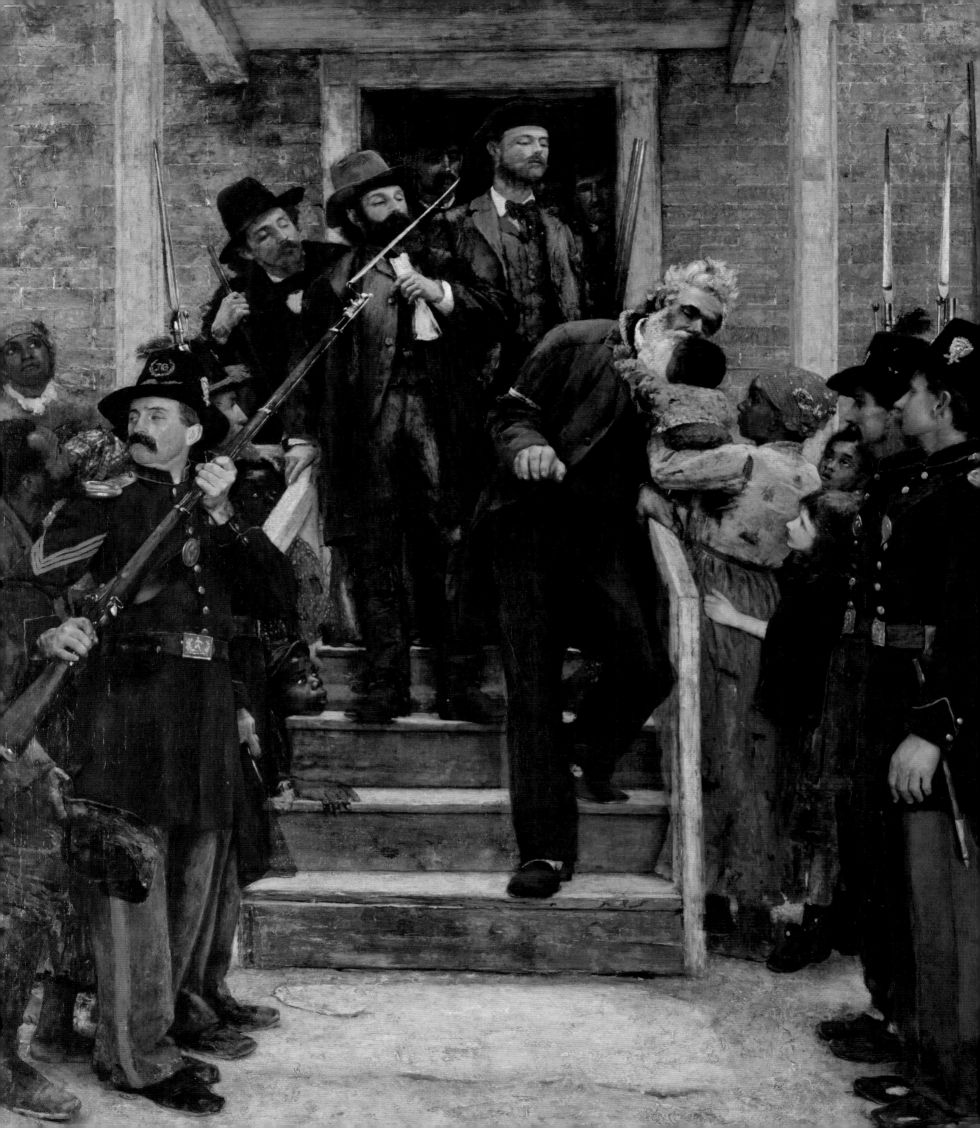

ABOVE: James Hope (1818–92)
The Battle of Antietam (1862). A Crucial Delay—Early Afternoon Looking West Across Burnside Bridge.

James Hope was a captain in the 2d Vermont Infantry, and a veteran of a dozen battles prior to Antietam. Originally exhibited in Hope's Watkins Glen, New York, gallery, this painting depicting the Union capture of a key bridge across Antietam Creek now hangs at Antietam National Battlefield.

OPPOSITE: Thomas Hovenden (1840–95)
The Last Moments of John Brown. 1882–84.
Oil on canvas, 77 3/8 x 66 1/2 in. (196.5 x 168.3 cm).
Gift of Mr. and Mrs. Carl Stoeckel, 1897. The Metropolitan Museum of Art, New York, New York.

John Brown was hanged on December 2, 1859, for his seizure of the federal arsenal at Harpers Ferry, Virginia. By the time Irish-born Thomas Hovenden depicted the condemned man's departure for the gallows 25 years later, Brown had entered American folklore as an abolitionist martyr.

The Wilderness and at Spotsylvania, as the Army of Northern Virginia and the Union Army of the Potomac clenched sporadically like two wary and tiring boxers. But by the end of the year, three Union achievements sealed secession's doom. Admiral Farragut, crying "Damn the torpedoes," took contol of Mobile Bay in August; Philip Sheridan laid waste to the fertile Shenandoah Valley in September; and— most terrible of all—William Sherman seized and burned Atlanta, then cut his devastating swath to Savannah, known ever since as The March to the Sea. By the spring of 1865, Sherman was sweeping north through the Carolinas, and Grant had run the Army of Northern Virginia to ground. He met Robert E. Lee in the town of Appomattox Court House on April 9, where, after "our conversation grew so pleasant that I almost forgot the object of our meeting," according to Grant, the one old West Pointer unconditionally surrendered to the other.

Less than a week later, the tragic coda to this greatest of American tragedies was played out at Ford's Theater in Washington, when the delusional actor and southern sympathizer John Wilkes Booth fatally shot the president. Abraham Lincoln had presided over four years of war—and five days of peace in an America transformed forever.

Winslow Homer and the Civil War

Camp of 31st Pennsylvania Infantry Near Washington, D.C.
1862.
Photograph.
Library of Congress.

In the early days of the Civil War, families of enlistees frequently accompanied them to encampments. Scenes such as this would have been familiar to the impressionable young Winslow Homer, who always sought out the human aspects of the conflict.

The Civil War was the first great conflict to be extensively photographed. The camera work of pioneers such as Mathew Brady is justly celebrated for its ability to convey the war with a haunting immediacy that is no less striking after nearly a century and a half. But it is important to remember that America's great national tragedy was also portrayed by a number of talented illustrators, who were able to reach a larger audience than ever before due to recent advances in printing and the rise of a new publishing phenomenon, the weekly news magazine. Winslow Homer was perhaps the most gifted of these artists, and surely the one who achieved the greatest fame in later life.

Winslow Homer was twenty-five years old, still unknown as an artist but already a freelance illustrator for *Harper's Weekly*, when the war broke out in 1861. *Harper's*, a New York–based venture launched in 1857 by Fletcher Harper, of the successful publishing family, sent Homer to the theaters of combat throughout the war. His earliest assignment was to copy Brady's photographs as sketches, which would then be used to create wooden engraving plates for the weekly—a cumbersome process, but in the 1860s the nearest thing to on-the-spot visual reporting that could appear in print within a short time of the events depicted.

Homer's earliest work for *Harper's*, which was only attributed to the weekly's "Special Artist," mostly involved head-and-shoulders portraits, and depictions of events such as Abraham Lincoln's inauguration. By the end of the year, though, he was

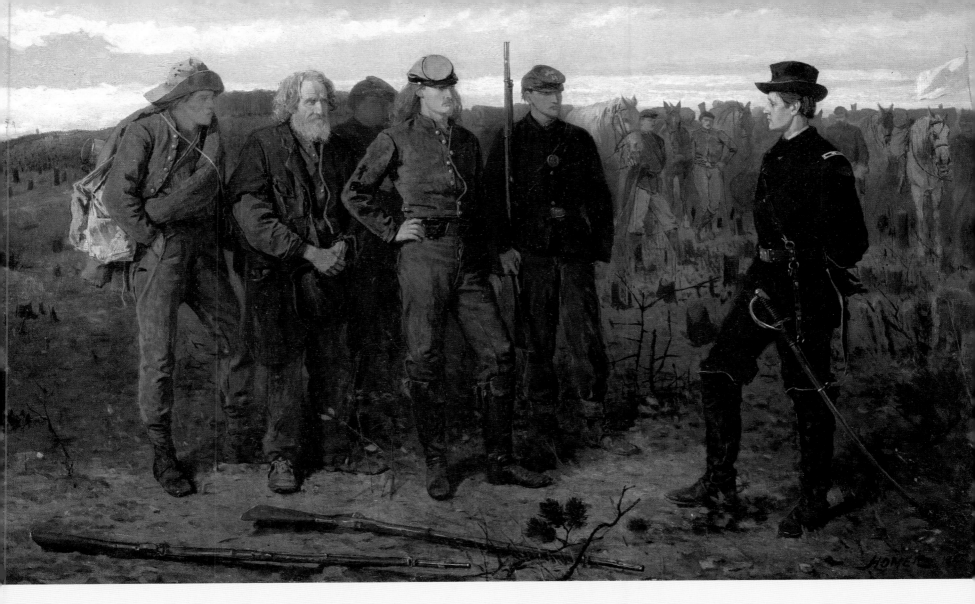

> ## "...whenever he was in the field, he kept busy with his personal sketchbook, privately chronicling the lives of enlisted men in the conflict's long interludes..."

Winslow Homer (1836–1910)
Prisoners from the Front. 1866.
Oil on canvas, 24 x 38 in. (61 x 96.5 cm).
The Metropolitan Museum of Art, New York, New York.

Winslow Homer's determination to present the quieter moments of everyman's war, rather than battlefield melodrama or the glory of victory, informs his sympathetic portrayal of a ragtag band of Confederate prisoners. A glint of defiance shows only in the stance of the sole fully uniformed member of the group.

portraying livelier scenes, such as soldiers dancing and relaxing around a bivouac fire. In 1862 and 1863, his images included a cavalry charge, a sharpshooter—what today we would call a sniper—perched in a tree, a surgeon at work in the open, and men passing time in winter quarters. All of Homer's subjects were of course Union troops; there were no Northern artists accredited to Confederate units, nor were there Southern publications corresponding to *Harper's* or the other Northern weeklies.

Homer contributed only infrequently to *Harper's* during the final two years of the war. But whenever he was in the field, he kept busy with his personal sketchbook, privately chronicling the lives of enlisted men in the conflict's long interludes and gathering raw material for his own Civil War paintings. The artist, who lived until 1910, ultimately became famous for his exquisite renderings, in oil and watercolor, of nautical scenes, bucolic subjects, and hunting and fishing in New York State's wild Adirondacks. But behind it all lay an apprenticeship in the cauldron of the Civil War, when he was "embedded" with the Union Army.

Edwin Forbes (1839–95)
Drummer Boy Taking a Rest, Culpeper, Virginia. 1863.
Pencil on paper.
Library of Congress.

In an age when martial music accompanied troops not only on parade but also into battle, the drummer boys of both the Union and Confederate armies were often among the youngest combatants—and the youngest casualties.

Alonzo Chappel (1828–87)
Lee Surrendering to Grant at Appomattox. Ca. 1870.
Oil on paperboard, 12 ³⁄₈ x 17 ¹⁄₂ in. (31.4 x 43.8 cm).
Smithsonian American Art Museum, Washington, D.C.

Chappel, a prolific painter of historical subjects whose work was frequently reproduced as steel engravings in popular books and school texts, here captures the Confederate surrender as a meeting of equals, drawing upon the common impression of Robert E. Lee as a figure of nobility and honor.

ABOVE: **Louis Kurz** (1833–1921) and **Alexander Allison** (n.d.)
Storming Fort Wagner. July 5, 1890. 1890.
Oil painting by Kurz; lithograph by Allison.
Library of Congress.

With a massing of flag and figures presaging the iconic Iwo Jima
photograph taken eight decades later—but this time chronicling
defeat rather than victory—Kurz and Allison depict the doomed charge
on Confederate Fort Wagner made by the all-black 54th Massachusetts
Regiment and its Boston Brahmin commander, Colonel Robert
Gould Shaw.

OVERLEAF: *Officers and Ladies on the Porch of A Garrison House
at Fort Monroe, Virginia.* 1864.
Photograph.
Library of Congress.

On April 17, 1861, Virginia became the eighth Southern state to
withdraw from the Union. In a move to prevent Virginia's Fort
Monroe from falling into Confederate hands, President Lincoln
quickly reinforced the fort, which remained in Union hands through
the Civil War.

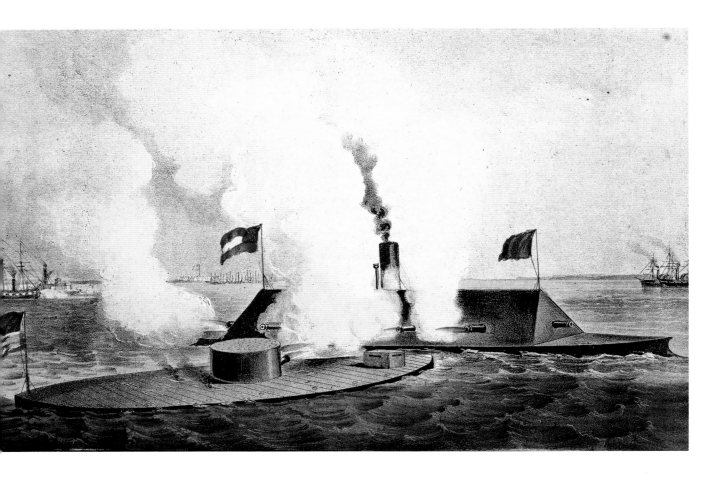

Currier & Ives
(fl. 1835–1907)
*Terrific Combat Between
the "Monitor" 2 guns and
"Merrimac" 10 guns. The first fight
between ironclad ships of war, in
Hampton Roads, March 9th 1862, in
which the little "Monitor" whipped
the "Merrimac" and the whole
"school" of Rebel steamers.* 1862.
Hand-colored lithograph.
*Museum of the City of New York,
New York.*

Throughout the latter nineteenth
century, the firm of Nathaniel
Currier and James Merritt Ives held
sway over popular tastes to a
degree unequalled prior to the
career of Norman Rockwell, several
generations later. Now
remembered largely for their
nostalgic scenes of rural life, they
also chronicled contemporary
events such as the first clash of
ironclad warships on March 9, 1862.

RIGHT: *Officers on Deck of the*
Monitor. Ca. 1862.
Photograph.
Library of Congress.

Dubbed the "Cheesebox on a
Raft," the ironclad Union warship
Monitor employed a
revolutionary revolving turret
gun. Its low profile in the water,
combined with its armor plating,
made it a difficult target, and it
fought the Confederate ironclad
Merrimac to a draw.

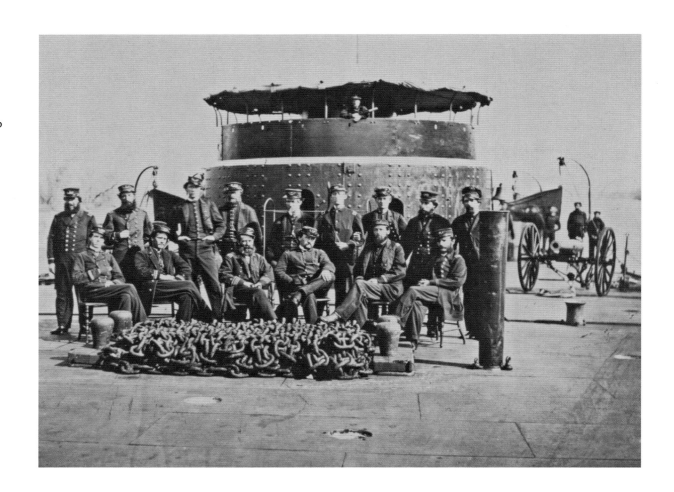

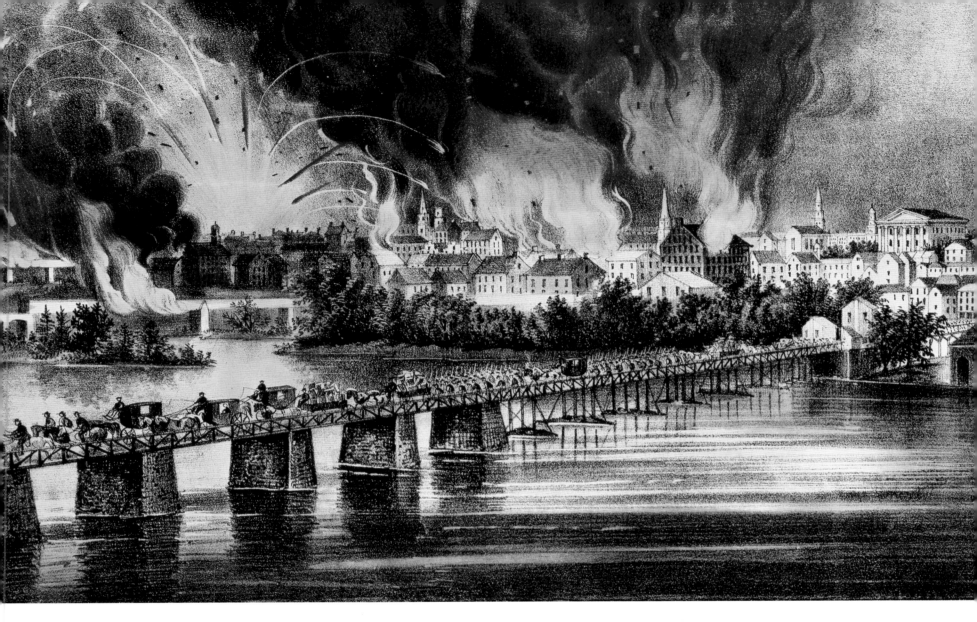

ABOVE: **Currier & Ives** (fl. 1835–1907)
The Fall of Richmond on the Night of April 2, 1865. Nineteenth century.
Color lithograph.
Museum of the City of New York, New York, New York.

Based in New York City, the firm of Currier & Ives maintained a northern
perspective in their depictions of Civil War campaigns and human-
interest incidents. The fall of the onetime Confederate capital of
Richmond, Virginia, was the final blow to the rebelling states; Lee's
surrender came less than two weeks later.

RIGHT: **Fogg, Hadley & Co.**
*Fourth Regiment New Hampshire Volunteers—Able Bodied Men
Wanted for the Fourth Regiment.* 1861.
Broadside.
Library of Congress.

At the outset of hostilities, the ranks of both armies were filled entirely
by volunteers; conscription was not introduced until later in the war.
In New England, where abolitionist sentiment ran high, a considerable
proportion of the young male population flocked to recruitment centers.
The bounty posted was an added inducement.

The Gilded Age

(1865–90)

"I don't build railroads. I buy them."

—Jay Gould

The tasks facing the United States as it entered the last third of the nineteenth century were immense, but so were the opportunities.

The most pressing—and most daunting—task was to heal the raw wounds of four years of Civil War, and to somehow reintegrate the secessionist states into the Union while granting millions of newly freed slaves the privileges of citizenship. But just as important was the task of resuming the territorial and industrial expansion that had been gathering force before the war.

The opportunities that accompanied these challenges were both public and private. In the public sphere, there was the prospect of a newly reunited

LEFT: Hiram Powers (1805–73)
Greek Slave. After 1869.
Marble, 44 x 13 x 13 ½ in. (111.8 x 33 x 34.3 cm).
Gift of Mrs. Benjamin H. Warder. Smithsonian American Art Museum, Washington, D.C.

Inspired by the Greek war of independence against the Turks in the 1820s, Hiram Powers's Neoclassical *Greek Slave* struck a sympathetic chord in an America still embroiled in the slavery debate. Themes of chaste modesty and Christian faith (a cross hangs on the post) broke the taboo against nude sculpture, and mass-produced replicas made the figure a middle-class cultural icon.

OPPOSITE: Eastman Johnson (1824–1906)
The Girl I Left Behind Me. 1870–75.
Oil on canvas, 42 x 34 ⅞ in. (106.7 x 88.6 cm).
Smithsonian American Art Museum, Washington, D.C.

When Eastman Johnson went to Europe to study art like other American artists of his day, his absorption of the Dutch masters' style earned him the sobriquet "the American Rembrandt." Returning home, he made realistic genre paintings depicting American life, from Civil War events to life on the Plains. *The Girl I Left Behind Me* was probably named after an old ballad popular with Union soldiers.

Currier & Ives
(fl. 1835–1907)
Chicago, As It Was. Ca. 1871.
Hand-colored lithograph.
Library of Congress.

Nathaniel T. Currier's refinements to the process of lithographic printing made the Currier & Ives name a by-word for mass-produced fine-quality hand-colored prints. Popular demand was met with an astonishing variety of scenes of American life. Perhaps best remembered for sentimental portrayals of domesticity, Currier & Ives also documented tragic events like the Great Chicago Fire of 1871.

The cities of the 1870s and 1880s were beginning to resemble modern conurbations more than the overgrown towns of the early eighteenth century. By the late 1870s, Thomas Edison's invention of incandescent electric light had begun to illuminate New York's business district, while gas for illumination was piped throughout larger cities and towns. At roughly the same time, Alexander Graham Bell's telephone joined the long-established telegraph in erasing distance. And as these new electrical devices revolutionized the moving of information, urban growth was accelerated by inventions that moved people: by 1878 hydraulic elevators could travel 800 feet per minute, making tall buildings practical. The first "skyscrapers"—the term was first applied to buildings 10 to 20 stories high—appeared in the 1880s, and were made possible not only by the development of safe elevators, but by the use of newly inexpensive steel framework. Expansion of urban areas also depended upon reliable sources of water and safe disposal of sewage, and the era met these needs as well. Reservoirs, pipelines, and sewers quickly replaced the wells and privies of earlier generations.

Industrialization and urbanization, along with the rapid growth of a population dependent upon a steady supply of consumer goods, fuel, and transportation infrastructure, created a conspicuous burgeoning of new fortunes. By no means all of the great magnates of the Gilded Age made their money through pure chicanery; although modern regulators might blanch at some of their methods, most of them made something other than money, and unlike Jay Gould built rather than simply bought. John D. Rockefeller Sr. may have been ruthless in his consolidation of the oil industry, but a gallon of kerosene was far cheaper after his machinations than before. Andrew Carnegie forged the steel for those skyscrapers, Cyrus McCormick's plows broke the plains, R .H. Macy made no-haggle, single-price retailing the norm, and George Westinghouse put air brakes on trains. The business practices of these men were indelicate, to say the least, and none of us today would want to work 10 or 12 hours a day for the miserable wages they paid, but their sheer acquisitiveness left a modern nation in its wake. They

also left behind some mind-bogglingly ostentatious architecture, and financed public institutions ranging from opera companies to art museums.

Like one of Andrew Carnegie's smelters in a Pennsylvania steel mill, the Gilded Age brought together a cauldron of elements—the iron, coke, and alloy agents of a new American era. Abundant capital, cheap immigrant labor, millions of acres of newly available farmland, and previously undreamed-of technological breakthroughs all came together to create, for better and for worse, a nation far more similar to the one we inhabit than the largely pastoral republic that had so recently been riven in the war between the states.

James Bard (1815–97)
Sarah A. Stevens. 1873.
Watercolor, 25 x 39 ½ in. (63.5 x 100.4 cm).
Smithsonian American Art Museum, Washington, D.C.

Self-taught watercolorist James Bard captured the can-do spirit of America in his portraits of the steam-powered vessels that plied the waters of the Hudson River. His attention to meticulous detail, thought to have been achieved by taking careful measurements, earned him the patronage of the many proud ship owners.

P. T. Barnum (1810–91)
Circus Poster. Ca. 1900.
Chromolithograph.
Library of Congress.

One of the richest Americans of
the Gilded Age was freak-show
host and circus master Phineas
Taylor Barnum, whose "greatest
show on earth" traveled across
America and around the world.
This poster features "The
Marvelous Foot-Ball Dogs," one
of the trained animal acts that
would bring audiences to the Big
Top from far and wide.

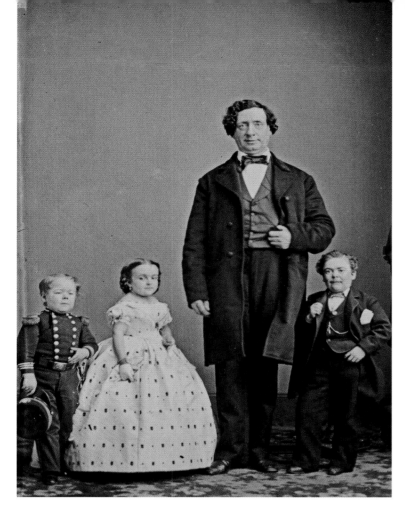

LEFT: *Commodore Nutt, Miss Lavinia Warren, The Giant, and General Tom Thumb.* Ca. 1860
Photograph.
Library of Congress.

P. T. Barnum's most famous performer was Charles Sherwood Stratton (aka General Tom Thumb). Here, the show's star is pictured at right; Miss Lavinia Warren, whom he would marry in a lavish "Fairy Wedding" in 1863 in New York City, is pictured next to another of Barnum's attractions, The Giant; best man for the nuptials was George Washington Morrison Nutt (aka Commodore Nutt), at far left.

BELOW: Herter Brothers (Nineteenth century)
Library Table. 1882.
Rosewood, brass, mother-of-pearl, 31 ¼ x 60 x 35 ¾ in. (79.4 x 152.4 x 90.8 cm).
Purchase, Mrs. Russell Sage Gift, 1972. The Metropolitan Museum of Art, New York, New York.

Designing everything from tables and cabinets to mantels, paneling, upholstery, and more, the firm of Herter Brothers dressed the finest homes of the Gilded Age in exquisite revival styles. Commissions included the Fifth Avenue mansions of Jay Gould, William Henry Vanderbilt, and Darius Ogden Mills, and the East Room of the White House during Theodore Roosevelt's administration.

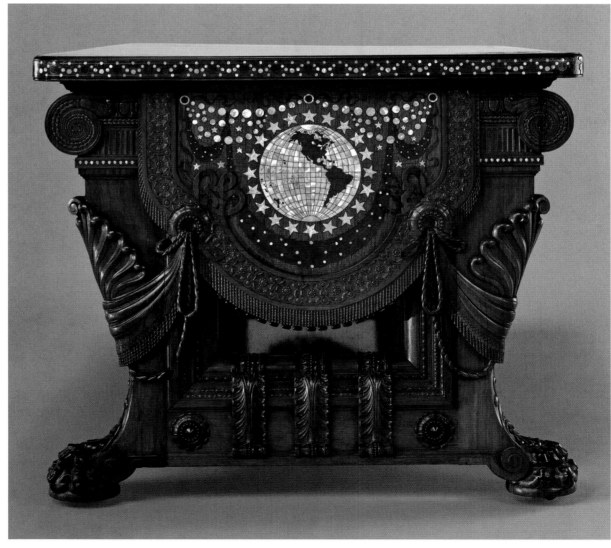

ABOVE: Louis Comfort Tiffany (1848–1933)
Landscape.
Stained-glass window.
Private Collection.

During the closing decades of the nineteenth century, Tiffany defined the American response to England's Arts and Crafts Movement, using stained glass in lushly pictorial as well as purely decorative designs. Tiffany's experiments and innovations in glassmaking, among them the creation of the luminous Favrile glass, earned him international acclaim.

RIGHT: Augustus Saint-Gaudens (1848–1907)
Adams Memorial. Modeled 1886–91, cast 1969.
Bronze, 69 ⅞ x 39 ⅞ x 44 ½ in. (177.4 x 101.4 x 112.9 cm).
Smithsonian American Art Museum, Washington, D.C.

When historian Henry Brooks Adams's wife Marian ("Clover") committed suicide in grief over her father's death, Adams commissioned Augustus Saint-Gaudens to sculpt a memorial in keeping with the couple's sympathy for Eastern philosophies. Enigmatic and ambiguous, expressing neither hope nor despair, the figure conveys the Buddhist concept of nirvana, the plane of consciousness beyond joy and sorrow.

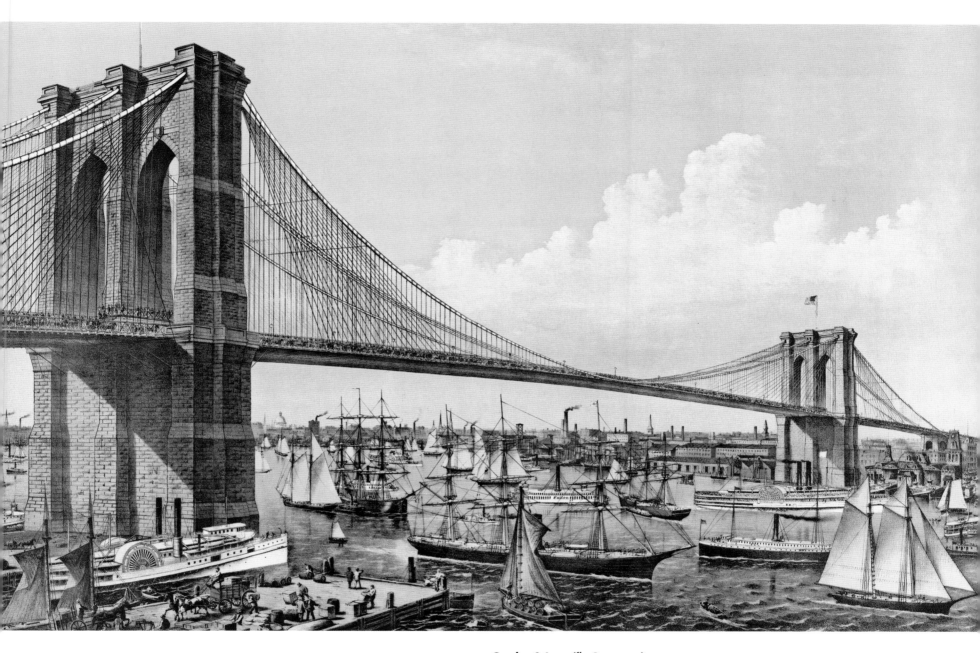

Currier & Ives (fl. 1835–1907)
The Great East River Suspension Bridge: Connecting the Cities of New York and Brooklyn From New York, Looking South-East. Ca. 1883.
Chromolithograph.
Library of Congress.

With a webwork of steel cables suspending the bridge in a catenary curve, the Brooklyn Bridge was a feat of nineteenth-century engineering that cost the life of designer John Roebling and more than two dozen workers during the 14 years of its making (1869–83). The monumental bridge became a popular subject of chromolithographs and stereoviews.

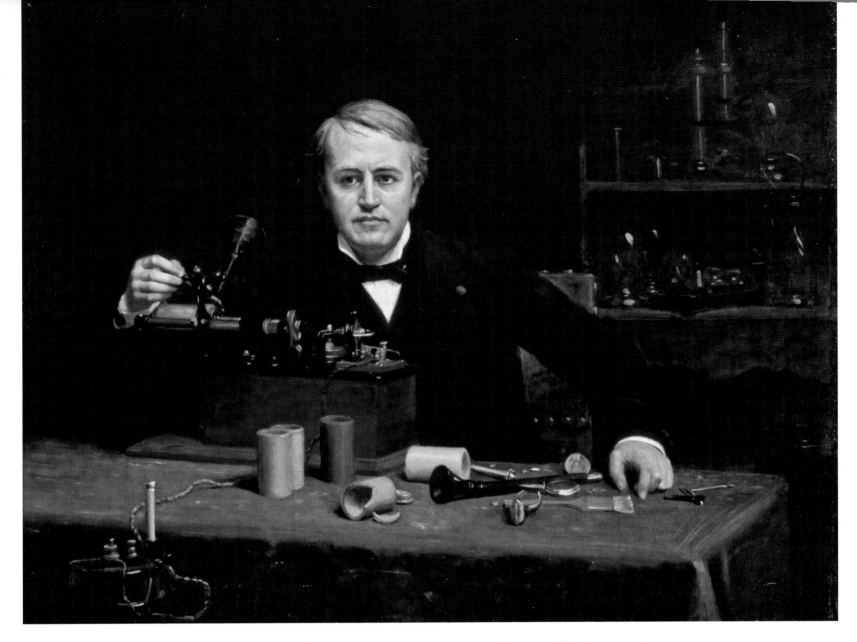

ABOVE: Abraham Archibald Anderson (1847–1940)
Thomas Alva Edison. Ca. 1889.
Oil on canvas, 44.7 x 54.5 in. (113.6 x 138.4 cm).
National Portrait Gallery, Smithsonian Institution, Washington, D.C.

Edison's investment of more than $100,000 in his exhibition at the Paris
Exposition of 1889 paid off: it was hailed as one of the most popular. The
socially retiring Edison did not speak French, so his friend and portraitist
Abraham Archibald Anderson accompanied him to galas and dinners,
including the ceremony in which the French government awarded
Edison the title of Commander of the Legion of Honor.

OPPOSITE: Thomas Eakins (1844–1916)
The Gross Clinic. 1875.
Oil on canvas, 96 x 78 in. (244 x 198 cm).
The Philadelphia Museum of Art, Philadelphia, Pennsylvania.

Samuel Gross, head of surgery at Jefferson Medical College in
Philadelphia, was world-renowned for advances in medicine. But when
realist painter Thomas Eakins's portrait of Dr. Gross instructing surgery
was submitted to the city's Centennial Exposition of 1876 (the first
World's Fair) celebrating American progress, the work was deemed too
shocking for exhibition.

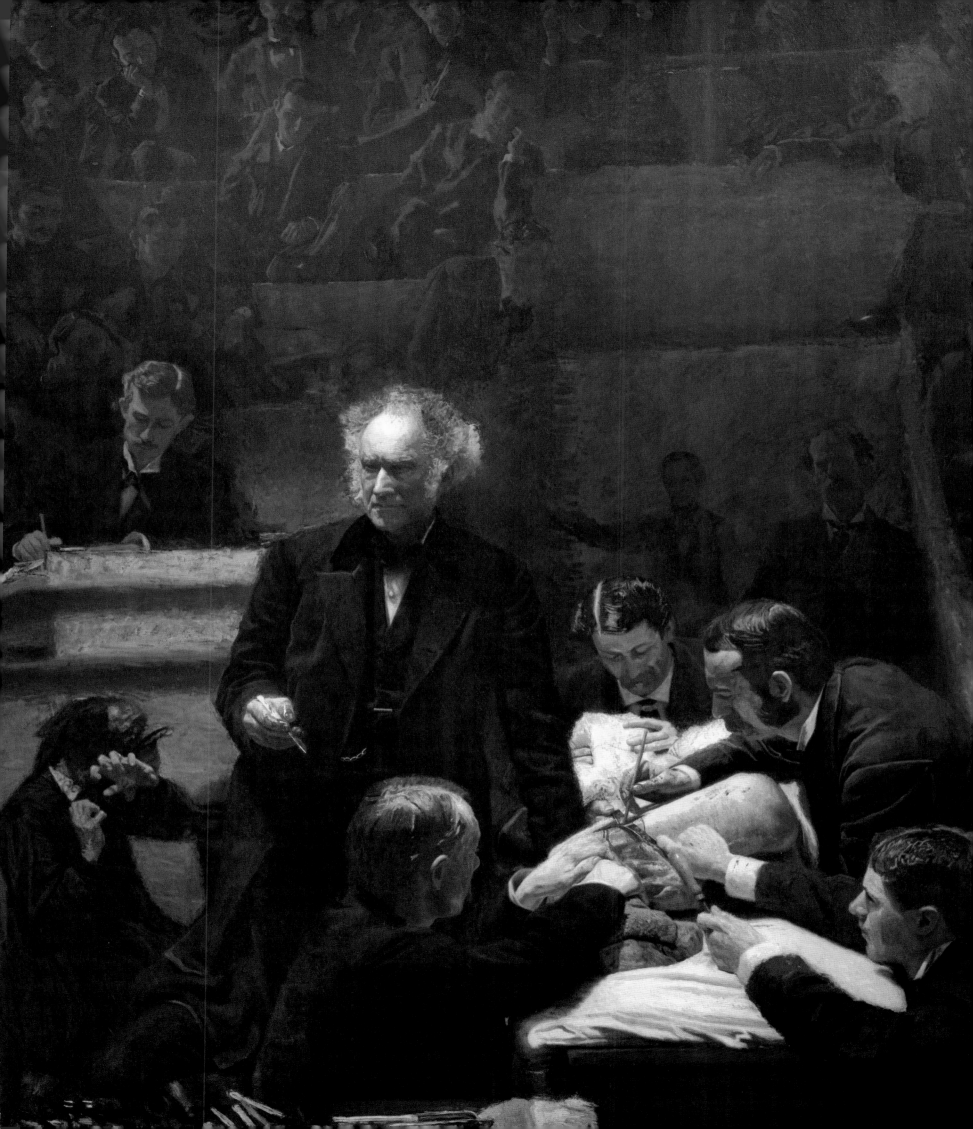

A New Colossus

(1890–1901)

"Remember the Maine*!"*

—Spanish-American War Slogan

In 1893, American historian Frederick Jackson Turner gave an address at the Chicago World's Columbian Exposition, titled "The Significance of the Frontier in American History." In his speech, Turner made a pronouncement that has since served as shorthand to define an American turning point. "The frontier has gone," Turner stated, "and with its going has closed the first period of American history."

Turner based his conclusion on the data contained in the federal census of 1890, and the definition of "frontier" as territory inhabited by less than two people per square mile. Up until the 1890s, it was more or less possible to draw lines on a map of the United States that indicated just where in the West that territory began, and where, farther west still, it ended in the fertile valleys and coastal settlements of California. But by Turner's time, the lines had blurred

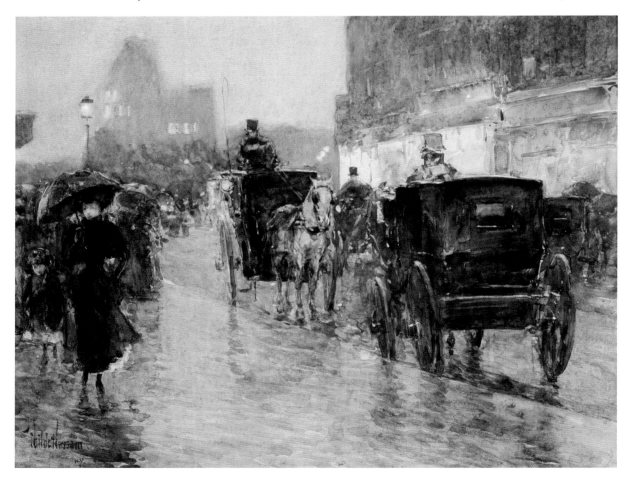

Childe Hassam (1859–1935)
Horse-Drawn Cabs at Evening, New York. Ca. 1890.
Watercolor, 14 x 17 ¾ in. (35.6 x 45.1 cm).
Daniel J. Terra Collection. Terra Foundation for American Art, Chicago.

At the turn of the twentieth century the horse-drawn cab was the fashionable mode of urban transportation, romantically rendered here by Childe Hassam, one of America's foremost Paris-trained Impressionists. For mass transit the horse-drawn omnibus, electric streetcar, and elevated railway were available. New York City's first subway system (which eventually became the IRT) opened in 1904, 35 years after the appearance of the city's first elevated railway.

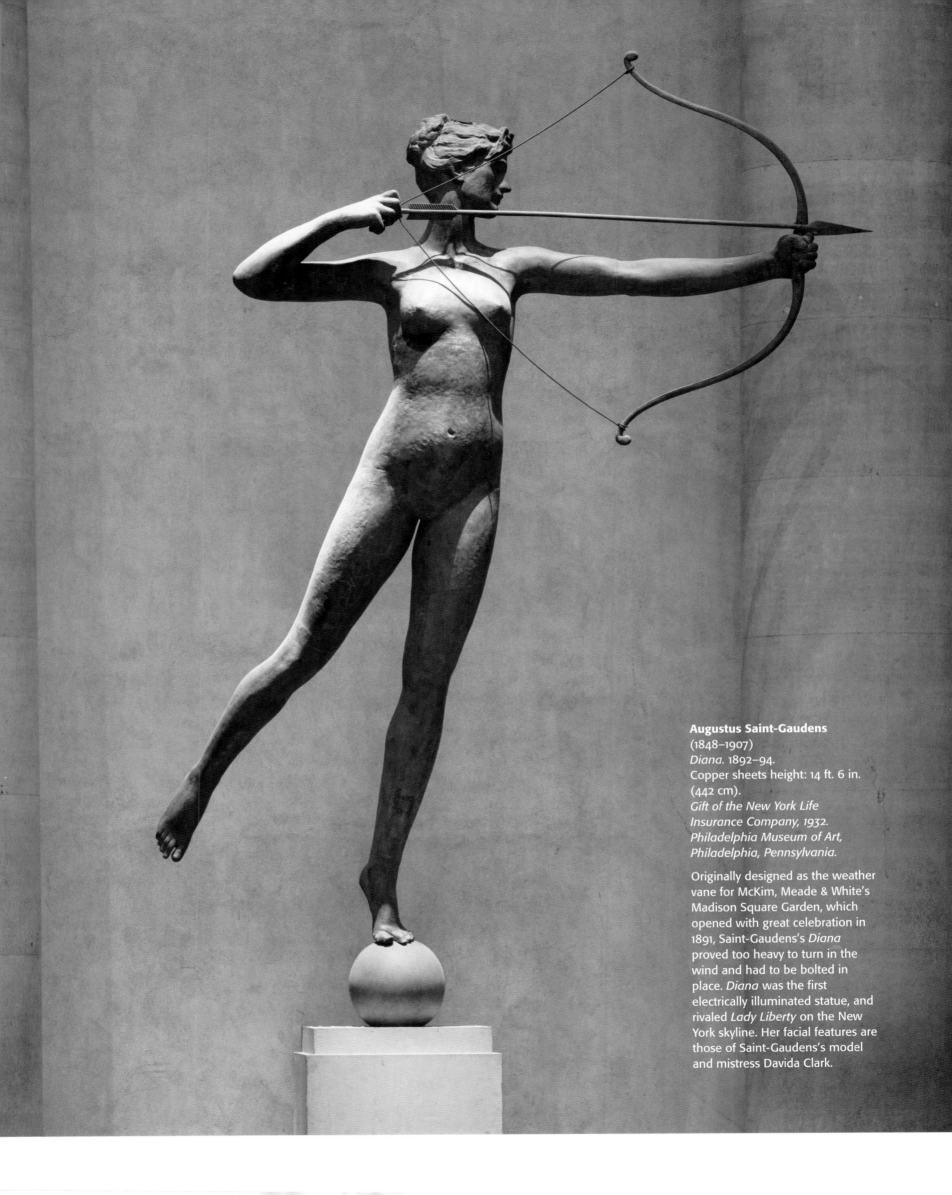

Augustus Saint-Gaudens
(1848–1907)
Diana. 1892–94.
Copper sheets height: 14 ft. 6 in.
(442 cm).
*Gift of the New York Life
Insurance Company, 1932.
Philadelphia Museum of Art,
Philadelphia, Pennsylvania.*

Originally designed as the weather
vane for McKim, Meade & White's
Madison Square Garden, which
opened with great celebration in
1891, Saint-Gaudens's *Diana*
proved too heavy to turn in the
wind and had to be bolted in
place. *Diana* was the first
electrically illuminated statue, and
rivaled *Lady Liberty* on the New
York skyline. Her facial features are
those of Saint-Gaudens's model
and mistress Davida Clark.

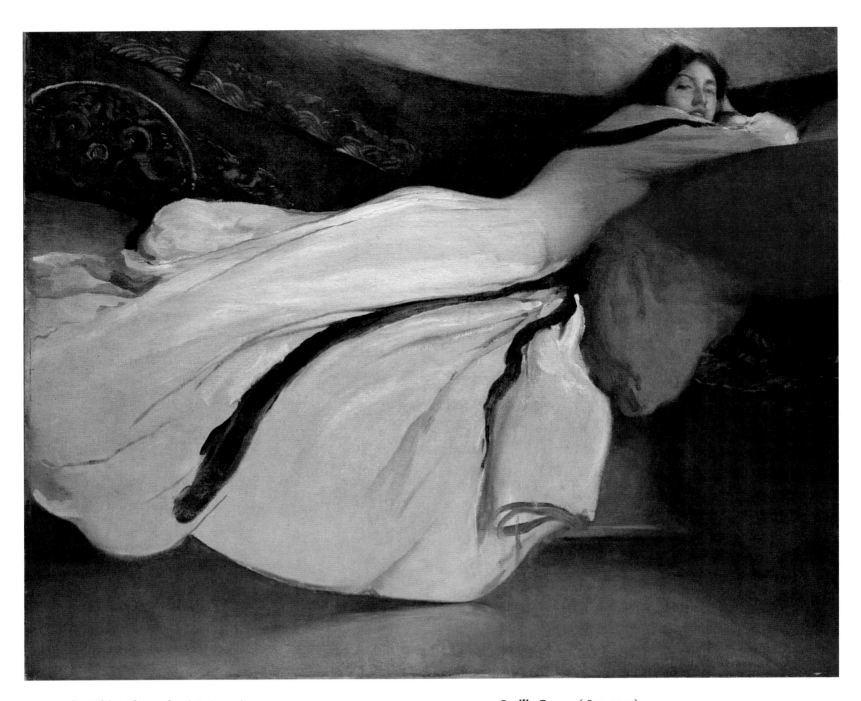

ABOVE: John White Alexander (1856–1915)
Repose. 1895.
Oil on canvas, 52 ¼ x 63 ⅝ in. (132.7 x 161.6 cm).
Anonymous Gift, 1980. The Metropolitan Museum of Art, New York, New York.

Arising in Belgium in the 1880s as an art movement in protest against pervasive mass production, Art Nouveau became a popular design style in Europe and America and was admired for its fluid lines imitating organic natural forms. The style is embodied in every line of Alexander's painting: the curved sofa, the folds of the woman's gown, and even her languid pose.

OPPOSITE: Cecilia Beaux (1855–1942)
Sita and Sarita, or Young Girl with a Cat. 1893–94.
Oil on canvas, 37 x 25 in. (94 x 63.5 cm).
Musée d'Orsay, Paris.

To be an "American in Paris" was every artist's dream—to study with the masters in academies or private studios. Most academies did not admit women pupils, but Cecilia Beaux's portrait of her cousin Sarah Alibone Leavitt ("Sarita") won her election to the Société Nationale des Beaux-Arts when it opened its doors to women in 1896.

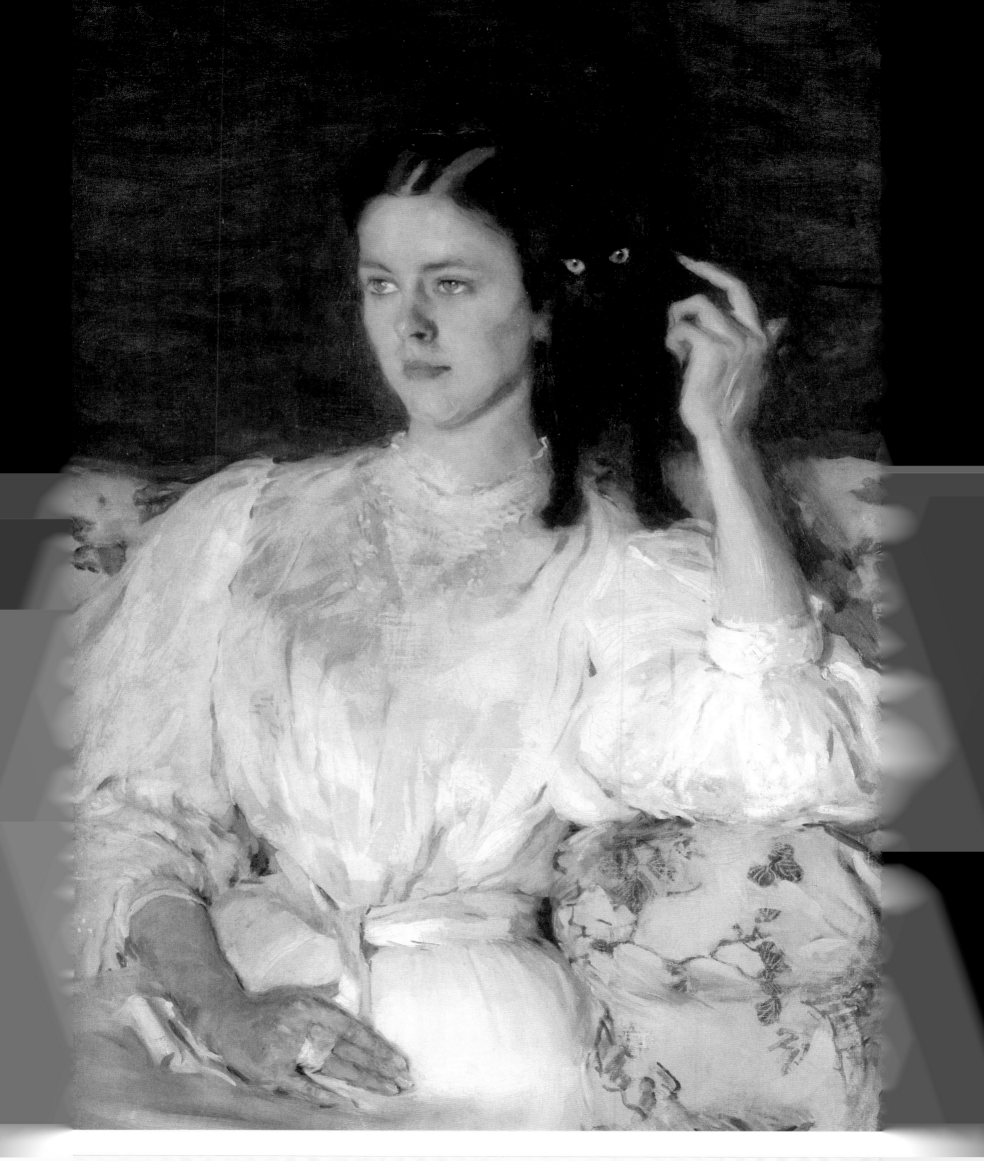

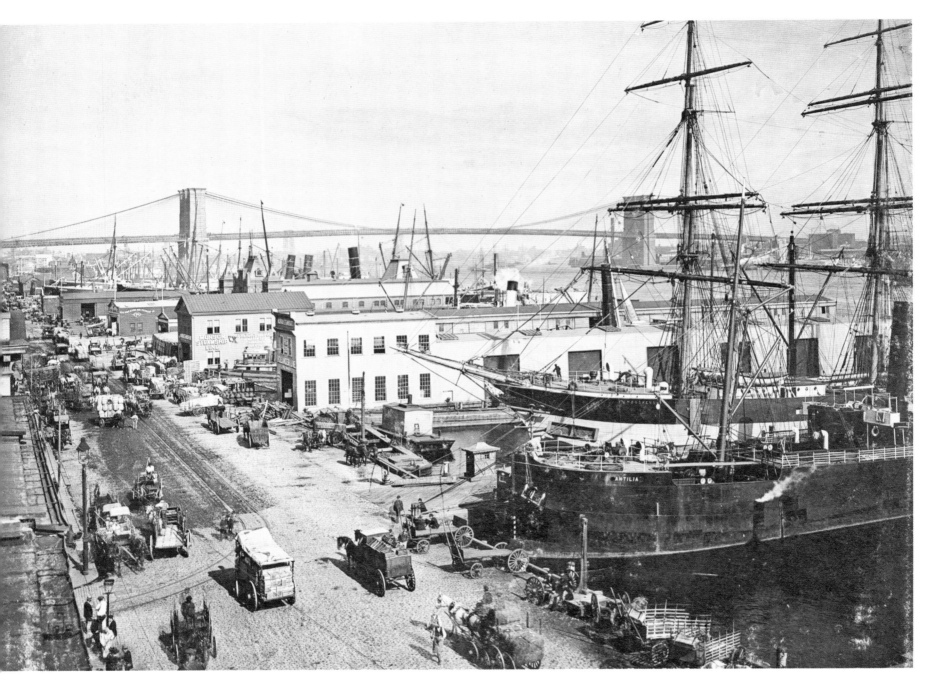

South Street, New York. 1900.
Photograph.
The Branch Libraries, Astor, Lenox and Tilden Foundations.
The New York Public Library, New York, New York.

By 1900, declining rail freight rates and inland expansion had taken their
toll on many of America's seaports. Manhattan's Chelsea Piers were
better equipped for oceangoing steamships, leaving South Street
Seaport a seedy neighborhood of saloons that catered to out-of-work
sailors and the less-than-glamorous lifestyle that their status offered.

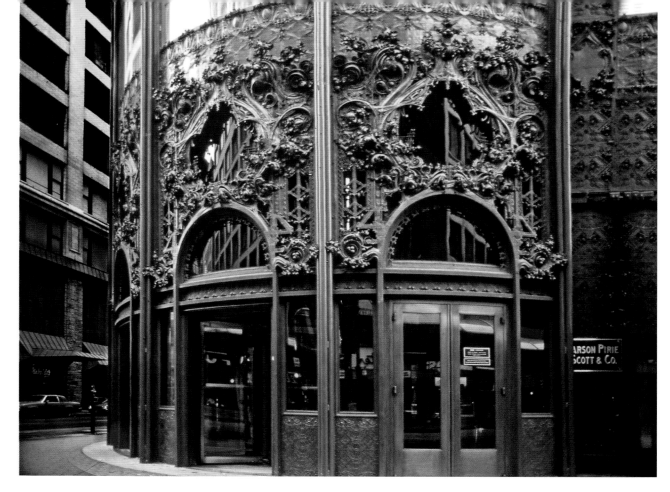

ABOVE: Louis Henry Sullivan (1856–1924)
Entrance to the Carson, Pirie, Scott Building, Chicago. 1899–1904.
Cast-iron.

Carson, Pirie, Scott, Chicago's first department store (originally Schlesinger Meyer), was built during the city's lengthy rebuilding phase following the Great Fire of 1871 by architect Louis Sullivan, one of the greatest of the day and an influence on Frank Lloyd Wright (who worked for Sullivan). The cast-iron Art Nouveau entrance at the base of the building's rounded corner exemplifies Sullivan's dictum "Form follows function," by making the graceful ornament an integral part of the structure.

LEFT: Augustus Saint-Gaudens (1848–1907)
Head of Victory. 1897–1903; this cast, 1907.
Bronze, 8 x 7 x 6 ½ in. (20.3 x 17.8 x 16.5 cm).
Rogers Fund, 1907. The Metropolitan Museum of Art, New York, New York.

Civil War hero William Tecumseh Sherman, whose "scorched-earth" campaigns brought down the Confederacy, was living in New York when Saint-Gaudens began studies for the *Sherman Monument* in 1888, but died before the monument was unveiled in 1903. Shown is one of several versions of the laurel-crowned *Head of Victory*.

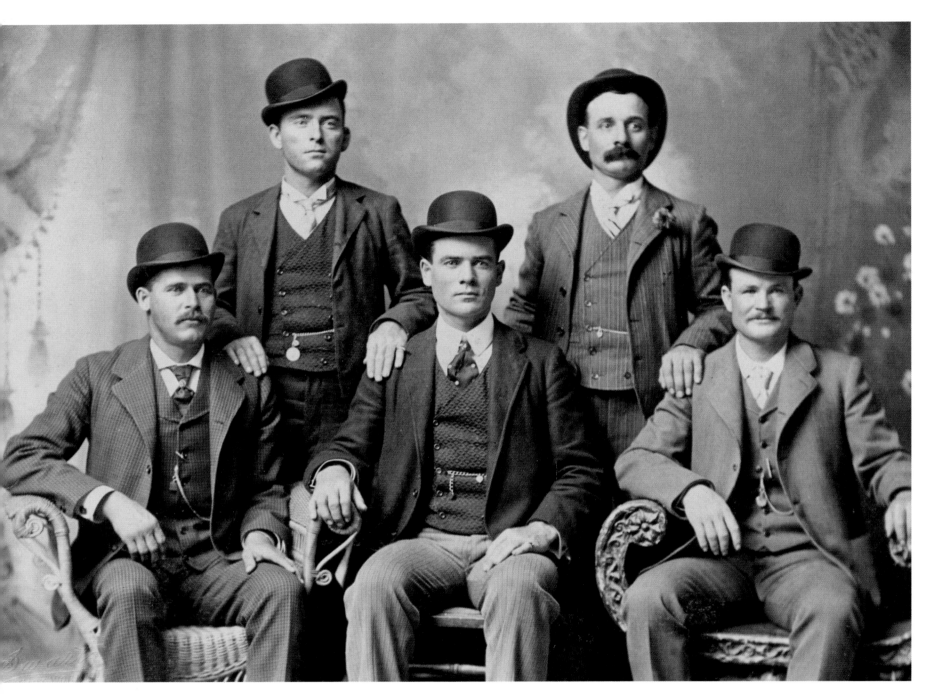

ABOVE: *"The Wild Bunch."* 1900.
Photograph.
Gift of the Pinkertons', Inc. National Portrait Gallery, Smithsonian Institution, Washington D.C.

Butch Cassidy's "Wild Bunch" gained notoriety at the turn of the century for their train-robbing exploits. Unlike several outlaw gangs, this group repeatedly stated their objection to violent means, a claim that their dead victims would certainly find bogus. Pictured are five of the gang's members: seated (left to right) are Harry Longbaugh ("The Sundance Kid"), Ben Kilpatrick ("The Tall Texan"), Robert Le Roy Parker ("Butch Cassidy"); standing are William Todd Carver ("Bill") and Harvey Logan ("Kid Curry"). The group disbanded when Butch and Sundance relocated to South America, apparently tired of running from dogged pursuers like the Pinkerton detectives—in whose possession this portrait of the fearless bunch remained until it was given to the Smithsonian.

OPPOSITE: John Singer Sargent (1856–1925)
Lady Astor. 1909.
Oil on canvas, 59 x 39 in. (149.9 x 99 cm).
Cliveden, Buckinghamshire, Great Britain.

Born in Florence, Italy, to American expatriate parents, John Singer Sargent spent his later life between England and America, painting portraits of the rich and famous, like fellow expatriate Nancy Astor (1879–1964), wife of Waldorf Astor and the first woman to serve as a Member of Parliament. Her sister Irene's portrait by husband Charles Dana Gibson launched the turn-of-the-century ideal of the "Gibson girl."

Progressivism and a Call to Arms

(1901–18)

"We are not building this country of ours for a day. It is to last through the ages."

—THEODORE ROOSEVELT

Early on the rainy morning of September 14, 1901, a 42-year-old man thundered through New York's Adirondack Mountains on a horse-drawn buckboard wagon. President William McKinley had just died, the victim of an anarchist's bullet, and Vice-President Theodore Roosevelt—having cut short a typically strenuous hiking vacation—was rushing to catch a train to Buffalo, where the president had been shot. It was oddly appropriate that Roosevelt was in motion at the moment he assumed the presidency, because he would remain feverishly in motion throughout the next eight years, and would move the nation with him.

Theodore Roosevelt was the first activist chief executive in the modern mold. He was a member of the old Dutch aristocracy of New York City, a descendant of the "Knickerbockers" who had been gently lampooned by Washington Irving. But he had cut his teeth politically in the reform wing of the Republican Party, beginning his career as a New York State legislator when he was still in his twenties. He subsequently served as New York City police commissioner, assistant secretary of the Navy, and—

LEFT: **Joseph Keppler** (1838–94) and **Joseph Keppler Jr.** (1872–1956)
"Next!" Political cartoon in *Puck,* September 7, 1904.
Lithograph.
Library of Congress.

America's first magazine devoted to political satire was *Puck,* edited by cartoonists Joseph Keppler and son, with cartoons printed in full-color lithography. This one pokes fun at the greedy dominance of Rockefeller's Standard Oil, which many critics felt wielded influence not only on the steel, copper, and shipping industries, but the federal government as well.den Hartley (1877–1943)

OPPOSITE: **Marsden Hartley** (1877–1943)
Portrait of a German Officer. 1914.
Oil on canvas, 68 ¼ x 41 ⅜ in. (173.4 x 105.1 cm).
Alfred Stieglitz Collection, 1949. The Metropolitan Museum of Art, New York, New York.

Before the outbreak of World War I sent Marsden Hartley back home to America, he studied art in Berlin, where he created a series of paintings honoring the German military. The emblematic abstract style, learned from Wassily Kandinsky and others in the Munich-based Blaue Reiter group, made Hartley one of America's first Modernist painters.

Henry Ford and the Triumph of the Model T

Henry Ford on an 1896 Ford.
Ca. 1940s.
Photograph.
National Motor Museum,
Beaulieu, Great Britain.

Henry Ford's first automobile was his Quadricycle of 1896, built in his home workshop. The concept of the four-wheeled one-seater was not new, but the source of power was. Instead of the rider pedaling, a small combustion engine provided the energy. The revolution launched the American automobile industry.

Railroads were the dominant American industry during the Progressive era, and—in instances such as the Northern Securities case, prosecuted in the Supreme Court—they were often the most high-profile targets of President Theodore Roosevelt's "trust busting" antimonopoly reforms. But it was during the Roosevelt presidency that another industrial colossus arose, one destined to supplant the railroads as a mover of people and goods, and as the prime engine of the American economy. For decades, its dominant player would be a plain-spoken Midwestern machinist, who by 1918 controlled half of the world's automobile market.

Henry Ford was raised on a Michigan farm, and was working as an engineer for a power plant when he built his first car, which he called a "Quadricycle," in 1896. Organizing the Ford Motor Company in 1903, he at first concentrated on building the typically expensive, handcrafted machines that appealed to an adventurous upscale market but could never catch on with the laboring masses. Then, in about 1906, he hit upon an entirely different model for the automobile business. Two years later, he started building a spartan little vehicle with a 20-horsepower four-cylinder engine and a paint job that was invariably black. He called it the Model T, and he put it on the market for

Model T Ford. Ca. 1913.
Photograph.
National Motor Museum, Beaulieu, Great Britain.

Ford's Model T, or "Tin Lizzie," answered the population's need for cheap transportation. Produced from 1908 to 1927, and selling for $350—a fraction of the $2,000 to $3,000 fetched by upscale automobiles—it was made affordable by the efficiency of assembly-line production.

> *"For decades, its dominant player would be a plain-spoken Midwestern machinist, who by 1918 controlled half of the world's automobile market."*

$800 at a time when most cars sold for $2,000 to $3,000. Eventually, a "Tin Lizzie," as the cars were affectionately called, could be purchased for $350.

The secret of the Model T's affordability was Ford's means of production, an assembly line at which each worker remained in the same place, repeating the same task while the cars proceeded down the line. Every 98 minutes, a new Model T was completed. Another radical innovation was Ford's pay scale of $5 per day—an amount that scandalized his fellow capitalists but made perfect sense to a man who wanted his employees to be able to afford the automobiles they were building.

Ford was so dedicated to pursuing economies of scale that he built the world's largest integrated manufacturing facility, the River Rouge complex near Detroit, in 1917. At "the Rouge"—still an active Ford facility—barges unloaded coke and iron ore, and the raw materials for glass, which were turned on the spot into parts for Model Ts (automobile assembly itself did not begin at River Rouge for another decade).

In 1927, the last Model T rolled off Ford's assembly lines, as retooling for the replacement Model A proceeded. It bore the serial number 15,000,000, in a progression that had started in 1908, with number 1.

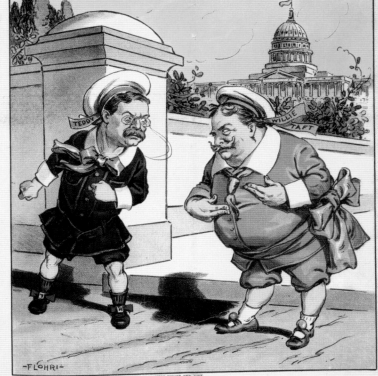

UP TO DATE

Little Teddy—" I can *lick* my *weight* in *wildcats*, C. Q. D !"
Little Willie—" Oh, that 's nothing ; I can *eat* my weight in *'possums*, P. D. Q !"

LEFT: *Up to date/Flohri.* Cover of *The Judge*, February 20, 1906. Lithograph.
Library of Congress.

Founded by expatriates from *Puck, The Judge* published Republican satire. This 1906 cartoon of Roosevelt and Taft as little boys in sailor suits, with the Capitol in the background, seems to portray their joint determination to clean up government: "I can lick my weight in wildcats, C.Q.D.!" says Roosevelt, to which Taft replies, "Oh, that's nothing; I can eat my weight in 'possums, P.D.Q.!" The humor may also be a jest at Taft's hearty appetite, although he did not "hanker" for opossums.

OPPOSITE: Marsden Hartley (1877–1943)
Red Tree. 1910.
Oil on fiberboard, 14 x 11 ⅞ in. (35.6 x 30.2 cm).
Smithsonian American Art Museum, Washington, D.C.

Marsden Hartley regularly exhibited at 291, Alfred Stieglitz's gallery at 291 Fifth Avenue, and Stieglitz sponsored Hartley's prewar trip to Germany to study with Kandinsky. *Red Tree* was painted before that trip, while summering in Maine. Unexpectedly, the viewer looks *down* from a hilltop to a clearing in a thicket of trees. The restless energy of the painting expresses the "inherent magic" Hartley found in nature.

RIGHT: Joseph Keppler (1838–94) and **Joseph Keppler Jr.** (1872–1956)
Trimming the Pampered Darling. Cover of *Puck,* April 7, 1909.
Lithograph.
Library of Congress.

"What fools these mortals be!" declared the cover of every *Puck* magazine, quoting the eponymous Shakespearean mischief-maker. *Puck* was noted for its political cartoons—this one has Taft wielding the scissors of "revision" to cut off the curls of "hold-up profits," as he warns, "Stop kicking! I might cut your head off," a reference to Taft's continuation of Roosevelt's famed trust-busting efforts.

TRIMMING THE PAMPERED DARLING.
Mr. TAFT.—Stop kicking! I might cut your head off!

LEFT: James Carroll Beckwith
(1852–1917)
The Blacksmith. 1909.
Oil on canvas, 52 ¼ x 32 ¼ in.
(132.6 x 81.5 cm).
*Smithsonian American Art
Museum, Washington, D.C.*

James Beckwith painted portraits
of famous people, among them
William Merritt Chase, General
John Schofield, and Mark Twain—
Beckwith and Twain shared
Hannibal, Missouri, as their
birthplace. Beckwith also
painted the common man; this
portrait of a blacksmith pays
homage to the sweat and toil of
ironwork, tool-making, and
farriery still needed in the
machine age.

OPPOSITE: John Sloan (1871–1951)
Scrubwomen, Astor Library.
Ca. 1910–11.
Oil on canvas, 32 x 26 in.
(81.3 x 66 cm).
*Museum Purchase. Munson-
Williams-Proctor Arts Institute,
Utica, New York.*

A member of the Ashcan school,
John Sloan had an eye for earthy
realism and sympathy for the
downtrodden, but his style of
execution was that of the Old
Masters. Sloan was a pacifist
committed to social justice, and
expressed his sentiments not
only in his compassionate
paintings but also more
pointedly in political cartoons in
the Socialist magazine *The
Masses,* which he served as art
editor.

Prendergast

Maurice Prendergast
(1859–1924)
Summer, New England. 1912.
Oil on canvas, 19 ¼ x 27 ½ in.
(48.9 x 69.9 cm).
Gift of Mrs. Charles Prendergast.
Smithsonian American Art
Museum, Washington, D.C.

Post-Impressionism in the first
two decades of the twentieth
century was not one particular
style but various innovations of
artists moving beyond
Impressionism. Maurice
Prendergast's unique style omits
the focal point and perspective,
translating everything to a flat
plane of colorful pattern. His
appreciation for pattern was
likely acquired from early
experience as a sign painter.

OPPOSITE: Alfred Stieglitz (1864–1946)
The Steerage. 1907.
Photograph, from *291 Magazine,* September–October 1915.
Musée d'Orsay, Paris.

Borrowing the name from the Secessionist art movements in Europe, Alfred Stieglitz founded the Photo-Secession in 1902 with a group of photographers for whom camera work was not a technological pastime but a fine art. Its members included Edward Steichen, Clarence White, Gertrude Käsebier, and others, exhibiting at 291 and publishing, in camera periodicals, their own work and that of others, including European photographers of like mind.

ABOVE: Alfred Stieglitz (1864–1946)
The City of Ambition, from "Camera Work." October 1911.
Photograph.
Musée d'Orsay, Paris.

Alfred Stieglitz's ambition to bring photography into acceptance as a fine art was realized through 291, his Fifth Avenue gallery, where he introduced America to the photographic works of Edward Steichen, Clarence White, and others in Stieglitz's Photo-Secession; to the works of Picasso, Cézanne, and other European artists; and to America's avant-garde artists, among them Max Weber, John Marin, and Georgia O'Keeffe (whom he married in 1924).

RIGHT: Cass Gilbert (1859–1934)
Woolworth Building, New York. Ca. 1913.
Photograph.
Library of Congress.

At its completion in 1913, the 60-story Woolworth building was the tallest building in the world, and held that status until 1930, when the Chrysler Building surpassed it. Architect Cass Gilbert (who got his start working for McKim, Mead & White) topped the building with Gothic details on a scale large enough to be appreciated from the street below, earning the building the nickname "Cathedral of Commerce."

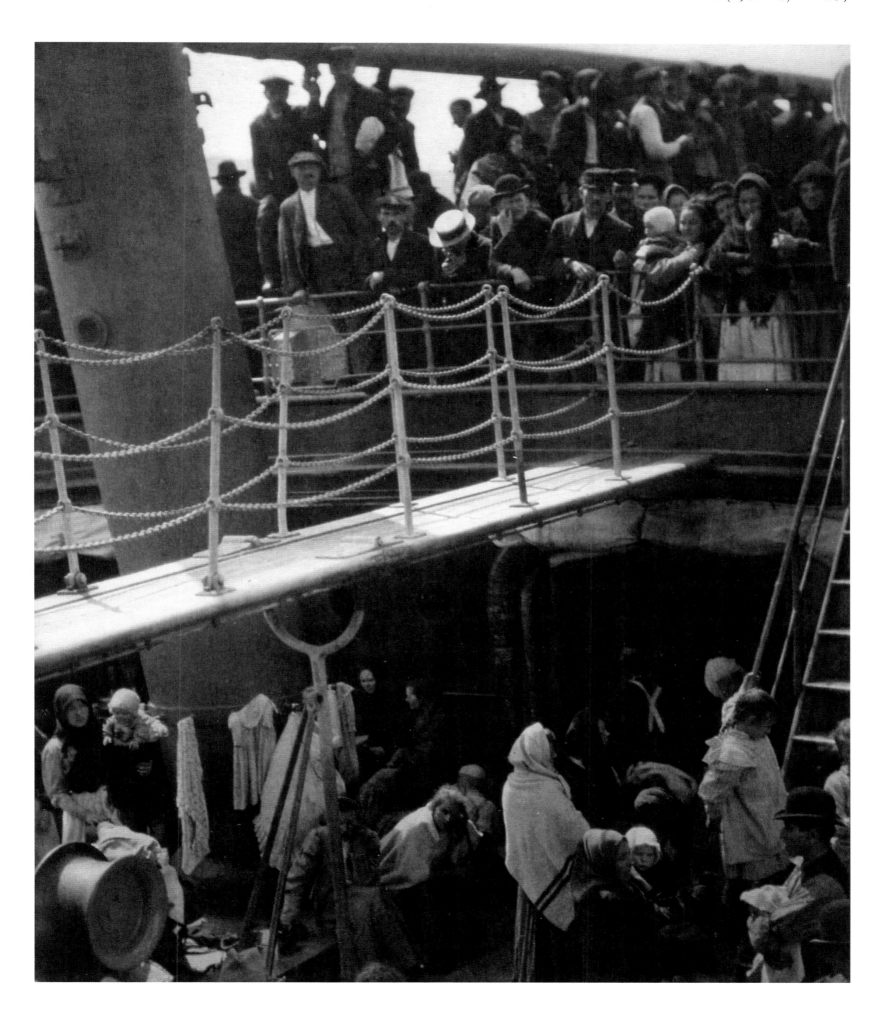

ABOVE: Frank Lloyd Wright (1867–1959)
Frank Lloyd Wright Room. 1912–15.
Purchase, Emily Crane Chadbourne Bequest, 1972.
The Metropolitan Museum of Art, New York, New York.

Say "twentieth-century architect" and Frank Lloyd Wright is invariably the
first name that comes to mind. But his vision reached as well into every
detail of the interior space: stained-glass windows, wallpaper, furniture,
textiles, tableware, and more. The living room at "Northome," the
summer residence of Francis W. Little (now installed in the Metropolitan
Museum), exemplifies Wright's unified aesthetic.

LEFT: Stickley Brothers (1891–1954)
Desk. 1904.
Quarter-sawn oak, oak veneer, cedar, mahogany, brass, copper,
leaded glass.
Friends of the American Wing Fund, 1992.
The Metropolitan Museum of Art, New York, New York.

British reformers John Ruskin and William Morris inspired the Arts and
Crafts Movement in America, led by Gustav Stickley's Craftsman line of
furniture and home design. Stickley's brothers branched out into various
Stickley companies advancing Gustav's designs, along with furniture
designed by Frank Lloyd Wright, whose organic Prairie style marked a
major movement in home design in the early twentieth century.

William Glackens (1870–1938)
Beach Umbrellas at Blue Point. Ca. 1915.
Oil on canvas, 26 x 32 in. (66 x 81.3 cm).
Gift of Mr. and Mrs. Ira Glackens. Smithsonian American Art Museum, Washington, D.C.

Glackens was one of a group of revolutionary artists who called themselves "The Eight" and came to be known as the Ashcan school, headed by Robert Henri and including John Sloan, George Luks, and four others. "Ashcan" refers to the unrefined realism that was the focus of most of the artists in the group. Glackens, however, remained a romantic Impressionist.

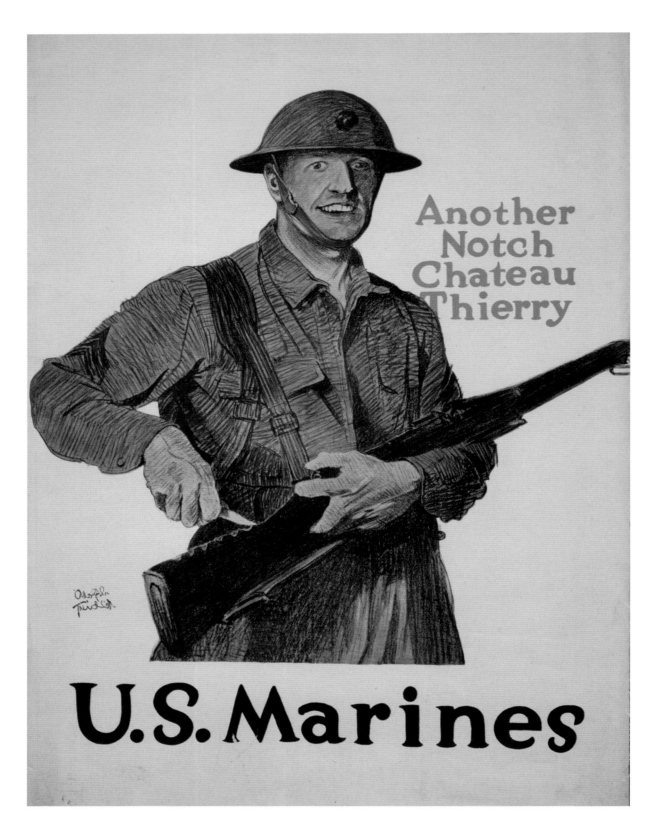

Another
Notch
Chateau
Thierry

U.S. Marines

LEFT: **Adolph Treidler**
(1886–1981)
*Another Notch, Château
Thierry—U.S. Marines.* 1917.
Color lithographic poster,
40 ⅝ x 29 ⅞ in. (103 x 76 cm).
Library of Congress.

Adolph Treidler illustrated covers for *Collier's* and other magazines early in his career, but it was his war recruitment posters (unpaid) that led to a career in posters for travel, automobiles, and other advertisements. Here, a Marine carves "another notch" in his rifle for victory at Château-Thierry, the last German offensive in World War I. Recruitment posters were produced by President Wilson's Committee on Public Information, which also sent out "Four-Minute Men" to make public appeals; radio would not be commercially available until the end of 1920.

OPPOSITE: **James Montgomery Flagg** (1877–1960)
I Want You for U.S. Army. 1917.
Chromolithograph on paper,
39 ½ x 29 in. (100.3 x 73.7 cm).
*Gift of Barry and Melissa Vilkin.
Smithsonian American Art
Museum, Washington, D.C.*

The earnest face of Uncle Sam in this legendary recruitment poster is none other than that of the artist himself. Flagg was a member of the Division of Pictorial Publicity, an organization of artists working for various federal agencies. While the poster was created near the end of World War I, it served a longer term of duty in World War II.

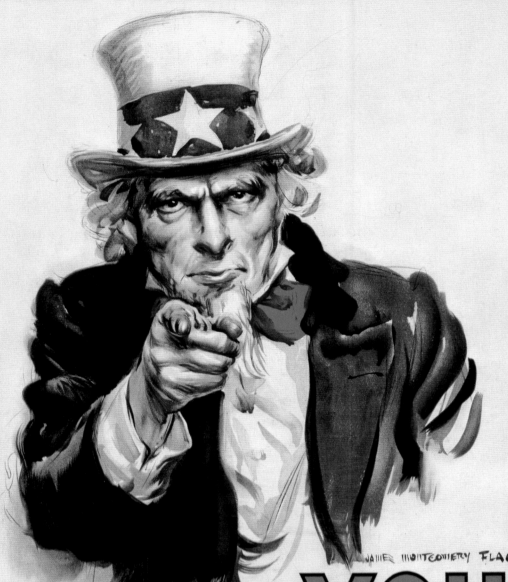

Prosperity and Depression

(1918–39)

"Once I built a railroad, now it's done—
Brother, can you spare a dime?"

—E. Y. HARBURG AND JAY GORNEY, 1931

John Marin (1870–1953)
Lower Manhattan. 1920.
Watercolor and charcoal on paper, 21 ⅞ x 26 ¾ in. (55.6 x 67.9 cm).
The Philip L. Goodwin Collection. The Museum of Modern Art, New York, New York.

John Marin's innovative and exuberant watercolors combine an inherently delicate medium with a Cubist interpretation of form (absorbed during a 1905–09 sojourn in Paris), and retain the Impressionist sensitivity to light. Besides cityscapes of Manhattan, Marin also painted the coast of Maine. *Lower Manhattan* was inspired by Marin's own dictum, "If these buildings move me they too must have life."

The mood of the United States following World War I might be best expressed in the words of the man who succeeded the ailing Woodrow Wilson as president. Coining a word that has since entered the language, Warren G. Harding spoke of a "return to normalcy" as he led the Republican Party in its return to the White House in 1920. Americans, he correctly assumed, were proud of their accomplishments on European battlefields but wanted no more of foreign obligations. That aspect of the national mood, after all, was what had helped Senator Henry Cabot Lodge and other isolationists defeat Wilson's cherished goal of U.S. participation in the League of Nations. The new decade of the 1920s, Harding and his substantial electoral majority believed, was a time for Americans to take care of America first.

Americans went about that task in a variety of often conflicting ways. The 18th Amendment to the Constitution, outlawing the manufacture, sale, and transport of alcoholic beverages, went into effect in January 1919, and represented a victory for conservative rural states and the conservative religious forces that were gaining strength in the nation—and yet the decade that followed has since been regarded as one of the most worldly and indulgent of all American eras (it was a cynical era as well, as far as respect for law was concerned, as Prohibition made willing criminals of

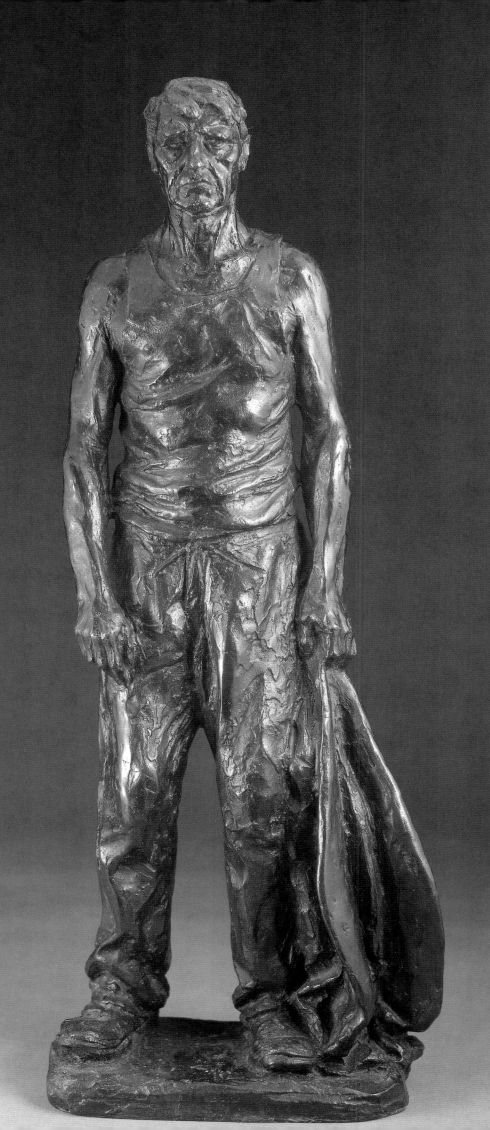

Max Kalish (1891–1932)
The End of Day. 1930.
Bronze, 15 ½ x 5 ⅞ x 3 ½ in.
(39.2 x 15.0 x 8.9 cm).
*Gift of Max Kalish. Smithsonian
American Art Museum,
Washington, D.C.*

After studying sculpture with
Herman Matzen in Ohio,
Lithuanian-born Max Kalish chose
as his theme the rhythms of labor
and rest, particularly as expressed
by those who labored in the steel
and metal factories. With the
Great Depression taking its toll on
the nation's workforce, Kalish
sought to renew a spirit of hope
through his sculptures of the
"heroic worker."

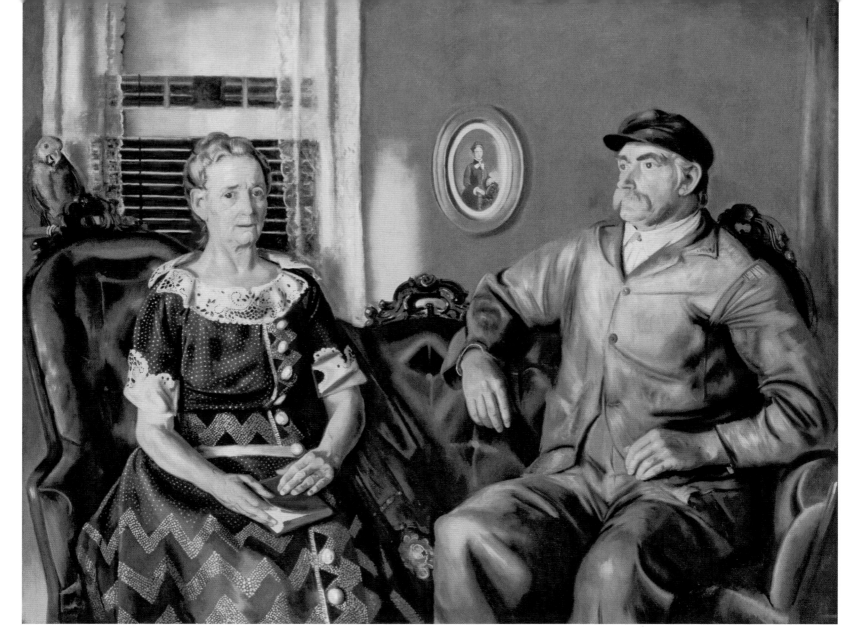

George Bellows (1882–1925)
Portrait of Mr. and Mrs. Phillip Wase. 1924.
Oil on canvas, 51 ¼ x 63 in. (130.2 x 159.9 cm).
Smithsonian American Art Museum, Washington, D.C.

A ruptured appendix cut short the career of the most distinguished member of the Ashcan school. At age 27, George Bellows was the youngest artist elected to membership in the National Academy of Design, in recognition for his technical mastery of Realist painting. His sensitive yet hard-edged vision is exemplified in this 1924 portrait of an elderly couple in Woodstock, New York, where Bellows was part of the Woodstock artists' colony.

millions of ordinary Americans and wealthy criminals of the gangland elements who provided them with illegal liquor). The Progressive Movement was largely played out by the end of World War I, yet 1920 marked the passage of the most socially progressive constitutional amendment since the repeal of slavery and the enfranchisement of African Americans: the 19th Amendment granted women the right to vote, effectively doubling the size of the American electorate. The 1920s saw the rise of a freer-thinking,

better-educated middle class—the caustically iconoclastic H. L. Mencken was the most-read social critic on college campuses, while experimental modes in art, literature, and music were increasingly accepted—yet there was a substantial backlash against unorthodoxy, best exemplified in the 1925 trial of Tennessean John T. Scopes for teaching evolution.

There was also an ugly streak of nativism in 1920s America. The "Red Scare" that immediately followed the war was stoked by fears of Bolshevism, seen as a disease that might be carried to the U.S. by immigrants inspired by the recent revolution in Russia. Two longer-lasting results of the scare—as well as of simple, unpoliticized prejudice—were the drastic restrictions on immigration that took effect in 1924, and the rebirth of the Ku Klux Klan, once a post–Civil War fraternity of revanchist Southerners but now enjoying a nationwide resurgence as a self-proclaimed bulwark against foreigners, Jews, and Catholics (themselves often immigrants) as well as blacks.

But for all its contradictions, the decade of the 1920s is remembered primarily as an era of prosperity. The generalization implicit in this recollection isn't entirely accurate—the economy didn't reach a solid footing until about 1923, and there were elements of American society, notably farmers, who never really benefited from the boom—but by and large, the Twenties were a time of confidence and economic expansion. To a certain extent there was a raffishness and air of corruption about the nation's improving fortunes, exemplified not only by the rise of

"During Coolidge's administration (1923–29), the economy seemed as if it would expand indefinitely, and the federal government assiduously avoided regulation of business."

Prohibition-fueled organized crime but by the scandals that racked the administration of the genial but generally incompetent President Harding (in the worst of these, the Teapot Dome Scandal, Interior Secretary Albert Fall leased oil rights on government land in return for a hefty bribe). But there were solid underpinnings to the nation's prosperity, especially in a manufacturing sector suddenly flush with the profits from the burgeoning automobile, appliance, energy, and public utility industries. The urban landscape reflected the boom, as is evidenced in the opening line of Sinclair Lewis's classic satire on business culture, *Babbitt*: "The towers of Zenith aspired above the morning mist." In cities across the nation, more and more towers were aspiring, and by the end of the decade the New York skyline was well on its way to attaining its signature outline with the addition of the Chrysler and Empire State Buildings. Urban America

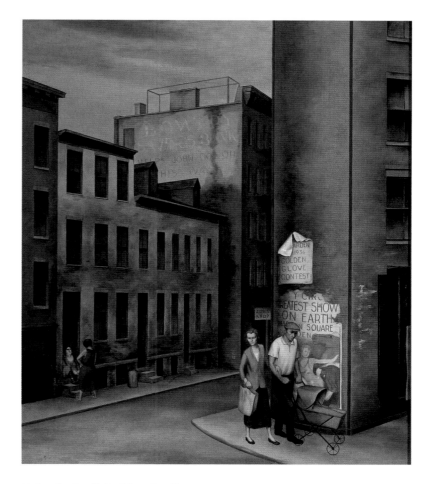

O. Louis Guglielmi (1906–56)
View in Chambers Street. 1936.
Oil on canvas, 30 1/4 x 24 in. (76.8 x 61.6 cm).
Collection of The Newark Museum, Newark, New Jersey.

O. Louis Guglielmi was among those artists that came to be known as Magic Realists, his vision based in daily life but heightened by elements of fantasy. Much of his art was informed by the difficult conditions the family experienced after immigrating to New York City in 1914. His talent lifted him out of poverty but he never lost compassion for the needy, his works moving expressions of his social consciousness. *View in Chambers Street* shows an almost abandoned city street with surprisingly few people performing ordinary tasks. Muted colors and an almost eerie interest in deserted spaces had developed in Guglielmi's work by the mid-1930s.

was bicoastal now, with Los Angeles and environs enjoying the fruits of the oil and motion picture industries as well as a massive influx of migrants from the Midwest. And even in places far from the big cities, Americans felt connected with their glamour and zest via the new technologies of movies and radio.

"The business of America is business," said Harding's successor, Calvin Coolidge, and most of his fellow citizens would have agreed. During Coolidge's administration (1923–29), the economy seemed as if it would expand indefinitely, and the federal government

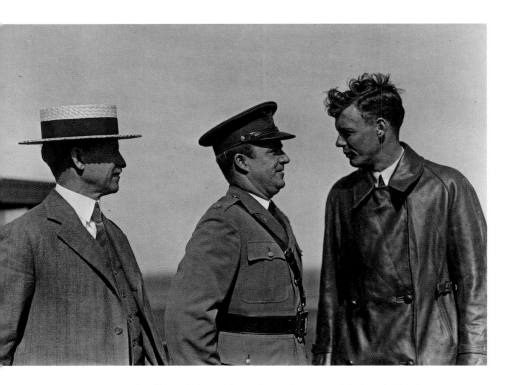

ABOVE: *Orville Wright, Major John F. Curry, and Colonel Charles Lindbergh.* June 22, 1927.
Photograph.
Library of Congress.

When brother Wilbur died in 1912, nine years after the Wright brothers' first powered airplane flew at Kitty Hawk, Orville persevered in efforts to win a reluctant America to the idea of flight, and in 1930 he was honored with the first Guggenheim Medal for aeronautic achievement. This 1927 photo shows Orville visited by aviators John F. Curry and Charles Lindbergh at Wright Field in Dayton, Ohio.

assiduously avoided regulation of business. More and more people wanted to be a part of the boom, and stock speculation was rampant. The overheated atmosphere on Wall Street was not the root cause of the reckoning that followed the Twenties boom—a deeper and more complicated factor was an inability to distribute income so that consumer buying power could keep up with industrial output—but the precipitousness of the stock market's sudden fall in October of 1929 gave posterity a convenient starting date for the worst economic calamity in American history, the Great Depression.

The Depression manifested itself in a quick downward spiral of prices, investment, and employment, ruining the presidency of Coolidge's successor, a competent and aloof engineer named Herbert Hoover, and sending banks into panic, homes and farms into foreclosure, and many Americans— some 15 million of whom were out of work—into a flirtation with ideas of radical change that veered

across the political spectrum from fascism to communism. It also brought to the fore a man decried as a demagogue by his enemies, but who in fact was very likely the only individual capable of keeping the nation from falling into the hands of one of the true demagogues who stalked the land in those dark days. He was a veteran politician who had been defeated as a vice-presidential candidate in the Republican landslide of 1920, who had been crippled by polio the following summer, and who, wheelchair-bound, had ascended to the governorship of New York and

BELOW: Theodore Roszak (1907–81)
Airport Structure. 1932.
Copper, aluminum, steel, and brass, height: 19 1/8 in. (48.6 cm).
Collection of The Newark Museum, Newark, New Jersey.

Theodore Roszak's abstract expressionist sculptures of the 1930s are built with the materials of the metalworking industry, and their clean lines express the geometric precision of the machine age. Like other artists of his day, Roszak participated in federal art projects. After World War II he was to turn toward a spiritual focus in art.

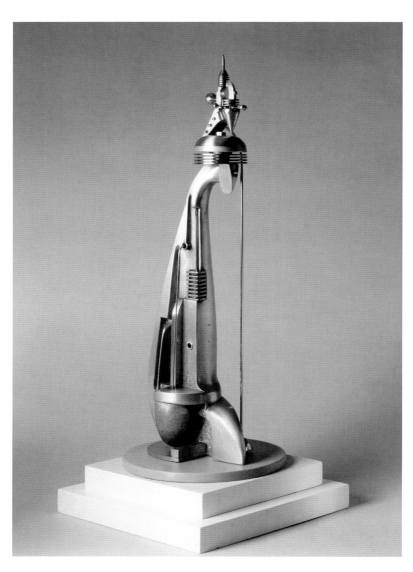

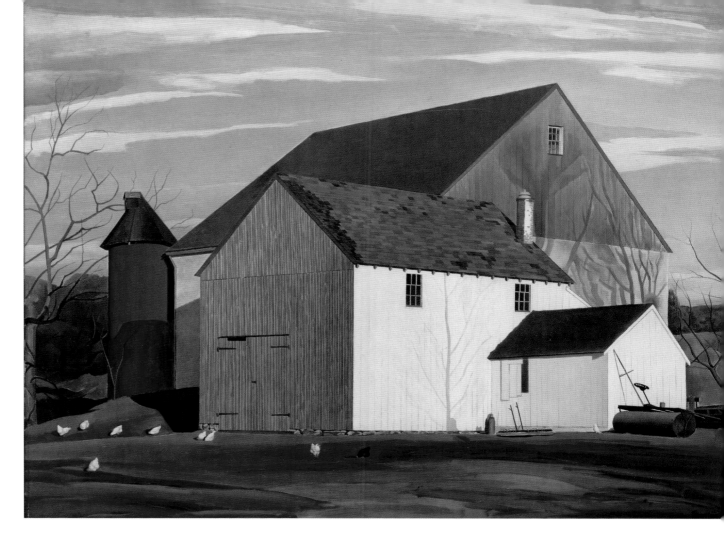

Charles Sheeler (1883–1965)
Bucks County Barn. 1932.
Oil on gesso composition board,
23 ⁷/₈ x 29 ⁷/₈ in. (60.6 x 75.9 cm).
*Gift of Abby Aldrich Rockefeller.
The Museum of Modern Art,
New York, New York.*

Charles Sheeler's interest in photography spilled over into his paintings with the same attention to clearly delineated architectural forms surrounded by a natural setting. His focus on geometric accuracy, which he termed Precisionism, stemmed as much from his own admiration for Cubism's perspectiveless flat planes as from his era's enthusiasm for technological progress.

the 1932 Democratic nomination for the presidency. That autumn, Franklin D. Roosevelt was elected in a landslide.

Not since the election of Abraham Lincoln in 1860 had a new president faced a crisis as severe as the Great Depression, and Roosevelt—"FDR," as he was universally known—immediately set himself to the task of halting the free-fall of the American economy. Despite conservatives' cries that he was a socialist and a "class traitor" (FDR, like his distant cousin Theodore Roosevelt, was a product of the old New York Anglo-Dutch informal aristocracy), the president was determined not to replace America's basic economic model, but to save capitalism from its own worst flaws and excesses. His instrument for accomplishing this goal, and for restoring the nation's economic well-being, was a vastly enhanced arsenal of federal powers.

During the first hundred days of Roosevelt's administration, he unveiled a bold array of programs with the cooperation of a Congress solidly in the hands of the Democratic Party. To reassure a desperate public who, in his words, had "nothing to fear but fear itself" but who feared a great deal more, he declared a "bank holiday" to stanch the flow of funds from financial institutions, and pushed passage of legislation creating

the Federal Deposit Insurance Corporation. Americans were soon familiarizing themselves with an "alphabet soup" of new federal agencies: FERA, the Federal Emergency Relief Administration, distributed welfare to the needy; the WPA, the Works Progress Administration, gave the unemployed jobs on projects ranging from constructing government buildings to writing guidebooks to each of the states; and the CCC, the Civilian Conservation Corps, put young men to work in flood control, reforestation, and fighting forest fires.

A showpiece of the Roosevelt administration was the Tennessee Valley Authority (TVA), which addressed perennial flooding problems while harnessing the Tennessee River for hydroelectric power production. The New Deal, as FDR called his program of economic recovery, was not able to proceed without setbacks. The most serious of these was the U.S. Supreme Court's striking down of the National Industrial Recovery Act (NIRA), which had established a system of price and production controls that had been only marginally successful. Following his landslide reelection in 1936, FDR attempted to retaliate with his unsuccessful "court packing" scheme, which would have involved adding more justices to the nine traditionally seated.

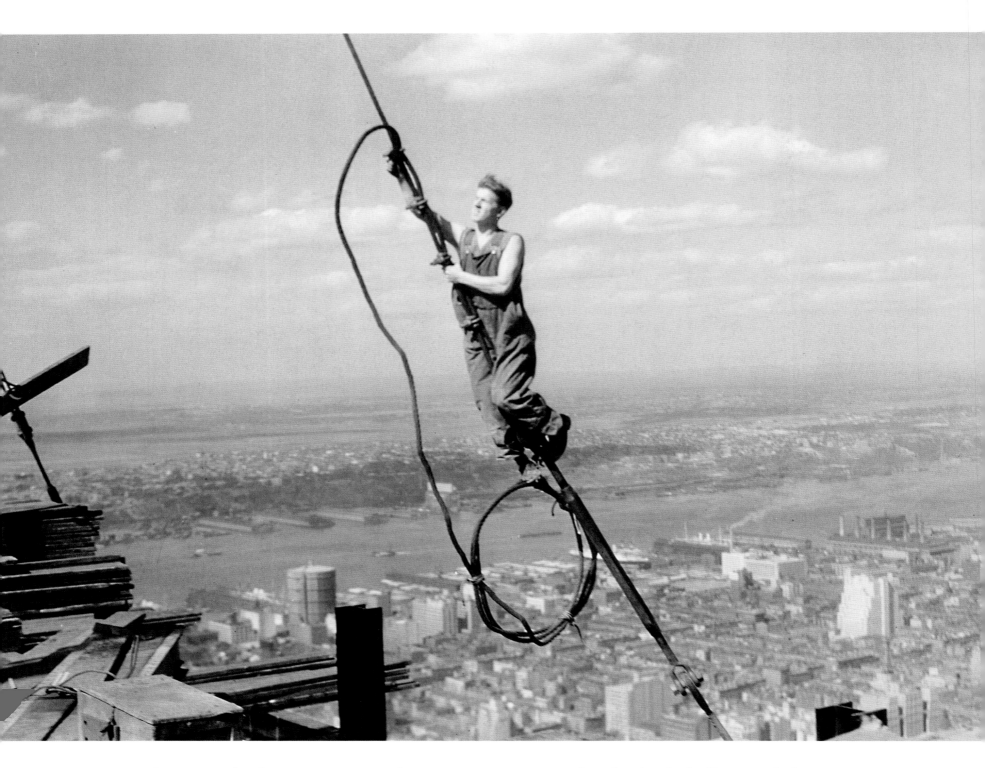

But the Roosevelt administration scored more lasting triumphs than defeats. These included passage of the Social Security Act; the National Labor Relations Act, strengthening unions' power to organize and bargain collectively in an era of bitter strikes; the Fair Labor Act, establishing minimum wages and maximum hours; and the establishment of the Rural Electrification Administration, which finally banished candles and kerosene from farm kitchens. FDR's greatest legacy, though, was twofold. He managed to shepherd a badly wounded American economic system through a time when many thoughtful observers—and not just those on the radical left—thought revolution might be imminent; and he gave lasting credibility to the idea that the federal government can use its authority to regulate trade and labor practices. That concept has weathered serious challenges since the 1980s, but it is difficult to imagine a complete return to the laissez-faire model of the pre-Depression era.

Critics of the New Deal continue to argue that the Roosevelt administration's measures were never as successful in ending the Depression as its supporters have claimed. But Americans derived no small degree of hope from the knowledge that their leaders were at least trying to solve their problems, and were giving new ideas a chance.

Regardless of the positive effects the Roosevelt programs had had in relieving the worst of the miseries of the Depression, though, the final reverse of the nation's economic fortunes came in response to a growing threat from overseas. During the 1930s, Americans had largely continued in their post–World War I disinterest in foreign developments—with the exception, to some extent, of fascination on the far left with what was still perceived as a noble experiment in socialism in the Soviet Union. But toward the end of the decade, it became impossible to ignore the growing bellicosity of Nazi Germany, fascist Italy, and a Japanese Empire bent on east Asian hegemony. Many Americans remained staunchly isolationist, but a growing preoccupation with defense and war preparedness gave a new impetus to job creation and investment. While the gathering clouds of World War II were not solely responsible for ending the Great Depression, they created the climate for the final release of its grasp on the United States.

OPPOSITE: Lewis Wickes Hine (1874–1940)
Icarus, High Up on Empire State. 1931.
Photograph.
Miriam and Ira D. Wallach Division, The New York Public Library, New York, New York.

Documentary photographer Lewis Wickes Hine perched in a bucket high above Fifth Avenue to photograph this construction worker attaching cables to the Empire State Building. Hine's photographs of hazardous jobs brought out the human side of the modern age, and his images of child labor led to social awareness and reform.

RIGHT: Shreve, Lamb, and Harmon (founded 1929)
Empire State Building. 1931.

In the height of the Great Depression, construction of the Empire State Building provided employment for thousands of out-of-work men. The building's 200-foot (60-meter) spire was originally envisioned as a mooring mast for dirigibles, but powerful updrafts made that idea nothing but a dream—the spire later became a radio transmitter. The Empire State was and is New York's tallest building, having unfortunately regained that status by the tragic destruction of the World Trade Center by terrorists in 2001.

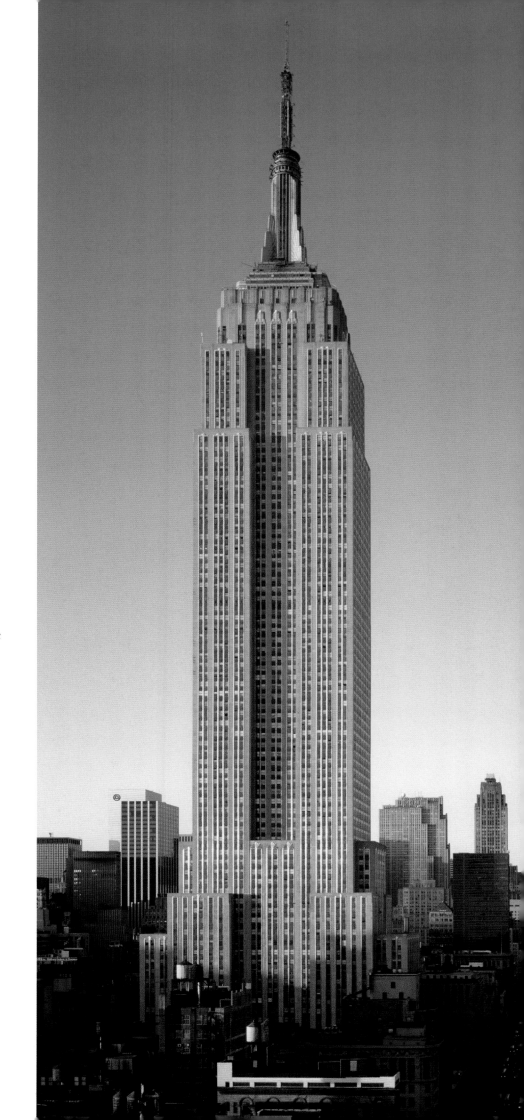

FDR's Fireside Chats

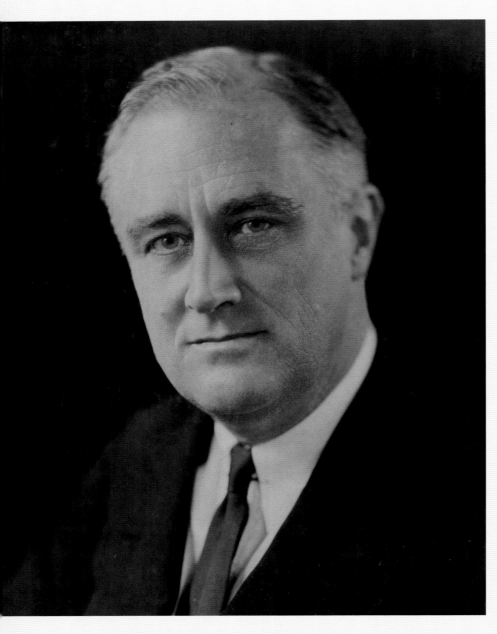

Franklin Delano Roosevelt (1882–1945). Ca. December 27, 1933.
Photograph.
Library of Congress.

Through the dark years of the Depression and World War II, Roosevelt guided the nation to victory and prosperity, speaking in radio broadcast "Fireside Chats" directly to the American people as "my friends." So popular was FDR that his presidency lasted four terms, until he died in office. Shortly after, the 22nd Amendment limiting a president to two terms was ratified by the states.

O n the evening of March 12, 1933, at 10 P.M., some 60 million Americans gathered around the radios that by now stood on the kitchen counters and living room floors of most of the nation's households. They listened intently as a warm tenor voice crackled over the airwaves. "My friends," the speaker began, "I want to talk for a few minutes with the people of the United States about banking."

"'My friends,' the speaker began, 'I want to talk for a few minutes with the people of the United States about banking.'"

Few subjects, if any, could have engaged so large an audience so thoroughly in those closing days of the dark winter of 1933. As the Great Depression sunk to its lowest depths, bank after bank had failed, unable to survive the loss of public confidence that had caused millions of citizens to rush to withdraw their dwindling funds. And few speakers could have riveted America to its radios as urgently as the man behind the microphones—it was he who had closed the banks for four days, immediately following his inauguration as the 32nd president of the United States. The radio talk that followed, in which he sought to explain the banking system that would reopen the next morning following its forced cooling-off period, was the first of Franklin D. Roosevelt's "fireside chats."

Roosevelt had used radio before, to explain his positions to the people of New York while he was serving as the state's governor. Now, as the national mood wavered between despair over three years of Depression and hope for the new administration,

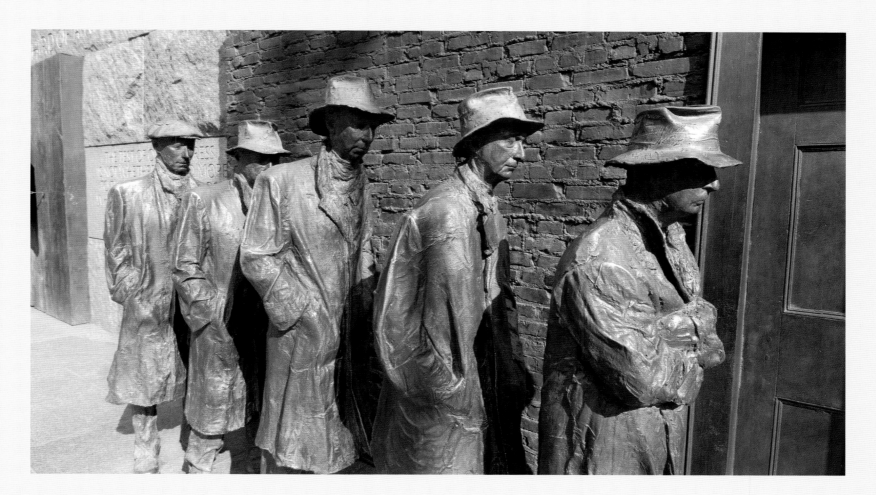

FDR spoke to the vast national audience that the commercial broadcast medium, still barely 15 years old, was capable of reaching. "What, then, happened," the president asked, "during the last few days of February and the first few days of March? Because of undermined confidence on the part of the public, there was a general rush by a large part of our population to turn bank deposits into currency or gold—a rush so great that the soundest banks couldn't get enough currency to meet the demand.... By the afternoon of March 3, a week ago last Friday, scarcely a bank in the country was open to do business. It was then I issued the proclamation providing for the national bank holiday."

Roosevelt went on to explain how the banks had been set on a more even footing during the "holiday," with the time out affording the government the opportunity "to supply the currency necessary to meet the situation." Assuring the nation that there would be money available to meet all needs except "the hysterical demands of hoarders," he went on to encourage the "confidence and courage" of the American people—"We have provided the machinery to restore our financial system," he concluded, "and it is up to you to support and make it work."

No president had ever spoken to the nation in quite this way before—indeed, only the most recent presidents prior to Roosevelt could have, and such an intimate use of the new medium was hardly in the style of Harding, Coolidge, or Hoover. Over the coming years, FDR would draw Americans to their radios for 30 more of these sessions, explaining the progress of the New Deal and, eventually, preparing the nation for the sacrifices of the Second World War. No president since has put himself on such a personal footing with the people—a televised speech, for all its immediacy, could never replace the imagined face-to-face rapport conjured by the fireside chat.

George Segal (1924–2000)
The Breadline. 1997.
Franklin Delano Roosevelt Memorial, Washington, D.C.

Built in 1997 to honor one of the twentieth-century's greatest presidents, the Franklin Delano Roosevelt Memorial commemorates American history during his four terms of office. The great challenge of FDR's first two terms was the Great Depression, with its breadlines of out-of-work Americans; the Depression was relieved by Roosevelt's New Deal and World War II.

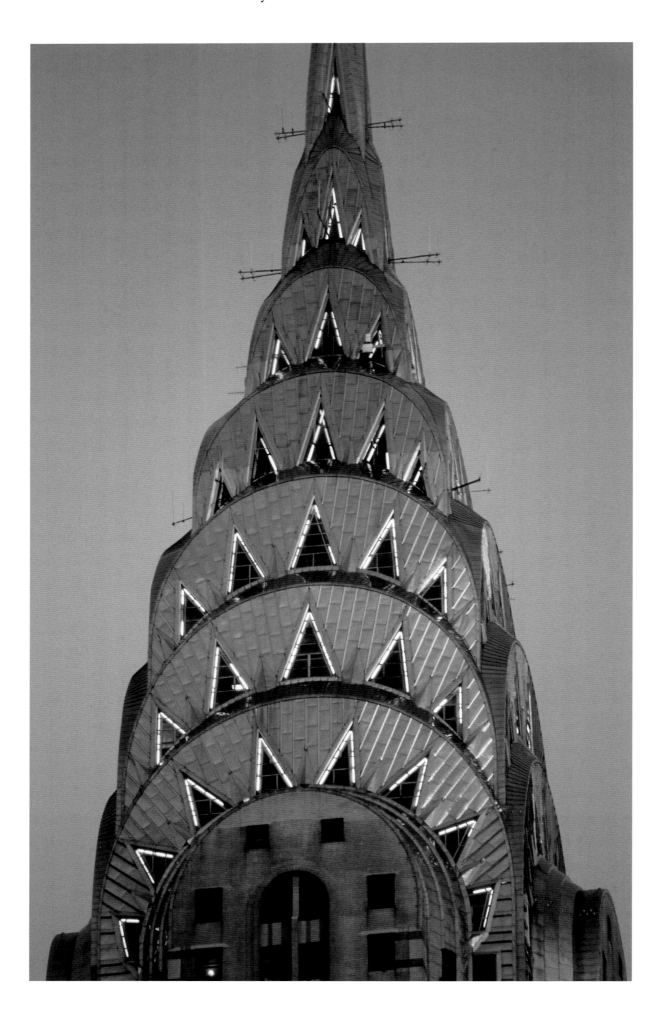

William van Alen (1883–1954)
Chrysler Building. 1931.
Photograph.

Built by automobile magnate Walter P. Chrysler, the 77-story Chrysler Building enjoyed the status as the world's tallest building for less than a year—in 1931 the Empire State Building surpassed it by 25 stories. Architect William van Alen, who trained at the École des Beaux-Arts in Paris, topped the automaker's building with Art Deco sunbursts imitating hubcaps.

RIGHT: Frank Lloyd Wright
(1867–1959)
Fallingwater. 1935. Bear Run, Pennsylvania.

Cantilevered balconies give the appearance of floating in midair over the waterfall the house is named for. "Fallingwater" realized Frank Lloyd Wright's ambitious dream of completely integrating a home with its natural environment. The organic structure was originally intended to serve as a weekend retreat for its owner, Pittsburgh businessman Edgar Kaufmann Sr., and is now a historic landmark.

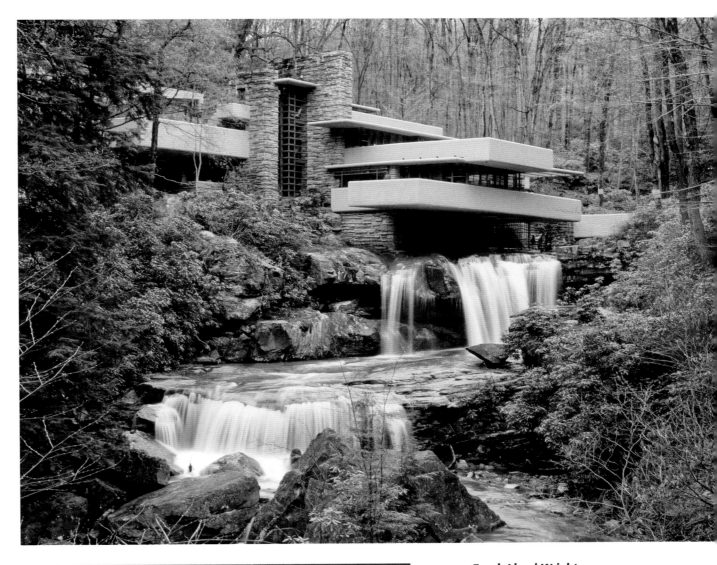

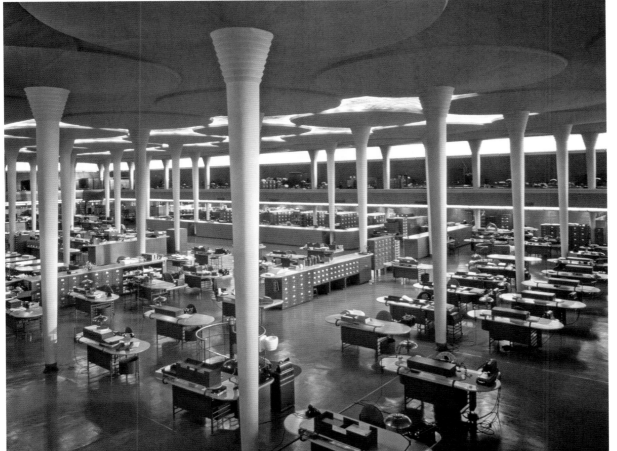

LEFT: Frank Lloyd Wright
(1867–1959)
Johnson Wax Towers. 1936. Racine, Wisconsin.

Wright intended the Great Workroom of SC Johnson Wax headquarters to be an open space for the secretarial pool, but authorities were concerned that the columns, which are wider at the top than the base, would not meet building codes. Despite their delicate appearance, tests proved that they were able to withstand five times the weight requirement.

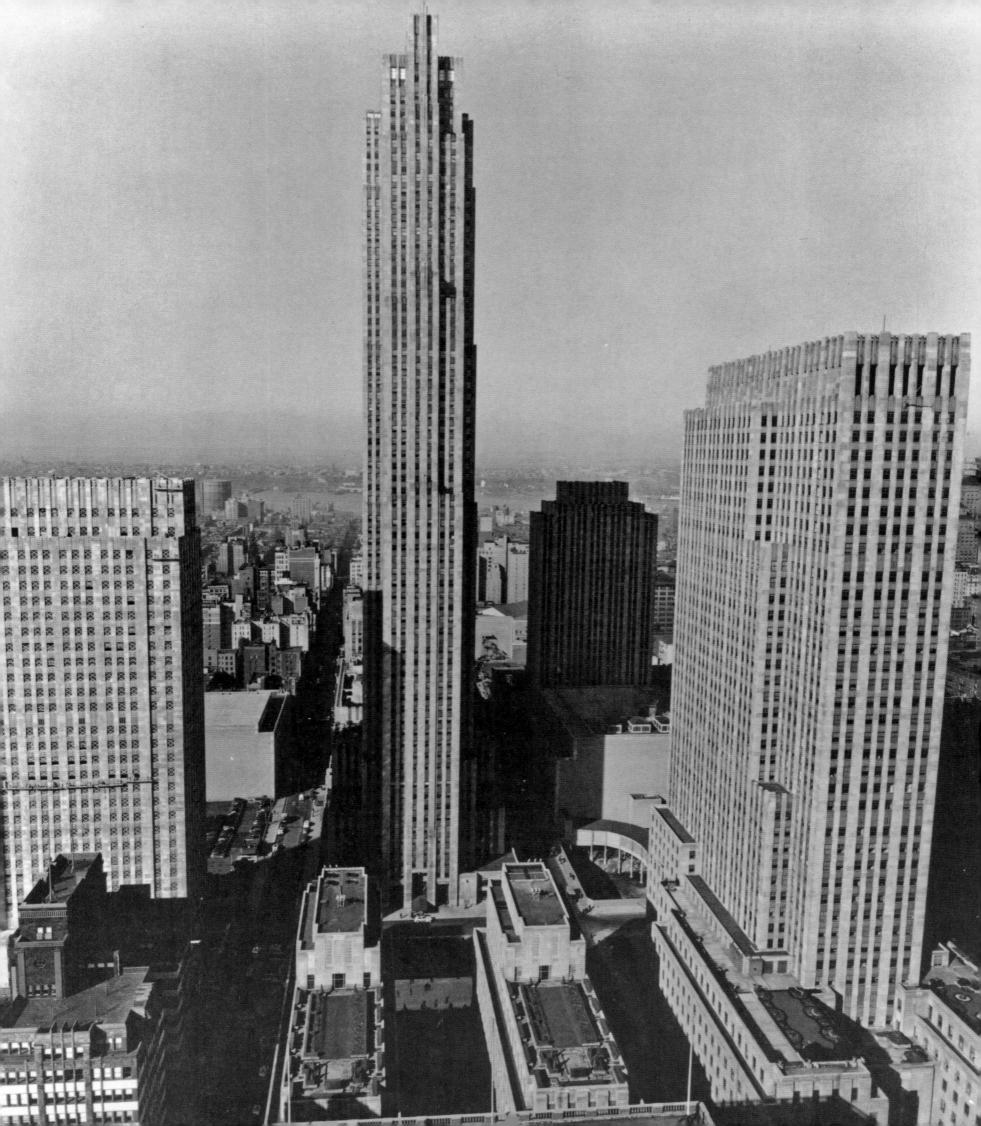

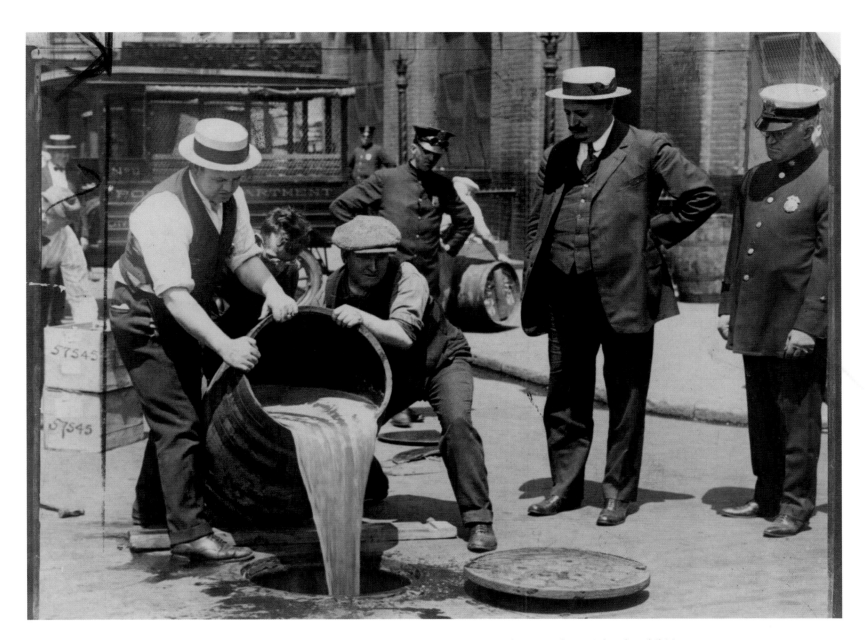

OPPOSITE: Berenice Abbott (1898–1991)
Rockefeller Center. 1937.
Gelatin silver print mounted on paperboard.
Smithsonian American Art Museum, Washington, D.C.

A few years after a solo show of photographic portraits of James Joyce and other avant-garde personalities in Paris in 1926, Berenice Abbott returned to New York, where from 1935 to 1939 she directed the WPA Federal Art Project's "Changing New York," documenting in photographs the evolving city, both its skyscrapers and its people.

ABOVE: *Raid During the Height of Prohibition.* Ca. 1921.
Photograph.
Library of Congress.

Prohibition's objective of outlawing the manufacture, transportation, and sale of alcoholic beverages had the unwanted consequence of bootlegging. Raids were a common occurrence but were unable to keep up with the rampant problem. Here, New York City Deputy Police Commissioner John A. Leach (right) observes as agents empty a liquor barrel into a sewer.

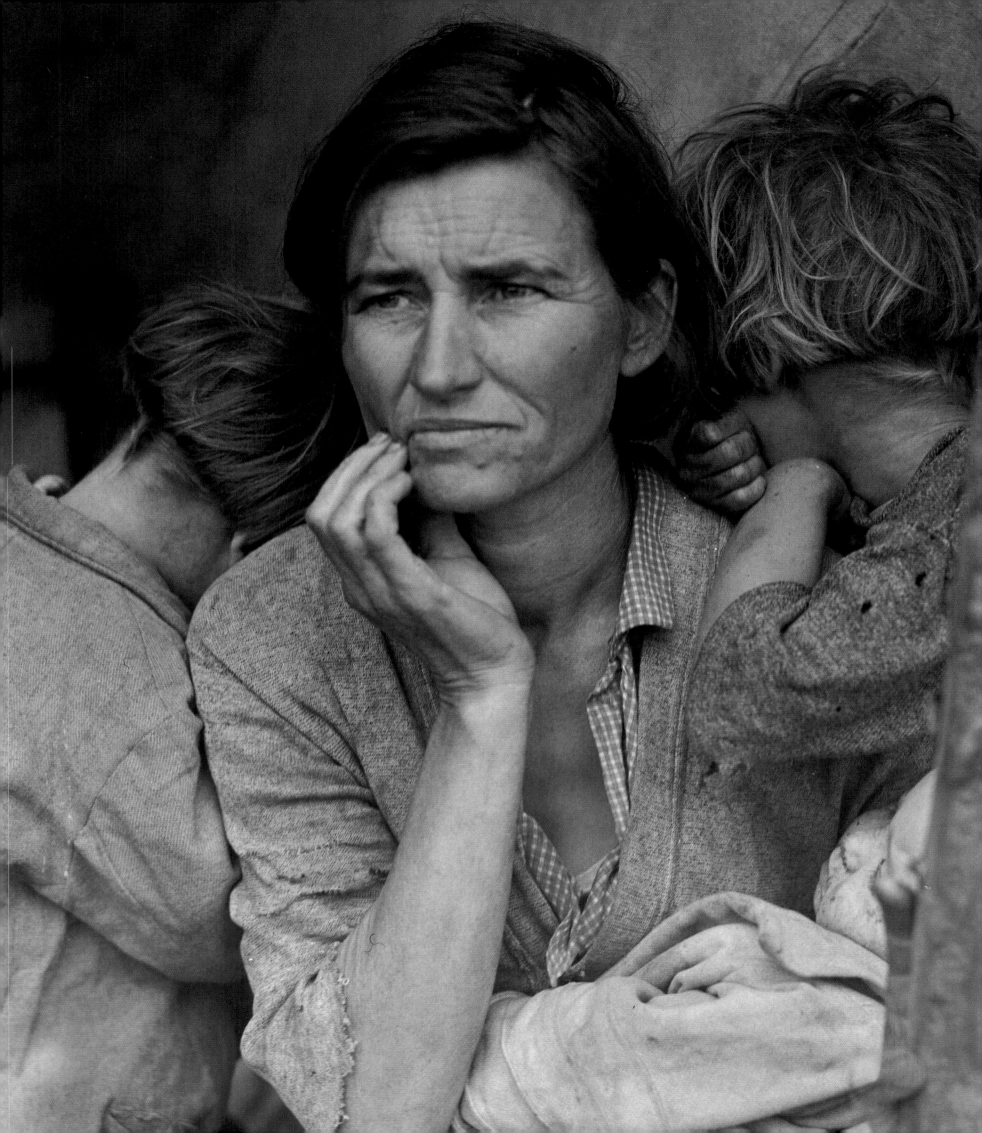

OPPOSITE: **Dorothea Lange**
OPPOSITE: **Dorothea Lange**
(1895–1965)
*Migrant Mother, Nipomo,
California.* 1936.
Photograph.
Library of Congress.

Like Walker Evans, Dorothea
Lange also worked for the
Resettlement Adminstration,
photographing migrant workers
in California. This photograph,
Lange's most famous, portrays a
worried migrant mother holding
a baby in her lap while two
other children cling to her in
shyness or fear. The image
evoked sympathy not only for
the people in it, but also for all
migrant workers suffering in the
Great Depression.

ABOVE: **Edwin Locke** (n.d.)
Walker Evans (1903–75). February 1937.
Photograph.
Library of Congress.

Walker Evans, photographed here by Edwin Locke, ranks as the
preeminent documentary photographer in America, noted for his ability
to capture the poetic eloquence of the unvarnished truth. Evans's
assignment with the Resettlement Administration in rural Alabama
brought him into contact with James Agee, on assignment for *Fortune,*
as a result of which Evans and Agee collaborated on the now-classic *Let
Us Now Praise Famous Men.*

LEFT: **Walker Evans** (1903–75)
Part of the Kitchen. 1935 or 1936.
Photograph.
Library of Congress.

FDR's Resettlement Administration was a controversial, short-lived
agency designed to relocate poverty-stricken sharecroppers to urban
areas and reappropriate unproductive farmland to other uses, an effort
publicized in part by documentary photographs. Walker Evans's photo
shows a view of the kitchen, with a washstand in the foreground dog
run, in the home of an Alabama sharecropper.

BELOW: Albert M. Bender (fl. 1930s)
A Young Man's Opportunity for Work, Play, Study & Health. 1941.
Color silkscreen print on poster board.
Library of Congress.

The Civilian Conservation Corps was one of FDR's first New Deal programs, providing work, shelter, medical care, and literacy for its 3 million unmarried young male recruits. Conservation work initially focused on forest preservation through land reclamation, tree planting, and fire control, but in 1940 the focus shifted to national defense—until 1942, when Congress cut off support to fund the war effort.

ABOVE: Ben Nason (fl. 1930s)
WPA Federal Art Project Exhibition. 1938.
Color silkscreen print on poster board.
Library of Congress.

During the Great Depression, the WPA Federal Art Project provided creative work for more than 5,000 American artists, with $35 million funding the creation of thousands of paintings, prints, murals, and sculptures. This poster advertises a 1938 exhibition of WPA artworks in Boston, one of many such exhibitions in cities across the nation.

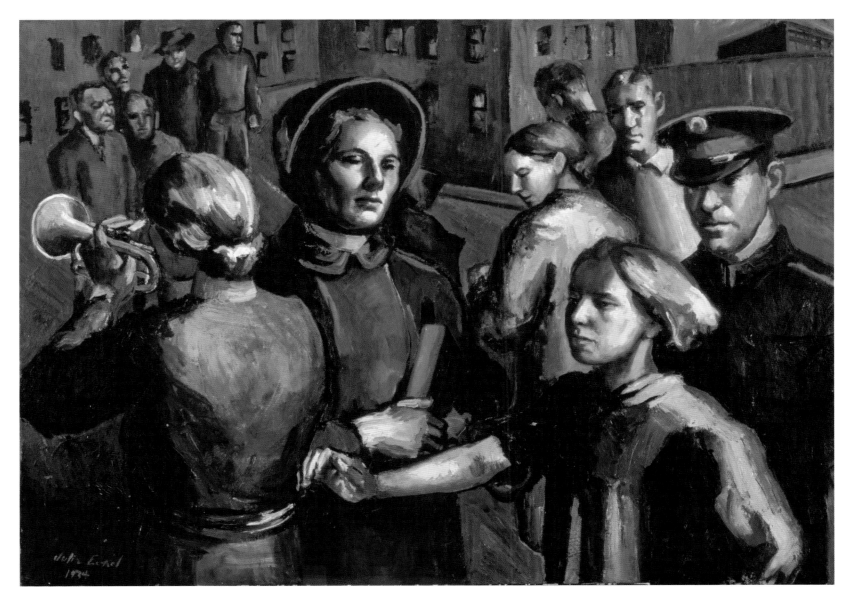

Julia Eckel (1907–88)
Street Service. 1934.
Oil on canvas, 40 ⅛ x 55 ⅝ in. (101.9 x 141.3 cm).
Smithsonian American Art Museum, Washington, D.C.

Julia Eckel's portrait of a Salvation Army street service, with the army band playing instruments, pays homage to the famous charitable organization. The Salvation Army began reaching out beyond local services to the needy in the Galveston hurricane of 1900 and the San Francisco earthquake of 1906, the organization's first national appeals for donations to help disaster victims.

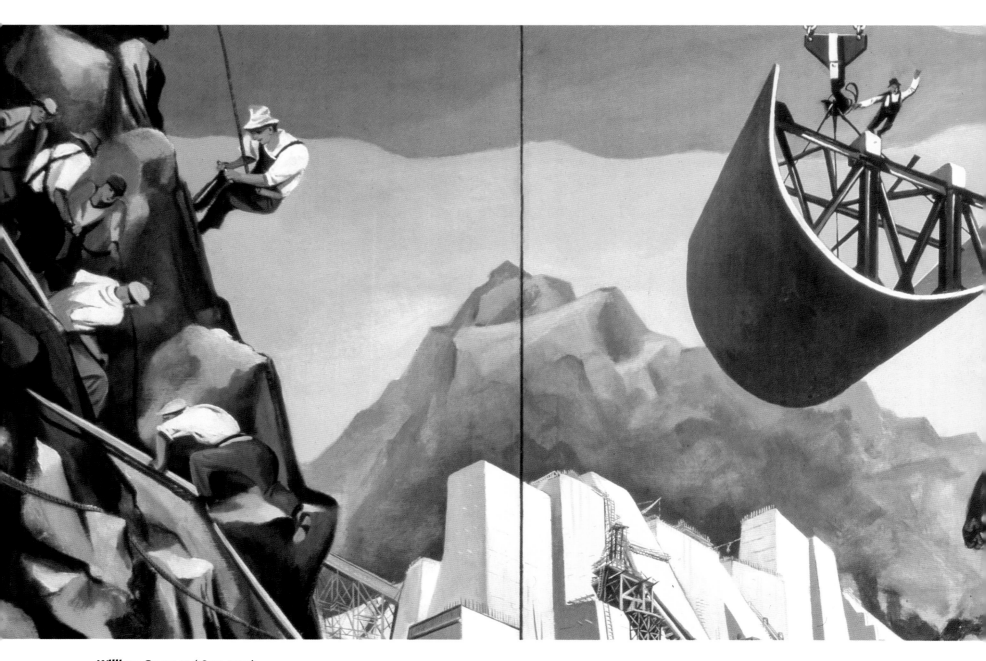

William Gropper (1897–1977)
Construction of the Dam (Mural study, Department of the Interior).
Ca. 1937.
Oil on canvas, overall: 27 ¼ x 87 ¼ in. (69.3 x 221.7 cm).
Smithsonian American Art Museum, Washington, D.C.

Power dams like Grand Coulee and Hoover invigorated the economy
and provided electricity across the nation, but the construction work was
dangerous. Gropper's mural for the Department of the Interior lobby
dramatically portrays the hazardous conditions.

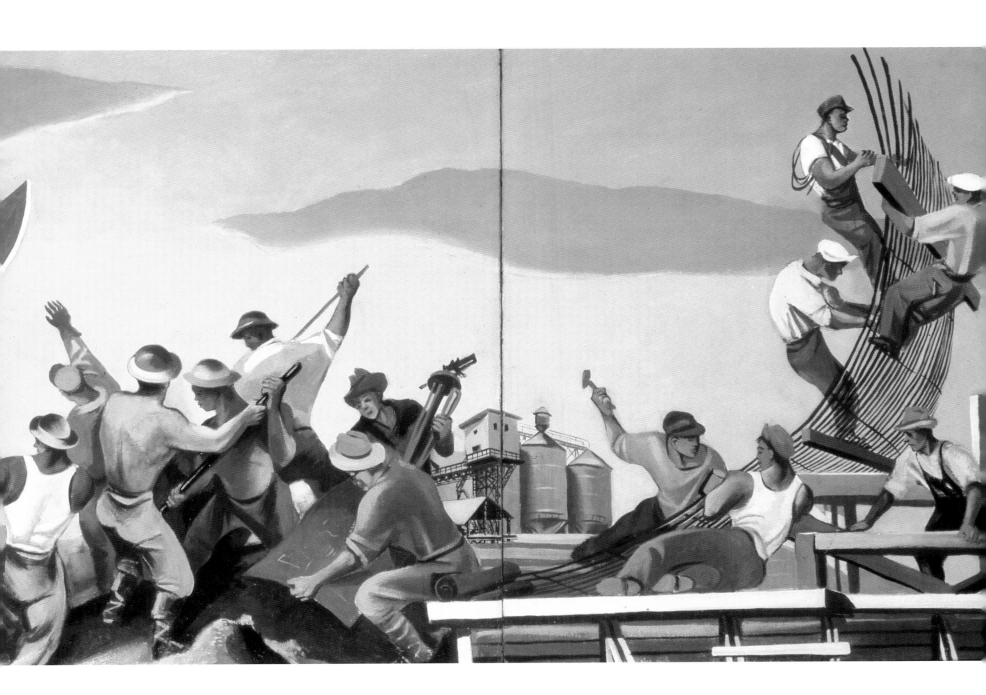

Georgia O'Keeffe (1887–1986)
Ram's Head, Blue Morning Glory. 1938.
Oil on canvas, 20 x 30 in. (50.8 x 76.2 cm).
Promised gift. The Burnett Foundation. The Georgia O'Keeffe Museum, Santa Fe, New Mexico.

At once ethereal and austere, George O'Keeffe's art was a departure from the realism dominating American art when Alfred Stieglitz (whom she later married) introduced her through exhibitions at 291. Her attention was on a harmonious interaction between line, color, and *notan,* the Japanese concept of juxtaposing light and dark—an iconic visual vocabulary present in the elements of *Ram's Head, Blue Morning Glory.*

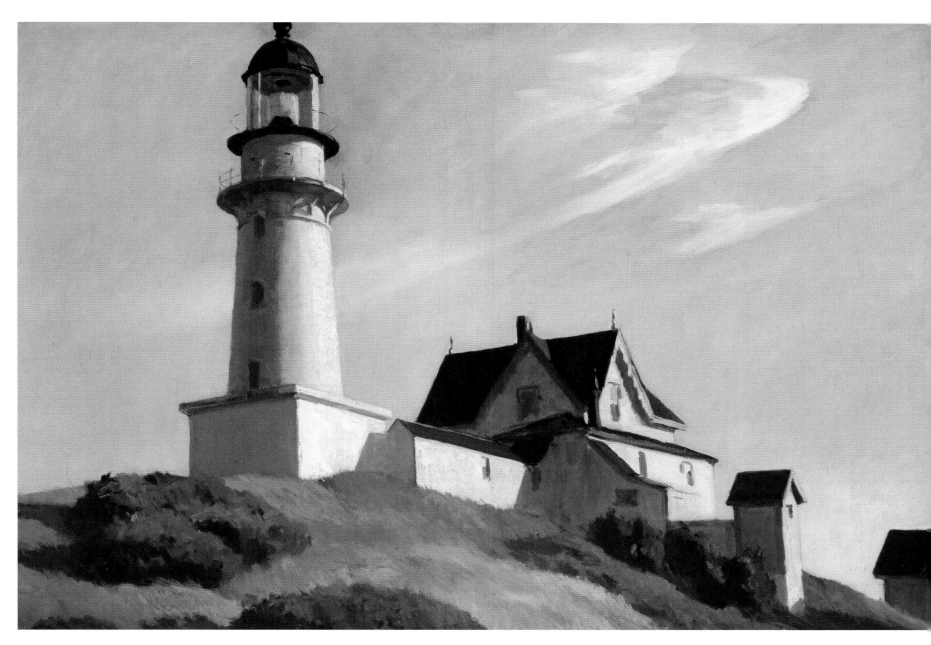

Edward Hopper (1882–1967)
The Lighthouse at Two Lights. 1929.
Oil on canvas, 29 ½ x 43 ¼ in. (74.9 x 109.9 cm).
The Metropolitan Museum of Art, New York, New York.

"My aim in painting has always been the most exact transcription possible of my most intimate impressions of nature," Edward Hopper said around the time he painted *The Lighthouse at Two Lights*. He is considered the most important of the American Scene artists, who portrayed everyday people and scenes, but his sentiments were those of the Impressionists he admired.

The Second World War

(1939–45)

"We must be the great arsenal of democracy."

—FRANKLIN D. ROOSEVELT, DECEMBER 29, 1940

The most destructive war in history began without the direct participation of the United States, and continued for more than two years, with a lightning progression of successes for its perpetrators, before America was drawn into hostilities. As late as the last days of 1940, President Franklin Roosevelt, in one of his "fireside chats," told a nationwide radio audience, "There is no demand for sending an American expeditionary force outside our own borders.… Our national policy is not directed toward war. Its sole purpose is to keep war away from our country and away from our people."

If the president was stretching the truth—if, in fact, just such an expeditionary force was already being contemplated—history can well forgive him, as he was aware of the persuasive power of American isolationists as well as the mortal peril the nation would face if their arguments against taking sides in the world conflagration ever carried the day. For FDR, who had been reelected in 1940 to an unprecedented third term, the proper course was to provide all aid short of outright military support to the Allies fighting Nazi Germany, which at the end of that year meant Britain and Britain alone.

LEFT: *President Roosevelt Signs Declaration of War Against Germany.* December 11, 1941. Photograph. *Library of Congress.*

The United States was not yet at war with any nation on December 7, 1941, when Japan attacked Pearl Harbor. When President Roosevelt signed the declaration of war against Japan, Germany and Italy made their declarations of war on the United States, with Roosevelt immediately responding with counter-declarations on Japan's allies.

OPPOSITE: *Pearl Harbor, Hawaii.* December 7, 1941. Photograph. *Library of Congress.*

Seventy sailors trapped below decks went down with the USS *West Virginia,* sunk by the Japanese attack on Pearl Harbor on December 7, 1941. The recovery team found a calendar with December 23 as the last date X'd out. Despite massive damage, the *West Virginia* was rebuilt and returned to service three years later in operations in the Philippines, Iwo Jima, and Okinawa, remaining through the occupation of Japan.

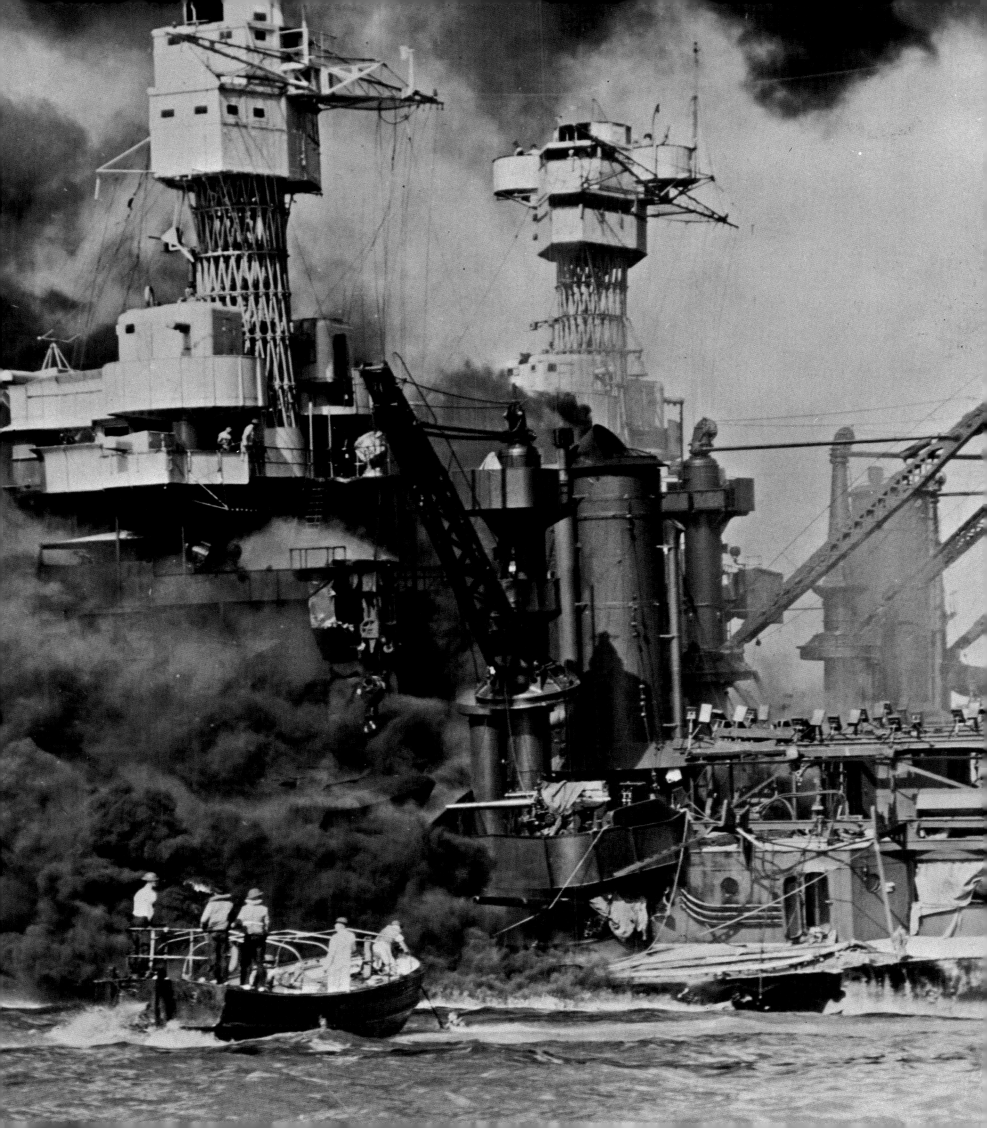

Aside from building up America's own capacity for defense, by means of increased production of weapons and munitions and by the initiation of the first peacetime draft in the nation's history, the administration's strategy included the Lend-Lease program, which gave the president the authority to lend, transfer, or sell outright whatever equipment might be required by countries fighting Germany and its allies. Britain was of course the prime beneficiary, but after Germany's surprise invasion of his erstwhile Soviet ally, the Russians received American aid as well.

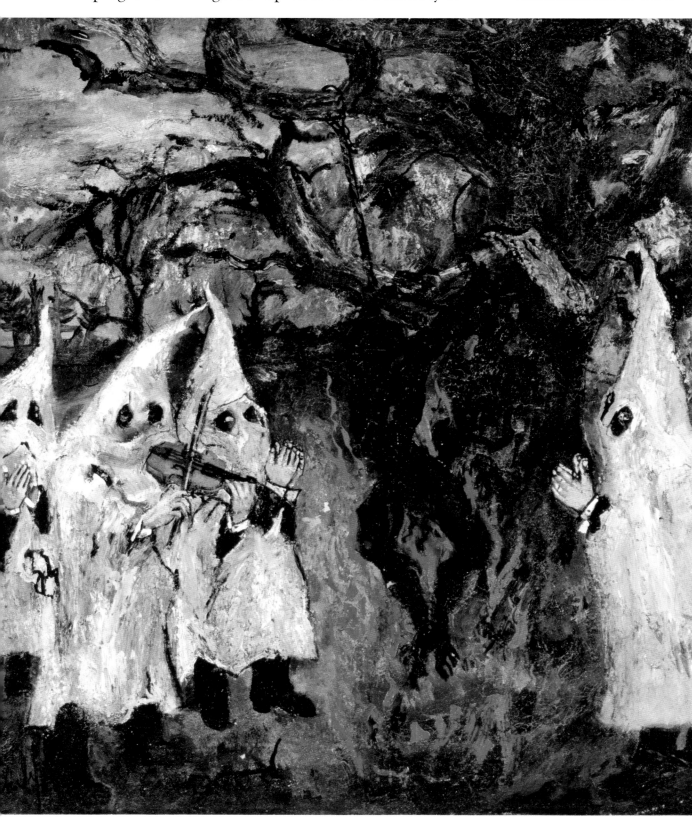

LEFT: Philip Evergood (1901–73)
The Hundredth Psalm.
Ca. 1938–39.
Oil on canvas, 20 x 16 ⅛ in.
(50.8 x 41 cm).
Purchase: Miriam and Milton Handler and Kristie A. Jayne Funds. The Jewish Museum, New York, New York.

As one of the foremost Social Realists of twentieth-century art, Philip Evergood expressed his support of victims of social injustice through paint with the same militant energy displayed in the strikes and protests for which he was sometimes arrested. *The Hundredth Psalm,* named for David's song of thanksgiving, is a pointed attack on the hateful atrocities of the Ku Klux Klan.

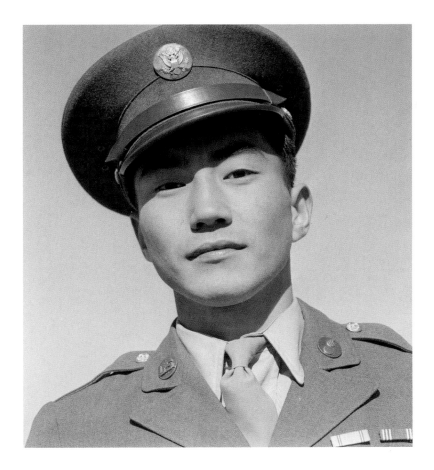

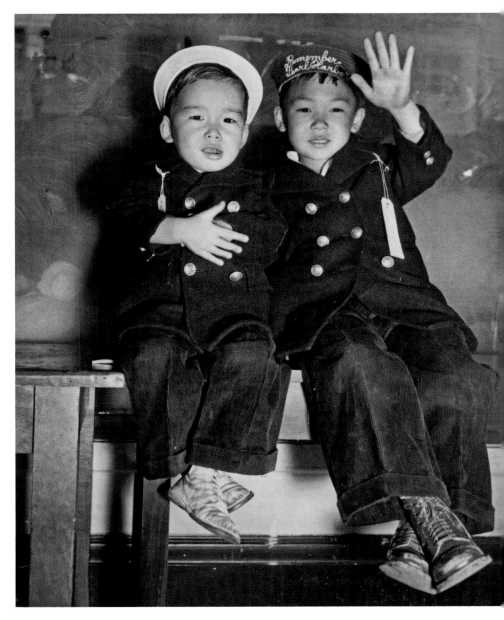

LEFT: Ansel Adams (1902–84)
Corporal Jimmie Shohara Has Two Ribbons. 1943.
Photograph.
Library of Congress.

Corporal Jimmie Shohara, wearing two military ribbons, was one of more than 10,000 Japanese interned at Manzanar Relocation Center in California's Sierra Nevada. Their story of creating a community under armed guard, particularly in bringing the landscape to life through farming, was documented by famed photographer and conservationist Ansel Adams.

BELOW: *San Francisco Evacuation: Two Japanese Boys.* 1942.
Photograph.
Library of Congress.

After Pearl Harbor, the U.S. government ordered the incarceration of Japanese Americans and resident aliens in military-style internment camps. Ten camps interned 110,000 men, women, and children, including these two Japanese boys from San Francisco, escorted away by the U.S. Army Signal Corps. One boy wears a hat with a band reading "Remember Pearl Harbor."

Although such direct aid to its enemies might well have put Germany on a quick path to war with the U.S., America entered the global conflict in the Pacific, rather than on the sea lanes of the North Atlantic. On December 7, 1941, the Japanese Navy launched a surprise attack on Pearl Harbor, on the Hawaiian island of Oahu, headquarters of the U.S. Pacific Fleet. As the tremendous losses in ships, planes, and lives were tallied, the president asked for and received a congressional declaration of war on the following day. Similar declarations were pronounced by and against Germany and Italy within a matter of days.

Despite the increased production of war materiel and the initiation of selective service, the United States was far from prepared for a global conflict—particularly in view of the massive damage done to the Pacific fleet by the Pearl Harbor attack. Nevertheless, the United States had several advantages that enabled it to overcome its relative lack of preparedness and assume an effective role among the Allied powers—which, again, at this stage of the war meant only Britain and its colonial possessions and associated autonomous dominion states. France had been defeated and occupied by Adolf Hitler's Germany in June of 1940, and the Soviet Union had not yet been

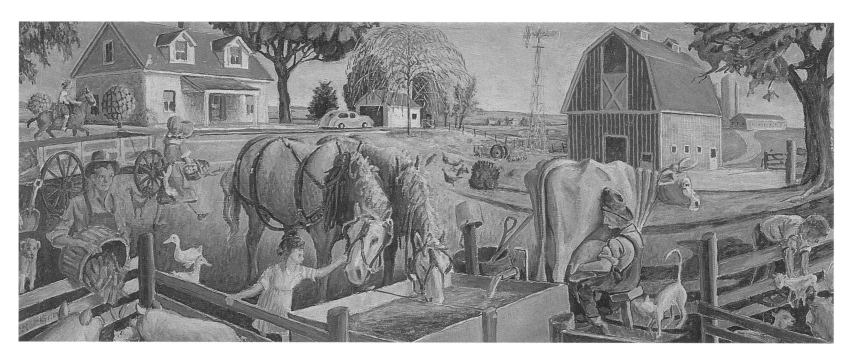

Orr C. Fisher (1885–1974)
Evening on the Farm (Mural study, Forest City, Iowa, Post Office).
Ca. 1942. Oil on fiberboard, 17 x 31 ¾ in. (43.0 x 80.6 cm).
Smithsonian American Art Museum, Washington, D.C.

The prestigious arm of FDR's Federal Art Project was the Section of Fine Arts of the Public Buildings Administration of the Federal Works Agency, or "the Section" for short, selecting artists by competition to decorate public buildings with high-quality art. This mural study was one of two such pieces created by Orr C. Fisher for Iowa post offices; the other one, titled *The Corn Parade* and painted in 1941, was for the facility in Mount Ayr.

This was England's near-miraculous success in holding out against Germany's relentless air assault in the "Battle of Britain" that had been waged over the island nation and the English Channel in the late summer and early autumn of 1940. Inspired by Prime Minister Winston Churchill, who had reversed the near-defeatist stance of previous British governments and stiffened his nation's resolve to remain the last European holdout against Nazi aggression, the nation had refused to succumb to Germany's terror-bombings of civilian populations—the "Blitz"—and its air force had denied the German Luftwaffe the mastery of the skies that would have made a cross-Channel invasion feasible. Had Germany overrun the British Isles, direct air assaults on the North American mainland would have loomed as an ever more likely possibility; and the U.S. would have been denied the use of Britain as a staging area for its own bombing campaigns against continental targets, and for the eventual massing of forces for the invasion of western Europe.

Great Britain had bought the United States time—and, in a sense, so had Hitler, by making what is generally considered his biggest mistake of the war: attacking the Soviet Union without having first knocked Britain out of the conflict. Another gift of the British to the United States was its leader. Winston Churchill and Franklin Roosevelt, although not always in complete agreement on strategy, forged one of the great working friendships among wartime allies. An encounter with FDR, Churchill once said, "was like uncorking your first bottle of champagne."

> *"An encounter with FDR, Churchill once said, 'was like uncorking your first bottle of champagne.'"*

As the United States prepared to throw its industrial and military muscle into the fray, its government was fundamentally altered. During the Great Depression, federal authority had been broadly increased, and the number and scope of government departments and programs had grown at an unprecedented pace. The war accelerated this trend. Washington now had authority over consumer prices,

Stuart Davis (1894–1964)
Report from Rockport. 1940.
Oil on canvas, 24 x 30 in.
(61 x 76.2 cm).
Edith and Milton Lowenthal
Collection, Bequest of Edith
Abrahamson Lowenthal, 1991.
The Metropolitan Museum of Art,
New York, New York.

Believing that art is by definition
artificial and therefore not
representative of nature, Stuart
Davis presented the painting
itself as its own reality. His use of
saturated hues in jazzy Cubist
compositions breathed a fresh
air of modernity into the
American Scene movement, as
exemplified by *Report from*
Rockport, an exuberant portrait
of small-town New England.

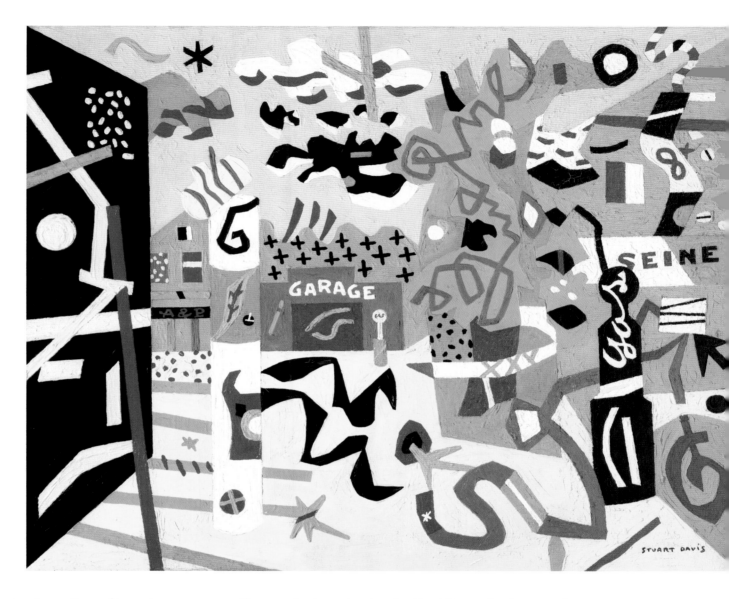

and initiated a system of rationing of gasoline, tires,
and strategic food supplies. Manufacture of
nonessential consumer goods, automobiles in
particular, was suspended for the war's duration.
Contrary to the rosy picture often painted of the
World War II "home front," there was plenty of
grumbling over rationing, and plenty of black market
activity. But there was an undeniable cohesiveness
among American civilians during the war years, a
spirit sharpened by the suddenness of the Japanese
attack on Pearl Harbor, and a growing awareness that
the struggle was not about narrow political advantage
on the world stage, not about balances of power or
colonial prizes, but about the survival of humane
civilization. There was very little heard from
isolationists after December 7, 1941.

Although the U.S. scored a symbolic stroke against
Japan with a bombing raid on Tokyo in April 1942, its

first real victories in the Pacific took place at the
battles of the Coral Sea, in May of that year, and
Midway in June. But Japan's conquest of the
Philippines, accompanied by the humiliating capture
of that archipelago nation's American defenders, set
the stage for a long, bitter campaign across the
Japanese-held islands of the Pacific. This "island
hopping" phase of the war began in deadly earnest
with the landing of American troops at Guadalcanal,
in the Solomon Islands, in June 1942. It would continue
for more than three years, as the U.S. drove the
Japanese farther back, island by island, to their
homeland. The Philippines were not retaken until July
1945, the same month in which the bloody battle for
Okinawa, the last stepping-stone to Japan itself, was
won by the Americans.

The United States was not able to immediately
engage in ground combat in the European theater of

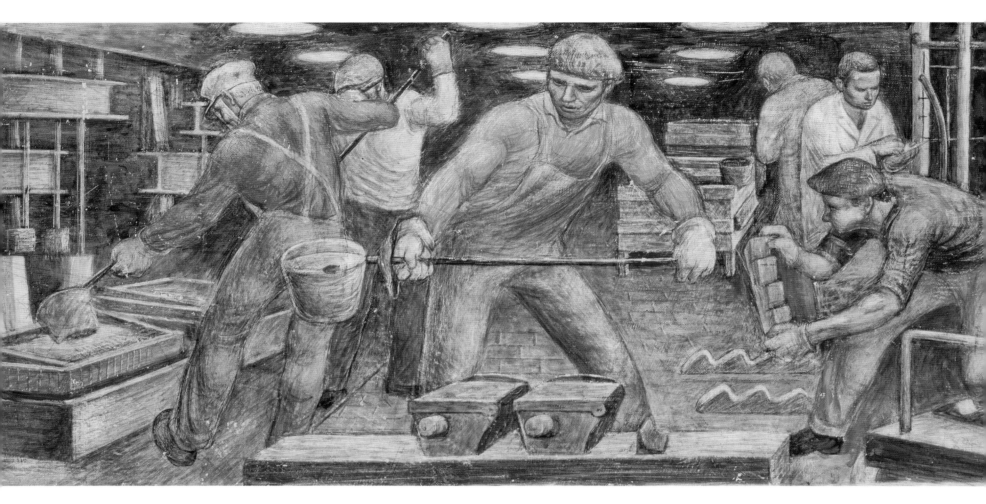

Henry Bernstein (1912–64)
Fabricating Steel, or *Steel Casting* (Mural study, Midland, Michigan, Post Office). Ca. 1934–43.
Tempera on canvas, 11 ⅝ x 25 in. (29.5 x 63.5 cm).
Smithsonian American Art Museum, Washington, D.C.

Between its establishment in 1934 and its demise in 1943, the Treasury Department's Section of Fine Arts commissioned more than 1,400 works of art for public buildings. Many of these were murals for New Deal post offices constructed in those years. Like Henry Bernstein's steelworker mural, they depicted the more heroic side of the American Scene rather than Social Realism's construction accidents or breadlines.

the war; for the most part, hostilities against Germany during most of 1942 were limited to protection of naval convoys carrying supplies to Britain and the Soviet Union in the "Battle of the Atlantic" against German U-boats. But in November 1942, American forces landed in North Africa, to join with the British in pushing back the German Afrika Korps under Field Marshal Erwin Rommel. By July 1943, the British and Americans had leaped the Mediterranean to seize Sicily, after which they began an arduous campaign up the length of the Italian peninsula. The enemy in Italy was not the Italian army—after the loss of Sicily, Hitler's Italian ally Benito Mussolini was overthrown,

and German armies stood against the Allied advance. Rome was not liberated until June of 1944, and German forces held out in the far north of Italy until the war's end. What Churchill had called the "soft underbelly" of Europe, and his preferred path to Germany itself, had proven to be not so soft at all.

While the Russians relentlessly pushed the Germans westward across the Soviet and eastern European territory the Nazi armies had so swiftly conquered in the war's opening phase, Soviet leader Joseph Stalin finally got the initiative he had long asked for from the western Allies. On June 6, 1944, American, British, and Canadian forces staged the greatest amphibious assault in history on France's Normandy coast. Germany had expected the invasion, although not at that particular location; nevertheless, the Nazi defenses were formidable, and preliminary Allied naval barrages had not been effective in neutralizing them. It took more than a month for the Allies to break free of the coastal areas they had initially seized, but by August Paris had been liberated, and the drive toward Germany itself had

begun. Despite a fierce German counterattack in the Ardennes forest in December 1944—the "Battle of the Bulge"—the Nazi war machine was doomed by an exhaustion of its manpower resources, the 'round-the-clock bombing of industrial centers (as well as of civilian populations), and the impossibility of continuing to wage a two-front war. As Soviet forces drove ever nearer to Berlin, the Americans crossed the Rhine on March 23, 1945. Five weeks later, Hitler committed suicide in his bunker beneath the rubble of his capital as Soviet troops advanced into the city. One week after Hitler's death, Germany surrendered.

Americans' celebration of the victory over Germany was muted by the knowledge that Japan was still fighting fiercely, and, more immediately, by the grieving that followed the sudden death of President Roosevelt, who had succumbed to a cerebral hemorrhage on April 12. Harry S. Truman, elected vice-president when Roosevelt was returned to the White House for a fourth term the preceding November, assumed the presidency and the prosecution of the war. The most momentous decision of Truman's career—and one of the most momentous in American history—was made by the president as he attended a conference of the European victors at Potsdam,

Germany, that summer. Faced with a fanatically intransigent Japanese military leadership, and with the prospect of an estimated million American casualties in the event of an invasion of Japan's home islands, Truman gave the order to drop an atomic bomb on the city of Hiroshima on August 6, 1945. When the demanded Japanese surrender was still withheld, an American plane dropped a second atomic bomb on Nagasaki.

Japan surrendered on September 2. A postwar era far different than that which had followed the First World War had begun—an era dominated by fear of the terrible new weapon that had so abruptly ended hostilities, and by a new sort of hostility, cold and implacable, among nations that had so recently been allies against a common foe.

Marvin Beerbohm (1908–81)
Automotive Industry (Mural, Detroit Public Library). Ca. 1935–43.
Oil on canvas mounted on board, 78 x 184 in. (198.1 x 467.4 cm).
Smithsonian American Art Museum, Washington, D.C.

Besides post offices, public libraries also were decorated with murals by artists from the Treasury Department Section of Fine Arts, this one by Marvin Beerbohm, an art teacher in the Detroit public schools and a colleague of Henry Bernstein. The Detroit Public Library had been built earlier in the century, and Beerbohm's mural pays homage to the city's automotive industry.

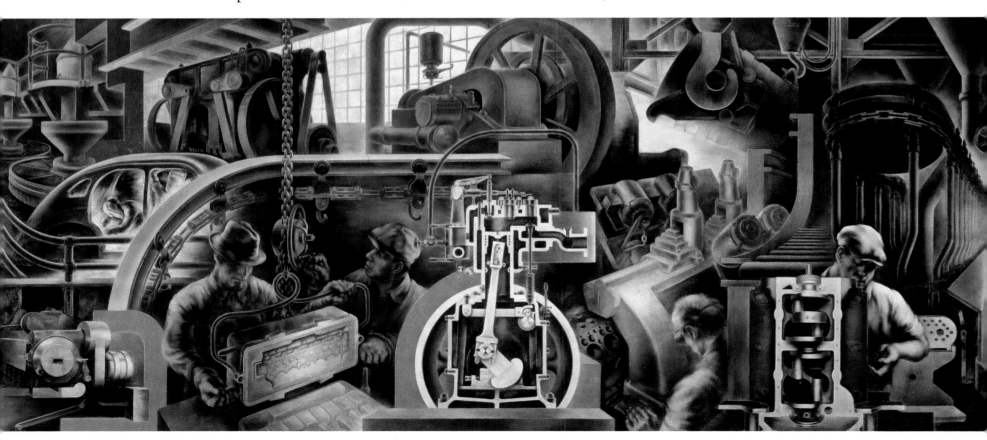

The Liberty Ships

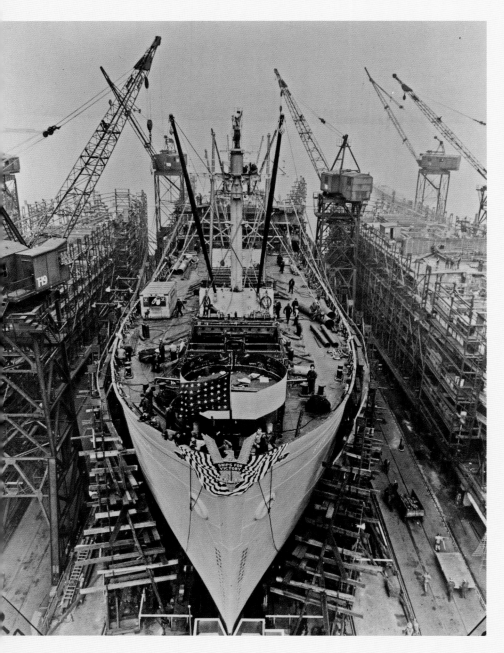

"Construction of a Liberty Ship," in St. Louis Post-Dispatch. May 23, 1943.
Photograph.
Library of Congress.

Called "Liberty ships" for their objective in securing liberty for Europe,
and "Ugly Ducklings" for their looks, these steam freighters were quick to
build because they were made of sheet metal welded, not riveted,
together. During the war, 18 American shipyards, including Bethlehem-
Fairfield near Baltimore, produced a total of 2,751 Liberty ships, at a rate
of three a day by 1943.

When the United States entered the Second
World War, one problem that had to be
addressed immediately involved the
shipping of vast amounts of weapons, ammunition,
fuel, and other materiel to European war zones. It was
clear that the existing American merchant fleet was
hardly equal to the task—especially given the terrible
attrition caused by German U-boats, which prowled
the shipping corridors of the North Atlantic and
succeeded in sending thousands of tons of vital cargo
to the bottom.

*"Built with assembly-
line speed and completed,
at the peak of the program,
at the rate of three per day,
the doughty freighters made
an incalculable contribution
to the war effort."*

America's response was an unprecedented
shipbuilding program that led to the construction of
some 5,500 vessels, the most famous of which were the
2,710 Liberty ships. Built with assembly-line speed and
completed, at the peak of the program, at the rate of
three per day, the doughty freighters made an
incalculable contribution to the war effort.

Based on a British design that was modified by the
United States Maritime Commission with an eye
toward faster and cheaper construction methods, the
ships were given their name—and, allegedly, a less

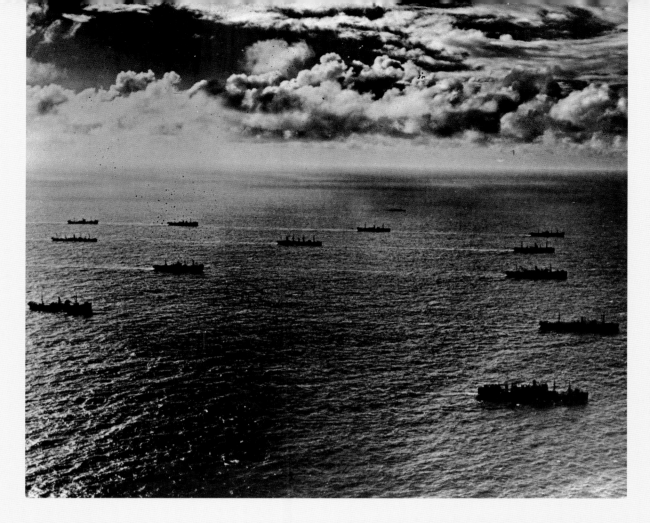

Liberty Ships in a Convoy of Cargo Ships. Ca. 1942. Photograph. *Library of Congress.*

The United States' ability to build and launch Liberty ships at a faster rate than German U-boats could sink them gave the Allies the advantage by enabling crucial delivery of guns, tanks, and planes to the various European battlefronts. This photograph shows Liberty ships in a section of a convoy of other cargo ships.

attractive nickname—by President Franklin D. Roosevelt. The vessels, he publicly proclaimed, would help bring liberty to Europe. But in a private conversation with Admiral Emory Land, commissioner of the Maritime Administration, the president is supposed to have approved of the design's serviceability, but called it a "real ugly duckling."

But beauty contests were not part of the plan for the Liberty ships. Typically 440 feet in length and powered by a 2.5-million-horsepower, oil-fired steam engine, the ships' most important feature was a cavernous cargo hold that could carry the equivalent of 300 railroad boxcars.

The order for the ships was given to a consortium called the Six Companies, led by Henry J. Kaiser. Kaiser, whose named later appeared on the Kaiser automobile, was an industrialist renowned for his organizational and problem-solving skills. He adopted a modular construction system, assembling the ships in sections by means of welding rather than the traditional riveting method (workers included many of the first women to be employed in American shipyards—in this instance, the "Rosie the Riveter" image wasn't altogether accurate). At first, each Liberty ship took nearly eight months to build, but the average construction time was eventually reduced to a

blazingly fast six weeks. As a special demonstration project, a crew assembled and launched the *Robert E. Peary* in four days, 15 ½ hours, although much interior outfitting remained to be completed after the ship went into the water.

There was a price to pay for so much speed and economy, as a number of the earlier Liberty ships developed cracks in their hulls and decks; 19 of them actually broke in half. Studies showed that the effect of frigid seawater on the type of steel used, and not the welding, was at fault; still, welded hulls allowed cracks to spread farther while rivets would have impeded their progress. Eventually, the ships were reinforced to address the cracking problem. But a greater danger— from German torpedoes—took a terrible toll until the Battle of the Atlantic was won.

Of the hundreds of Liberty ships that survived the war to take up peacetime cargo-carrying duties throughout the world, only two survive today. The *John W. Brown*, a floating museum in Baltimore harbor, takes passengers for occasional nostalgia cruises on the Chesapeake Bay. Another restored Liberty, the *Jeremiah O'Brien*, took a far longer trip in 1994: steaming from San Francisco to France, she was the only large ship to serve in the D-day invasion, and then return to Normandy for the 50th anniversary ceremonies.

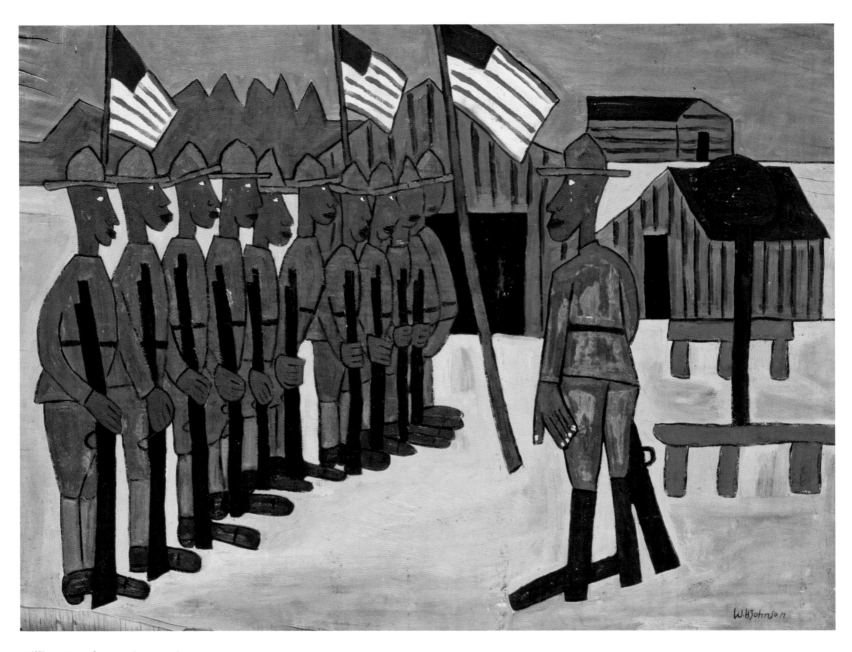

William H. Johnson (1901–70)
Training for War, or *In the Army.* 1941–42.
Oil on plywood, 37 ¾ x 49 ¼ in. (95.9 x 125.1 cm).
*Gift of the Harmon Foundation. Smithsonian American Art Museum,
Washington, D.C.*

The U.S. military was still segregated in World War II, and although blacks
saw little action, a number of all-black support units on the battlefronts
distinguished themselves, paving the way for Truman's 1948 order to
desegregate the Armed Forces. African American folk artist William H.
Johnson warmly portrays the patriotism of black enlistees.

RIGHT: **Herbert Bayer** (1900–85)
Grow It Yourself, Plan a Farm Garden Now. 1941–43.
Color silkscreen poster.
Library of Congress.

To free up commercial agriculture for feeding the troops, the U.S. Department of Agriculture urged families and communities to supplement their rations with "victory gardens." These continued in practice after the war as well, when relief shipments of food were needed in war-torn Europe. Poster artist Herbert Bayer is noted for designing the classic Bauhaus typeface Universal.

LEFT: **Jean Carlu** (1900–97)
Production, America's answer!
1941.
Color poster.
Library of Congress.

French poster artist Jean Carlu was in service to the French Information Service's exhibition "France at War" at the New York World's Fair when Hitler took over Paris in 1940. Unable to return, the one-armed artist (disfigured in youth by a trolley accident) remained in New York, creating war posters like this one proclaiming the importance of industry to the war effort.

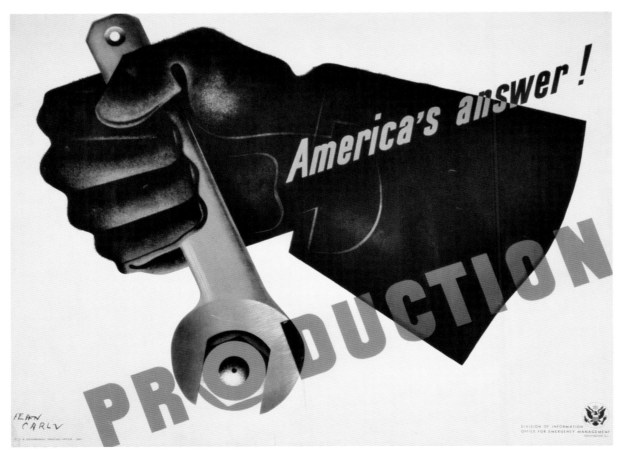

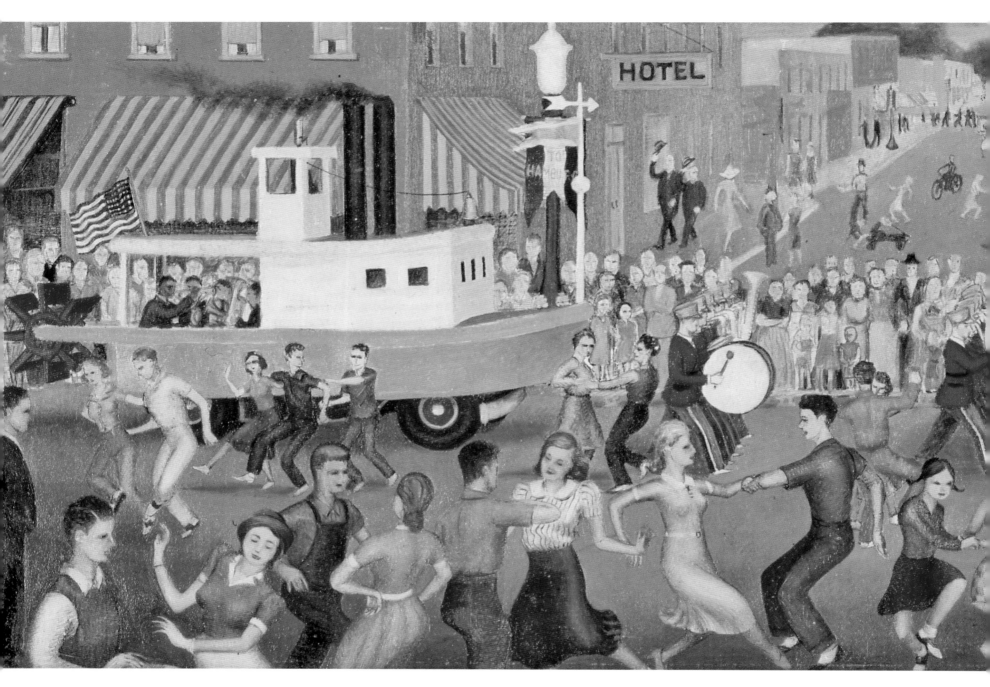

William Edward Lewis Bunn (b. 1910)
Peony Festival at Hamburg (Mural study for the Hamburg, Iowa,
Post Office). 1941.
Tempera on fiberboard, 8 ³⁄₁₆ x 24 ³⁄₁₆ in. (20.8 x 61.4 cm).
Smithsonian American Art Museum, Washington, D.C.

Section muralists William E. L. Bunn and Bertrand Adams were protegés
of Grant Wood (known to all for his iconic *American Gothic* farm
couple). When Wood was not available for the Dubuque, Iowa, post
office mural, the commission was split between Bunn and Adams.
The Hamburg, Iowa, post office mural was Bunn's own, and he also
made murals for post offices in Nebraska and Kentucky.

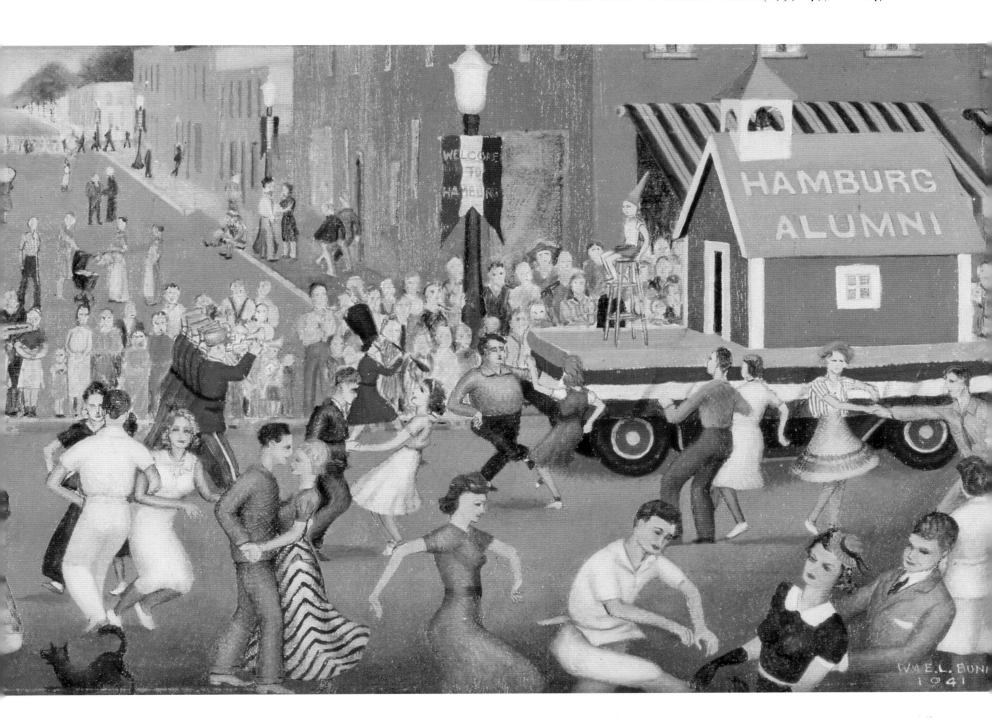

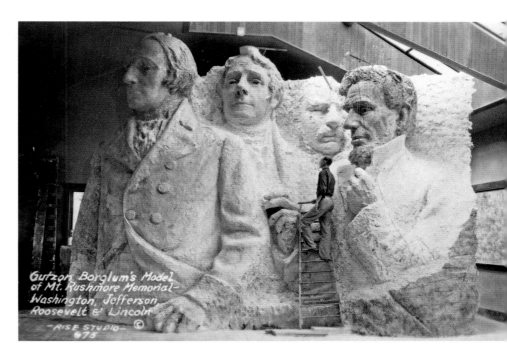

ABOVE: *Gutzon Borglum's Model for the Mount Rushmore Memorial.*
Ca. 1936.
Photograph.
Library of Congress.

Gutzon Borglum's plaster model for the colossal sculpture at Mount Rushmore was carved on a 1 to 12-in. scale; the dimensions were transferred onto the site by a point system, whereby each inch on the model became one foot on the mountain.

LEFT: Gutzon Borglum (1867–1941)
Mount Rushmore, Black Hills, South Dakota. Portraits of Presidents George Washington, Thomas Jefferson, Theodore Roosevelt, and Abraham Lincoln. 1927–41.

Carving the busts of four presidents atop Mount Rushmore was literally a monumental effort involving Gutzon Borglum's team of granite-carvers in 14 years of labor that ended when funds ran out. George Washington stands for independence, Thomas Jefferson for democracy, Theodore Roosevelt for international leadership, and Abraham Lincoln for equality.

RIGHT: Howard R. Hollem (fl. twentieth century)
Mrs. Hazel Wheeler Places Screws Into Electric Terminals. January 1942.
Photograph.
Library of Congress.

Hazel Wheeler, shown here placing screws into electric terminals, was one of 6 million women who went to work in the nation's factories producing munitions and materiel for the war effort. Mrs. Wheeler's upbeat mood at the time of this photograph can be attributed to recent confirmation that her son, attached to a naval medical unit in Pearl Harbor, was not harmed in the December 7 attack.

BELOW: Alfred T. Palmer (1906–93)
Marian Anderson Christens the S.S. Booker T. Washington.
September 29, 1942.
Photograph.
Library of Congress.

The S.S. *Booker T. Washington* was the first of 17 Liberty ships named for a black American, the noted educator and founder of Tuskegee Institute. Its captain, Hugh Mulzac, was the first black to command a ship of the U.S. Merchant Marine (one of the few integrated crews). Appropriately, the ship's christening was performed by celebrated black contralto Marian Anderson, on September 29, 1942.

OPPOSITE: Martha Moffett Bache (1893–1983)
Wartime Marketing. 1942.
Oil on canvas, 24 ⅜ x 19 in. (61.8 x 48.2 cm).
Smithsonian American Art Museum, Washington, D.C.

Consumer habits changed during World War II, with the rationing of everything from gasoline to canned peaches. The Office of Price Administration issued coupons with point values that varied in response to supply and demand, a system that provided for governmental control over the nation's fluctuating goods while also giving the American people the liberty to choose how they used their points.

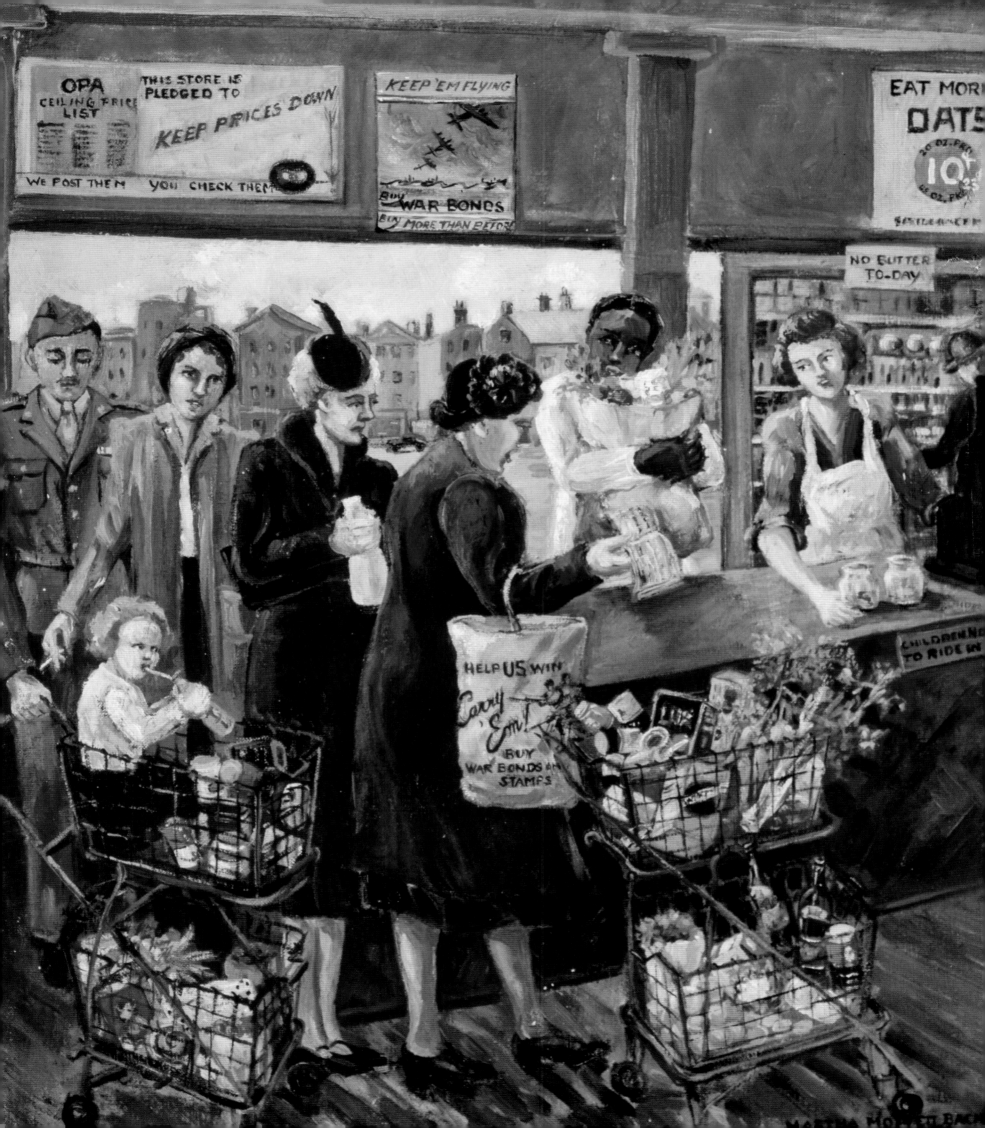

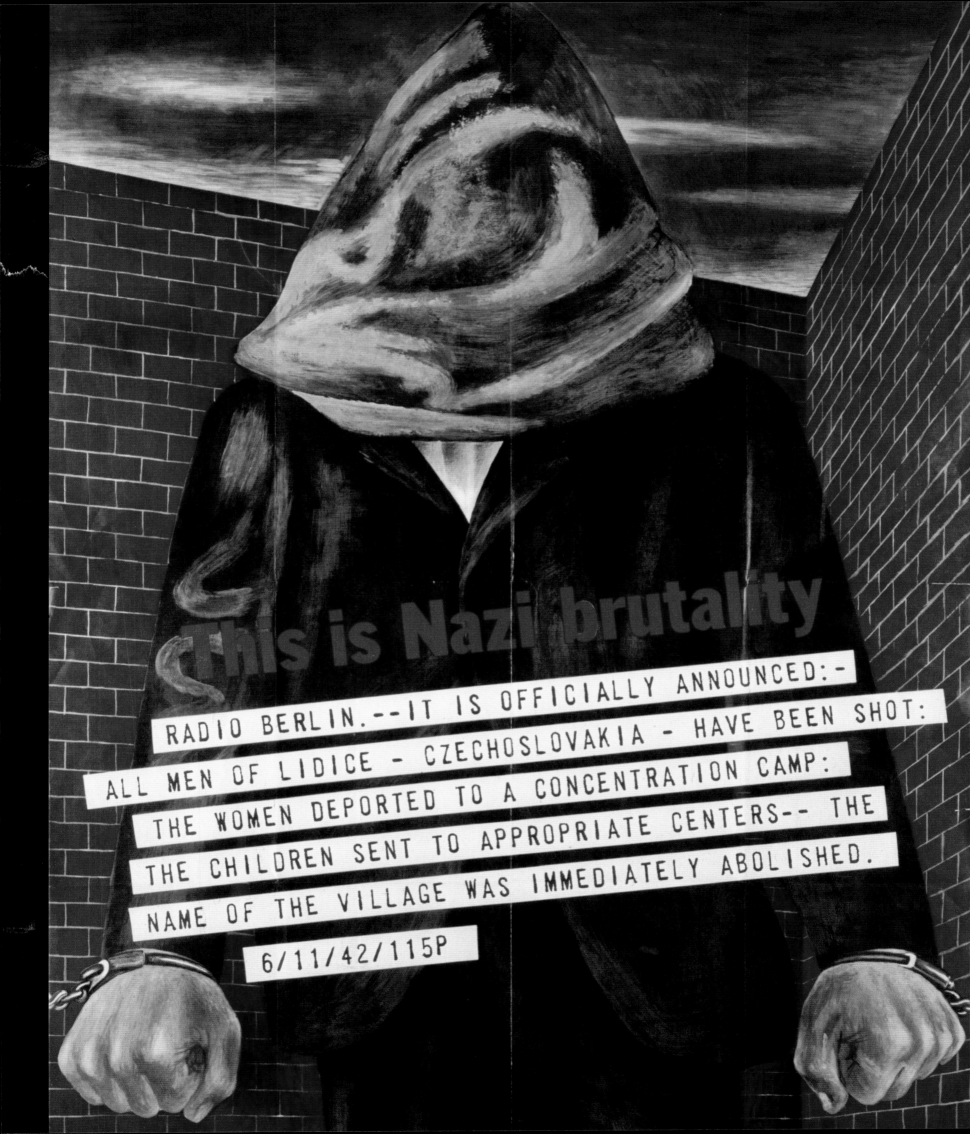

BELOW: **Thomas Hart Benton** (1889–1975)
Back Him Up. Early 1940s.
Oil on masonite, 48 ¼ x 35 in. (122.6 x 88.9 cm).
Private Collection.

Atrocities of the war in Europe cast Thomas Hart Benton into a malaise of creative sterility, but the attack on Pearl Harbor raised a fire of anger that propelled him to productivity. *Back Him Up* is a sympathetic portrait of a military man, behind him two farmers lending hand-on-shoulder moral support. The painting was used in a poster to sell war bonds.

ABOVE: **Norman Rockwell** (1894–1978)
Freedom from Fear, in *The Saturday Evening Post,* March 13, 1943.
From the Permanent Collection of Norman Rockwell Museum, Stockbridge, Massachusetts.

Freedom of speech, freedom of worship, freedom from want, and freedom from fear—these Four Freedoms, the fundamental liberties of everyone in the world, were first articulated in FDR's 1941 State of the Union speech, a call to the American people to aid the Allies. Norman Rockwell's *Four Freedoms* were serialized with essays in the *The Saturday Evening Post*, and used to sell war bonds.

OPPOSITE: **Ben Shahn** (1898–1969)
This is Nazi brutality. 1942.
Poster.
Imperial War Museum, London.

"Radio Berlin.—It is officially announced:—All men of Lidice – Czechoslovakia – have been shot: the women deported to a concentration camp: the children sent to appropriate centers—the name of the village was immediately abolished. 6/11/42/115P." Ben Shahn's poster for the U.S. Office of War Information was a chilling exposé of the Nazi massacre of Lidice, a Bohemian village outside Prague that was burned to the ground, with everyone save a dozen children executed, in brutal retaliation for the assassination of a Nazi official.

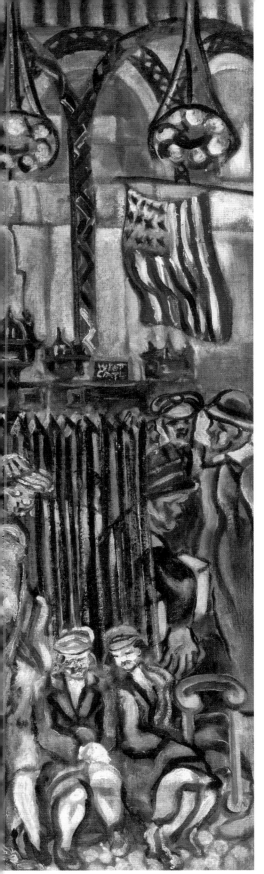

LEFT: Joseph Delaney (1904–91)
Penn Station at War Time. 1943.
Oil on canvas, 34 x 48 ⅛ in. (86.4 x 122.3 cm).
Smithsonian American Art Museum, Washington, D.C.

The panoramic view of *Penn Station at War Time,* with its crowd of
weary travelers from all walks, reflects Joseph Delaney's enthusiasm for
everyday people. Devoted all his life to removing the barriers of racial
discrimination, he developed his swirling American Scene style under
the tutelage of Thomas Hart Benton at the Art Students League, and also
created works for the Federal Art Project.

BELOW: William B. Finley (fl. twentieth century)
Keep Mum, Loose Talk Costs Lives. 1941–43.
Color silkscreen print on poster board.
Library of Congress.

Among the war posters created by artists of the Federal Art Project were
a special group urging civilians not to chatter about the movement of
loved ones in the military. This poster, by William B. Finley, depicts a train
exploding, and warns: "Keep mum. Loose talk costs lives," suggesting
that saboteurs acted on careless chatter.

LEFT: **Felix W. de Weldon**
(1907–2003)
U.S. Marine Corps War Memorial. 1945–54.
Washington, D.C.
Bronze.

Nine years in the making, the iconic U.S. Marine Corps War Memorial commemorates the retaking of Iwo Jima in World War II, but it is dedicated to all Marines who have given their lives since 1775. The monument is modeled on the Pulitzer Prize–winning photograph by Joe Rosenthal and clay models of the faces of three of the surviving Marines. By presidential proclamation, the cloth flag flies 24 hours a day.

OPPOSITE: *Atomic Bomb Explosion, Hiroshima.*
August 6, 1945.
Photograph.

To avoid the loss of a million fighting men in a land war with Japan, President Truman issued the order to drop an atomic bomb on the city of Hiroshima. The blast killed as many as 200,000 Japanese civilians, but Japan did not back down. A second bomb, on the Nagasaki shipyards a few days later, combined with Russia's attack at Manchuria, broke Japan's intransigence, ending the world war, and ushering in the Cold War.

ABOVE: Jackson Pollock (1912–56)
Silver over Black, White, Yellow, and Red. 1948.
Enamel primer on canvas, 24 x 32 in. (61 x 80 cm).
Musée National d'Art Moderne, Centre Georges Pompidou, Paris.

Inspired by Navajo sand painting, Jackson Pollock tacked his canvas to
the floor and moved around it, flinging and drizzling paint from all
directions. Wife Lee Krasner deferred her own career to support Pollock,
the icon of Abstract Expressionism who, according to rival Willem de
Kooning, "broke the ice" in painting.

OPPOSITE: Mark Rothko (1903–70)
Untitled. 1949.
Oil on canvas, 32 x 23 ⅝ in. (81 x 60 cm).
Collection, Christopher Rothko.

Friendship with expressionist Milton Avery inspired Russian émigré Mark
Rothko to develop Color Field painting, where large patches of color
invite mystic contemplation of infinity. Rothko's avowed interest was not
the personal but the "tragic and timeless," a view shared by Adolph
Gottlieb and Barnett Newman.

But as the dust settled over the vast devastation of
World War II, no such retreat into isolationism was
possible. Far from simply taking its place as an equal
among the victors, the U.S. was in an overwhelmingly
dominant position, having been unscathed by bombing
of civilian and industrial targets and in possession of
the most powerful military machine—and the most
destructive weapon—in the world. But more important
still was the new dichotomy that had suddenly taken
shape in world affairs: with Nazi Germany and
imperial Japan vanquished, a new adversary had arisen
from the ranks of America's former allies. The Soviet
Union, still ruled by Joseph Stalin, sought to work its
will upon a prostrate Europe, and to extend its
influence throughout the world in a manner inimical
to the ways of the western democracies that had helped
it to defeat Hitler. In Winston Churchill's words, "an

iron curtain has descended across Europe"—and the global politics of the coming decades would be dominated by the Cold War, and the very hot proxy wars, that would engage the implacable powers that stood on either side of that curtain.

Throughout the postwar era, the domestic atmosphere in the United States was substantially influenced by the tense, protracted conflict with the Soviet Union. There had been a "Red Scare" in the years following World War I, as well, although that brief episode was primarily fueled by fears that foreign revolutionaries would bring Bolshevism, newly triumphant in Russia, to the United States. Now, the fear was of armed conflict between the U.S. and the Soviet Union, especially after the Soviets' arsenal came to include atomic and, later, hydrogen bombs. Alarmed at the U.S.S.R.'s sudden nuclear parity with the United States, Americans were quick to assume that domestic treachery was involved, and the hunt for traitors who had presumably given atomic secrets to the Russians loomed large on the American political and legal landscape in the late 1940s and early 1950s. The hunt

"In Winston Churchill's words, 'an iron curtain has descended across Europe'— and the global politics of the coming decades would be dominated by the Cold War, and the very hot proxy wars, that would engage the implacable powers that stood on either side of that curtain."

OPPOSITE: Philip Johnson
(1906–2005)
Glass House, New Canaan, Connecticut. 1949.

Philip Johnson coined the term "International" style to describe the sleek steel-and-glass architectural designs of Le Corbusier, Mies van der Rohe, and others he had seen in Europe in the 1920s. His own home in Connecticut takes glass-box construction into a non-urban setting where occupants can feel at one with nature.

RIGHT: Willem de Kooning
(1904–97)
Woman I. 1950–52.
Oil on canvas, 75 7/8 x 58 in. (193 x 147 cm).
The Museum of Modern Art, New York, New York.

During the 1930s Dutch émigré Willem de Kooning shared a studio with Arshile Gorky, who introduced the concept of "biomorphism," where shapes suggest but do not represent living organisms. Later, de Kooning asserted that "even abstract shapes must have a likeness"—but his series on women was largely reviled as grotesque.

for atomic spies culminated in the 1953 executions of Julius and Ethel Rosenberg following their convictions for espionage, but even on a less lethal level, accusations not of spying but merely of Communist sympathies worked their way through all levels of American society. Decades later, after the fall of the Soviet Union, documents came to light which did corroborate the involvement of some Americans with espionage tantamount to treason. But the bulk of the "sympathy" accusations were either baseless, or rooted in individuals' activities in left-wing or antifascist groups during the Great Depression. Investigations by the House of Representatives'

committee on "Un-American Activities," and, more prominent still, by Senator Joseph McCarthy, ruined careers and tainted the reputations of otherwise innocent citizens for years to come.

While preoccupation with the often shadowy issues of loyalty and subversion dominated American political life at home, the confrontation with communism took on a far more tangible aspect in Europe and Asia. At a Harvard commencement speech in June of 1947, Secretary of State George C. Marshall proposed a massive U.S. aid program for the prostrate nations of western Europe. Shepherded successfully through Congress by the Truman administration, the Marshall Plan became a

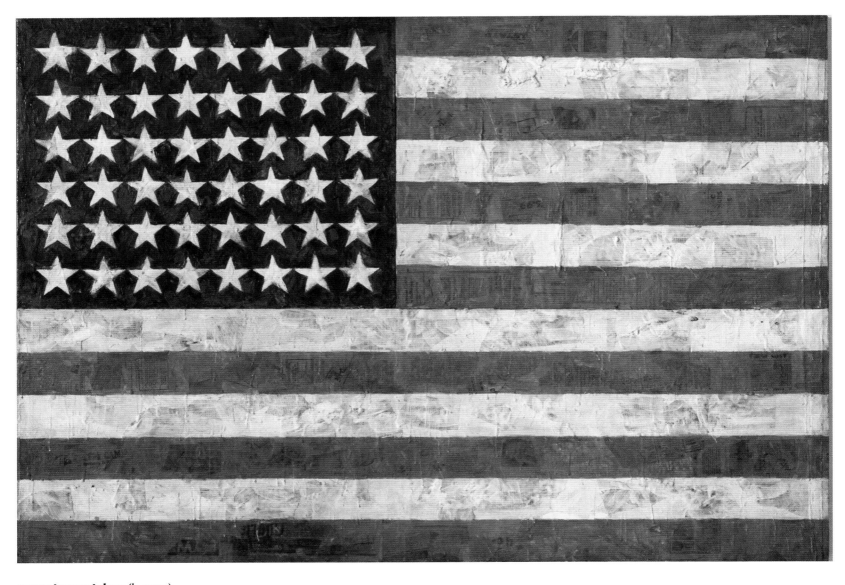

ABOVE: Jasper Johns (b. 1930).
Flag. 1954–55; dated on reverse 1954.
Encaustic, oil, and collage on fabric mounted on plywood
42 ¼ x 60 ⅝ in. (107 x 154 cm).
Gift of Philip Johnson in honor of Alfred H. Barr Jr. The Museum of Modern Art, New York, New York.

After military service, Jasper Johns created window displays for department stores with Robert Rauschenberg, and began creating artworks in encaustics, a wax-paint medium requiring great control to get the desired translucency. The flag provided an appropriate motif for the first work using the new process.

OPPOSITE: Louise Nevelson (1899–1988)
Tropical Garden II. 1957.
Carved and painted wood, 90 ¼ x 114 ⅝ x 12 ¼ in. (229 x 291 x 31 cm).
Musée National d'Art Moderne, Centre Georges Pompidou, Paris.

From playing with wood scraps in her father's lumberyard in Maine, Louise Nevelson grew up to create Assemblage sculptures from found objects—wood, steel, Lucite, and broken household items, rendered more mysterious by matte black paint. She also created wood totems, an interest shared by friend Louise Bourgeois.

bulwark of the American policy of containment of Soviet expansionism, providing much of the wherewithal for the economic and social stabilization of a Europe, which, if left impoverished, might have proven readily susceptible to the westward expansion of Communist influence or even outright control.

On the other side of the world, the nascent Cold War suddenly turned hot. After its liberation from Japanese occupation at the close of World War II, Korea had been divided into Soviet and American zones of occupation, with the line of demarcation at the 38th parallel. On June 24, 1950, the U.S.S.R.'s North Korean client state crossed this border and invaded South Korea. This was the first test of the United Nations, chartered in 1945 as an international organization devoted, in part, to deterring just this sort of aggression. Officially, the response to North Korea's invasion of its southern counterpart was a UN "police

action," and a number of nations were involved. But the bulk of the military effort was American, with World War II hero General Douglas MacArthur in command (until his abrupt removal by President Truman in 1951) and an eventual U.S. casualty count of 148,000, including 33,000 killed. A turning point in the war was the intervention by China, Communist since the 1948 victory of revolutionary Mao Zedong. The Chinese drove American/UN forces south of the 38th parallel, and it was MacArthur's desire to retaliate by attacking China itself that led to his dismissal by Truman, who feared a wider, and perhaps nuclear, confrontation eventually involving the Soviet Union. The war dragged on until July of 1953, shortly after the death of Joseph Stalin, and is largely regarded to have ended in stalemate. The 38th parallel remains the border between a Communist North and a U.S.-aligned South Korea.

President Truman had been reelected in 1948, in a surprise victory over Republican Thomas E. Dewey, but by 1952 public dissatisfaction with the course of the Korean War, and an increasingly conservative public mood after two decades of progressive Democratic administrations, led to the election of retired General Dwight D. Eisenhower as president (Truman had decided not to seek reelection; the defeated Democratic candidate in '52, and again in 1956, was Illinois Governor Adlai Stevenson). Enormously popular because of his high-profile command of U.S. forces in Europe during World War II, Eisenhower presided over a generally prosperous and socially calm era in American domestic life, an era later cast in a negative light as oppressively staid and conformist. The "witch hunt" atmosphere fostered by Senator McCarthy had subsided, especially after McCarthy's 1954 censure by the Senate and the end of

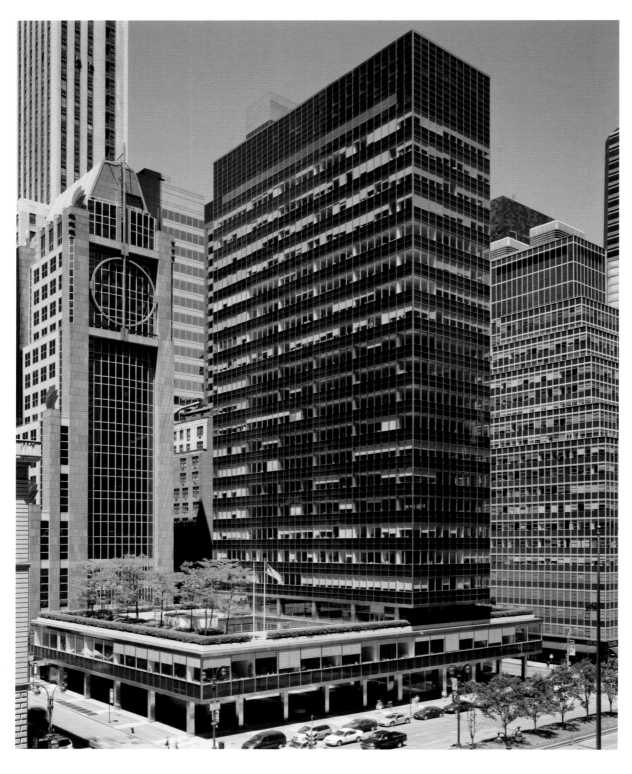

LEFT: **Skidmore, Owings & Merrill**
Lever House, New York, New York. 1951–52.

One of the first buildings erected in Manhattan in the new International style was Lever House on Park Avenue. Not only did its curtain of green-tinted glass on a steel frame stand in contrast to its Beaux-Arts neighbors, but also the building was set off to expose all four walls, relieving the congestion of abutment.

OPPOSITE: **Ludwig Mies van der Rohe** (1886–1969)
Seagram Building, New York, New York. 1958.

Sheathed in amber-tinted glass on a bronze-clad steel frame, the Seagram Building in Manhattan exemplifies Mies van der Rohe's aesthetic of "less is more" construction. Coming to America to flee Nazi persecution, Mies joined Philip Johnson in introducing the new International style to American architecture.

hostilities in Korea; still, the 1950s were not a time conducive to radical or even non-majoritarian points of view. What later social critics often overlook, however, is that the American populace during the Eisenhower years had been exhausted by more than 20 years of economic depression, world war, and the onset of the struggle with Soviet expansionism: if the national mood was one of quiet conformity, of a Hardingesque "return to normalcy," nothing very

different could have been realistically expected.

On the international front, the U.S. continued to pursue anti-Communist policies under Eisenhower and Secretary of State John Foster Dulles, with a particular emphasis on cultivating pro-Western policies on the part of what would later be called "Third World" nations, recently released from European colonial rule. One of those nations, the former French colony of Vietnam, had like Korea been divided along

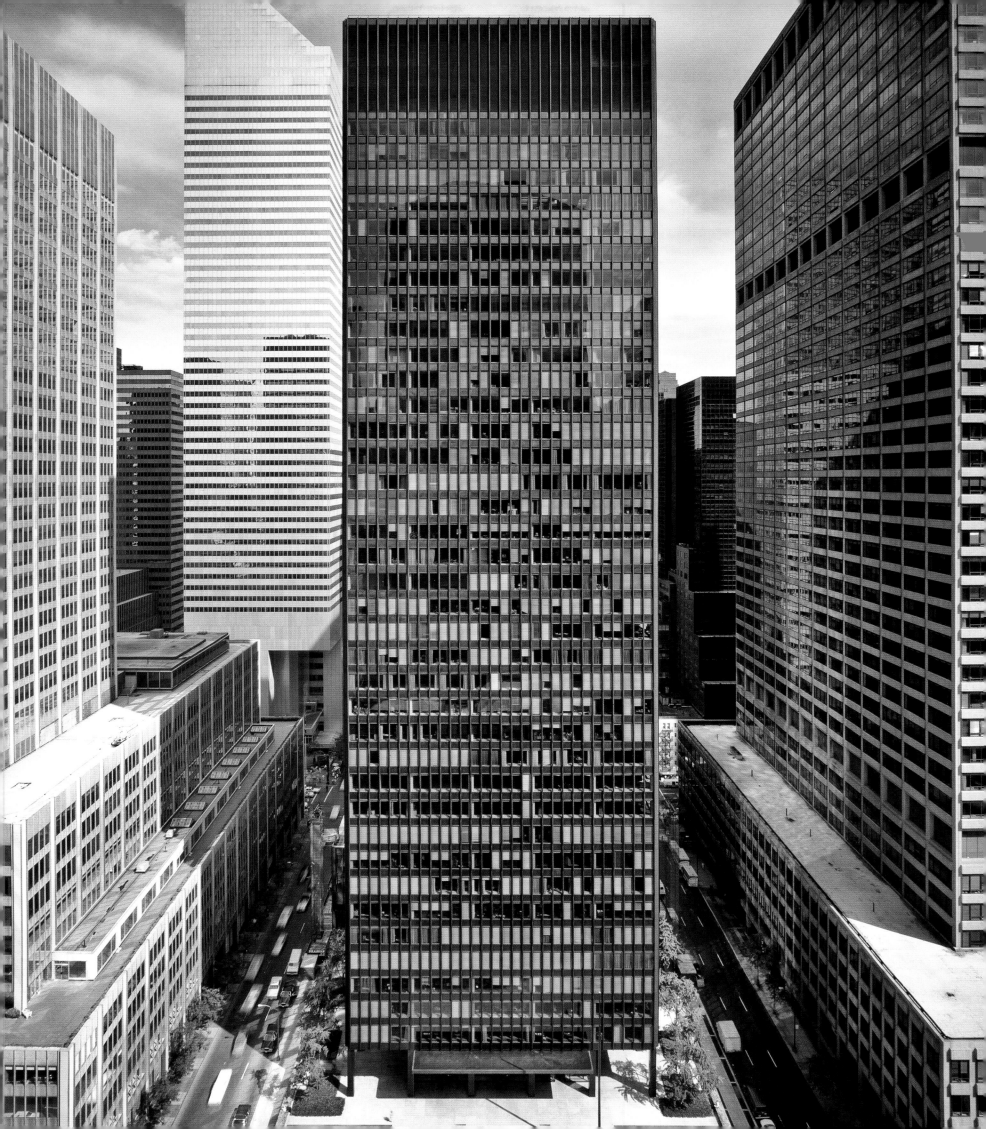

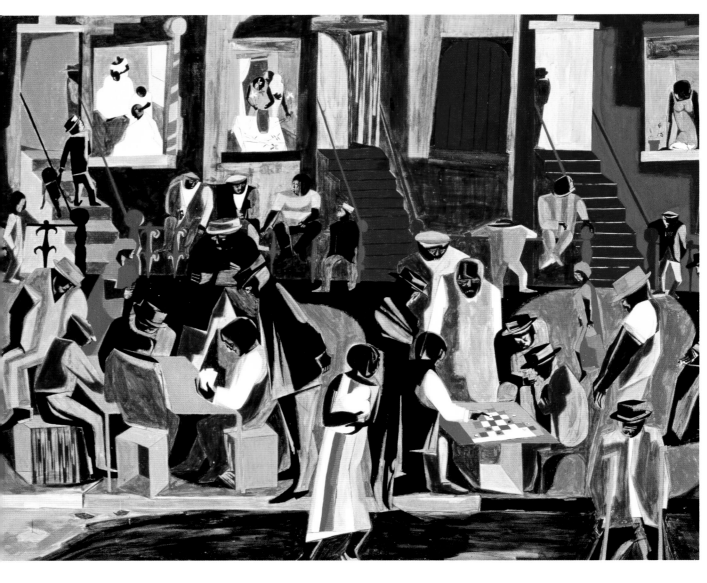

Jacob Lawrence (1917–2000)
Street Shadows. 1959.
Egg tempera on hardboard,
24 x 30 in. (61 x 76 cm).
*Private Collection. New York,
New York.*

Revealing influences of Cubism, Mexican mural painting, and the Harlem Renaissance, Jacob Lawrence's vivid paintings concerned issues of African American life—themes taken up also in the collages of Romare Bearden, the folk art of Horace Pippin, and the tribal paintings of Lois Mailou Jones.

north-south, Communist and pro-Western lines; eventually, the sundered nation's conflict would evolve into a proxy war longer and deadlier than the Korean "police action."

At home, the seeds of the other great struggle of the 1960s were planted with the 1954 ruling of the U.S. Supreme Court in *Brown v. Board of Education*, concerning the segregating of students by race in the Topeka, Kansas, schools—and, by extension, in schools throughout states that had traditionally countenanced segregation. The adamant resistance to desegregation, often abetted by elected officials in states practicing de facto apartheid, came to a head with President Eisenhower's 1957 deployment of federal troops to Little Rock, Arkansas, to support the racial integration of that city's schools. Another seminal event in the early history of what would become known, during the next

decade, as the civil rights movement was the 1955 arrest of Rosa Parks for refusing to give up her bus seat to a white man in Montgomery, Alabama. The subsequent boycott of the city's public transit system by its black citizens was the movement's first organized mass protest, and marked the emergence of the Reverend Dr. Martin Luther King Jr. as a leader in nonviolent resistance to a system of segregation that had been institutionalized in the South since the end of the Reconstruction period.

The Cold War took on a new dimension with the Soviet launching of the first artificial earth satellite, Sputnik, in 1957. Suddenly, competition between East and West became not only a matter of economic success and military prowess, but a struggle over achievement in science's latest frontier. The U.S. initially lagged in the "space race"—the Soviets were

also first to put a man in orbit—but within five years of Sputnik, American satellites, and an American astronaut, were also in earth orbit, and a new administration had set the goal of a manned moon landing by 1970.

The president who set his sights on the moon, and who sought to inspire Americans toward greater terrestrial accomplishments as well, was John F. Kennedy. Victor over Vice-President Richard M. Nixon in a close 1960 election, and the youngest person ever elected president (Theodore Roosevelt had been younger when he succeeded the assassinated William McKinley), Kennedy represented no radical transformation in American politics; he was an heir to the liberal Democratic tradition of Franklin Roosevelt and Harry Truman, and was as dedicated as his predecessors to continuing what he described, in his inaugural address, as the "long twilight struggle" against Communist expansionism. Early in his administration, Kennedy supported the ill-fated Bay of Pigs invasion of Fidel Castro's newly Communist Cuba by anti-Castro Cubans based in the U.S.; in October 1962, he faced down Soviet Premier Nikita Khruschev

over the U.S.S.R.'s attempt to install nuclear-armed missiles in Cuba. And it was during his administration that the U.S. stepped up its advisory role in supporting the South Vietnamese regime against a Communist-backed insurgency—although the debate continues to this day as to whether he would have made the massive American troop commitments for which his successor was responsible. But Kennedy nevertheless injected a note of idealism into American foreign policy, particularly with his establishment of the Peace Corps, and with his successful push for a ban on nuclear weapons testing in the atmosphere. On the domestic front—despite his administration's failure to secure congressional passage of initiatives in education, urban

Claes Oldenburg (b. 1929)
Two Cheeseburgers, with Everything (Dual Hamburgers). 1962.
Burlap soaked in plaster, painted with enamel, 7 x 14 ¾ x 8 ⅝ in. (18 x 38 x 22 cm).
Philip Johnson Fund. The Museum of Modern Art, New York, New York.

The "pope of Pop" was Stockholm-born Claes Oldenburg, whose witty, oversized soft sculptures parodied everything from cheeseburgers to bathtubs. His shop/studio The Store staged "happenings," a term coined by John Cage's pupil Allan Kaprow to describe improvised theatrical events bringing Expressionism to performance.

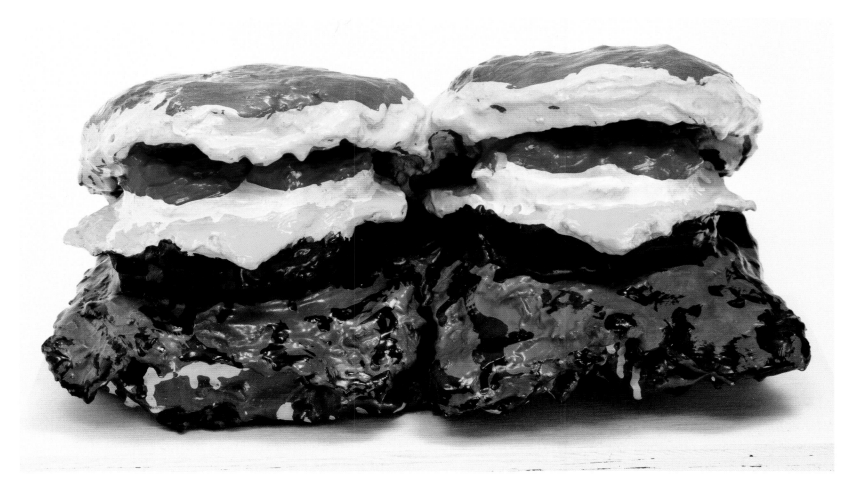

The Kennedy Administration and the Arts

Leonard Bernstein (1918–90).
Photograph. September 1, 1971.
Library of Congress.

Even before he brought classical music into American homes through his televised Young People's Concerts, Leonard Bernstein, music director of the New York Philharmonic, was crossing genres with the Broadway musical *West Side Story,* a gang war retelling of *Romeo and Juliet* that enjoys enduring popularity.

Each year, when the John F. Kennedy Center for the Performing Arts honors outstanding contributors to the nation's cultural life, it celebrates not only the individuals selected, but also the legacy of a presidential administration uniquely devoted to the cultivation of the arts.

On the first day of his presidency, Kennedy signaled his respect for the best in American literary and artistic achievement by having the inaugural poem read by the nation's greatest living poet, Robert Frost. The glare of sunlight kept the 86-year-old Frost from reading the poem he had written especially for the occasion, but he recited from memory "The Gift Outright," one of his best-known works.

> *"Kennedy's brief administration was a gift outright to America's arts community, and to all citizens committed to the elevation of the nation's cultural life."*

Kennedy's brief administration was a gift outright to America's arts community, and to all citizens committed to the elevation of the nation's cultural life. The young president possessed, in the words of composer and conductor Leonard Bernstein, a "reverence…for the functions of the human mind in whatever form, whether as pure thinking or political thinking or creative functions of any sort, including those of art and literature."

President and Mrs. John F. Kennedy Before a Concert by the National Symphony. Photograph. *Library of Congress.*

Despite political upheavals nationally and abroad which challenged the young President Kennedy, his brief term in office was romanticized as "Camelot" for its high ideals, concern for the downtrodden, and patronage of the arts. Pictured are the president and First Lady being presented with a musical score titled "From Sea to Shining Sea" to be played by the National Symphony. They are accompanied by Pulitzer prize–winner John La Montaine (right) and musical director Howard Mitchell.

Kennedy enthusiastically supported plans for the cultural center that would eventually bear his name, and issued an executive order establishing a Federal Advisory Council on the Arts. But his enthusiasm for encouraging artistic excellence, abetted always by his culturally sophisticated wife Jacqueline, extended well beyond official proclamations and lip-service encouragement. With the Kennedys in residence, the White House became the venue for a marvelous array of performances by some of the finest musicians, singers, actors, and dancers of the day. At an event honoring French Minister of Culture André Malraux, Isaac Stern, Leonard Rose, and Eugene Istomin performed a Schubert string trio; on other occasions, performers from the Metropolitan Opera, American Ballet Theater, Jerome Robbins Ballet, and American Shakespeare Festival were featured. And for the first time, jazz musicians gave concerts at the Executive Mansion: the Paul Winter Sextet was part of an otherwise all-classical program on November 19, 1962.

Perhaps the most celebrated White House performance was the November 13, 1961, recital by cello master Pablo Casals, following a state dinner honoring Luis Munoz Marin, governor of Puerto Rico, Casals'

adopted home. Casals' last invitation to play before a president had been in 1904, during the Theodore Roosevelt administration. Now, 57 years later, before an audience that included many of America's greatest composers—Aaron Copland, Walter Piston, Gian Carlo Menotti, and Roger Sessions, among others— and conductors Leonard Bernstein, Eugene Ormandy, and Leopold Stokowski—the 84-year-old Casals demonstrated his undimmed virtuosity in a program of Couperin, Mendelssohn, and Schumann.

President Kennedy's interests ranged beyond the performing arts into a broad range of cultural, scholarly, and scientific achievement. In April of 1962, he invited 49 Nobel laureates in diverse disciplines to a White House dinner. It was on this occasion that he famously remarked that the evening marked "the most extraordinary collection of talent, of human knowledge that has ever been gathered together at the White House with the possible exception of when Thomas Jefferson dined alone." Like Jefferson, John F. Kennedy is remembered as a president whose interests roamed beyond the merely political, and encompassed America's intellectual and cultural development as vital to its standing as a truly great nation.

LEFT: Franz Kline (1910–62)
Untitled. Ca. 1959.
Oil on paper, 24 x 19 in.
(61 x 48 cm).
Smithsonian American Art Museum, Washington, D.C.

To achieve his calligraphic abstractions, Franz Kline used the tools of the house-painter—large brushes and oil-based house paint—laying the paint on in broad, linear strokes with no reference to figure-ground. Labeled an "action painter," his style exemplified the spontaneity and intensity of Abstract Expressionism.

OPPOSITE: Andy Warhol
(1928–87)
Campbell's Soup Can. 1962.
Saatchi Collection, London.

"Being good in business is the most fascinating kind of art," proclaimed Pop icon Andy Warhol. From his New York studio the Factory, he commented on consumer-oriented society in provocative silkscreen paintings of celebrities, grocery items, and news topics, blurring the borders between fine and commercial arts.

Roy Lichtenstein (1923–97)
Whaam! 1963.
Magna acrylic and oil on canvas, 2 canvases, each 68 x 80 in.
(173 cm x 203 cm).
Tate Gallery, London.

Pop Art's mirror of popular culture was in essence a magnifying glass, writ large. Roy Lichtenstein exaggerated the art of the comic book, even going so far as to stencil dots of paint in imitation of the printing process, while James Rosenquist produced canvases as big as the billboards he painted in his first job after college.

Turbulence and Transition

(1963–89)

"Mr. Gorbachev, tear down this wall!"

—President Ronald Reagan, West Berlin, Germany, June 12, 1987

Lyndon Baines Johnson took office on November 22, 1963, on the plane that was about to carry him, and the body of murdered President John F. Kennedy, back to Washington, D.C. In the days that followed, Americans were preoccupied with their grief over the loss of a popular and charismatic figure. National attention also turned to the substantial difference in style between the late president and his successor: while the New England–bred Kennedy had projected an air of youthful urbanity, Johnson, a Texan nearly 10 years older, had the reputation of a gruff and wily Senate insider from an older political school. But Americans soon learned that Johnson's political savvy—he had been Senate majority leader—enabled him to successfully carry out much of Kennedy's unfinished legislative agenda, to which he had pledged his support soon after taking office. Johnson soon put his own stamp on a liberal Democratic program that harked back through Kennedy to Truman and Roosevelt, calling for a "Great Society" and an activist federal role in its realization.

LEFT: Maya Lin (b. 1959)
Vietnam Veterans Memorial ("the Wall"). 1982.
Washington, D.C.

The surface of the Vietnam Veterans Memorial, which is oriented toward the Washington Monument to the east and the Lincoln Memorial to the west, contains the names of those who perished in the Vietnam War, or are still missing. Maya Lin's design—a mirrorlike wall of polished black granite—won a nationwide competition open to any U.S. citizen 18 years or older, fulfilling all the criteria required by the Vietnam Veterans Memorial Fund. The result is an elegant structure that reflects the surrounding landscape, structures, and visitors and inspires contemplation without making a political statement.

OPPOSITE: Milton Glaser (b. 1929)
Dylan. 1966.
Offset lithograph, 33 x 22 in. (83.8 x 55.9 cm).
Gift of the Designer. The Museum of Modern Art, New York, New York.

With its psychedelic rainbows flowing from the head of '60s voice Bob Dylan, Milton Glaser's 1966 poster was an icon of the age, produced at the peak of productivity in his studio, Push Pin Graphics. Glaser's illustrations and advertising designs are characterized by fluid line, vivid color, and vintage-inspired typography.

James Rosenquist (b. 1933)
F-111. 1964–65.
Oil on canvas with aluminum,
23 sections, 10 x 86 ft.
(304.8 x 2,621.3 cm).
*Gift of Mr. and Mrs. Alex L.
Hillman and Lillie P. Bliss
Bequest. The Museum of
Modern Art, New York, New York.*

Pop Art, the 1950s movement
that blurred the borders
between fine art and
commercial art, continued into
the 1970s. The style is writ large
in James Rosenquist's room-
filling *F-111,* where segments of a
warplane are juxtaposed with
artifacts of popular culture: a tire,
a child under a hair dryer, light
bulbs, and other images of
everyday objects.

While the Kennedy administration's sympathies had been with the civil rights movement, it was Johnson who, in spite of the entrenched opposition of southern legislators, achieved passage of the landmark Civil Rights Act of 1964, banning segregation in schools and public places; and the 1965 Voting Rights Act, striking down an assortment of practices used to keep black citizens from southern polling places. Passage of the two acts was the culmination of a movement that had come to dominate the national consciousness, as Americans came to grips with the long-simmering issue of institutional and de facto racism. On an almost daily basis, the news media had reported on sit-in protests, marches, and demonstrations that had often ended violently when broken up by police, and "freedom rides" in which northern civil rights sympathizers traveled south to show solidarity with struggling African Americans. In August of 1963, some 250,000 participants in a march on Washington had heard Martin Luther King Jr. deliver his "I Have a Dream" speech, since considered the inspirational high-water mark of the movement, and a prelude to the legislative accomplishments of the next two years.

Lyndon Johnson, who overwhelmingly defeated conservative Republican candidate Barry Goldwater in 1964, hoped to build his legacy on his civil rights achievements and on the signature components of his Great Society—especially his war on poverty, waged through an array of federal programs; and his success in establishing the Medicare health insurance system for older Americans. But Johnson's domestic accomplishments were destined to be overshadowed— and his presidency destroyed—by a military adventure that ultimately cost 58,000 American lives, and created stark and bitter divisions in American society.

Throughout the preceding decade, the United States had supported the South Vietnamese government in its struggle against a revolutionary movement supported by Communist North Vietnam. Prior to the mid-1960s, however, American engagement had been limited to a largely advisory role, albeit one that had begun to involve the U.S. military in an increasing number of combat situations. But in August of 1964, a reported attack on American naval vessels in the Gulf of Tonkin—an attack whose nature and very existence has since been

David Smith (1906–65)
Cubi XVIII. 1964.
Stainless steel.

David Smith began making openwork metal sculptures after seeing photos of Picasso's, and Smith approached his own constructions as if the bits and strips of salvaged metal were elements of a Cubist painting. *Cubi XVIII*'s boxy and cylindrical components are welded together, the surfaces polished to give the illusion of frosty windowpanes.

a matter of intense debate—led President Johnson to request, and Congress to pass, a resolution enabling him to substantially increase the number of American troops in South Vietnam, and to make them full participants in combat against Communist Viet Cong insurgents and regular North Vietnamese troops. Escalation of the war proceeded steadily, as did domestic protest against American involvement. Officially, the argument for the war was that it would block the eventual Communist domination of Southeast Asia—the so-called domino effect. But those who dissented with the policy of escalation felt

that it was a tragic misuse of American power on behalf of a corrupt South Vietnamese government; further on the left, protesters saw a deliberate frustration of what they felt was a legitimate revolutionary struggle. The fact that a military draft was then in effect only added fuel to the protesters' ire.

By 1968, some 500,000 American troops were engaged in Vietnam, and American bombers were targeting the North. In February of that year, the Tet (Vietnamese New Year) offensive launched by the Viet Cong and its Northern allies demonstrated a power to

strike at will that unnerved Americans at home, and gave yet more impetus to the antiwar movement. Shaken by his near-loss to antiwar candidate Eugene McCarthy in the New Hampshire presidential primary, Johnson announced that he would not be a candidate for reelection that fall.

For the United States, 1968 was destined to become the most explosively divisive year since the end of the Civil War. In April, Martin Luther King Jr. was assassinated by a white racist in Memphis, sparking riots throughout major cities. In June, Democratic presidential contender Senator Robert Kennedy—the late president's brother—was shot and killed immediately after winning the California primary,

"Johnson's domestic accomplishments were destined to be overshadowed—and his presidency destroyed—by a military adventure that ultimately cost 58,000 American lives."

OPPOSITE: **Philip Pearlstein**
(b. 1924)
Two Female Models in the Studio. 1967. Oil on canvas, 50 1/8 x 60 1/4 in. (127.3 x 153.1 cm). *Gift of Mr. and Mrs. Stephen B. Booke. The Museum of Modern Art, New York, New York.*

Illuminating his subjects with glaring light to heighten the contours of flesh—and the imperfections—Philip Pearlstein makes no apologies to his viewer. His objective is to tell it like it is, through Photorealism, even going so far as to crop the composition as if it were a spur-of-the-moment snapshot, as he did for this painting of two female models.

RIGHT: **Richard Lindner** (1901–78)
And Eve. 1970.
Musée National d'Art Moderne, Centre Georges Pompidou, Paris.

Richard Lindner's playfully brash and at times sadistic graphic style was admittedly influenced by his birthplace—Nuremberg, home to major toymakers and the iron maiden (a medieval torture device). Lindner fled Germany to escape Hitler's atrocities, eventually settling in New York, finding success as an illustrator for *Vogue* and other magazines.

which, many believed, had made him the likely nominee of his party. Protests against the war had meanwhile become subsumed into what was amorphously defined as a "youth movement"— a catch-all phrase encompassing a growing allegiance to a "counterculture" embracing drugs, socially and politically charged rock music, and antimaterialistic alternative lifestyles. In the spring, a wave of campus protests, most notably involving the takeover of administration offices at Columbia University, had been associated in part with local issues but were ultimately stoked by incendiary anger over the war.

Out of this social and political maelstrom came the reemergence of a figure once written off as politically moribund: Richard M. Nixon. In a highly polarized three-way campaign involving independent southern

segregationist George Wallace and Democratic Vice-President Hubert Humphrey, handicapped by his association with Johnson's war policies, Nixon triumphed on a platform involving a "secret plan" to end the war. Far from being a radical solution, Nixon's plan involved the gradual turning over of responsibility for prosecuting the war to South Vietnamese forces, and he did begin to draw down the number of American troops involved. But as peace talks in Paris proceeded, Nixon continued to rely on bombing of the North as a tactic, and also, in the early 1970s, undertook the bombing of neighboring Cambodia in order to interrupt North Vietnamese and Viet Cong supply routes in that country. Not until 1973 was a peace accord signed, and a substantial American withdrawal accomplished. In 1975—nearly a year after

OPPOSITE: **Wayne Thiebaud** (b. 1920)
Boston Cremes, from *Seven Still Lifes and a Silver Landscape.* 1970, published 1971.
Linoleum cut from two etchings, two linoleum cuts, two lithographs, and two screenprints, composition: 13 ⁹⁄₁₆ x 20 ⁵⁄₁₆ in. (24.4 x 51.6 cm).
John B. Turner Fund, 1971. The Museum of Modern Art, New York, New York.

Wayne Thiebaud once worked at a café in Long Beach, California, called Mile High and Red Hot serving ice cream (Mile High) and hot dogs (Red Hot). His best-known artworks focus on food, and have the pronounced shadowing of advertisements and the assembly-line composition of cafeteria food displays.

BELOW: **Duane Hanson** (1925–96)
Woman Eating. 1971.
Mixed media, life size.
Museum Purchase through the Luisita L. and Franz H. Denghausen Endowment. Smithsonian American Art Museum, Washington, D.C.

Duane Hanson's sculpture *Woman Eating* was cast in fiberglass reinforced with polyester resin, polychromed in oil paint with every detail of lifelike flesh, then dressed in salvaged clothes and propped with table, chair, and accessories. It is more than a likeness—it verges on the theatrical, leaving the viewer to provide the story of the woman's life.

Nixon left office—the Vietnam War ended with the fall of the South's capital of Saigon and the unification of the country under Communist rule.

Richard Nixon's administration is remembered for two significant accomplishments: the first manned landing on the moon, in July 1969; and the beginning of rapprochement with the Communist People's Republic of China, associated with his historic visit to that country in February 1972. But just four months after that high-water mark in the Nixon presidency came the event that sealed its fate: the burglary of the Democratic Party's headquarters in Washington's Watergate complex by a team of undercover operatives in the employ of Nixon's reelection campaign. Not enough of the campaign's involvement—or of the White House's determined stymieing of an investigation into the burglary—had been brought to light by November to prevent Nixon's landslide reelection. But by the following summer, a vigorous Senate investigation had riveted the nation, and a growing list of administration officials were resigning and being prosecuted. Ultimately, Nixon himself was heavily implicated, in large part because of incriminating conversations on White House tapes he had authorized. With certain impeachment looming, he resigned from office effective August 9, 1974.

Nixon was succeeded in office by Vice-President Gerald Ford, who urged a time of national healing but lost a measure of good will by pardoning his predecessor for whatever criminal acts he might have committed in office. Attempting to secure election in his own right, Ford was narrowly defeated, in the American bicentennial year of 1976, by the centrist Democratic governor of Georgia, Jimmy Carter. But although Carter's administration was free of the political baggage of Watergate, it was plagued by the same domestic difficulties as Ford's—most notably, rampant inflation combined with a sluggish economy. The inflationary pressures had in large part been caused by increases in the price of oil, a point of national preoccupation ever since the Arab oil embargo of 1973 (brought on by American support of Israel in that year's Yom Kippur War) and the ensuing "energy crisis" during which Americans had, for the first time since World War II rationing, experienced shortages of gasoline. Energy, once so abundant that it

had been universally taken for granted, was suddenly a focus of national policy—a phenomenon linked, to no small extent, with the rise of an environmental movement that saw abundant fossil fuels as a significant source of pollution, even in the days before they were associated with climate change.

America's energy woes were exacerbated in 1979, when religiously motivated revolutionaries overthrew the pro-American shah of Iran. The ensuing upheaval resulted in a cutoff of oil from that nation, and gas lines again snaked around the nation's filling stations. But the Carter presidency's undoing, after a single term, was largely a function of its inability to deal with the Iranian revolutionaries' taking of 52 American hostages and holding them for 444 days— a term of captivity that lasted, as it turned out, until Carter's last day in office. In the election of 1980, he was soundly defeated by the aging but ebullient

conservative Republican Ronald Reagan, former film actor and governor of California.

Proclaiming that it was "morning in America," Reagan considered himself a revolutionary—a messenger of smaller government, lower taxes, a reinvigorated military, and restored national pride. On that last count, he was helped immeasurably by Iran's release of the hostages on the day of his inauguration, though through no action of his own. With regard to the other principles behind his campaign, he did set about reducing taxes, deregulating industries that had previously been subject to greater government control, and increasing military spending.

Although Reagan kept up a dialogue with the succession of three Soviet leaders who served during his two terms of office, he did resort to the traditional Cold War practice of pursuing proxy conflicts with communism. He ordered an invasion of the Caribbean

The Environmental Movement Takes Shape

Planet Earth from Space. Photograph.

In December 1968, the people of Earth saw for the first time a portrait of their home planet, when astronauts of Apollo 8 took photographs from space. Photos of Earthrise over the horizon of the moon—a rocky terrain with no biological life—put the matter in perspective: Earth is a fragile habitat, and the only home we have.

The fuel that fed the fire was unspectacular—trash, tree limbs, spilled fuel oil. But when Ohio's Cuyahoga River burst into flames on June 22, 1969, far more was ignited than a single polluted waterway. The burning of the Cuyahoga posed a frightening question: if a river could be so badly abused that it catches fire, what other nasty surprises were in the offing?

By the early 1970s, ominous news about the environment had become commonplace: the "death" of Lake Erie, through the oxygen-depriving process called eutrophication linked to phosphates in detergents; a vast portion of the Atlantic Ocean fouled with oil, tar, and bits of plastic; urban air quality so bad that the fledgling Environmental Protection Administration (EPA) floated the idea of

transportation controls to alter the American public's "long-standing and intimate relation to private automobiles."

The alarms were not ignored. The first celebration of Earth Day had been held in April 1970, and in that same year the EPA was given responsibility for enforcing federal environmental legislation. That phrase itself—"federal environmental legislation"—applied to only a tiny body of law prior to the late 1960s. But by 1970, both a Clean Water Act and an amended and reinforced Clean Air Act were on the books.

> *"In 1968, the astronauts aboard Apollo 8 trained their cameras on the planet while on their way to lunar orbit…the sight of that blue-and-white orb reminded millions that Earth was all they had."*

The transformation in public thinking had taken a giant stride with the 1962 publication of Rachel Carson's book *Silent Spring*, its title a warning of a not-too-distant spring without birdsong. The threat to bird life was the rapid contamination of the environment with chemical pesticides, especially DDT, and Carson's underlying message was that humans were ultimately as susceptible as wildlife to the hazards of the contaminants we had introduced into our air, water, and soil. Over considerable objection, DDT was outlawed in the United States, though it remains in use throughout much of the world.

The late 1960s had also provided the nascent environmental movement with a powerful symbol of Earth in all its beauty and fragility. In 1968, the astronauts aboard Apollo 8 trained their cameras on the planet while on their way to lunar orbit. Their

photograph was taken from too great a distance to tell if there were any rivers on fire, or how many lakes were dying from eutrophication or acid rain, or where toxic waste dumps might be hidden. But the sight of that blue-and-white orb reminded millions that Earth was all they had.

The 1970s marked the beginning of an era that began to take seriously a broad range of environmental issues, ranging from sewage treatment to overburdened landfills, from recycling to development of alternative energy sources, from wetlands preservation to the deterioration of the ozone layer and global warming. It wasn't always easy to rally the public around any of these issues, but at least a dialogue had begun.

Smog Blanketing Downtown Los Angeles.
Photograph.

In the 1970s the federal government was already aware of the environmental impact of the American public's "long-standing and intimate relation to private automobiles." Three decades later, China's vigorous industrial growth and surging rates of car ownership—third highest in the world—would bring discussion to a global level, with no effective international environmental agreement in place.

I. M. Pei (b. 1917)
East Wing, National Gallery of Art, Washington, D.C. 1974–78.

To compensate for the uneven site, I. M. Pei laid out the East Wing of the
National Gallery of Art in two triangular structures—one housing galleries,
the other offices—connected at various levels by free-floating
passageways within a skylit courtyard. The mobile hanging in this
courtyard photo is one of Alexander Calder's "kinetic sculptures."

Philip Johnson (1906–2005) and **John Burgee** (b. 1933) *AT&T Building* (now the Sony Building), *New York, New York.* 1984.

Johnson/Burgee's AT&T Building softened Philip Johnson's International style of earlier decades, gracing the boxy steel-and-glass skyscraper design with a massive arched entrance, a colonnaded arcade, and a roofline shaped like the pediment atop a Chippendale highboy. This return to ornament classes the building as Postmodern.

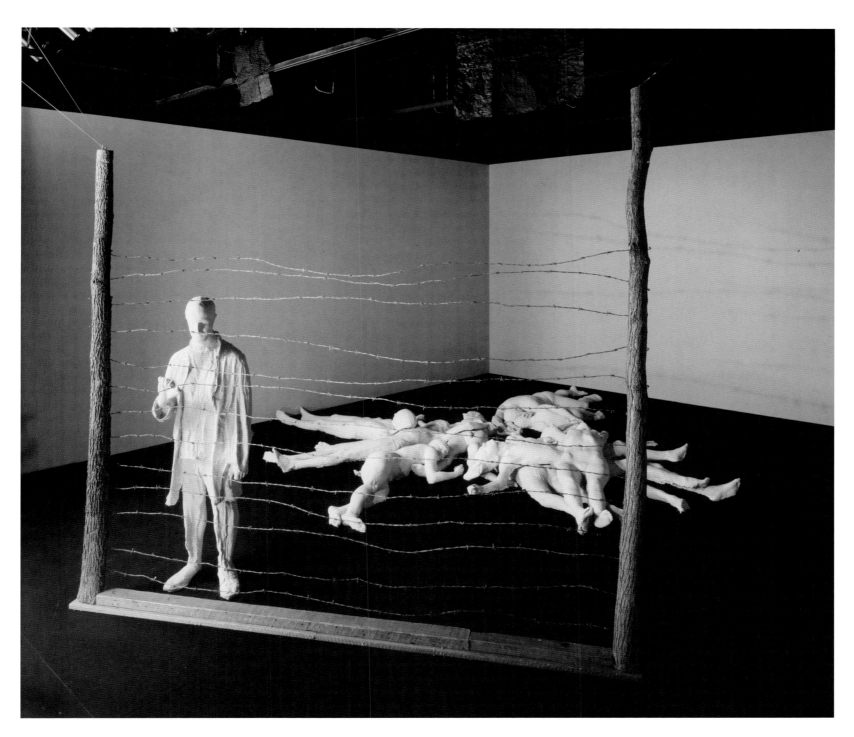

OPPOSITE: Chuck Close (b. 1940)
Phil III. 1982.
Cast paper pulp, 68 x 52 ½ in. (172.7 x 133.3 cm).
Smithsonian American Art Museum, Washington, D.C.

Chuck Close's 1982 portrait of friend Philip Glass (composer of the "portrait opera" *Einstein on the Beach*) is made from tiny squares of handmade paper pulp. Earlier versions used black and white paint, watercolors, and stamped fingerprints. In each, Close worked from a photo, translating the image cell by cell to the finished work.

ABOVE: George Segal (1924–2000)
The Holocaust. 1982.
Plaster, wood, and wire.
Purchase, Dorot Foundation Gift, 1985. The Jewish Museum, New York, New York.

Stirring the viewer not to forget the Nazis' genocide of Jews and non-Aryans, George Segal's sculpture is made more chilling by its very lack of color, something he did for most of his sculptures because white signified intuitive awareness. His figures were created by manipulating layers of plaster-dipped cloth strips over live models.

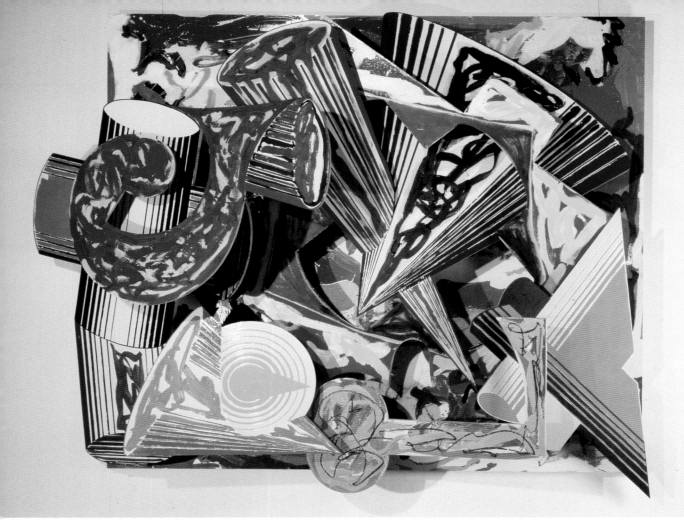

ABOVE: Frank Stella (b. 1936)
La vecchia dell'orto, 3x, from the series *Cones and Pillars.* 1986.
Mixed media and painted aluminum.
Musée National d'Art Moderne, Centre Georges Pompidou, Paris.

In 1996 art critic George Stolz described Frank Stella as "America's greatest living baroque painter," referring to Stella's long career evolving abstract art with perpetual surprise and innovation—he was a leader, not a follower. His mixed-media sculpture/paintings explore the interlaced geometry of painted objects.

RIGHT: Bruce Nauman (b. 1941)
Learned Helplessness in Rats (Rock and Roll Drummer). 1988.
Video installation: plexiglass maze, closed-circuit video camera, scanner and mount, switcher, two videotape players, 13-inch color monitor, 9-inch back-and-white monitor, video projector, and two videotapes (color, sound); Maze: 22 x 126 x 130 in. (55.9 x 320 x 330.2 cm).
Acquisition from the Werner Dannheisser Testamentary Trust. The Museum of Modern Art, New York, New York.

Learned Helplessness in Rats may be about the defeatist attitude humans acquire by repeated failures, or about the use of laboratory rats to confirm hypotheses, or about the shaping of attitudes by culture. Bruce Nauman's enigmatic installations are open to interpretation. They are praised by many as innovative, scorned by others as anti-art.

Helmut Jahn (b. 1940)
United Airlines Terminal, O'Hare International Airport, Chicago. 1988.

Trained in the glass-curtain building style of Mies van der Rohe, Helmut Jahn broke away from that strict Modernist approach to introduce color, pattern, and texture drawn from Art Deco and other vintage styles. Terminal 1 at Chicago's O'Hare airport is an example of Jahn's high-tech yet visually appealing structures.

(1989–PRESENT)

"What we may be witnessing is not just the end of the Cold War, or the passing of a particular period of postwar history, but the end of history as such…"

—FRANCIS FUKUYAMA, "THE END OF HISTORY?" 1989

The Cold War was the longest conflict in which the United States was ever involved, and the only one that ended because of the internal collapse of its adversary. In August of 1991, two years after the Communist governments of its Warsaw Pact allies began to totter and fall, the Soviet Union itself came to its final crisis when an unsuccessful coup attempt against Premier Mikhail Gorbachev ended with the U.S.S.R.'s component republics successively declaring their independence, leaving Russia itself as the largest and most powerful remaining fragment of the former Eurasian monolith. After years of global confrontation with the Soviets—always with the threat of nuclear war in the background—the United States suddenly found itself being spoken of as the world's only remaining superpower. But while that may have been true in a strictly military sense—and while no potential rival as powerful as the Soviets had yet appeared on the horizon—it hardly meant that there were no competing ideologies or regional hegemonists to deal with, or that a "Pax Americana"

Nam June Paik (1932–2006)
Electronic Superhighway: Continental U.S., Alaska, Hawaii. 1995.
(Continental U.S. only).
49-channel closed circuit video installation, neon, steel and electronic components, approx. 15 x 40 x 4 ft. (457.2 x 1,219.2 x 121.9 cm).
Gift of the Artist. Smithsonian American Art Museum, Washington, D.C.

Nam June Paik coined the term "electronic superhighway" to refer to the stream of television and Internet video that has replaced cross-country travel. Taking the viewer back in time and into the future, Paik's video installation plays film clips from *Looney Tunes* to CNN broadcasts on hundreds of monitors outlined in neon like states on a map.

World Trade Center, Lower Manhattan, New York, New York. September 11, 2001, 9:59 A.M. Photograph.

The War on Terror, as it was named by President George W. Bush, began after Islamic militants crashed hijacked planes into the World Trade Center on September 11, 2001. Pictured is the collapse of the south tower; the north tower collapsed at 10:28 A.M. Ironically, the first battlefront was against that militant group's base in Afghanistan, which the U.S. had formerly backed in the 1979–89 Afghan War against Soviet invasions.

had suddenly been imposed upon the world. If anything, the global scene following the breakup of the U.S.S.R. resembled the world of the nineteenth-century "Pax Britannica," in which the designated superpower of the day was perpetually fighting little wars, and engaging in far-flung peacekeeping missions with varying degrees of success.

President Ronald Reagan's armed intervention in the politics of Grenada was a prelude to a flurry of pointed projections of American power. In 1989, Reagan's Republican successor George H.W. Bush invaded Panama to remove that country's dictator, erstwhile American ally Manuel Noriega, because of his involvement in the drug trade. Three years later, President Bush sent 28,000 troops to Somalia as that east African nation descended into anarchy; the stated reason was to enable humanitarian aid to succeed, but the Americans soon became entangled in a multidimensional civil war that they could not possibly resolve. The mission was curtailed by President Bill Clinton in the following year—but Clinton himself could not avoid the use of American military might in what critics called "nation building": he sent troops to Haiti in 1994, to fortify that desperately poor nation's failing democracy; and led the North Atlantic Treaty Organization (NATO) in its 1999 bombing of Serbia to halt its oppression of ethnic Albanians in its province of Kosovo.

It was George H.W. Bush, however, who launched the most formidable military action of the immediate post–Cold War era. This was the Gulf War, Operation Desert Storm, a response to Iraqi dictator Saddam Hussein's sudden invasion and annexation of the neighboring country of Kuwait in August 1990. Declaring that "this will not stand," Bush over the next six months assembled a coalition of nations allied

> *"If anything, the global scene following the breakup of the U.S.S.R. resembled the world of the nineteenth-century 'Pax Britannica,' in which the designated superpower of the day was perpetually fighting little wars, and engaging in far-flung peacekeeping missions with varying degrees of success."*

in the purpose of prying Saddam from his oil-rich "13th province" of Kuwait. After obtaining congressional approval to commence combat operations, Bush struck Iraq from the air, then ordered a lightning ground attack that quickly restored Kuwaiti independence. But the U.S. stopped short of driving deep into Iraq, and removing Saddam from power. Military and foreign policy analysts continue to debate the wisdom of this decision, particularly in light of the far deadlier and more protracted Iraq war that would dominate the coming decade.

George H.W. Bush was destined to be a one-term president. Despite his high approval ratings in the aftermath of victory in the Gulf War, the success of his administration was undermined by a deteriorating domestic economy in late 1991 and early 1992. The boom times of the 1980s had run their course, and Bush's high profile in foreign affairs—the very source of his popularity—now weighed against him, as he was perceived as not focusing sharply enough on the economy. He was defeated by Democratic Arkansas Governor Bill Clinton in a three-way race involving billionaire Independent H. Ross Perot; no candidate received a majority of the vote.

It was Bill Clinton's good fortune to assume the presidency not only on the threshold of a relatively peaceful interlude in international affairs, but at the beginning of a prolonged era of economic recovery that assured him a second term in office and sustained popularity that survived even his near conviction, in 1999, on impeachment charges stemming from his sexual affair with a White House intern. For some time, the U.S. economy had been in a process of transformation: having once been built on a largely manufacturing base, it was increasingly dependent on the service, financial, and high technology industries. Manufacturing's decline, which had been concurrent with the rise of overseas manufacturing economies with less expensive labor pools, was not without wrenching effect on factory workers and the urban areas they lived in, mostly in the Northeast and upper Midwest. But in the 1990s, high technology was the darling of the financial markets and the economic engine of newer, growing population centers,

ABOVE: Rackstraw Downes (b. 1939)
Canal Homes at Bayou Vista. 1993.
Oil on canvas, 11 ¼ x 120 ½ in. (28.6 x 306.1 cm).
Gift of Lily Auchincloss. The Museum of Modern Art, New York, New York.

Rackstraw Downes paints *en plein air* to create hyperrealistic works like *Canal Homes at Bayou Vista.* The canvas encompasses the artist's all-around view of the site—stilt houses near an oil refinery—but rather than freeze time like a photograph, Downes's paintings (made without photographic reference) widen the viewer's perception of the moment.

LEFT: Martin Puryear (b. 1941)
"North Cove Pylons" at Battery Park City, New York, New York. 1995.
Granite and stainless steel.

Stacked on a granite base, tapering tiers of barrel-shaped steel lattice function as lanterns, with the light scattered by mirrors inside each tier. Martin Puryear's *"North Cove Pylons"* are an interplay of geometry, light, and mass—the basic elements of sculpture—and like sculpture, their forms look carved, but they were fabricated with modern engineering techniques.

Eric Fischl (b. 1948)
Untitled. 1992.
Monotype, 36 x 73 ⅛ in. (91.4 x 185.7 cm).
Smithsonian American Art Museum, Washington, D.C.

"The underbelly, carnie world of Ed Paschke and the hilarious sexual vulgarity of Jim Nutt were revelatory experiences for me," says Eric Fischl in identifying the Chicago Imagists as major influences. Fischl's works—paintings, sculptures, monotypes, and other media—are aggressive and compelling, with the frankness of Photorealism.

particularly in California's "Silicon Valley" and the Pacific Northwest. Beginning in the 1980s, the computer industry had expanded broadly into the realm of personal computing—but it was during the '90s that the idea of linking those millions of home computers to an "information superhighway" (as the Internet was then popularly called) became not only a cultural phenomenon but a speculative bonanza for investors. Suddenly, the "dot-com boom" was on, as venture capitalists floated one Internet start-up company after another, and financial indicators soared accordingly. Some optimists even proclaimed that a new, cycle-proof economic era had commenced. In a way, their sense of things reflected the mindset of those who subscribed to the idea that the fall of communism

and the triumph of liberal democracy had brought about an "end of history," the title of a 1989 essay by Francis Fukuyama.

History, and business cycles, returned in a rush with the new millennium. Early in the year 2000, the dot-com bubble burst, erasing vast amounts of speculative capital and leaving in its aftermath an environment in which only the most soundly based Internet and related companies would survive. History of an unprecedented sort took center stage in that fall's presidential election, the first ever to be decided by the U.S. Supreme Court. While Democrat Al Gore, Clinton's vice-president, had achieved a popular vote plurality of 500,000, victory depended on a winning margin in the Electoral College. With Florida's electoral votes hanging in the balance, the Court halted a recount of the state's badly confused balloting, leaving Republican George W. Bush—son of the 41st president—with a Florida plurality of several hundred votes, an Electoral College majority, and the presidency.

Bush had been in office for less than eight months when the nation, and the world, received sudden and unequivocal proof that history had by no means come

Richard Meier (b. 1934)
Getty Center, Los Angeles. 1997.

Richard Meier's ideal has always been the smooth, pristine white constructs of early Le Corbusier, but to suit the landscape of the Getty Center he chose tawny rough-cut Italian travertine marble. The Getty Center complex is dominated by a museum, and also includes an auditorium, library, reading room, bookstore, and cafés.

to an end. On September 11, 2001, airliners hijacked by Islamic fanatics were deliberately piloted into the twin towers of New York's World Trade Center, toppling both. Within the same morning hour, another hijacked plane tore into the Pentagon. The combined death toll was nearly 3,000. Within weeks, the United States was at war in Afghanistan, a theocratic state ironically ruled by the faction that had driven out America's old nemesis, the Soviet Union. The "War on Terror," as the Bush administration called it, would come to involve not only the routing of the Taliban government that had allowed Afghanistan to become a safe haven and training ground for the al-Qaeda militants who had engineered the attacks on New York and Washington, but the creation of a Department of Homeland Security and passage of a "Patriot Act" to coordinate domestic protection. Debate still rages over the methods employed, which have ranged from attempted surveillance of citizens' library records to

sequestering of enemy combatants, deprived of due process, at the naval base in Guantanamo, Cuba; the administration's methods, critics have argued, suggest a triumph of sorts for the nation's enemies.

Less than two years after the terror attacks, the United States was at war on a different front, in Iraq. Saddam Hussein had remained in power after the Gulf War of 1991, despite the constrictions of internationally enforced no-fly zones over his fractious northern and southern provinces and an embargo on trade with Iraq. The Bush administration was convinced that Saddam was manufacturing and stockpiling what it termed "weapons of mass destruction," a contention reinforced by the dictator's prior use of deadly gas attacks against his own rebellious citizens, and by his refusal to cooperate with United Nations inspectors looking for evidence of nuclear weapons research and production. The administration also attempted to link Saddam with al-Qaeda, although his was a deeply secular

John Baeder (b. 1938)
Rosebud Diner. 2004.
Oil on canvas, 30 x 40 in. (76.2 x 101.6 cm).
Private Collection.

The roadside diner, the restaurant car of the train, the short-order cook at the lunch counter—these icons of the past branded in the childhood memory of John Baeder find their preservation in his paintings. "Take from culture in one dimension and contribute back in another dimension," says Baeder of the process of translating past to paint.

regime inimical to the radical Islamic principles of al-Qaeda mastermind Osama Bin Laden.

Having presented his case to the UN, secured congressional approval for hostilities, and assembled a military coalition—the chief foreign component of which was British—President Bush issued an ultimatum to Saddam to relinquish power and leave Iraq. When Saddam ignored the stated deadline, the

U.S. launched massive air attacks, followed by a ground invasion that quickly overthrew the Iraqi regime and sent its leader into hiding (later discovered, he was tried and executed by the new Iraqi government). As of this writing, the U.S. occupation of Iraq, and the roll of American casualties, continues in the sixth year of fighting. Meanwhile, an antiwar movement—not as dramatic or theatrically staged as in the days of Vietnam, but vocal nonetheless—sustains its role in public debate, and in the 2008 presidential contest.

The end of history did not come with the new millennium. Nor did the traditional economic cycles end, as became evident once again in the roiling financial markets of 2007 and 2008. And new threats loom: a lopsided balance of payments with China, the reemergence of Russia as a world power, the engineering

of a global response to climate change. But history—for the United States as well as for the rest of the world—is an assurance, not a millstone; a reminder, not a sentence. In America especially, only those who begin its study with the events of last week, or last month, or last year have any reason for pessimism—just as would have been true in 1941, or 1930, or 1861, or in the desperate days when George Washington was lucky to have escaped across New Jersey with the ragged remnants of an army. "We have not come this far," said a half-American named Winston Churchill, "because we are made of sugar candy."

BELOW: Louise Bourgeois (b. 1911)
Maman. 1999.
Bronze, stainless steel, and marble.
Turbine Hall, Tate Modern, London.

Like Louise Bourgeois's other sculptures, *Maman* arises from the depths of her childhood memories to evoke the complex emotions of universal human experience. The giant spider *Maman* signifies mother. Imposing, she inspires awe; protective, her eggs are held in a steel cage; vulnerable, her frail legs may collapse under the stress of her mate's infidelity.

ABOVE: Dale Chihuly (b. 1941)
Mingei International Museum Chandelier. 2005.
Glass and steel.
Mingei International Museum, Escondido, California.

Dale Chihuly is renowned for taking the art of glass-blowing to the cutting edge, with designs that capture the fluid movement of molten glass and are sensitive to the interplay of light and glass. Chihuly also goes beyond tradition by transforming the art of the solitary glass-blower into a team effort engaged in creating large installations.

LEFT: Stephen Fox (b. 1957)
Edge of the Woods. 1997.
Oil on canvas, 36 x 28 in.
(91.4 x 71.1 cm).
Private Collection.

Stephen Fox only paints night scenes, and leaves the interpretation to the viewer. In *Edge of the Woods,* we feel like intruders on a quiet moment: the seated man has heard our step, but the boy is absorbed by his reflection in the glass door of the illuminated phone booth.

OPPOSITE, BOTTOM: Gwathmey Siegel & Associates (founded 1968)
Naismith Basketball Hall of Fame (NBA Hall of Fame).
Springfield, Massachusetts.
2002.

The objective of Gwathmey Siegel is "to create buildings that perform as well as excite." For the Naismith Basketball Hall of Fame, the purpose of the facility is made unmistakable by the geometry of the architecture—in the ball-shaped dome that houses the basketball court, and the illuminated basketball atop the adjacent spire.

RIGHT: **Frank Gehry** (b. 1929)
Fisher Center for the Performing Arts. Bard College, Annandale-on-Hudson, New York. 2003.

Frank Gehry's early architectural designs were somewhat whimsical constructs made from corrugated steel, plywood, and other inexpensive materials. The collagelike assemblage concept is evident in later, costlier works as well, like the undulating steel that clads the $62 million Fisher Center for the Performing Arts in upstate New York.

Richard Serra (b. 1939)
Wake. 2004.
Steel, each piece: 125 ft. (3,810 cm) long.
Olympic Sculpture Park, Seattle Art Museum, Seattle, Washington.

What's it like to wend your way through the wiggly W's of *Wake*? That's
up to you to say. Of the wavy walls of steel, and the changing shape of
the space between them, sculptor Richard Serra says, "The subject of this
piece is not its image and it is not the steel. It is you. Your experience in
walking through becomes the content."

Thom Mayne (b. 1944)
Caltrans District 7 Headquarters. Los Angeles. 2004.

The architectural firm Morphosis drops the *meta-* to emphasize that design is not imposed from outside—the conventional approach—but is suggested by the changeable landscape. The environment around Caltrans District 7 Headquarters suggested that it be shrouded in a mechanical skin that opens and closes in response to changing temperatures.

Ralph Goings (b. 1928)
Five in Place. 2005.
Oil on canvas, 20 x 20 in. (50.8 x 50.8 cm).
Private Collection.

California artist Ralph Goings abandoned abstract painting in 1963 out of
a desire to "go as far to the opposite" as he could. But rather than copy a
photograph, as other Photorealists were doing, he projected the image
and traced it, enjoying the negative criticism his contrariness received.
Objects related to fast food are his chosen subject.

ABOVE: Robert Smithson (1938–73)
Floating Island, New York, New York. 2005.

Before his death in 1973, "earthwork" sculptor Robert Smithson envisioned a small island floating around Manhattan like a piece of Central Park set into orbit. His dream was realized for two weekends in September 2005, as part of a Whitney show, when a tugboat pulled a barge landscaped with boulders from Central Park, nursery trees, and paths.

RIGHT: Tom Pfannerstill (b. 1951)
Marlboro. 2004.
Oil on carved wood, 4 ½ x 3 ¼ in. (11.4 x 8.3 cm).
Private Collection.

Tom Pfannerstill's paintings of discarded objects are in a style called *trompe l'oeil,* "trick the eye"—they are so realistic they give the illusion of being three-dimensional, projecting out from the surface of the wood. Documented on the back with the place where the object was found, his works show us the other side of consumerism.

OPPOSITE: Robert Ginder
(b. 1948)
Essential Blue. 2002.
Oil and gold leaf on wood,
24 x 31 in. (61 x 79 cm).
Private Collection.

Robert Ginder's description of
his works as "contemporary
secular icons" reveals his
reverence for ordinary things and
vernacular architecture. Like
icons, his paintings are shaped
in an arch and dressed in gold
leaf, as in the southern California
sky of this painting. Distressing
the wood with insect trails and
scars adds to the feeling of
antiquity.

RIGHT: **Marilynn Gelfman**
(b. 1939)
PPF 76. 2007.
Mixed media, height: 15 in.
(38.1 cm).
Private Collection.

This work is about our national
pastime and the passing of time.
Gelfman's works are a chorus of
bits and pieces humming their
histories to the tune of a cultural
anthem. Each sculpture is
comprised of myriad small and
familiar objects: here, Whitey
Ford on top, Eddie Matthews
in the center of the sphere,
and a silver baseball trophy at
the bottom.

PHOTOGRAPHY CREDITS

Art Resource, NY: pp. 60 (bottom), 68, 78 (top), 81, 166 (left), 183 (top). The Andy Warhol Foundation, Inc./© 2008 The Andy Warhol Foundation for the Visual Arts/ARS, NY: p. 275. Bildarchiv Preussischer Kulturbesitz: p. 33. Christopher Burke, NY, © 2008 Kate Rothko Prizel & Christopher Rothko/Artists Rights Society (ARS), NY: p. 261. Art © Estate of David Smith/Licensed by VAGA, New York, NY: p. 281. Georgia O'Keeffe Museum, Santa Fe/© 2008 Georgia O'Keeffe Museum/Artists Rights Society (ARS), NY: p. 230. Giraudon, © 2008 Artists Rights Society (ARS), NY/ADAGP, Paris: p. 283. Grandma Moses Properties Co./Edward Owen: pp. 4–5. HIP: pp. 34, 194, 195. © 2008 The Jacob and Gwendolyn Lawrence Foundation, Seattle/Artists Rights Society (ARS), NY: p. 268. The Jewish Museum, NY: Art © The George and Helen Segal Foundation/Licensed by VAGA, New York, NY: p. 293; John Parnell: p. 234. Erich Lessing: pp. 21, 86. Timothy McCarthy: p. 256. The Metropolitan Museum of Art: pp. 14, 17, 70, 74 (top), 82 (bottom), 85 (left), 85 (right), 94 detail (top), 94 (bottom), 95, 96, 97 (left), 142, 145, 165 (bottom), 176, 183 (bottom), 186 detail (top), 187, 206 (top) (© 2008 Frank Lloyd Wright Foundation, Scottsdale, AZ/Artists Rights Society (ARS), NY), 206 (bottom), 231; Richard Cheek: p. 69, 78 (bottom); Licensed by Scala: p. 22; Art © Estate of Stuart Davis/Licensed by VAGA, New York, NY: p. 239; Paul Warchol: p. 67. Bruce White: p. 12 (bottom). Mingei International Museum: p. 303 (right). Munson-Williams-Proctor Arts Institute, © 2008 Delaware Art Museum/Artists Rights Society (ARS), NY: p. 199. The Museum of Modern Art, NY/Licensed by Scala: p. 141, 210 (bottom) (© 2008 Estate of John Marin/Artists Rights Society (ARS), NY), 215, 263 (© 2008 The Willem de Kooning Foundation/Artists Rights Society (ARS), NY), 264 (Art © Jasper Johns/Licensed by VAGA, New York, NY), 269 (Philip Johnson Fund, 1962, Courtesy of the Oldenburg van Bruggen Foundation, © 2008), 278 detail (top), 279, 280 (Art © James Rosenquist/Licensed by VAGA, New York, NY), 282 (© Philip Pearlstein) (© 2008 Delaware Art Museum/Artists Rights Society (ARS), NY), 285 (Art © Wayne Thiebaud/Licensed by VAGA, New York, NY), 294 (bottom) (© 2008 Bruce Nauman/Artists Rights Society (ARS), NY), 298–99. National Portrait Gallery, Smithsonian Institution: pp. 12, 39, 101, 107, 109, 131, 134 (bottom), 168, 184. National Trust: p. 185. The Newark Museum, Newark, NJ: pp. 2, 42 (bottom), 60 detail (top), 61, 117, 122, 122–23, 133, 137, 152 (right), 213; Peter Furst: p. 32 (bottom); Art © Estate of Theodore Roszak/Licensed by VAGA, New York, NY: p. 214 (bottom). The New York Public Library: pp. 79, 102, 104, 182, 216. Nimatallah: p. 201. Edward Owen: p. 143. The Philadelphia Museum of Art: pp. 19, 73, 100, 169, 170 detail (top), 171. Réunion des Musées Nationaux: pp. 72, 128–29; Gérard Blot: p. 200; Bulloz.: pp. 128–29; CNAC/MNAM © 2008 Frank Stella/Artists Rights Society (ARS), NY: p. 294 (top); CNAC/MNAM Jacqueline Hyde, © 2008 Estate of Louise Nevelson/Artists Rights Society (ARS), NY: p. 265; CNAC/MNAM Philippe Migeat, © 2008 the Pollock-Krasner Foundation/Artists Rights Society (ARS), NY: p. 260; CNAC/MNAM Wolfgang Volz, © Christo 1976: p. 286; C. Jean, © 2008 Georgia O'Keeffe Museum/Artists Rights Society (ARS), NY: 204 (left); Hervé Lewandowski: p. 192, 205 (repro-photo) (© 2008 Georgia O'Keeffe Museum/Artists Rights Society (ARS), New York); René-Gabriel Ojéda: p. 177. Ricco-Maresca Gallery: p. 158. Scala: pp. 150 (top), 151 (top). Smithsonian American Art Museum, Washington, D.C.: pp. 9, 23, 32 (top), 35, 63, 66, 82 (top), 90, 105, 112–13, 118–19, 121, 127, 130, 132, 146 (bottom), 152 (left), 154 detail (top), 154 (bottom), 155, 156 (bottom) (Hemphill), 161, 166 (right), 196, 197 (left), 197 (right), 198, 202–203, 207, 209, 210 detail (top), 211, 212, 222 (© Berenice Abbott/Commerce Graphics, NYC), 227, 228–29, 238, 240, 241, 242, 243, 244, 246–47, 251, 254–55, 274 (© 2008 The Franz Kline Estate/Artists Rights Society (ARS), NY), 284 (Art © Estate of Duane Hanson/Licensed by VAGA, New York, NY), 292, 296 detail (top), 296, 300, back cover. Snark: pp. 20, 163, 252 (Art © Estate of Ben Shahn/Licensed by VAGA, New York, NY). Tate Gallery: pp. 276, 303 (left). Terra Foundation for American Art, Chicago:

p. 157, 170 (bottom). Alto Tutino: p. 36 (bottom left). Vanni: p. 178 (top). Werner Forman: pp. 26 detail (top), 26 (bottom), 27, 30, 31, 36 (top), 38 (bottom). Yale University Art Gallery: pp. 62, 64–65, 74 (bottom), 75, 83, 84, 87, 88–89, 92–93, 97 (right), 114, 126, 153, 179, 287 (left).

The Bridgeman Art Library International: Boltin Picture Library: p. 162; DACS/Christie's Images: p. 253 (right).

Christie's Images Ltd: front cover, p. 18.

Licensed by Curtis Publishing, Indianapolis, IN, Printed by permission of the Norman Rockwell Family Agency, © 1943 Norman Rockwell Family Entities: p. 253 (left).

Detroit Institute of Arts: pp. 28 (© 1997), 36 (bottom right) (© 1999), 37 (Founders Society Purchase with funds from Flint Ink Corporation, © 1988).

Estostock: pp. 48 (top), 48 (bottom), 217, 221 (top), 221 (bottom); Peter Aaron: pp. 295, 305 (top); Lawrence Anderson: p. 309; Scott Frances: pp. 291, 301, 305 (bottom); Jeff Goldberg: pp. 297, 299 (bottom); Peter Maus: p. 266; Ezra Stoller: pp. 262, 267, 270, 271, 290; Roger Straus III: p. 25; Tim Street-Porter: pp. 258 detail (top), 258 (bottom), 259; David Sundberg: p. 311 (top); Laura Swimmer: pp. 24, 308.

Courtesy Marilynn Gelfman: p. 313.

Library of Congress, Prints and Photographs Division: pp. 7, 8, 10 detail (top), 12 (top), 13, 15, 16, 38 (top), 40–41, 42 (top), 43 (left), 43 (right), 44 detail (top), 44 (bottom), 45, 46, 47, 76 (bottom), 80, 134 (top), 135, 136, 138, 139, 140 (top), 140 (bottom), 144, 146 (top), 147, 148–49, 150 (bottom), 151 (bottom), 159, 160, 164, 165 (top), 167, 172, 173, 174, 175, 180, 181 (top), 181 (bottom), 186 (bottom), 188, 189, 190, 191, 193, 204 (right), 208, 214 (top), 218, 223, 224, 225 (top), 225 (bottom), 226 (left), 226 (right), 232 detail (top), 232 (bottom), 233, 235 (left), 235 (right), 236, 237, 245 (top), 245 (bottom), 249 (right), 250 (top), 250 (bottom), 255 (right), 272, 273, 306; Jack E. Boucher, 1976: pp. 76 detail (top), 77.

Andrew Moore: p. 98.

J. P. Morgan Chase Archives: p. 106.

© 2008 Museum of Fine Arts, Boston: pp. 50 (bottom), 51, 52, 53 (top), 53 (bottom), 56, 57 (left), 57 (right), 58, 71, 91, 103, 110 detail (top), 111, 116, 124–25.

NASA: p. 288.

National Archives, College Park, MD: p. 120; Washington, D.C.: p. 108.

OK Harris Gallery, NY: pp. 302, 304, 310, 311 (bottom), 312.

Peabody Essex Museum, Salem, MA: pp. 49, 50 (top), 54, 55.

SuperStock: age fotostock: Art © The George and Helen Segal Foundation/Licensed by VAGA, New York, NY: p. 219; Jon Arnold Images: p. 289; British Museum: p. 29; Richard Cummins: p. 10 (bottom); Digital Vision Ltd.: p. 99; SuperStock Inc.: pp. 115, 257, 278 (bottom), 307; Yoshio Tomii: pp. 248–49; Steve Vidler: p. 178 (bottom).

Worcester Art Museum, Worcester, MA: p. 59.

Courtesy Ellin Yassky: p. 156 (top).

Z Stock, Charles J. Ziga: pp. 220, 287 (right).